REVISITING 1759

The Conquest of Canada in Historical Perspective

The British victory on the Plains of Abraham in September 1759 and the subsequent Conquest of Canada were undoubtedly significant geopolitical events, but their nature and implications continue to be debated. *Revisiting 1759* provides a fresh historical reappraisal of the Conquest and its aftermath using new approaches drawn from military, imperial, social, and Aboriginal history.

This cohesive collection investigates many of the most hotly contested questions surrounding the Conquest: Was the battle itself a crucial turning point or just one element in the global struggle between France and Great Britain? Did the battle's outcome reflect the superior strategy of General James Wolfe or rather errors on both sides? Did the Conquest alter the long-term trajectories of the French and British empires or simply confirm patterns well under way? How formative was the Conquest in defining the new British America and those now living under its rule?

PHILLIP BUCKNER is a professor emeritus in the Department of History at the University of New Brunswick and a senior fellow at the Institute of Commonwealth Studies and the Institute for the Study of the Americas at the University of London.

JOHN G. REID is a professor in the Department of History and a senior fellow at the Gorsebrook Research Institute at Saint Mary's University.

Revisiting 1759

The Conquest of Canada in Historical Perspective

EDITED BY
PHILLIP BUCKNER AND JOHN G. REID

UNIVERSITY OF TORONTO PRESS
Toronto Buffalo London

© University of Toronto Press 2012
Toronto Buffalo London
www.utppublishing.com
Printed in Canada

ISBN 978-1-4426-4407-6 (cloth)
ISBN 978-1-4426-1242-6 (paper)

Printed on acid-free, 100% post-consumer recycled paper with
vegetable-based inks.

Library and Archives Canada Cataloguing in Publication

Revisiting 1759 : the conquest of Canada in historical perspective /
edited by Phillip Buckner and John G. Reid.

Includes bibliographical references and index.
ISBN 978-1-4426-4407-6 (bound). – ISBN 978-1-4426-1242-6 (pbk.)

1. Québec Campaign, 1759. 2. Plains of Abraham, Battle of the,
Québec, 1759. 3. Canada – History – Seven Years' War, 1755–1763.
4. Canada – History – 1763–1791. I. Buckner, Phillip A. (Phillip Alfred),
1942– II. Reid, John G. (John Graham), 1948–

FC386.R49 2012 971.01'88 C2012-901623-3

University of Toronto Press acknowledges the financial assistance to its
publishing program of the Canada Council for the Arts and the Ontario
Arts Council.

 Canada Council Conseil des Arts ONTARIO ARTS COUNCIL
for the Arts du Canada CONSEIL DES ARTS DE L'ONTARIO

University of Toronto Press acknowledges the financial support of the
Government of Canada through the Canada Book Fund for its publishing
activities.

Contents

Preface

On 14 September 1759 British and French troops fought a battle on the Plains of Abraham, just outside what was then the capital of the colony of Canada, Quebec City. There was nothing inevitable about the victory of the British forces under General James Wolfe and it was not irreversible. Indeed, the British forces met defeat at the Battle of Ste-Foy in April 1760 and only the arrival of a British rather than a French fleet later that spring ensured that Quebec remained in British hands. Conversely, even if Wolfe had been defeated on the Plains of Abraham, Quebec might still have fallen to the much larger British force slowly making its way north from the thirteen colonies in 1759–60 under the command of General Jeffery Amherst. And, of course, Canada might have been returned to France during the peace negotiations had the war gone slightly differently in Europe and the West Indies. Even after the Treaty of Paris of 1763 secured for the British what they had won on the battlefield, it was not inconceivable that France might have returned or assisted the thirteen colonies during the American Revolutionary War in taking from Britain what Britain had taken from France. But, as it turned out, the French cession of 1763 was never overturned. The Battle of the Plains of Abraham therefore had been decisive in enabling Britain to take possession of Canada. Renamed the province of Quebec in 1763 and subsequently divided into Upper and Lower Canada in 1791, what had been the colony of Canada eventually became part of the Dominion of Canada in 1867.

Because of the significance of the Battle of the Plains of Abraham in 1759, it seemed appropriate to hold an academic conference to mark the two hundred and fiftieth anniversary of the event in September 2009. The conference on '1759 Revisited: The Conquest of Canada in

Historical Perspective' was held at the University of London and co-sponsored by the Institute of Commonwealth Studies and the Institute for the Study of the Americas, both part of the School of Advanced Studies at the University of London, and by the Gorsebrook Research Institute at Saint Mary's University in Halifax, Nova Scotia. We would also to like to acknowledge the assistance provided by Richard Dennis, chairman of the London Conference of Canadian Studies, and by Olga Jimenez, the events manager at the Institute for the Study of the Americas, and to thank the Canadian High Commission in London for allowing us the use of Canada House as a site for the conference and also the Canadian Department of Foreign Affairs and International Trade for financial support. After three intensive days of the conference, we faced the difficult task of identifying a necessarily small number of the many high-quality papers that had been presented. Thematic unity was an important criterion, and after a great deal of agonizing we chose twenty-one papers to be revised for publication. This would still have made for a large and somewhat unwieldy volume. Fortunately, the papers given at the conference divided naturally into one of two categories: those that focused on the Conquest and its immediate aftermath and those that focused on the historical memory of the Conquest. We therefore decided to produce two volumes of essays: *Revisiting 1759: The Conquest of Canada in Historical Perspective* and *Remembering 1759: The Conquest of Canada in Historical Memory*. Each volume can be read on its own, though the two, of course, are interrelated. In their different ways, both volumes offer new and revealing insights into the impact, implications, and long-term significance of Wolfe's victory on the Plains of Abraham in 1759.

As the volumes took shape and moved through the publication process, we were reminded again of our good fortune in publishing with the University of Toronto Press. We thank Len Husband, history editor, who guided the books assuredly through the early parts of the process; and Wayne Herrington, associate managing editor, who then steered them through to publication. Barry Norris's excellent copy editing of both volumes brought about many improvements.

Some of the chapters included lengthy French-language quotations. In order to make the collections as useful a teaching tool as possible, we decided that all the quotations would be translated into English, but that where the quotation was a lengthy one, we would also include the original French version in the accompanying endnote.

Phillip Buckner and John G. Reid

REVISITING 1759

The Conquest of Canada in Historical Perspective

1

Introduction

PHILLIP BUCKNER AND JOHN G. REID

There is no doubt that the British victory on the Plains of Abraham on 13 September 1759 was a significant geopolitical event. But historians continue to debate how significant. Was the battle a crucial turning point or should it be seen as simply one part of a campaign that began with the British capture of Louisbourg in 1758 and was completed with the surrender of Montreal in 1760? It is possible, after all, that even if the British had been defeated on the Plains of Abraham, New France would still have fallen to the far larger force that General Jeffery Amherst was already gathering in 1759 in preparation for the advance on Montreal. Indeed, the Quebec campaign can be viewed as merely a part of the global struggle between France and Britain that lasted from 1754 to 1763. This struggle, somewhat erroneously described as the Seven Years' War, culminated in the Treaty of Paris, which gave effect to important changes in the nature of both the French and British empires. Moreover, even the reason for the outcome of the battle on the Plains of Abraham remains controversial. Did the British victory reflect the superior strategy of General James Wolfe or did it simply show, as W.J. Eccles argued some thirty years ago, that 'perhaps the most overlooked determining factor in history has been stupidity'?[1] The longer-term impact of the Conquest of Canada also continues to generate controversy. Did it significantly alter the structures and trajectories of the French and British empires or merely confirm patterns already well under way? And how formative was the Conquest in defining the nature of the new British America that emerged in the late eighteenth century and in altering the lives of the peoples who were now brought under British rule?

From a longer military and naval perspective, the events of 1759 could be represented as only the latest in a series of shipborne assaults

on Quebec that included those of the Kirke brothers in 1629, Sir William Phips in 1690, and Sir Hovenden Walker in 1711. Indeed, whether the 1759 expedition would share the fate of the last two was undecided until the battle on the Plains, and even that battle left unanswered the question of whether the result would be any longer lasting than had been the case when Champlain surrendered to the Kirkes. Yet such an interpretation ignores changing realities. Prior to the Seven Years' War the colony on the St Lawrence had been valued primarily for economic and strategic reasons that were inseparable from its access to the fur trade. It was this trade that underwrote the key aboriginal alliances of the French and enabled them to maintain an increasingly precarious balance of power within North America. But the immeasurably more lucrative North Atlantic fisheries exerted a separate and stronger influence on the priorities of both France and Britain. Fisheries were central in the negotiations that led to the Anglo-French Treaty of Utrecht in 1713. The treaty secured French fishing rights on the French Shore of Newfoundland, while France's cession of Acadia was balanced by its retention of the two key Gulf islands of Île Royale (Cape Breton) and Île St-Jean (Prince Edward Island).[2] The continuing importance of the North Atlantic fisheries was seen in the French construction on Île Royale of the fortified town of Louisbourg and the later British establishment of Halifax, and during the negotiations at Paris in 1763 the French proved willing to cede Canada to the British but not their rights on the island of Newfoundland.

But for the British, in particular, the eighteenth century had brought new strategic imperatives. The growing population density and expansionist potential of the thirteen colonies on the Atlantic seaboard produced tension along the frontier between the two empires in the interior of North America as the French created a series of aboriginal alliances west of the Great Lakes and south to the Mississippi and Louisiana, and attempted to strengthen their military position along the borders of the British colonies. The War of the Austrian Succession (1744–8) led to increased conflict, but in 1748 the North American provisions of the Treaty of Aix-la-Chapelle attempted simply to turn back the clock and restore an evidently unsustainable equilibrium.

The outbreak in 1754, and eventual conduct, of the North American conflict that would merge in 1756 into the Seven Years' War turned out very differently. Beginning in 1755, all but a few of the fourteen thousand Acadians were removed from *Acadie*/Nova Scotia and in 1758 the British captured Louisbourg, the major French base on the western side

of the North Atlantic. This was not the first time Louisbourg had been taken by a British force, but now there would be no restoration – British engineers levelled the walls of the fortified town to the ground. As A.J.B. Johnston has pointed out, the Louisbourg campaign inaugurated the series of British military and naval advances in various parts of the western hemisphere that led to the demise of New France.[3] Indeed, while the 1759 battle for Quebec involved a struggle for control of the North Atlantic, it also reflected Britain's developing ambition and growing determination to secure its colonies on the mainland and to enable them to expand by striking decisively at the heart of New France. For this reason, the Seven Years' War was much more than a simple continuation of the earlier French-English conflicts in North America.

It was, of course, by no means inevitable that Quebec would fall to the British in 1759 (or even in 1760). Indeed, there has been considerable debate over whether Wolfe owed his victory on the Plains of Abraham more to luck than to skill. In the nineteenth century, a triumphalist narrative held sway, at least in English-language accounts of the battle, which was then challenged and superseded by twentieth-century historians. While a young John Clarence Webster declared of Wolfe in 1897 that 'the brilliancy of his brief and meteoric career, achieving, as it did, such glorious results for the Empire, gave also the assurance that his life would have continued at the same high level of action had Providence prolonged his days,' the acerbic E.R. Adair devoted his 1936 presidential address to the Canadian Historical Association to a reassessment of Wolfe's generalship. Wolfe, for Adair, had been promoted above his ability and never demonstrated strategic acumen. His success at Quebec depended on 'blind chance,' showing him at best to have been 'a competent regimental officer despairingly faced with a problem that, alone and unaided, he did not know how to solve.'[4] Adair's arguments were followed and amplified by Eccles and by the post–Second World War *doyen* of Canadian military historians, C.P. Stacey.[5] Subsequently, Fred Anderson added the suggestion that Wolfe's behaviour at Quebec was not only reckless but also represented his personal death wish.[6]

In this volume, however, Stephen Brumwell rejects what has now become a historical orthodoxy. He argues that Wolfe's actions must be evaluated in the broader context of the overall British campaign against New France. Like Phips and Walker before him, Wolfe was conducting what was intended to be one part of a double assault that would also include a land-based attack on Montreal. Although Amherst had progressed towards this goal, he chose to delay any further advance until

he had received news from Quebec. Wolfe, with the wider campaign now hinging on his success or failure, moved boldly but with an astute calculation of the odds. The events of the morning of 13 September 1759 formed the result. 'Few generals in history,' Brumwell observes, 'can have endured so much sustained criticism as Wolfe has for actually *winning* a battle.'

Wolfe has also been censured by historians for unnecessarily ruthless tactics prior to the confrontation on the Plains of Abraham, and condemned for a campaign of terror and violence that led to a large number of unnecessary civilian casualties. The chapter by Matthew C. Ward addresses the extent to which the British observed the prevailing rules of war, in the context of a historiographical debate over the fundamental nature of North American imperial-colonial warfare of the era. That British forces visited death and destruction on civilians has been a long-standing theme of French-language historiography; in the words of the Abbé Henri-Raymond Casgrain, '[Wolfe's] rangers, supported by Highlanders and light infantry, swarmed over both sides of the St. Lawrence, torch in hand.'[7] This interpretation was endorsed by Stacey, who judged that the general's 'unpleasant policy of terror and devastation did little to advance his campaign.'[8] Ward's concern, however, is rather different. Agreeing that 'ferocity' characterized British aggression to the point that, when the bombardment of Quebec is considered along with the raids in rural areas, 'almost half of the *habitant* population suffered directly at the hands of Wolfe's army,' he seeks to account for the degeneration of a campaign that had begun with loftier ideals. Some military historians have argued that conflict in eighteenth-century North America was inherently characterized by what John Grenier has defined as 'a military tradition that accepted, legitimized, and encouraged attacks upon and the destruction of noncombatants, villages, and agricultural resources.'[9] Other historians have emphasized the European-influenced characteristics of imperial warfare. Guy Chet, for example, has argued that rangers and other light troops had only limited usefulness in a campaign that – always provided naval supremacy could be maintained – 'relied on tested and established European conventions.'[10] Ward demonstrates the formality with which the 1759 campaigning season began, but then documents its descent into a war of 'unusual brutality' on both sides. Although the *Canadiens* and the aboriginal allies of the French were used to irregular warfare, the campaign in Quebec, Ward argues, did not reflect an inherently distinctive North American style of warfare, but the distortion of what was still

a European way of war when confronted by the mobilization of the entire civilian population of Canada in a manner not seen anywhere in contemporary western Europe.

Wolfe's victory on the Plains of Abraham did not resolve the question of whether Quebec would remain in British hands. The *Canadiens* continued to resist the Conquest, and French and *Canadien* forces inflicted defeat on the British at the Battle of Ste-Foy on 28 April 1760. While French regulars made up some fifty-six per cent of the troops available to the chevalier de Lévis on that day, the great majority of the remainder were *Canadien* militia, supplemented by smaller aboriginal forces.[11] However, the arrival of a British fleet in the following month led to the retreat of Lévis to Montreal and ultimately to the surrender of that city on 8 September 1760. To be sure, it remained uncertain whether the peace treaty would confirm the conquests of war. Louisbourg, after all, had been returned to France in the Treaty of Aix-la-Chapelle. But 1763 was not 1748. From the perspective of British negotiators and their policy-making masters, the security from French attack that would result from retaining Canada – and that was expected to open the road to unprecedented prosperity for the British colonies in North America – prevailed over the opportunity to press for the takeover of islands in the French Caribbean and elsewhere. The return to France of the rich sugar island of Guadeloupe has often been seen as symbolic of British priorities, but the decision to allow France to retain the islands of St Pierre and Miquelon, just off Newfoundland, which gave access to abundant North Atlantic fishing grounds, was another clear indication of British priorities.[12] Both the French and the British empires thus emerged in altered forms from the Seven Years' War. The French Empire, shorn of a massive and sparsely populated continental territory, now conformed more closely to the mercantilist ideal of an empire manageable in territory and population but rich in the resources of the islands it had gained or retained.

Yet, as François-Joseph Ruggiu shows, both change and continuity characterized French thinking regarding the nature of empire, as seen particularly in two key ministers of marine between the Seven Years' War and the American Revolution, the duc de Choiseul and the comte de Vergennes. Continuity was reflected in the reality that, in the early 1760s as fifty years earlier, the North Atlantic fisheries had pre-eminent commercial importance, so that the French Shore of Newfoundland took priority over considerations in mainland North America. More generally, however, an evolution had taken place through which ap-

prehension of Britain's hegemonic aspirations was offset by a belief that France must avoid the error that likely ultimately would undermine the British Empire: the diversion into expensive and unmanageable colonies of settlement. In both France and Britain, debate as to the nature of empire centred on the uneasy relationship between commercial imperatives and territorial empire.[13] For Choiseul, Canada was not only commercially barren, but also, far from contributing to the defence of more productive colonies such as those in the Caribbean, a drain on imperial military resources. The logic was inescapable, and it extended forward to the determination of Vergennes that the American Revolutionary War should result neither in the reburdening of France with unwanted North American territory nor in the incorporation of Canada into an enlarged United States of America. Far better, as Ruggiu explains in analysing French goals, to let Britain continue to carry the load of a continental empire while France resolutely refused to do so.

The British Empire was also transformed by the Treaty of Paris (1763). Relieved of the immediate military threat from Canada, even though it would soon have to worry about a new and different threat from further south, it was now more sprawling than ever and more diverse – not just in North America but also in Asia – in its embrace of non-British peoples. The consequences for the British colonists in North America were particularly far reaching. As Jack P. Greene points out in his contribution to this collection, the British celebrations that greeted the news of the battle on the Plains of Abraham, the narrow French failure to reverse it in 1760, the fall of Montreal, and the Treaty of Paris pre-supposed a future that proved illusory. Although the outcome of the Seven Years' War enhanced the apparent grandeur of Britain's increasingly global but also increasingly ramshackle empire, it also led British ministries to attempt to consolidate metropolitan power at the expense of the interests of the settlement colonies. The Conquest thus contributed crucially to a sequence of events that led directly to the revolutionary crisis a decade or so later, and yet it did so in a way that contemporaries caught up in the patriotic excesses of 1759 could not have predicted. For Greene, as for P.J. Marshall, the empire that emerged after 1783 saw a growing commitment to a more authoritarian vision of empire and more authoritarian structures of government as Britain sought to establish its dominion over ever-larger populations of non-British peoples.[14] Yet in those parts of North America that continued to remain part of the British Empire – creating the ironic real-

ity that the British Empire in North America now consisted largely of what had once been the French Empire – the notions of colonial liberty that had underwritten the earlier British Empire in North America persisted. Through their assemblies, the colonies would continue to negotiate and renegotiate their relationship with the imperial Parliament and government. A complex new British North America emerged and eventually gave rise to the nineteenth-century Dominion, once again blending change and continuity.[15] On that extended process, as in the developments of the 'long' eighteenth century with which this collection is primarily concerned, the Conquest of Canada exerted a continuing influence, and the battle on the Plains of Abraham in turn formed an essential part of the Conquest.

For the indigenous nations of North America, the Conquest also brought profound changes. The collapse of French power had a catastrophic effect on the ability of the aboriginal peoples to resist the westward expansion of the thirteen colonies. Moreover, like earlier imperial treaties, the 1763 Treaty of Paris dealt in a cavalier manner with indigenous lands and interests, and led to conflicts, of which Pontiac's rising was only the most visible.[16] In his chapter in this volume, Thomas Peace demonstrates that, for the aboriginal nations affected in one way or another by the British-French conflict, the chronology could be much more extended. Peace does not claim that the case of the Huron-Wendat was 'typical,' arguing instead that indigenous experiences of the era were highly diverse. That the French-British contest was 'a primarily European conflict that took place in a primarily aboriginal landscape,' however, ensured that the impact on the Huron-Wendat community at Jeune-Lorette, as for others, was necessarily profound. It intensified a pattern of adaptation that dated from the community's final relocation in 1697, and embraced participation in the battle on the Plains of Abraham in support of their French ally, followed by adoption of a neutral position and a reconciliation agreement with the British that came to be known as the Murray Treaty. Following the consolidation of British rule, the departure of the Jesuits meant that Jeune-Lorette was no longer a mission village, and the end of French-British conflict ensured that it would now be demilitarized. Henceforth, community leaders focused on attempts to secure land within the seigneurial system and on pursuing formal education for potential leaders with a view to making literacy a tool of survival. Success was limited in both areas, but clearly the Conquest of Canada had produced a significant change of direction in a long process of adaptation.

Of course, it was the colonists of French descent who had the more immediate adjustments to make in meeting the challenges presented by the Conquest. Indeed, in both British imperial and Canadian historiography, the impact of the Conquest on the *Canadiens* has been a central issue for most historians who have written about 1759 and its consequences. For an earlier generation of historians, much of this debate revolved around the question of British intentions towards their new subjects and, in particular, the intentions that lay behind the Quebec Act of 1774. In US historiography, the Quebec Act, by creating a colony that lacked an elected assembly, making concessions to Catholicism, and placing the western territories under the control of the government of Quebec, has frequently been linked directly to the causes of the American Revolution.[17] In British imperial historiography, on the other hand, debate over the Act has centred not only on whether – as Philip Lawson argued – this was legislation that, in both political and religious contexts, 'grasped the nettle of toleration,' but also on how far it provided a gauge of imperial approaches to the incorporation of non-British populations. Recent imperial historiography is less sympathetic to the interpretation of the Act as an expression of toleration. For P.J. Marshall, the attribution of 'far-sighted imperial statesmanship' to the framing of the Act is questionable and beside the point: integration of the *Canadiens* was part of an irreversible process that would lead to the more widespread inclusion of the non-British people of the Americas and a huge population of South Asians into the vast and extended empire over which the British now ruled and that would be accompanied by a trend towards more authoritarian rule.[18] In this context, for Marshall, by the time of the second Treaty of Paris in 1783, Quebec had come to be seen by imperial policy-makers as integral to the empire in the sense that it was unthinkable to abandon the military and political investment that had gone into its acquisition and retention, so that 'the epic of Wolfe's taking of Quebec still cast its shadow in 1783 as it had done in 1763.'[19]

Two of the chapters in this collection focus directly on British imperial intentions in the framing of the Quebec Act. As Stephen Conway makes clear, the military surrender of New France created questions for Britain that closely mirrored those facing France. The British ministry had no higher an estimate of Canada's economic value than did Choiseul, but Great Britain had a collection of settlement colonies further south that had to be defended. In that strategic context of pre-empting any possibility of a renewed French attack, Conway shows, British re-

tention of Canada made sense even if it meant integrating a substantial French and Roman Catholic population into the empire. Sheer numbers ensured that any British consideration of a mass removal of the *Canadiens* would have faced the logistical problems that went with a population level some five times that of the Acadians who had been deported since 1755. The remaining question was that of governance. For British rule over largely Roman Catholic populations, there were models readily to hand, but they were divergent. The Royal Proclamation of 1763, in its provisions for colonial government, was strongly influenced by ministers with Anglo-Irish connections who foresaw the rule of the new province of Quebec by an English property-owning elite resembling its counterpart in Ireland – although one that would be steadily expanded, it was hoped, through Protestant immigration. The eventual calling of an assembly based on a Protestant electorate was intended to be the capstone of an Irish-style structure for Quebec. However, the disappointing level of immigration to Quebec was matched by the stubborn refusal of even the anglophone merchants of Montreal to behave like a landowning elite. Indeed, as Donald Fyson shows in this volume, what was emerging in Quebec was a pragmatic process of adjustment that defied classification by any imperial design. Thus, Conway traces the reluctant conversion of the ministry to a vision of Quebec, embodied in the Quebec Act of 1774, that was modelled on Minorca rather than on Ireland, with the existing society largely left to evolve on its own in terms of law and governance, subject only to the overarching authority of the Crown and the obligation to avoid actual contradiction of English law. In reaching this conclusion, imperial authorities had struggled, Conway shows, not – as Philip Lawson has argued influentially[20] – with a lack of applicable experience, but rather with contrasting precedents. More generally, the British failure to prompt immigration to Quebec during the 1760s invites comparison with the failure to attract migrants to Nova Scotia during the preceding decade, although there the consequences were violence and volatility as opposed to the difficult but effective process of accommodation that prevailed in Quebec.[21]

A longer-term dimension to the imperial thinking also underpinned the Quebec Act, as Heather Welland demonstrates. Tracing back the issues that informed the debates over the 1774 legislation, she argues that they represented a new round in a conflict that had been under way long before the Conquest itself between Whig and Tory approaches to empire. The Whig view of empire emphasized consumption as the engine

of expansion and so envisaged an empire consisting of colonies that had considerable political autonomy but were bound to Britain by commercial ties. The Tory – or, by now, neo-Tory – approach involved more heavy-handed imperial regulation and hence a more direct dependence on Britain. From the neo-Tory perspective, the purpose of colonies was to fulfil the long-standing mercantilist goals of supplying resources that would otherwise have to be imported and providing a captive market for products of the metropolis. The Quebec Act, in this context, was a neo-Tory initiative, aimed at maintaining Quebec's dependence on Britain, and the opposition of the Montreal merchants attested powerfully to its character. Yet, just as Conway shows that the Act reflected the failure to induce significant British and Protestant immigration into Quebec, so Welland portrays its authors as making a virtue of this deficiency by envisaging that the anglophone elite would remain a permanent minority in an essentially isolated colony tied to Britain both by the authority of the Crown and by economic dependence. Thus, while governance remains crucial to interpreting the Act, Welland moves our understanding away from certain of the pre-occupations of earlier historiographies. Certainly the Quebec Act was one of the triggers of the American Revolution. Even Lawrence Henry Gipson's sympathetic account of its framing allowed that the timing was 'most maladroit' and contributed to the inevitability of the Revolution both through the Act's extension of Quebec's boundaries and its perceived entrenchments on colonial liberties.[22] Welland does not contradict this contention, but the Act's rootedness in an established, though controverted, view of empire offers a more subtle interpretive framework. Notwithstanding the linkage of the Quebec Act with toleration, as put forward by Lawson, or Hilda Neatby's earlier and more sceptical balancing of the 'rational and humane' aspects of the legislation with an underlying pressure for anglicization, Welland demonstrates that the legislation sought to bind Quebec to the empire through isolation and dependence in the interests of a commercial rather than a primarily political or cultural agenda.[23]

Whatever the intentions behind the Quebec Act, historians of Quebec itself have been more concerned with the long-run socio-economic impact of the Conquest. From the 1950s to the 1970s, historiographical debates went back and forth over whether the Conquest had transformed what had been a complex and vibrant society in the colony of Canada during the French regime, one that, in time, could have evolved into an independent nation, into a colonized enclave under the British regime. This was the view of the 'Montreal school' and its most promi-

nent members, Maurice Séguin, Guy Frégault, and Michel Brunet. But their interpretation was challenged in the works of historians of the 'Laval school,' such as Marcel Trudel, Jean Hamelin, and Fernand Ouellet. These authors took a more self-critical view of Quebec's past, and provided a basis for regarding the Conquest as a significant geopolitical departure but otherwise an incident of limited importance and certainly not an explanation for any subsequent issues of socio-economic underdevelopment. Although the Conquest subsequently became a lesser preoccupation of historians, the closely related political argument over whether independence alone could reverse the destructive processes unleashed by 1759 was persistent enough to prompt public controversies in 2009 over planned commemorations of the battle's two hundred and fiftieth anniversary.[24]

In his chapter, Donald Fyson argues that even recent historians have continued to exaggerate the legal and other constraints on the *Canadiens* during the military regime and under the Proclamation of 1763. He stresses that the intense historiographical debates that forty years ago divided the 'Montreal school' from the 'Laval school' over whether the Conquest had decapitated Canadian society by removing an emerging bourgeoisie have given rise to a continuing contest between 'jovialist' and 'miserabilist' views of the interactions between the British authorities and their new subjects. Fyson insists that this simplistic binary must be re-evaluated in the light of the mutual adaptation that took place. Although a strict application of the Test Acts might have excluded *Canadiens*, as Catholics, from public roles, there was enough leeway in the interpretation of the law to allow pragmatic imperial officials, including Governors Murray and Carleton, to countenance the presence of Catholics in many positions – including the judiciary – where there was a need for competence and local expertise, while still keeping most lucrative positions for British immigrants. Similarly, the French language, far from retreating into private homes, was used extensively, and it was quickly evident that even conversations between British officials and *Canadiens* normally would be conducted more efficiently in French than in English. French regime institutions such as parish assemblies continued to transact business, while, conversely, the *Canadiens* were not slow to recognize the possibilities of the grand jury as a representative body. And the existing French law never ceased to function as the basis for civil jurisdiction, while English criminal law was not automatically rejected by *Canadiens*, who served on juries in increasing numbers. None of this, Fyson shows, meant that there was a cosy accommoda-

tion – there were difficult adjustments to be made, and frictions were inevitable. But the *Canadiens*, to an extent unacknowledged by many previous historians, were far from passive participants in this prickly and demanding process. *Canadiens* and the British among them had to find a way of living together, and it did not take the Quebec Act – important as it was – to induce the necessary adaptation.

Of those who lived under British rule in post-1759 North America, the need for adaptation was not, of course, confined to the *Canadiens*. Barry M. Moody identifies a consequence of the battle on the Plains of Abraham that changed an important existing dynamic and had long-lasting results. Attempts earlier in the eighteenth century to attract British and British-sponsored settlement to Nova Scotia had met with limited success. Even the foundation of Halifax in 1749 had been followed within months by a decline in its British population rather than continuing expansion. The deportation of the Acadians, although its harsh consequences were visited primarily among the Acadians themselves, devastated the colonial economy by leaving productive lands untended as well as by disrupting pre-existing patterns of trade and, most of all, removing most of the non-aboriginal population.[25] Still, for potential settlers, fear of attack by French or indigenous forces was a powerful disincentive. The fall of Louisbourg lessened the danger and emboldened the colonial government to launch efforts to recruit settlers in New England. Only with the British capture of Quebec, however, could the apprehensions of New Englanders be sufficiently allayed to prompt the migration of some eight thousand Planters. Whether or not the peace could be maintained in what was still Mi'kma'ki remained a question that was more open than must have been apparent to colonists who believed that Mi'kmaw resistance to settlement had been largely French inspired. But the fall of Quebec marked a critical turning point. It also had, Moody argues, a further important result. Planter settlement, notably in the Annapolis Valley and neighbouring areas, took a form that was unusual in British-occupied areas of northeastern North America. Rather than forming villages and towns, they occupied five-hundred-acre lots to create 'a solid line of settlements.' Only the sense of security created by the Conquest and confirmed by the 1763 Treaty of Paris permitted a distinctive and persistent landscape pattern that completely disregarded any defensive concerns.

The impact of the Conquest was not limited to those already settled in North America. It also encouraged an initially small but growing number of immigrants from Britain. Among them was a substantial number of Gaelic-speaking Scots, for whom the battle on the Plains of Abraham

assumed a symbolic significance that affirmed key changes in the relationship between Gaelic identity and British imperial expansion. Matthew P. Dziennik's chapter takes as its point of departure the famous charge of the 78th Foot, which was widely credited as completing the rout of the French army on the Plains. For Dziennik, however, it illustrates the paradox by which, from 1746 onwards, service with British forces became for many Highlanders a means of entry to the modern dynamic of empire and to the wealth and advancement it could open up, while at the same time an invented anti-modernism came to characterize romanticized images of the Highland soldiery. Certainly military service had cultural implications, and Gaelic poets celebrated both armed prowess and the steadfast loyalty to the Crown that it expressed. Yet, Dziennik shows, the settlement of Protestant veterans of the 78th and other Highland regiments in the province of Quebec allowed both officers and other ranks to enjoy the benefits of landowning – often adopting, in the process, the French language although not surrendering a Gaelic sensibility. The battle of 1759 and the succeeding years of settlement, therefore, offered an 'archetypal' expression of the complex reconciliation between Gaels and empire, a process that had been ongoing since the defeat of the Jacobite forces at Culloden.

Thanks to the collective insights of all the authors, *Revisiting 1759* allows a significant re-evaluation of the event and its contexts. Although the twentieth-century questioning of histories that glorified the British Empire and its agents was salutary in its day, triumphalism is no longer much of a historiographical foe. Accordingly, Brumwell's examination of the personal role of Wolfe reminds us that individuals and their decisions do matter. Evaluation of Wolfe's generalship provides a sharp lens through which to assess the range of possible outcomes that initially characterized the siege of Quebec, and the reasons events concluded as they did. At the same time, as Ward's analysis of the deterioration of the Quebec campaign into the terrorizing of non-combatants demonstrates, Wolfe and the other protagonists made decisions in a context in which the very conduct of war had shifted in defiance of the expectations with which the campaign had begun. Although the winning and losing of the battle on the Plains did not in itself seal the result of the larger conflict, it was a key factor in the process leading to the surrender of Montreal a year later.

As Ruggiu and Conway make clear, imperial considerations now came into play in both London and Versailles. Both French and British politicians shared a profound scepticism as to the value of Canada, certainly by comparison with the priority they gave to fisheries and other

lucrative trades; the difference was that the British had a strategic incentive to hold on to Canada even at the cost of concessions elsewhere, while there was a strong and continuing French reluctance to shoulder the burden of settlement colonies. But the decision of the British to retain Quebec, while it resolved old problems, raised new ones. It unleashed, as Greene shows, forces that ultimately would lead to the loss of the thirteen colonies. It also raised the question of how to govern the large francophone majority in the new province of Quebec. For Britain and its ministry, Ireland now offered an attractive paradigm for governance, but Quebec proved resistant to such modelling, and the Quebec Act represented not only, in Conway's analysis, a resort to the alternative example of Minorca, but also, as Welland argues, a rooted commitment to a future for Quebec that conformed more to a long-standing mercantilist view of empire than to Whig notions of shared commercial interest. Yet if the Conquest raised significant imperial questions, it also launched within Quebec the wary, pragmatic process of adaptation Fyson defines. While there were elements of the Conquest that could only be traumatic for *Canadiens* – particularly the physical destruction associated with the military campaign and the sudden imposition of an alien regime – resilience and self-direction were not erased but were soon deployed in forging new if uneasy *modi vivendi* in which the *Canadiens* were far from passive.

As an event, therefore, the Conquest introduced to Quebec a profound discontinuity, but one that ultimately brought dialectical rather than crudely imposed change. For other affected peoples and places, the Conquest also had dramatic consequences and the power to shift long-standing patterns of evolution – whether in the settlement of Nova Scotia by New England Planters, in the reconciliation of empire with Gaelic identity, or in the extended adaptations of indigenous groups such as the Huron-Wendat. All would form part of the reshaped British America that would emerge from the perils that accompanied the fall of Quebec and other British successes in the Seven Years' War. Taking its cue from the events of 1759, the Conquest of Canada was formative in this process, and altered the historical trajectories of all concerned.

NOTES

1 W.J. Eccles, 'The Battle of Quebec: A Reappraisal,' in Eccles, *Essays on New France* (Toronto: Oxford University Press, 1987; first published 1978), 133.

2 See J.K. Hiller, 'Utrecht Revisited: The Origins of French Fishing Rights in Newfoundland Waters,' *Newfoundland Studies* 7, no. 1 (1991): 23–39; also John G. Reid, 'Imperialism, Diplomacies, and the Conquest of Acadia, in Reid et al., *The 'Conquest' of Acadia, 1710: Imperial, Colonial, and Aboriginal Constructions* (Toronto: University of Toronto Press, 2004), 103–6.

3 A.J.B. Johnston, *Endgame 1758: The Promise, the Glory, and the Despair of Louisbourg's Last Decade* (Lincoln: University of Nebraska Press, 2007), 286–7 and *passim*.

4 J. Clarence Webster, 'A Visit to the Birthplace of James Wolfe, the Conqueror of Quebec,' *Canadian Magazine* (May 1897), 31; E.R. Adair, 'The Military Reputation of Major-General James Wolfe,' *Canadian Historical Association Report* (1936): 7–31, quotations from 31.

5 Eccles, 'The Battle of Quebec,' 128; C.P. Stacey, *Quebec, 1759: The Siege and the Battle* (Toronto: Macmillan, 1959), 170–8; idem, 'James Wolfe,' *Dictionary of Canadian Biography*, http://www.biographi.ca (accessed 8 March 2010).

6 Fred Anderson, *Crucible of War: The Seven Years' War and the Fate of Empire, 1754–1766* (New York: Knopf, 2000), 349–62.

7 Abbé H.-R. Casgrain, *Wolfe and Montcalm* (Toronto: Morang, 1905), 149.

8 Stacey, 'James Wolfe.'

9 John Grenier, *The First Way of War: American War Making on the Frontier, 1607–1814* (New York: Cambridge University Press, 2005), 10.

10 Guy Chet, *Conquering the American Wilderness: The Triumph of European Warfare in the Colonial Northeast* (Amherst; Boston: University of Massachusetts Press, 2003), 113–16, 137–41, quotation from 113.

11 See Stephen Brumwell, *Redcoats: The British Soldier and the War in the Americas, 1755–1763* (Cambridge: Cambridge University Press, 2002), 257.

12 Philip Lawson, *The Imperial Challenge: Quebec and Britain in the Age of the American Revolution* (Montreal; Kingston, ON: McGill-Queen's University Press, 1989), 6–24; Colin G. Calloway, *The Scratch of a Pen: 1763 and the Transformation of North America* (New York: Oxford University Press, 2006), 7–10.

13 See P.J. Marshall, *The Making and Unmaking of Empires: Britain, India, and America, c. 1750–1783* (Oxford: Oxford University Press, 2005), 2–8.

14 See P.J. Marshall, 'Britain without America: A Second Empire?' in *The Oxford History of the British Empire*, vol. 2, *The Eighteenth Century*, ed. P.J. Marshall (Oxford: Oxford University Press, 1998), 576–95; Marshall, *Making and Unmaking of Empires*.

15 See Phillip A. Buckner, *The Transition to Responsible Government: British Policy in British North America, 1815–1850* (Westport, CT: Greenwood Press, 1985), esp. chap. 2.

16 Gregory Evans Dowd, *War under Heaven: Pontiac, the Indian Nations, and the British Empire* (Baltimore: Johns Hopkins University Press, 2004). There is, of course, an extensive literature on the more general theme of indigenous responses and resistance to imperial and settler expansion during the immediate post-1763 era and later. See, for example, Calloway, *The Scratch of a Pen*; idem, *The American Revolution in Indian Country: Crisis and Diversity in Native American Communities* (Cambridge: Cambridge University Press, 1995); and Alan Taylor, *The Divided Ground: Indians, Settlers, and the Northern Borderlands of the American Revolution* (New York: Knopf, 2006).

17 Although the role of the Quebec Act in sharpening revolutionary sensibilities and its contemporary association with the coercive legislation of the same year have been noted throughout much of the extensive literature on the Revolution and its causes, a fresh context can be found in Brendan McConville, *The King's Three Faces: The Rise and Fall of Royal America, 1688–1776* (Chapel Hill: University of North Carolina Press, 2006), 288–90.

18 Lawson, *Imperial Challenge*, quotation from 151; Marshall, *Making and Unmaking of Empires*, quotation from 196. The earlier and nuanced analysis of Hilda Neatby had portrayed the Act as rational and conciliatory, but also argued that its religious provisions had more to do with extending the centralizing influence of the Church of England than with enabling Quebec Catholicism to resist the progress of anglicization; Neatby, *Quebec: The Revolutionary Age, 1760–1791* (Toronto: McClelland and Stewart, 1966), 125–41.

19 Marshall, *Making and Unmaking of Empires*, 365.

20 Lawson, *Imperial Challenge*, 25–6.

21 See Geoffrey Plank, *An Unsettled Conquest: The British Campaign Against the Peoples of Acadia* (Philadelphia: University of Pennsylvania Press, 2001), 122–34.

22 Lawrence Henry Gipson, *The Coming of the Revolution, 1763–1775* (New York: Harper and Row, 1954), 226–7.

23 Lawson, *Imperial Challenge*; Neatby, *Quebec*, 139–41.

24 The role of historical memory is explored more fully in the essays contained in Phillip Buckner and John G. Reid, eds., *Remembering 1759: The Conquest of Canada in Historical Memory* (Toronto: University of Toronto Press, 2012). The historiographical debates are thoroughly discussed in Ronald Rudin, *Making History in Twentieth-Century Quebec* (Toronto: University of Toronto Press, 1997), chaps. 3, 4.

25 See Julian Gwyn, *Excessive Expectations: Maritime Commerce and the Economic Development of Nova Scotia, 1740–1870* (Montreal; Kingston, ON: McGill-Queen's University Press, 1998), 7, 27.

2

'One more card to play': Revisiting Wolfe's Final Stratagem at Quebec

STEPHEN BRUMWELL

Towards the end of September 1759, Colonel George Williamson of the Royal Artillery wrote from Quebec to Britain's commander-in-chief in North America, Major-General Jeffery Amherst, outlining the remarkable events that had finally delivered the battered city into British hands. After months of frustrating stalemate, during which Major-General James Wolfe had failed to pierce the guard of his opponent, Louis-Joseph, marquis de Montcalm, that outcome had been both sudden and unpredicted. As Williamson recalled, 'General Wolfe having one more card to play at a place they least expected & which he communicated with all secrecy but two days before ... [on] the 13th of September at 4 in the morning we made another effort with about 5000 men and took Post with all expedition on the back of the Town within two small miles of Point Diamond.'[1] In the short, sharp firefight that followed, Wolfe's redcoats and Williamson's gunners blasted Montcalm's army from the Plains of Abraham. The campaign to which that clash gave a suitably dramatic climax remains the most celebrated, and controversial, episode of the entire Conquest of Canada. In particular, Wolfe's decision to opt for a nighttime amphibious assault upon the Anse-au-Foulon, a cove close to the city of Quebec, rather than a landing far higher up the St Lawrence River, as recommended by his three brigadiers, continues to draw accusations of wanton recklessness.

Contemporaries attributed Wolfe's victory to his determination and inspired generalship, a verdict that early biographers and historians were happy to uphold. But two hundred and fifty years after the event, both mainstream and scholarly opinion has swung against the young general. It is commonly argued that Wolfe's strategy was needlessly risky, and succeeded only owing to incredible luck – even that it deliv-

ered a victory against his own expectations. Circulating since the 1930s, such theories are now firmly entrenched. In this chapter, however, I contest the current consensus, suggesting that there were rational factors behind Wolfe's last-ditch attack on the Foulon Cove. Exploring the controversies surrounding the assault, I consider whether Wolfe's 'last card' was thrown down in a heedless gamble or after a more carefully calculated assessment of the odds, and whether, contrary to the prevailing verdict of historians, it in fact offered his best chance of victory.

First, it is necessary to sketch in the immediate historical background to the Foulon plan. In late August 1759 prospects looked bleak for the British force that had been besieging Quebec for the previous two months. Despite vicious skirmishing, an unrelenting bombardment that had reduced much of the city to ruins, and a deliberate policy of devastating the St Lawrence Valley below Quebec, Wolfe was no closer to capturing his objective than he had been when he arrived at the end of June. Nor had Wolfe succeeded in tempting General Montcalm into abandoning his extensive defences and fighting him in the open.[2]

For Wolfe himself the situation was especially dire. He had been suffering from painful illness throughout the summer, but in the last week of August his health broke down completely and he was obliged to take to his bed. No longer able to direct operations in person, on 27 August he asked his brigadiers to 'consult together' upon how best to attack the enemy and upon his own suggestions for breaking the deadlock.[3] In a joint written reply on 29 August the trio, Robert Monckton, George Townshend, and James Murray, bluntly rejected Wolfe's proposals, which all involved attacks upon the main French position at Beauport, on the northern shoreline below Quebec, and instead put forward their own 'Plan of Operations.'[4] This entailed shifting the bulk of the British troops – some three thousand six hundred men – above the city and attempting to get ashore upriver within a zone stretching twelve miles above the Cap Rouge River, itself about seven miles from the city. Wolfe accepted their reasoning, although with little obvious enthusiasm, and in early September the move upriver began. In line with his brigadiers' recommended landing zone, some days later Wolfe selected 'a place a little below Pointe-aux-Trembles' – a settlement about twenty miles from Quebec – for the attack.[5]

But wet weather halted operations. On 9 September, during this enforced lull, Wolfe conducted a downriver reconnaissance on his own. This had immediate and dramatic results: Wolfe decided to abandon the brigadiers' favoured objective for another, far closer to Quebec.

Next day, 10 September, Wolfe pointed out the location to a party of senior officers: it was the Foulon Cove, just a mile and a half from the city walls. Writing to his trusted friend, Colonel Ralph Burton of the 48th Foot, Wolfe confided that the Foulon scheme now offered the best chance of delivering what he had sought in vain all summer: a decisive clash with Montcalm. If the 'first business' – the landing itself – succeeded, it might bring on a general action, and that could yield 'the total conquest of Canada.'[6]

While New France's subjugation would require another campaign, Wolfe's plan delivered a remarkable and famous victory. Yet few generals in history can have endured so much sustained criticism as Wolfe has for actually *winning* a battle. The ink was barely dry on the Quebec victory dispatches before the carping began. In a letter written on 18 September, Rear-Admiral Charles Holmes of the Royal Navy still shuddered at the risks involved in implementing the Foulon assault, 'the most hazardous and difficult task' he had ever been obliged to undertake. Indeed, Wolfe's 'alteration of the Plan of Operations was not,' Holmes believed, 'approved of by many, beside himself,' and, in the sailor's opinion, Wolfe acted at a time when 'it was highly improbable he should succeed.'[7]

Holmes's stance was shared by James Murray, Wolfe's junior brigadier. Writing to George Townshend from Quebec on 5 October 1759, Murray was already busy assembling the paperwork needed to counter rumours that he and his fellow brigadiers had been at loggerheads with Wolfe and to demonstrate the 'suddenness' by which the general had abandoned 'his Scheme of landing between Point au Tremble and St Augustin' for the Foulon strike.[8] To this end, Murray collected copies of all the correspondence between Wolfe and the brigadiers in the crucial fortnight between late August and 12 September.[9] Years later, in 1774, Murray was still obsessed with the events of September 1759, and remained unable to forgive his long-dead commander for jettisoning the brigadiers' scheme and replacing it with his own. Writing to Townshend, Murray railed against Wolfe's desertion of the 'sensible, well concerted, Enterprise to land at [near] the point Au Tramble' – where, without opposition, he could have entrenched his army across the enemy's supply line – for 'the almost impossible, tho successful attempt, thanks to Providence at the Foulon.'[10]

By then, Townshend had long since lost patience with Murray's gripes, but subsequent historians have been more receptive to his core argument that Wolfe's plan involved an unnecessary element of risk,

and that the brigadiers' strategy offered a much safer option. Some of this criticism has come from surprising quarters. In the second volume of his monumental *History of the British Army*, published in 1899 at the very apogee of the British Empire for which Wolfe had become an icon, the Honourable John Fortescue took a decidedly dim view of the Foulon plan: had it backfired, he observed, 'it would very likely have brought Wolfe to a court martial.'[11] Another pro-imperial writer, Lawrence Henry Gipson, was likewise scathing of Wolfe's plan, regarding it as a 'desperate venture' when set beside the 'solid advantage that would have come by a determined attack on Pointe-aux-Trembles.'[12] When Gipson wrote, in the mid-twentieth century, Wolfe's final stratagem, along with his reputation more generally, had already sustained its most damaging assault. Using words that would surely have brought a smile to James Murray's Punch-like features, in his 1936 presidential address to the Canadian Historical Association, Professor E.R. Adair concluded that, while 'much less spectacular' than Wolfe's, the brigadiers' plan 'would have produced the same results, without the risk of a serious disaster.' Wolfe's plan, Adair continued, 'was hardly the sound military strategy in which a general, responsible for the lives of his soldiers, ought to indulge.'[13]

In 1959 the bicentenary of the siege brought the most reasoned and influential endorsement of the brigadiers' plan, and condemnation of Wolfe's. In his carefully researched and lucid account of the Quebec campaign, Canada's leading military historian, Lieutenant-Colonel Charles P. Stacey, delivered a damning and unequivocal verdict: in strategic terms, Wolfe's Foulon scheme was inferior to the brigadiers', which 'would have gained the desired strategic end more satisfactorily and with much less risk.'[14] Here, once again, the key word is 'risk.' In the half-century since Stacey's conclusions were first published they have become widely accepted, their influence reinforced by his protégé and inheritor of his mantle as Canada's pre-eminent military historian, Professor Desmond Morton.[15] In consequence, Stacey's book is still frequently cited as the standard study of the Quebec campaign: it remains the secondary source of choice, particularly for scholars and writers grappling with broader themes, who have disseminated its judgments through their own books.[16]

Criticism of Wolfe's generalship at Quebec has gone side by side with concerted attacks upon his character. The paternalistic young colonel, who was mourned by his own men as 'the Officer's Friend, and Soldier's Father,' and revered by the celebrated former slave Olaudah

Equiano as the 'good and gallant General Wolfe' after he intervened to save the young African from a flogging, is now more likely to be vilified as a vindictive 'war criminal' responsible for inflicting untold misery upon the helpless inhabitants of New France in 1759.[17] Drawing more heavily on speculation than on hard evidence, this 'black legend' has proved pervasive, particularly in French-speaking Canada. Indeed, Wolfe has become such a hate figure for some Quebec sovereigntists that, on 13 September 2009, the two hundred and fiftieth anniversary of his victory and death on the Plains of Abraham, not only were there no commemorative ceremonies at the obelisk marking the spot where he died, but the monument remained barricaded throughout the day to protect it from vandalism.[18] So widespread are these negative assessments that they have now become something of a mantra: at times, it is as if the chorus of respectful mourners in Benjamin West's epic 1770 painting 'The Death of General Wolfe' has been replaced by a gang of muggers, each waiting to deliver a crafty kick to the recumbent general as he gasps his last.

While repeated assaults on James Wolfe's character have clearly influenced perceptions of his generalship, in the remainder of this chapter I am not concerned with whether he was a decent man or deserving of the 'heroic' status he enjoyed before the debunkers set to work. Instead I focus squarely on the viability of his Foulon attack, a question upon which, in the view of many commentators, his broader military reputation must be judged. According to his critics, in devising his Foulon plan, Wolfe essentially hijacked the brigadiers' sensible upriver strategy, and then transformed it into a needlessly hazardous one. Allied to this allegation, it is frequently suggested that Wolfe turned his gaze above Quebec only because his long-suffering subordinates Monckton, Townshend, and Murray forced him do so through the unassailable logic of their 'Plan of Operations.'[19]

It is undeniable that, when the sickly Wolfe invited the brigadiers to 'consult' at the end of August, the three plans he offered for their consideration were all variants of an attack upon Montcalm's main position at Beauport, *below* Quebec. But it is also clear that, from the very start of the campaign, Wolfe himself had been aware of the potential for a strike *above* Quebec, and within much the same zone that eventually would be targeted in the early hours of 13 September. Wolfe had first considered landing at St-Michel – some three miles above Quebec and about a mile from the Foulon Cove – in the first week of July, only to abandon the plan as too risky: at that time, local naval support was

lacking, with no warships in the vicinity to provide covering fire, nor any of the purpose-built flat-bottomed boats needed to land the troops efficiently. Indeed, while Wolfe's army had been delivered to Quebec by an exceptionally powerful naval force, the fleet's effectiveness was subsequently hampered by navigational conditions in the St Lawrence River. Throughout that summer, the combination of prevailing westerly winds and a fierce ebb tide provided precious few opportunities to move shipping past Quebec.

The idea of an attack at St-Michel was revived a fortnight later, after six vessels, including the fifty-gun *Sutherland* and the frigate *Squirrel*, exploited a brief change in the wind direction to pass Quebec's gun batteries during the night of 18–19 July. Leading naval historians have claimed that the appearance of this small squadron in the upper St Lawrence immediately tilted the strategic balance in Wolfe's favour.[20] But this was not the case. While certainly creating the potential for troublesome upriver raids, such as that mounted by Colonel Guy Carleton at Pointe-aux-Trembles on 21 July, the squadron's capacity to transport and disembark troops was too limited to stage a landing in decisive strength. This deficiency is all too clear from Brigadier Murray's prolonged activities above Quebec in August. Although these have been taken to demonstrate that the British already enjoyed the capacity to strike at will in the upper river, they in fact prove the very opposite. When Murray attempted to land at Pointe-aux-Trembles on 8 August he was bloodily repulsed by no more than three hundred defenders after his landing craft, like Wolfe's at Montmorency on 31 July, grounded on shoals. More than a week later, Murray made an unopposed landing on the north shore and destroyed Montcalm's supply depot at Deschambault, but he swiftly re-embarked when French troops converged on the scene. The point here is that, even when Murray succeeded in getting ashore, he was too weak to consolidate his position and confront the defenders in a major engagement: it was one thing to cruise the St Lawrence above Quebec, quite another to land there in force.

Murray's manpower was restricted to about twelve hundred redcoats by the shipping then available in the upper river. It was not until the last days of August that the Royal Navy was able to assemble a viable squadron above Quebec, with five more ships, including the frigate *Lowestoft* and sloop *Hunter*, passing by its batteries on the night of 27–28 August. As the fleet commander, Vice-Admiral Sir Charles Saunders, pointed out to William Pitt, this was their *fourth* attempt to do so.[21] Now, for the first time during the campaign, there was a realistic chance

of landing in strength above Quebec. The timing of this breakthrough surely influenced the brigadiers' plan to shift operations upriver. Significantly, their deliberations began immediately after this development: their resulting 'Plan of Operations' exploited the new situation, a scenario unavailable to Wolfe when he put his own proposals before them.[22] So, there was nothing startlingly novel about the brigadiers' plan to strike above Quebec. What *was* new was the army's ability to act there in strength, and with some prospect of success.

The key difference between the brigadiers' upriver plan and Wolfe's final stratagem was the specific objective. The evidence indicates that Wolfe plumped for the Foulon on 9 September, after his solo downriver reconnaissance. There is some evidence, albeit inconclusive, that he had been considering it as a possible target for several weeks. As already noted, during the first month of the siege, Wolfe had twice contemplated attacks nearby, at St-Michel. On 19–20 July, after the success of *Sutherland*'s squadron in getting above Quebec had resurrected hopes of a landing there, Wolfe reconnoitered the south shore of the St Lawrence up to the Chaudière River and observed the opposite bank. This episode is well documented, both in Wolfe's own journal and in that kept by his aide-de-camp, Captain Thomas Bell. Wolfe seems to have been pleased by what he saw during the scout: 'General cheerful,' Bell reported.[23]

In addition, there is the more detailed and specific recollection of another of Wolfe's officers who was present during the same reconnaissance, Captain-Lieutenant Samuel Holland of the Royal Americans. Many years later, in 1792, Holland maintained that Wolfe had pointed out the Foulon to him, stating that, if all other plans failed, it would be his 'last resort.'[24] The clear implication of these words – that the Foulon plan was an 'ace up Wolfe's sleeve' – dovetails neatly with Colonel Williamson's 'one more card to play.' But given the hiatus of more than three decades between the event and its retelling, Holland has been dismissed as an unreliable source, a Wolfe-worshipper whose memory was hopelessly tainted by hindsight.[25] Yet Holland was certainly close to Wolfe, who had gained a high opinion of him when they served together at the siege of Louisbourg in 1758. In a letter to his friend, the Duke of Richmond, Wolfe wrote, 'Hollandt [*sic*] the Dutch Engineer has been with me the whole siege, & a brave active fellow he is, as ever I met with; he shou'd have been killed a hundred times, his escape is a Miracle; I promiss'd to mention him to your Grace, because he looks upon himself, as in some measure under your protection, & upon my word he deserves it.'[26] Given this personal bond, and despite the dis-

parity in rank, it is not inconceivable that Wolfe would have confided his thoughts to Holland, or that the impressionable young engineer took pains to remember them and later recalled them accurately.

It is also possible that Wolfe's attention may have been directed towards the Foulon by Major Robert Stobo, a Scottish-born officer in the Virginia Regiment who had spent four years as a prisoner in Quebec before escaping in May 1759. Stobo certainly joined Wolfe's Quebec army, and his local knowledge proved helpful, for example, during Carleton's July raid on Pointe-aux-Trembles. According to a published memoir of his life, it was Stobo who alerted Wolfe to the crucial path running up from the Foulon, although, as his biographer notes, while 'intriguing,' the evidence for this is 'inconclusive.' Whatever Stobo's role, it must have been played before Wolfe's reconnaissance of 9 September, as the major left the Quebec army two days previously with a party taking dispatches to General Amherst.[27] Even if one bluntly rejects Holland's anecdote about the Foulon and likewise discards Stobo's claim, the fact remains that Wolfe had long been aware of the scope for a landing in that general zone, within two or three miles of Quebec. Were this not the case, it is difficult to comprehend how, when conditions finally favoured a strike there, a detailed plan to attack that precise target could be put together so swiftly, within just forty-eight hours.

What specific factors influenced Wolfe's unilateral decision to strike at the Foulon, rather than further upriver as advised by his brigadiers? Before considering the obvious reason – that Wolfe believed his own plan offered the best chance of achieving his objective of beating Montcalm and capturing Quebec – it is necessary to discuss some of the other theories suggested to explain it. By far the best known of these, put forward by Fred Anderson in his widely acclaimed and extremely influential study of the Seven Years' War in North America, *Crucible of War*, maintains that the Foulon attack was in fact an elaborate suicide mission that was never intended to succeed. Put simply, Anderson posits that the despondent Wolfe believed himself dying, and rather than face the stigma of returning home defeated and disgraced, preferred to go out in a blaze of glory, 'courting his grim muse' at the head of a forlorn hope.[28] Indeed, it is common to read in secondary accounts that, by the summer of 1759, Wolfe was 'dying' of consumption.[29] Yet, while Wolfe was certainly in poor health, with his long-term ailments of rheumatism and 'the gravel' (crystals or 'stones' in the urinary tract) exacerbated at Quebec by dysentery and, ultimately, a dangerous fever, there is no contemporary evidence that he was in the grip of tuberculo-

sis. Wolfe had used the adjective 'consumptive' to describe his haggard appearance in a letter written back in 1755, but that cannot be taken as evidence that he was actually suffering from consumption, let alone dying from it, four years later.[30]

While undoubtedly ill, Wolfe was not at death's door. Neither is there any conclusive evidence that he was motivated by a 'death wish'; on the contrary, he had plenty to live for. Much has been made of Wolfe's penchant for Thomas Gray's *Elegy Written in a Country Churchyard*. It is known that Wolfe had a copy of the poem with him at Quebec, and there is credible evidence that he really did recite, or perhaps read, it to his officers shortly before the Foulon attack.[31] Remarkably, that book survives, complete with Wolfe's comments and underlinings, which include that celebrated line, 'The Paths of Glory lead but to the grave.' Yet mere possession of a doom-laden poem, however well thumbed and annotated, is insufficient evidence upon which to convict Wolfe of self-destructive impulses.

Significantly, Wolfe's copy of Gray's *Elegy* was a gift from his fiancée, Katherine Lowther, whom he planned to marry if he survived the Quebec expedition. That Wolfe actually hoped to do just that is clear from contemporary evidence. In a letter to his Uncle Walter before the start of the campaign, he wrote, 'You may be assured that I shall take all proper care of my own person, unless in case of the last importance, where it becomes a duty to do otherwise. I never put myself unnecessarily in the way of danger.'[32] As this passage shows, Wolfe was well aware of the risks he faced – on the congested pre-twentieth-century battlefield, death or wounds were an occupational hazard for any soldier, from general to drummer boy. Through their conspicuous leadership role, officers were statistically more likely to become casualties, and the battle of the Plains of Abraham was no exception; indeed, that morning French officers were heard ordering their men to target their British counterparts.[33] Given these proven dangers, there is no need to hint, as Stacey did, that Wolfe actively 'courted' death; still less to maintain, like another prominent Canadian historian, William Eccles, that both Wolfe and Montcalm died because of the 'stupidity' of their tactics.[34]

Further evidence against the 'death-wish' theory comes from Wolfe's statements of his intention to leave the army once the Quebec campaign was over. He said as much in letters to his commanding officer, Jeffery Amherst, and to his mother, while, as one newspaper noted, the pain he suffered from his 'stone and gravel' was so acute that he 'had determined to resign his commission, on his return to England.'[35]

But what of the other plank upon which Anderson's theory rests, that Wolfe never expected his plan to deliver a victory, that it was instead an elaborately staged suicide bid? Interestingly, as Lawrence Henry Gipson first pointed out in 1949, some support for this interpretation can be found in two near-contemporary French sources.[36] According to an anonymous journal maintained by an officer in Montcalm's defeated army, 'divers British officers' claimed that a council-of-war had been held, at which all the general officers voted unanimously in favour of raising the siege. While agreeing with them, Wolfe made a proposition of his own: 'as the glory of our arms appears to me to require that we should not retire without making one final attempt ... With this view, I am about to try to get a detachment of only one hundred and fifty men to penetrate through the Sillerie woods [west of Quebec], and the entire army will prepare to follow. Should this first detachment encounter any resistance on the part of the enemy, I pledge you my word of honour that then, regarding our reputation protected against all sort of reproach, I will no longer hesitate to re-embark.' Another gossipy version of much the same anecdote was related by Intendant Bigot to Marechal Belle-Isle in October 1759: Bigot, too, claimed to have been told 'the particulars' of the landing by British officers, who maintained that 'Mr Wolf did not expect to succeed ... and that he was to sacrifice only his vanguard, which consisted of 200 men; that were these [to be] fired on, they were all to reembark.'[37]

Those who argue that the Foulon strike was essentially a face-saving exercise that exceeded Wolfe's expectations also cite an episode that occurred soon after the first division of troops got ashore. At that stage, Wolfe decided to temporarily halt any further disembarkation until he was sure of enemy strength in the vicinity. Anderson, like Gipson before him, maintains that Wolfe was dumbfounded by his own success.[38] But Wolfe's reaction, as reported in the journal kept by one of his close-knit 'family' of staff, was logical enough: 'if the post was to be carry'd,' Wolfe had explained, 'there were enough ashore for that purpose, if they were repuls'd a greater number would breed more confusion.'[39] Wolfe's adjutant-general, Isaac Barré, was accordingly sent with the order. On reaching the shore, however, Barré found 'but very few boats there.' As most of the landing craft were already alongside the transports carrying the second wave and full of troops ready to go ashore, Barré decided against delivering the original order to pause the disembarkation, and instead hurried it on. According to Wolfe's critics, it was only Barré's fortuitous initiative that maintained the momentum of an

assault that the hesitant general had allowed to stall. A rather different slant was given by Barré himself when commenting upon James Murray's retrospective efforts to discredit Wolfe's plan. He declared 'that it was notorious to everybody, who had any the least knowledge of Mr Wolfe's wishes and intentions that campaign that they were most ardently bent on bringing the enemy to an action on any thing like equal terms, and that his ordering him [Barré] to stop the boats, could be only a temporary measure 'til he learned the enemys force in the neighbourhood of the landing place.'[40]

Of course, Barré was a life-long devotee of Wolfe, whose patronage had given his career a crucial boost, but that should not be allowed to discredit his account. Rather, the picture that emerges from all of these sources, both French and British, is a consistent and convincing one: Wolfe was determined to engage the enemy, but had no intention of sacrificing his entire force needlessly if it became clear that resistance was too strong to permit a landing. This interpretation, in which Wolfe reacted to events as they unfolded, and had a contingency plan if things went wrong, is bolstered by the recollection of an unlikely ally, Brigadier Townshend. In his 1774 rebuttal of Murray's interpretation of events, Townshend left no doubt of Wolfe's intentions: 'The General's view was to support the experiment, if he found it practicable.'[41]

Perhaps the strongest evidence against the theory that the Foulon assault was never even intended to succeed is the sheer scale of the operation. If it really was a device by which Wolfe could die in a blaze of glory, salvaging his honour and that of British arms, why involve virtually all of his available manpower – some four thousand five hundred men – in a meticulously planned operation in which, as recent research has convincingly argued, both the precise location and exact timing of the landing exploited the optimum meteorological conditions?[42]

Accepting, for the moment, that Wolfe's plan was a genuine gambit to win the campaign, and not some selfish suicide mission, how viable was it in military terms, particularly when compared with the brigadiers' favoured approach? Admiral Holmes's misgivings about the daunting difficulties of implementing a night-time riverborne assault upon a small cove – that, compared to a landing higher upriver, where the shoreline was lower and more accessible, an attack on the cliff-backed Foulon introduced an unnecessary element of risk – have been echoed by eminent historians.

There are other, more specific, criticisms of Wolfe's plan. It is argued that its success hinged upon two unpredictable factors: that the Fou-

lon path was not heavily defended and that, once Wolfe's troops were safely ashore, Montcalm would obligingly lose no time in quitting his entrenchments to come out and fight him in the open. In addition, by seeking to place his army so close to Quebec's westward defences, Wolfe would fail to sever Montcalm's communications with Montreal completely. Besides the road that ran alongside the St Lawrence, there was another inland route, intersecting with it some fifteen miles above Quebec. This provided a means of side-stepping any blocking force, and gave Quebec's defenders an escape route in the event of defeat. Finally, by striking at the Foulon, Wolfe placed his army between two French forces: the larger, some six thousand men under Montcalm at Beauport, below Quebec, and another, totalling perhaps three thousand, commanded by Colonel Louis-Antoine de Bougainville and mostly strung up the river from Cap Rouge.[43]

On the other hand, what can be said in the plan's favour? First, time was running out, and there was need for decisive action. Even the sceptical Admiral Holmes conceded *that*, noting: 'the season was far spent, and it was necessary to strike some stroke, to ballance the campaign upon one side or another.' Second, for all the widespread assumptions – at the time and since – that the upper river offered an easy landing option, this is by no means clear. Given the vigilance and determination of Bougainville's men, the success of a British landfall on the thickly wooded shoreline above Cap Rouge was not guaranteed. Third, an assault upon the Foulon early on 13 September apparently exploited the best possible combination of tidal flow and moonlight; these important advantages were unique to that time and place, and did not apply to the brigadiers' preferred objective. Fourth, by striking close to Quebec, Wolfe could concentrate all of his limited regular manpower, including the two battalions of redcoats left behind at Île d'Orléans and Point Lévis when most of the army moved above Quebec in early September: both units would have missed the upriver operation. Fifth, unlike a landing above the Cap Rouge River, which would have allowed Bougainville and Montcalm to join forces without interference, Wolfe's plan prevented such a juncture by placing his army between them. Of course, as already noted, he thereby ran the risk of a fight on two fronts. But if he had judged the situation correctly, it would provide an opportunity to destroy his opponents in detail before they could unite against him, engaging them on relatively open ground where his highly disciplined regular infantry and artillery could maximize their firepower. Sixth, Wolfe's chosen objective would allow him to strike

where the enemy did not expect him, harnessing the most important weapon of all – surprise. Unlike the brigadiers' plan, which would have given Montcalm ample time to react and consider his options, Wolfe's denied him that priceless breathing space.

Finally, there was another, all-important factor in favour of Wolfe's plan. Previously overlooked by historians of the campaign, it puts a very different complexion upon the respective merits of the strategies proposed by Wolfe and his brigadiers, making it possible to outflank the formidable position first established by Adair in 1936, consolidated by Stacey in 1959, and tenaciously defended by their followers ever since.

To appreciate this last factor's full significance, it is necessary to examine the wider strategic background to the Quebec campaign. Like that implemented in 1758, the strategy thrashed out for 1759 by William Pitt and the British Army's overall commander, Sir John Ligonier, envisaged simultaneous assaults on several fronts. The most important of these was the amphibious expedition up the St Lawrence River against Quebec.[44] Besides ensuring that troops, supplies, and shipping for Wolfe's expedition were ready at Louisbourg by the projected start date of 7 May, Amherst, as commander-in-chief, was to stage his own 'irruption' into Canada via Crown Point, at the foot of Lake Champlain, or by La Galette, on the St Lawrence River facing Lake Ontario, or by *both* routes if possible. He was to attack Montreal or Quebec, 'or both of the said places successively,' either in one body or by splitting his forces. As secondary objectives, Amherst was to re-establish Oswego, destroyed by Montcalm in 1756, and, if viable, push operations as far west as Niagara. Amherst should begin his own campaign by 1 May, as nothing was more important for the operations in North America – particularly against Quebec – 'as putting the forces early in motion, on the other frontiers of Canada, and thereby distracting the enemy and obliging them to divide their strength.' Reinforcing this point, Ligonier wrote a personal letter to his protégé on 12 February 1759, hoping that operations would be 'so concerted as to take place at the same time as near as the nature of the thing will permit, which cannot fail of creating a diversion equally advantageous to both.'[45]

The essence of the 1759 plan, therefore, was that Canada must face synchronized assaults on a minimum of two fronts. This underlying strategy was clear to Wolfe from the beginning. Writing to Amherst from Bath on 29 December 1758, Wolfe promised to 'find employment for a good part of the force of Canada,' so helping to clear Amherst's

path to Montreal. Unless the enemy managed to inject strong reinforce-
ments, Wolfe added, he could see nothing to stop him and Amherst
uniting 'for their destruction.'[46] Amherst, too, plainly grasped the es-
sence of the plan: on 6 May he wrote to Wolfe from his headquarters
in Albany, outlining his intention to 'take post at Oswego and make an
attack on Niagara' and to keep the French 'in hot water at La Gallette
[sic].' Amherst continued, 'I will close in upon the enemy to the utmost
I can at the time you are up the [St Lawrence] River and till then I will
act so as to give them jealousies in different corners at a greater distance
and distract them and force them to abandon some posts or divide to
defend them [so] that they shall weaken themselves everywhere which
I hope will ensure success to us.'[47]

By mid-May, Wolfe had reached Louisbourg. From there, on the 19th,
he wrote a revealing letter to his uncle, Major Walter Wolfe, setting out
his priorities and also reflecting his Secret Instructions. These empha-
sized that he and his naval colleague, Admiral Saunders, were only to
embark on any 'ulterior' – or additional – operations, *after* they had
secured their primary objective of Quebec. Wolfe wrote: 'If I find the
enemy is strong, audacious, and well-commanded, I shall proceed with
the utmost caution and circumspection, giving Mr Amherst time to use
his superiority. If they are timid, weak, and ignorant, we shall push
them with the more vivacity, that we may be able before the summer is
gone to assist the Commander-in-Chief.'[48]

At Quebec, Wolfe encountered the first scenario: despite military
convention, which reckons that a besieging force should outnumber the
defenders by a ratio of four to one, Wolfe had just nine thousand men to
pitch against Montcalm's fourteen thousand.[49] Quebec was a far tough-
er nut than the strategists in London had anticipated. From the outset,
it was obvious to Wolfe that he would need Amherst's help to capture
it. Such co-operation was assumed in Wolfe's official orders. Those read
to the troops on 5 July, at the outset of the siege, left no doubt of this:
'The object of the campaign is to compleat the conquest of Canada and
to finish the war in America. The army under the Commander-in-Chief
will enter the colony on the side of Montreal, while the fleet and army
here attack the Governour-General and his forces.'[50] From the size of
the army facing him at Quebec, Wolfe concluded Amherst would meet
only light opposition on the Lake Champlain front and that his progress
would be correspondingly swift. Writing to Brigadier Edward Whit-
more at Louisbourg on 11 August, he conjectured correctly that Ticon-
deroga and Crown Point must by then be in British hands.[51] By early

August, Amherst held both posts, which had been evacuated by forces under Brigadier-General François-Charles de Bourlamaque. With about three thousand regulars and militia, de Bourlamaque was to make his real stand at Île-aux-Noix, at the northern end of Lake Champlain. In addition, in late July, the western wing of Amherst's army captured Fort Niagara, so raising hopes for a distinct strike against Montreal from that direction. Confirmation of all these conquests reached Wolfe on 25 August, when Brigadier Murray returned from his upriver raid with prisoners and intelligence.

From Wolfe's perspective, the 'divide-and-conquer' strategy thrashed out in London appeared to be working: while he fixed the bulk of Canada's defenders at Quebec, Amherst's troops were making rapid headway against their own more lightly defended targets. Wolfe's interpretation was shared by officers in Amherst's army. Writing from Fort Edward on 6 August, a Black Watch captain reported how Ticonderoga and Crown Point had fallen into their hands 'without striking a stroke.' This was, he emphasized, 'Thanks to Mr Wolfe for the diversion he makes, or else there would have been a tough piece of work of it.'[52]

As the summer progressed, however, delight at Amherst's success was tempered by unease that Wolfe was shouldering a disproportionate share of the burden. In fairness to Amherst, Lake Champlain was dominated by a small French flotilla, and he needed to build warships of his own to control it. Yet a growing body of opinion felt that the general could be doing more to help the hard-pressed Quebec army. Rather than actively pushing on to support Wolfe, it was increasingly clear that Amherst was adopting a passive stance, awaiting developments at Quebec instead of seeking to influence them. By mid-August, such concerns had heightened. Amherst's aide-de-camp, the bullish Captain James Abercrombie, feared that, by rebuilding Ticonderoga and constructing a huge new fort at Crown Point, the general was broadcasting that he had abandoned all thoughts of further conquests that year. Once Bourlamaque realized this, he could release enough of his own troops 'to turn the scale against Mr Wolff at Quebeck.' Unless they moved soon, Wolfe's fate would be decided without them. For Brigadier Thomas Gage, upon whom Amherst's hopes now largely rested, Abercrombie had a thorough contempt: 'I don't imagine G – g will try much for the wrenching [of] the laurels of Montreal from us,' he wrote.[53]

Amherst had sent Gage northwest on 28 July, after hearing that the commander of the British siege of Niagara, Brigadier John Prideaux, had been killed. If he found Niagara and Oswego already in British

hands, Gage was to build a fleet on Lake Ontario and forge ahead to take La Galette. On 1 August, when Amherst learned that the French had abandoned Crown Point, he sent fresh orders, urging Gage to take La Galette without delay, then push on against Montreal; a fortnight later he repeated the commands.[54] Events soon proved that Abercrombie's scornful assessment of Gage was accurate. Despite Amherst's explicit orders he did nothing, so squandering a real chance to influence the campaign's outcome. In a vindication of overall British strategy, Niagara's capture had already caused consternation within Montcalm's Quebec army. Fearing for the Montreal front, the marquis immediately detached eight hundred men to shore it up, under his capable subordinate, François-Gaston, the chevalier de Lévis. But French nerves soon steadied after it became clear that Gage had no intention of attacking La Galette. When known at Crown Point, on 21 September, Gage's woeful lack of enterprise drew a stinging reprimand from Amherst, while an angry William Pitt subsequently conveyed the king's own displeasure.[55]

Amherst's rage at Gage reflected the high hopes he had pinned upon him. Yet Amherst himself had scarcely pursued an aggressive campaign. While his own officers, and likewise the colonial press, felt that much more needed to be done to help Wolfe, the general's correspondence suggests a blasé attitude.[56] Without concrete intelligence from Quebec, Amherst believed that no news was good news. As late as 11 September, in a letter to Gage from Crown Point, Amherst told how a French flag of truce that came into camp the previous day had delivered a letter, dated 30 August, which made it clear that Quebec was still in French hands at that date. As the French officer who brought it said nothing of events at Quebec, save for a failed attack by Wolfe on 17 August (actually the Montmorency assault of 31 July), Amherst lamely concluded that 'whatever has passed since the 17th to the 30th has been in favour of Mr Wolfe, and the enemy is therefore silent.'[57] This was an extraordinary assumption to make. Instead of pushing to help Wolfe, true to the spirit of his instructions from Pitt, Amherst was regulating his own movements by the outcome of events at Quebec.

By late August, Amherst's overwhelmingly defensive stance was obvious to Canada's defenders, confirmed by an extraordinary breach of security. This blunder resulted from Amherst's belated attempts to get dispatches to Wolfe and to receive accurate intelligence from Quebec. Establishing communications between the far-flung British-American armies was not easy. They were separated by several hundred miles of

wilderness, much of it under enemy control. A round-trip from Crown Point to Quebec, or visa versa, might take more than a month – if it dodged hostile patrols. Interestingly, a 'cipher' had been worked out by Colonel Williamson of the Royal Artillery and Amherst's younger brother and adjutant-general, Colonel William Amherst, so that coded messages could be sent between the Quebec and Lake George fronts. Unfortunately, when William Amherst went home in August with the dispatches announcing the conquest of Ticonderoga and Crown Point, he inadvertently took the all-important cipher with him.[58]

In early August Amherst resolved to establish contact with Wolfe by sending out two scouting parties, hoping that at least one would get through. The first, dispatched from Crown Point on 7 August and led by ranger ensign Benjamin Hutchins, was to make for the St Lawrence via the Kennebec River. Next day, another party, under Captain Quinton Kennedy of the 17th Foot, left on a more direct northeasterly tack, travelling via Lake Champlain and then heading for Quebec across country. Hutchins's party finally reached Quebec on 3 September, although his dispatches told Wolfe nothing he did not already know. Besides announcing his conquests and asking Wolfe to make contact, Amherst repeated his familiar pledge of support: 'You may depend upon my doing all I can for effectually reducing Canada; Now is the time.'[59] The arrival of Hutchins and his scouts nonetheless boosted the morale of the Quebec army, which now believed – mistakenly, of course – that Amherst was just a week's march away.[60]

Kennedy's men never reached Wolfe. Captured by hunters from the Abenaki mission village of St Francis, they destroyed their official dispatches, but not a cache of uncoded letters from officers in Amherst's army to their friends with Wolfe. These candid, personal communications let slip that Amherst had no intention of advancing until sure of Wolfe's 'success.'[61] Regardless of how 'success' is interpreted here, whether as a clear-cut victory or a more general assessment of affairs, the undisputed point, as Amherst emphasized to Gage on 14 August, was that his own 'motions' must be guided by Wolfe's progress. This crucial intelligence was soon circulating among the French forces defending Île-aux-Noix and Quebec. For the moment at least, Amherst's 'Grand Army' no longer posed a threat; there would be no need to drain further troops from the force opposing Wolfe.

Frustration at the discovery of Kennedy's scout played a part in Amherst's decision to unleash the celebrated ranger, Major Robert Rogers, upon the St Francis Abenaki. Yet there was another, strategic, justifi-

cation for what became known as 'the St Francis Raid.' As Amherst confided to Lieutenant-Governor James De Lancey of New York, by striking at the settlements along the southern shore of the St Lawrence, and so deflecting attention to that sector, Rogers would 'hinder' the enemy from reinforcing the vulnerable La Galette front.[62]

Rogers and his force of about two hundred and forty men left Crown Point on the evening of 13 September. Unknown to Amherst, by then the victorious Wolfe was already dead, Montcalm defeated and dying of his wounds. Neither was Amherst aware that Gage had resolved against attacking La Galette. Rogers's raiders duly torched St Francis on 4 October, and were hailed as heroes by the colonial press, but the coup came too late to influence the outcome of the 1759 campaign. Its undoubted impact within New France, however, suggests what might have been achieved had Amherst authorized such a diversionary strike soon after reaching Crown Point in early August, instead of waiting until mid-September.

Ironically, Amherst's very inactivity throughout August 1759 itself contributed to the Quebec campaign's dramatic climax. Had the strategy envisaged by Ligonier and Pitt in December 1758 unfolded as planned, with coordinated advances on several fronts, Wolfe need never have executed his controversial Foulon assault. Determined pushes by Amherst and Gage, or either one of them, would – as the colonial press emphasized – in all likelihood have taken Montreal, so severing Quebec's logistical lifeline as effectively as the upriver strategy recommended by Wolfe's brigadiers, and likewise achieving a more decisive result than the young general's tactical victory on the Plains of Abraham.

Writing to Colonel Burton on 10 September, Wolfe maintained that Amherst was still forging onwards into Canada, exerting pressure that had obliged Montcalm to send Lévis west.[63] Wolfe said much the same thing in his final, morale-boosting orders to his troops, issued on 12 September when they were already aboard the transports and preparing to climb down into their landing craft. Whether Wolfe still believed this himself is impossible to say: the arrival of Hutchins's scouts on 3 September had raised hopes that Amherst was just a week away; yet that interval had now passed without any sign of him, or even accurate intelligence of his whereabouts. Whatever the uncertainty about Amherst, it was obvious to Wolfe that time was running out. If, as seems likely, Wolfe knew of the meteorological conditions in favour of attacking the Foulon in the early hours of 13 September, then he had another

strong reason for striking there and then, without waiting upon his tardy commander.

Keeping this broad strategic background in mind, it is time to return to the final factor that gave Wolfe's 'needlessly risky' Foulon plan a significant edge over the much-admired strategy of Monckton, Townshend, and Murray. With Amherst's progress still unclear, Wolfe acted independently of him. As events would show, this was not just a bold decision, but a wise one. By contrast, the brigadiers' plan relied upon Amherst's support. In formulating their own upriver strategy in late August, they had assumed that the commander-in-chief and his 'armies' were advancing 'into the heart' of Canada, and that the enemy forces on the Richelieu River–Montreal front would be busy 'opposing' him.[64] There is no evidence that they changed their minds on this essential point during the ensuing fortnight in which the campaign reached its climax or that they subsequently appreciated the gravity of their strategic error.

Several historians have censured Amherst for his failure to support Wolfe more vigorously,[65] yet they have not appreciated the dire implications for the brigadiers' 'Plan of Operations.' Under the circumstances, with Amherst still stalled some two hundred miles away at Crown Point, had the brigadiers' strategy been implemented, most of Wolfe's army would have been trapped far up the St Lawrence River between two hostile forces – the combined Quebec army of Montcalm and Bougainville to the south and whatever troops could be withdrawn from the stabilized Richelieu River–Montreal front, under the leadership of Lévis or Bourlamaque, to the north. Owing to the interception of Kennedy, the French at Quebec and Montreal knew more about Amherst's whereabouts and intentions than did Wolfe and his subordinates. Forewarned, they could have exploited that intelligence accordingly. It follows that the brigadiers' plan, widely hailed as so much 'safer' than Wolfe's, was in fact anything but, and instead a blueprint for disaster.

Much of the criticism levelled at Wolfe's Foulon plan is speculative: what if the path up from the Foulon had been more heavily guarded? What if the sentries lining the St Lawrence had been told that an expected provision convoy from Montreal had been cancelled? What if a password had been circulated? What if Montcalm had waited for Bougainville before attacking Wolfe's army on the Plains of Abraham? And so on. Given all this speculation, perhaps one other hypothesis is justifiable: what if the brigadiers *had* gone upriver, in the mistaken belief that Amherst was advancing and preoccupying the enemy forces to the

northwest? At best, there might have been a hazardous, Dunkirk-style evacuation aboard the available shipping. A more likely scenario would have been a protracted bushfight by an isolated and heavily outnumbered British force, tormented by Canadian militia and Indian warriors exploiting wooded terrain to practise their distinctive and formidable brand of irregular warfare, the probable result a bloody rout such as befell General Edward Braddock on the Monongahela River in 1755 or a humiliating capitulation to match that of General John Burgoyne at Saratoga in 1777.

Unlike the brigadiers' paper plan, Wolfe's was actually put to the test, and worked. It was fortunate for Jeffery Amherst, and particularly for Thomas Gage, that it did. Had Wolfe's mission misfired, Amherst's conduct might have been questioned, while Gage surely would have faced more than the mere reprimand he received – that same summer, Lord George Sackville, the commander of the British troops in Germany, was dismissed from the service in disgrace for refusing to bring up the cavalry at Minden.[66]

As Wolfe himself declared, 'In war something must be allowed to chance and fortune, since it is in its nature hazardous.'[67] The successful execution of his plan certainly benefitted from its fair share of luck, but that was only part of the story. Its outcome also rested upon the meticulous planning of the entire operation, and the consummate professionalism of the soldiers and sailors who implemented it. James Wolfe, too, surely deserves more credit as a commander than his many critics have allowed – not simply for the determination with which he pursued his own objective, but, given the unravelling of Britain's North American strategy for 1759, for the acumen that underpinned its selection. In short, the 'hapless' Wolfe devised and implemented a strategy that was infinitely superior to that of his brigadiers. For all its undeniable risks, Wolfe's final plan – his last card, as Colonel Williamson saw it – was not simply the most viable alternative to sailing lamely off from Quebec in defeat; it was the *only* alternative. Wolfe's 'military reputation,' currently so debased, must be revalued accordingly.

NOTES

1 Amherst Family Papers, Centre for Kentish Studies (hereafter cited as CKS), U1350/O33/4.

2 For general accounts, see C.P. Stacey, *Quebec, 1759: The Siege and the Battle*

(1959: rev. ed. Toronto: Robin Brass Studio, 2002); D. Peter MacLeod, *Northern Armageddon: The Battle of the Plains of Abraham* (Vancouver: Douglas & McIntyre, 2008); Matthew C. Ward, *The Battle for Quebec, 1759: Britain's Conquest of Canada* (Stroud: Tempus, 2005); see also Stephen Brumwell, *Paths of Glory: The Life and Death of General James Wolfe* (London: Hambledon Continuum, 2006), chaps. 7–9. Dan Snow's *Death or Victory: The Battle of Quebec and the Birth of Empire* (London: Harper Press, 2009) shares the prevailing negative assessments of Wolfe's generalship that this chapter seeks to challenge.

3 *The Siege of Quebec and the Battle of the Plains of Abraham*, vol. 2, ed. A. Doughty and G. W. Parmelee (Quebec: Champlain Society, 1901), 238–9. Wolfe's memorandum is undated, but the evidence suggests compilation on, or before, 27 August. Stacey (*Quebec, 1759*, 111) concludes it was 'probably' written on the 27th.

4 Dated Point Lévis, 29 August 1759, United Kingdom National Archives (hereafter cited as UKNA), Chatham Papers, Public Records Office (PRO) 30, 8/50, ff. 162–3.

5 'Journal of Moncrief [actually kept by Major Patrick Mackellar],' in *Siege of Quebec* (see note 2), vol. 5, 48.

6 See Wolfe to Burton, *HMS Sutherland*, 10 September 1759, in R. Wright, *The Life of Major-General James Wolfe* (London: Chapman and Hall, 1864), 569.

7 'Letter of Holmes,' 18 September 1759, in *Siege of Quebec* (see note 2), vol. 4, 296.

8 *HMC: Marquess of Townshend Manuscripts* (London, 1887), 316.

9 'Copies of Some Papers which Passed between General Wolfe and the Brigadiers, with Regard to the Operations of the Army, employed up the River St Lawrence,' National Library of Scotland, MS 4853, 1–14 from rear of book.

10 5 November 1774, Amherst Family Papers (CKS) U1350/073/11.

11 John Fortescue, *A History of the British Army*, vol. 2 (London: Macmillan, 1899), 393–4.

12 L.H. Gipson, *The British Empire before the American Revolution*, vol. 7, *The Great War for Empire: The Victorious Years, 1758–1760* (New York: Alfred Knopf, 1949), 412–13.

13 E.R. Adair, 'The Military Reputation of Major-General James Wolfe,' *Canadian Historical Association Report* (Ottawa, 1936), 30–1.

14 Stacey, *Quebec, 1759*, 188. Stacey warmed to his theme in his subsequent entry on Wolfe in the prestigious *Dictionary of Canadian Biography*, vol. 3 (Toronto: University of Toronto Press, 1966–), 673, writing that Wolfe's choice of landing 'placed the whole operation at the mercy of luck.'

15 Morton has brought Stacey's verdicts before a broad readership. For example, writing in one of Canada's leading newspapers, he praised Stacey for highlighting 'the tactical misjudgments and risk-taking' of both Wolfe and Montcalm; see 'The forgotten heroes of the Plains of Abraham,' *Ottawa Citizen*, 12 September 2009. Such assessments have become widely accepted by Canada's mainstream journalists, Ian Brown, for example, observing that 'Wolfe and Montcalm were equally hapless tacticians' ('In Wolfe's clothing,' *Globe and Mail*, 1 August 2009).

16 For example, Fred Anderson, *Crucible of War: The Seven Years' War and the Fate of Empire in British North America, 1754–1766* (New York: Alfred Knopf, 2000), 344–68; Bruce Lenman, *Britain's Colonial Wars, 1688–1783* (Harlow: Longman, 2001), 511; and Ian K. Steele, *Warpaths: Invasions of North America* (New York: Oxford University Press, 1994), 217–19. An important recent article on events at Quebec in 1759 praises Stacey's book as 'the single most complete and reliable account'; see Donald W. Olson et al., 'Perfect Tide, Ideal Moon: An Unappreciated Aspect of Wolfe's Generalship at Quebec, 1759,' *William and Mary Quarterly*, 3rd series, 59 (2002): 957, n. 1. More recently, Ian K. Steele has characterized Stacey's 'revisionist' perspective as 'still-dominant'; see his review of Brumwell, *Paths of Glory*, in *International History Review* 30 (2008): 127–8. Stacey's interpretation of events and personalities at Quebec also dominated their depiction in Episode 4: 'Battle for a Continent,' of the Canadian Broadcasting Commission's lavish and frequently repeated drama-documentary series, 'Canada: A People's History' (originally broadcast 2000–1).

17 Letter from Quebec, 14 September 1759 in *New-York Gazette*, 3 December 1759; *The Interesting Narrative of the Life of Olaudah Equiano* ... 8th ed. (Norwich, 1794), 78. According to Equiano, the episode occurred in 1758 when he and Wolfe were aboard HMS *Namur*. For Wolfe's 'war crimes,' see, for example, Anderson, *Crucible of War*, 344; and F. McLynn, *1759: The Year Britain Became Master of the World* (London: Jonathan Cape, 2004), 287–90.

18 By contrast, the two hundred and fiftieth anniversary of Montcalm's death the following day saw wreath-laying ceremonies at both the general's flamboyant statue on Quebec City's Grande Allée and his mausoleum in the cemetery of the Hôpital général.

19 Stacey's *Dictionary of Canadian Biography* entry on Wolfe (see note 14, vol. 3, 671–3), makes both points with characteristic force.

20 See N.A.M. Rodger, *The Command of the Ocean: A Naval History of Britain, 1649–1815* (London: Allen Lane, 2004), 278; and Jonathan R. Dull, *The French Navy and the Seven Years' War* (Lincoln: University of Nebraska Press, 2005), 149.

21 Saunders to Pitt, *Stirling Castle*, off Point Lévis, 5 September 1759, in *The Correspondence of William Pitt*, vol. 2, ed. G.S. Kimball (1906; reprinted New York: Kraus, 1969), 161.

22 This important point was first made in D. Grinnell-Milne, *Mad, Is He? The Character and Achievements of James Wolfe* (London: Bodley Head, 1963), 13.

23 See under the relevant dates in McCord Museum, 'Wolfe's Journal,' Wolfe Collection, C-173, box 1, Ms. 255; Library and Archives Canada, 'Bell's Quebec Journal,' in 'Northcliffe Collection,' Separate Items, MG18-M / microfilm reel C-370.

24 See A.G. Doughty, 'A New Account of the Death of Wolfe' *Canadian Historical Review* 4 (1923): 48.

25 Steele, review of Brumwell, *Paths of Glory*, 128.

26 Wolfe to Richmond, 'Isle Royale' [Louisbourg], 28 July, 1758, in R.H. Whitworth, 'Some Unpublished Wolfe Letters, 1755–58,' *Journal of the Society for Army Historical Research* 53 (1975): 84.

27 *Memoirs of Major Robert Stobo of the Virginia Regiment* (London, 1800), 65. See also Robert C. Alberts, *The Most Extraordinary Adventures of Major Robert Stobo* (Boston: Houghton Mifflin, 1965), and his entry on Stobo in *Dictionary of Canadian Biography* (see note 14), vol. 3, 600–2.

28 Anderson, *Crucible of War*, 353–4.

29 For example, one biographer states (without giving a source) that, when Wolfe sailed for Quebec, there was 'little doubt that he was suffering from an advanced state of tuberculosis'; see Robin Reilly, *The Rest to Fortune: The Life of Major-General James Wolfe* (London: Cassell, 1960), 220. Similarly, the entry on Wolfe in a popular reference work maintains: 'Had he escaped French musketry he would have died of the galloping consumption that was already eating him away'; see Richard Holmes, 'Wolfe, Maj Gen James,' in *The Oxford Companion to Military History*, ed. R. Holmes (Oxford: Oxford University Press, 2001), 997.

30 Wolfe to his mother, Bristol, 19 January 1755, in B. Willson, *The Life and Letters of James Wolfe* (London: William Heinemann,1909), 300.

31 Discussed in Brumwell, *Paths of Glory*, 271–2.

32 Wolfe to Major Walter Wolfe, Louisbourg, 19 May 1759 (Willson, *Life and Letters of Wolfe*, 553).

33 *Edinburgh Chronicle*, 27–29 October 1759.

34 Stacey, *Quebec, 1759*, 163; also his entry on Wolfe in *Dictionary of Canadian Biography* (see note 14), vol. 3, 672; Eccles, 'The Battle of Quebec: A Reappraisal,' in his *Essays on New France* (Toronto: Oxford University Press, 1987), 133.

35 Wolfe to his mother, 31 August 1759, in Wright, *Life of Wolfe*, 553; Wolfe to

Amherst, Louisbourg, 27 May 1759, UKNA, War Office (WO) 34/46B, f. 300; *New-York Gazette*, 25 February 1760.

36 Gipson, *Victorious Years*, 415–16.

37 See 'Extract of a Journal Kept at the Army Commanded by the Late-General de Montcalm,' in *Documents Relative to the Colonial History of the State of New York*, vol. 10, ed. E.B. O'Callaghan and B. Fernow (Albany, NY: Weed Parsons, 1853–87), 1037; Bigot to Belle-Isle, 25 October 1759, in ibid., 1052.

38 Anderson, *Crucible of War*, 354.

39 Public Record Office of Northern Ireland, DOD, 162/77, part 2, p. 8; also Library and Archives Canada microfilm reel A-652. While anonymous, the memoir's handwriting resembles that of Wolfe's deputy-assistant-quarter-master-general, Captain Matthew Leslie, who was certainly present at the Foulon that morning, having had 'the honour to conduct the embarkation and landing of the troops.' See Leslie's petition to William Pitt, 24 February 1767, UKNA, PRO 30, 8/48, f. 101.

40 In a letter from Major Henry Caldwell to James Murray, London, 1 November 1772, Amherst Family Papers, CKS, U1350/C21.

41 Townshend to Murray, Rainham, 29 October, 1774, Amherst Family Papers, CKS, U1350/073/9.

42 Olson et al., 'Perfect Tide, Ideal Moon,' 958.

43 See, especially, Eccles, 'Battle of Quebec; and Adair, 'Military Reputation of Wolfe.'

44 Pitt to Amherst, Whitehall, 29 December 1758, in *Correspondence of Pitt* (see note 21), vol. 1, 432–42.

45 Amherst Family Papers, CKS, U1350/035/8.

46 UKNA, WO 34/46B, ff. 286–8.

47 UKNA, WO 34/46B, f. 310.

48 Willson, *Life and Letters of Wolfe*, 427–9.

49 In addition to Montcalm's field army, about two thousand men garrisoned Quebec City (Stacey, *Quebec, 1759*, 59). Stanley Pargellis made the important, although often-overlooked, point that Wolfe's siege of Quebec was the sole operation in the American war 'which the British won with the odds against them'; see *Military Affairs in North America, 1748–1765: Selected Documents from the Cumberland Papers in Windsor Castle*, ed. S. Pargellis (New York: D. Appleton-Century, 1936), xix–xx.

50 'General Orders in Wolfe's Army During the Expedition Up the River St Lawrence, 1759,' in *Literary and Historical Society of Quebec: Manuscripts Relating to the Early History of Canada* (1875), item 2, 17–18.

51 From 'Camp near the Falls of Montmorency,' UKNA, WO 34/46B, ff. 305–6.

52 *Edinburgh Chronicle*, 20–22 September 1759.
53 Abercrombie to Loudoun, Crown Point, 13 August 1759, Huntington Library, Loudoun Papers (LO) 6137.
54 UKNA, WO 34/46A, ff. 171, 175–6.
55 Amherst to Gage, Crown Point, 21 September 1759, UKNA, CO 5/56, f. 223; Pitt to Amherst, Whitehall, 11 December 1759, in *Correspondence of Pitt* (see note 21), vol. 2, 216–17.
56 See the editorial in *Boston Gazette*, 17 September 1759, reprinted in *New-York Gazette*, 24 September 1759.
57 Amherst to Gage, Crown Point, 11 September 1759, UKNA, WO 34/46A, ff. 180–1.
58 New York, 27 April 1759, UKNA, WO 34/46B, f. 309; same to same, Crown Point, 7 August 1759, UKNA, CO 5/56, f. 201.
59 Crown Point, 7 August 1759, UKNA, CO 5/56, ff. 201–2.
60 'Extract of a Letter from Point-Levee,' 4 September 1759, *Boston Gazette*, 8 October 1759.
61 'Extract of a Journal' (see note 37), 1033–4.
62 Crown Point, 25 September 1759, UKNA, WO 34/30, f. 82.
63 *An Historical Journal of the Campaigns in North America for the Years 1757, 1758, 1759, and 1760, by Captain John Knox*, vol. 2, ed. A.G. Doughty (Toronto: Champlain Society, 1914), 91–3.
64 Point Lévis, 29 August 1759, UKNA, PRO 30, 8/50, ff. 162–3.
65 See, for example, Brumwell, *Paths of Glory*, 256–7, 308–9; Dull, *French Navy and the Seven Years' War*, 147–8; Fortescue, *History of the British Army*, vol. 2, 377–8; *Military Affairs in North America* (see note 49), xix–xx; John Shy, *Toward Lexington: The Role of the British Army in the Coming of the American Revolution* (Princeton, NJ: Princeton University Press, 1965), 94–5; and C.P. Stacey, 'Amherst, Jeffery,' in *Dictionary of Canadian Biography* (see note 14), vol. 4, 23.
66 See Piers Mackesy, *The Coward of Minden: The Affair of Lord George Sackville* (London: Allen Lane, 1979).
67 Wolfe to Major Rickson, Blackheath, 5 November 1757, in Willson, *Life and Letters of Wolfe*, 339.

3

Crossing the Line? The British Army and the Application of European 'Rules of War' in the Quebec Campaign

MATTHEW C. WARD

On the evening of 18 June 1759, a British fleet carrying a force of more than eight thousand regular troops commanded by Major-General James Wolfe, which had entered the St Lawrence a few days earlier, finally came to anchor off the French-Canadian settlement of Bic. Its arrival sparked fear and consternation among the inhabitants of the shores of the great river. Fearing for their fate, many *habitants* abandoned their homes and fled to the woods. To officers in the British Army and Royal Navy, such behaviour was all but inexplicable. Unlike many of the previous operations in North America, this expedition was composed exclusively of regular troops, and the following campaign, they understood, would reflect the practices of Enlightenment warfare and be conducted in a formal and regulated fashion. In particular, British officers strongly believed that this expedition would spare citizens and non-combatants the horrors of war,[1] in stark contrast to the behaviour of the French that Wolfe would later characterize as 'irregular, cowardly, and cruel.'[2] Indeed, shortly after his arrival in the St Lawrence, Wolfe issued a formal proclamation to the inhabitants of New France. In it he assured the *habitants* that 'The King of Great Britain wages no war against industrious Colonists and peasants, nor against women and children, nor the sacred ministers of religion; he foresees their distressful circumstances, pities their lot and extends to them offers of protection.'[3]

Such assurances did not last long. Within six weeks, Wolfe had ordered Brigadier-General Robert Monckton to 'burn every House and Hutt' and commence a war of devastation.[4] During late August and early September 1759, just two months after Wolfe had promised his protection, the British destroyed nearly all the settlements on the St

Lawrence River below Quebec and many of those upriver between the city and Trois-Rivières. The civilian governor of Canada, Pierre Rigaud de Vaudreuil de Cavagnial, was horrified. In mid-August he fretted that all Wolfe sought to do was 'to pillage, ravage and burn the settlements which are near his army. This proceeding is so contrary to the rules of war.'[5] The ferocity of the campaign dismayed not only the Canadian governor, but also some of Wolfe's senior officers, including, in particular, Brigadier-General George Townshend, who lamented to his wife that he had 'never served so disagreeable a Campaign as this. Our unequal Force has reduced our Operation to a Scene of Skirmish, Cruelty & Devastation. It is War of the worst Shape.'[6]

The Quebec campaign of 1759 is significant not only because it saw the reduction of France's principal stronghold in North America, but also because it was the most European-style or regular campaign fought in North America before the Revolutionary War. Understanding how and why the campaign degenerated from one waged in full accord with European traditions of 'limited' warfare, where the civilian population had a degree of protection, to one where the civilian population was the principal target of the army is important for understanding the nature of North American warfare in the eighteenth century.

Many studies of the 'early American way of war,' such as Russell Weigley's, presume that there was something intrinsically 'American' about the propensity to violence, particularly against civilians – that it was the conditions experienced by armies in North America that led to particularly brutal conflict, and thus that warfare in North America was rather different from warfare in Europe.[7] John Shy, in particular, has argued that, in North America, armies did not adopt the 'rules of war' that limited European warfare. Colonists continued to fight total wars, and to fight with a zeal for annihilating their enemies.[8] John Ferling takes Shy's argument still further, claiming that, by the eighteenth century, in response to their environment and their resources, Americans had developed a unique style of total warfare. In the woods and mountains of the American wilderness, with no roads, no supply depots, poor communication, thick woodlands, and rough terrain, highly organized and disciplined armies could not campaign.[9] John Grenier has perhaps taken this concept furthest, arguing that a distinct 'American way of war' emerged in which the annihilation of the enemy, including civilians, became the

aim of campaigns.[10] In this 'wilderness of miseries,' to use Ferling's description of warfare, the Quebec campaign of 1759 stands out as an exception – a conflict ostensibly fought in the European style. Wolfe's army did not encounter conditions notably different from those they might have experienced in Europe: it was fought in a relatively heavily populated region of North America, there were relatively few problems in maintaining communications and moving supplies, and British regular troops, not provincial levies, formed the army.

Most studies of the Quebec campaign have focused on the personalities of the commanders and on conflicts between the commanders and their subordinates, and generally have paid little attention to the campaign outside the Quebec basin. More recently, however, some studies have examined in greater detail the experiences of civilians and ordinary soldiers in the campaign. Most notably, Peter MacLeod portrays the growing ferocity of the British against the civilian population of New France as part of a predetermined strategy to draw the Canadians into battle and deprive them of supplies. As MacLeod demonstrates, however, the nature of this strategy caused considerable concern among many officers in both the French and British armies.[11]

At the start, Wolfe and his officers had intended that their campaign should be a formal one waged according to the established 'rules of war.' While these rules were not formally promulgated in any one document, they were recognized by officers of all ranks and nationalities. The concept of regularized rules of war had its origins in the work of Dutch theorist Hugo Grotius, who in 1625, during the early stages of the Thirty Years' War, published *De Juri Belli ac Pacis* (On the law of war and peace), in which he argued for the protection of the rights of the individual during times of war. By the middle of the eighteenth century, the concept of a set of 'rules of war' had become widely accepted by most European armies.[12] To aid their officers in following such rules, many armies published their own instructions, and officers of all armies frequently consulted France's *Code Militaire*. Concepts of the rules of war were echoed in works such as the Comte de Turpin de Crissé's *Commentaires de Caesar* and the writings of Sébastien Le Prestre, Marshall Vauban, which provided advice and guidance on the correct conduct of a campaign. Wolfe had certainly read such works, for he provided his subordinates with a list of studies on military affairs that detailed the distinct rights of civilians in warfare.[13] The 'civilized' and 'enlightened' warfare of the eighteenth century required

that civilians be spared the worst horrors of combat, that armies should campaign against each other, not the civilian population.[14]

In western Europe civilians did suffer during wartime and atrocities did occur, but normally under relatively specific conditions. For example, under the accepted 'rules of war,' which regulated warfare between two monarchs, the destruction of civilian property and the spreading of terror among the civilian population were allowable when those civilians were in revolt against a recognized monarch. The supporters of Charles Edward Stuart clearly fell in this category, and the brutal suppression of the Jacobite rebellion was justifiable in terms of the prevailing rules. Similarly, in 1755 and 1756, the British round-up and deportation of several thousand francophone civilians from the former French colony of Acadia – in modern terms an act of brutal 'ethnic cleansing' – was also justified by eighteenth-century 'rules of war.' By the Treaty of Utrecht of 1713, the Acadians had become subjects of the British Crown, but their refusal to swear an oath of loyalty to George II placed them outside the rules of war. The Acadians, in essence, were rebels during time of war.[15] Civilians in besieged towns that were stormed by enemy troops could also expect little quarter from their conquerors if they had refused an honourable surrender.[16]

The most notable discussion of the rules of war was *Le droit des gens, ou les principes de la loi naturelle*, by the Swiss writer Emmeric de Vattel, published in London in 1758, the year before the Quebec expedition. Vattel's work was quite specific in defining the rights of civilians in war:

> Women, children, feeble old men, and sick persons come under the description of enemies; and we have certain rights over them, inasmuch as they belong to the nation with whom we are at war, and as, between nation and nation, all rights and pretensions affect the body of the society, together with all its members. But these are enemies who make no resistance; and consequently we have no right to maltreat their persons or use any violence against them, much less to take away their lives. This is so plain a maxim of justice and humanity, that at present every nation in the least degree civilized, acquiesces in it.[17]

While there is no direct evidence that Wolfe had read Vattel, the work reflects a general consensus about the regulation of warfare in the middle of the eighteenth century. Rules and regulations of warfare gov-

erned the conduct of armies in many other ways. Prisoners should be exchanged, subject to their agreeing not to serve again in the campaign. Officers captured in battle could expect treatment markedly different from their men. Indeed, many were kept on parole with few restraints on their freedom until an agreement could be made for their release. The wounded were also offered a degree of protection: hospitals and wagons transporting the wounded were protected from combat.

These constraints on the brutalities of warfare led most British officers who embarked for the St Lawrence in the spring of 1759 to believe that the Quebec campaign would be waged in a honourable manner, and, indeed, it began in a promising fashion. On 27 June, as British forces occupied Île d'Orléans and began to move on to the southern shore around Point Lévis, Wolfe issued his first formal message to the Canadian people. He promised that if they remained in their homes and on their farms they should not fear 'the least molestation,' and guaranteed that they would be able to 'enjoy their property, attend to their religious worship; in a word, enjoy, in the midst of war, all the sweets of peace, provided they will take no part directly or indirectly in the contest between the two crowns.'[18] At the beginning of July, when over-enthusiastic troops who had been landed near Beaumont on the south shore of the St Lawrence, or Côte-du-Sud, pillaged civilians' household furniture and clothing, they were ordered to return their loot to the parish church so that owners could reclaim their belongings.[19] Then, in the middle of the month, the British released a large number of farmers whom they had captured on Île d'Orléans and the Côte-du-Sud and who praised the treatment they had received.[20] The British also ensured that all the French women who fell into their hands were speedily returned. Following an attack near Pointe-aux-Trembles on 21 July, for example, the British captured more than two hundred women and children; officers took special care to ensure that the women and their property were protected. When sailors began to pilfer their belongings, Wolfe quickly intervened, threatening to punish any miscreants severely and forcing the sailors to return all the possessions they had taken.[21]

The British went even further to make their captives feel at home. They were wined and dined by the officers, especially Wolfe, who seemed to take delight in his new role as host.[22] Wolfe even allowed a Catholic priest to celebrate mass with the women on board the Royal Navy warship on which they were temporarily incarcerated. Many returned to Quebec after their three-day captivity with mementoes of

their adventure, including the names of their captors.[23] Indeed, this interaction between British officers and their female captives might explain, in part, the frequent contacts that seem to have taken place between civilians in Quebec and British officers during the frequent ceasefires in the hostilities that took place throughout late July and early August.[24] The exchange of letters and even visits of British officers and men to an enemy city 'under siege' during the campaign underlines the formality with which the campaign was waged in its early stages.

It was not only women and civilians who were treated humanely. The crowns of Britain and France had negotiated a formal cartel detailing how prisoners and the wounded should be treated.[25] At the start of the campaign, both Wolfe and Montcalm agreed to abide by the cartel, and it was generally honoured. Montcalm even allowed Wolfe to evacuate his wounded from the Pointe-aux-Trembles expedition from the British base at St-Nicolas to the main field hospital below Quebec on Île d'Orléans, which required the French batteries in Quebec to halt their fire to allow the hospital ship to pass.[26]

Towards the end of July, however, the campaign began to acquire a rather less 'honourable' nature. On 15 July the British had completed their first batteries and soon began to open fire on Quebec. As the bombardment continued day after day, to the surprise of the civilians the British seemed as intent on bombarding the suburbs and civilian areas of the town as on the military fortifications. Indeed, many of the French began to suspect that the primary intention of the British was to spread fear and panic among the town's inhabitants, rather than to weaken its ability to resist a siege. One Quebec resident wrote in his journal that 'it was remarked, that the English, altered the direction of their Bombs; at first they flung them into the heart of the place; but having learnt from the letters they found upon the women whom they had taken Prisoners, (and which contained the news of every thing that was passing in the Town of Quebec,) that almost all the inhabitants had fled from it they brought all their fire to bear upon the suburbs, wither the inhabitants had retired.'[27] British officers seemed to take a particular delight in watching the town burn, and this delight appears to have grown as the campaign progressed. On 22 July Patrick Mackellar recorded in his journal, 'At night there was a considerable fire in Town by one of our Carcasses w[hi]ch burnt the Cathedral & Ten or Twelve good houses.' An officer in Fraser's Regiment recorded, 'the town much bombarded, set

on fire, and burnt most of the night.' A few days later another of-
ficer reported that the British batteries had had 'great effect on the
town, setting [it] frequently on fire, and the lower town is almost
destroy'd.' By early September Admiral Charles Saunders was able
to boast to William Pitt that 'The Town of Quebec is not habitable,
being almost entirely burnt and destroyed.'[28]

While the bombardment of Quebec might have begun as an act of
military strategy, the total destruction of the town and the delight
with which British troops viewed the devastation became symbolic
of changing British attitudes to the campaign. Over a period of about
two weeks, following the exchange of the prisoners from Pointe-aux-
Trembles on 25 July, the campaign degenerated quickly into a brutal
and irregular war. On that day, Wolfe issued a proclamation to the
civilians of the St Lawrence, warning that he was 'indignant at the
little regard paid by the inhabitants of Canada to his [earlier] proc-
lamation' and was 'determined no longer to listen to the sentiments
of humanity.' Further, he added, 'The Canadians have, by their con-
duct, proved themselves unworthy the advantageous offers he held
out to them. Wherefore he has issued orders to the Commanders of
his Light Infantry and other officers, to proceed into the country and
to seize and bring in the farmers and their cattle, and to destroy and
lay waste what they shall judge proper.'[29]

At the beginning of August, Wolfe began to form detachments to
'scour the Country.'[30] The men were given strict orders to protect
only the churches and to respect only 'the persons of ancient men
or women, or helpless children.' They were, however, allowed 'to
despoil them of whatever moveables they could find in their posses-
sion.' Further, they were 'allowed to kill and destroy by every means
they could, all the Cattle they could find, of every kind, and specize.
They were allowed to burn and destroy all their Magazines, whether
of Corn, Hay, Provisions, or whatsoever kind they might be. They
were allowed by every means they could to harm and destroy all
the Corn, or any other produce of the Field, Garden, or Orchard, and
whatsoever else they found growing in the ground.'[31] This would
now be a war of devastation and destruction, and it would be the
civilian *habitants* of the St Lawrence who would suffer the worst
hardships.

The first major raiding party set out on 4 August, when Wolfe dis-
patched Captain Joseph Gorham of the rangers to the north shore of
the St Lawrence to destroy the settlements between La Petite Rivière

and La Malbaie.[32] From La Malbaie Gorham sailed to Île-aux-Cou-
dres and established a temporary base of operations there before
continuing across the St Lawrence to the Côte-du-Sud, where he took
great delight in destroying fifty farms. He reported back to Wolfe
that the south shore seemed much more prosperous than the north
shore – indeed, 'the Parish of St Anne & St Roch contain the largest
farms & produce the greatest Quantity of grains I have seen.' He
continued with a hint to Wolfe, 'in case any further Dutys should be
Required on the S. Shore in Collecting the Cattle etc. which are good
& Numerous ... the knowledge I have gain'd would greatly facilitate
that Duty and be attended with Dispatch & advantage.'[33] Such settle-
ments, he said, should be destroyed as quickly as possible.

Wolfe needed little encouragement to follow up on Gorham's
hint.[34] The Côte-du-Sud was one of the more prosperous and fertile
parts of Canada, and had been relatively untouched by warfare. It
would not be so lucky now.[35] On 1 September Wolfe gave Gorham
command of an even larger detachment of more than six hundred
rangers, regulars, and seamen, and orders to ravage the entire Côte-
du-Sud as far east as Kamouraska. Gorham kept meticulous details
of his party's progress, which he was duly to report back to Wolfe.
Landing on 10 September close to Kamouraska, over the following
week Gorham's men left a trail of destruction along the south shore.
'Upon the whole,' Gorham commented 'we marched fifty two Miles,
and in that distance, burnt nine hundred and ninty [sic] eight good
Buildings.'[36] Another raiding party, commanded by Brigadier Gen-
eral Murray, was sent upriver from Quebec to destroy settlements
between Deschambault and Rivière Etchemin. Establishing a base of
operations in the village of Ste-Croix on the south shore,[37] Murray
sent parties out to burn settlements and seize all the cattle and corn
they could find.[38] Another major destructive raid took place at the
end of August, when Wolfe sent out parties along the Beaupré shore,
destroying the settlements of L'Ange-Gardien, Château-Richer, Ste-
Anne-de-Beaupré, and St-Joachim. By 1 September one officer was
able to report, 'All the houses below Montmorency Falls, or to the
eastward, sett on fire by our army.'[39]

The destruction of civilian property and the bombardment of Quebec
could be viewed as merely the consequence of military necessity. After
several months in the St Lawrence, when the only battle between the
two armies – at the end of July near the Falls of Montmorency – had
seen his men soundly defeated, Wolfe was forced to face the pos-

sibility, indeed the probability, that he would not be able to reduce Quebec in a single campaign. He began to deliberate what would need to be done if a campaign were to be waged in 1760. He contemplated leaving behind a garrison on Île-aux-Coudres to harass French communications and prevent supplies reaching Quebec. He also considered what should be done to deprive Canada of much needed supplies. It was to this end that he justified the bombardment of the town, the destruction of magazines of provisions, the slaughter of cattle, and the ripping up of crops as an undesirable, but at least to some extent permissible, military policy. If Canada were robbed of supplies, any British army that returned to the St Lawrence the following spring would have an easier task of reducing the colony than had Wolfe. Indeed, Governor Vaudreuil, the civilian governor of Canada, wrote to the Chevalier de Lévis, second in command of the French Army, on 18 August, that Wolfe 'no longer makes a secret of saying that the expedition to Canada has failed ... The only resource he has found in his despair is to pillage, ravage and burn the settlements which are near his army.'[40]

Soon, the focus of the activities of Wolfe's men changed from depriving the French of supplies and shelter for a future campaign to seeking to inflict maximum destruction in any form. Colonel Malcolm Fraser, for instance, recorded in his journal that, on 25 August, his men set about cutting down the orchards near L'Ange-Gardien even while not bothering to destroy the cornfields. A French diarist who later ventured into the region was astonished to discover that Wolfe's men had ensured 'the burning of *every house* to the ground and cutting down *all the Fruit* Trees – The Church was spared, and the cornfields were untouched – They found in the Camp and around it, about fifty horses feeding quietly.'[41] Rather than touch crops or kill horses – two items that might seem to have been of the greatest military significance – the raiding party instead sought to inflict long-term losses on the civilian population by destroying buildings and orchards. This was not military necessity. Indeed, Vattel concluded that 'those who tear up the vines and cut down the fruit-trees are looked upon as savage barbarians, unless when they do it with a view to punish the enemy for some gross violation of the law of nations. They desolate a country for many years to come, and beyond what their own safety requires. Such conduct is not dictated by prudence, but by hatred and fury.'[42]

A further element of ferocity, clearly not required by military necessity, was added to the repertoire of British troops when they began to

adopt the practice they had felt most offensive, that of scalping. Even during the horrors of the brutal repression of the Jacobite rebellion in Scotland, British regulars had not resorted to scalping, and initially the thought that their troops might scalp the enemy was anathema to British officers. On 27 July, however, Wolfe relaxed the army's regulations and issued an order allowing scalping 'when the Enemy are Indians, or Canads. dressed like Indians.'[43] By mid-August, British rangers, in particular, routinely displayed the scalps of their victims as trophies of their victories.[44] Wolfe himself boasted to Townshend after a skirmish near the Falls of Montmorency on 15 August that 'our little Detachment brought off one Scalp & a number of Trophies.'[45] The most notorious occasion occurred on 23 August when a party of Light Infantry commanded by Captain Alexander Montgomery of the 43rd Regiment was posted west of St-Joachim on the Côte-de-Beaupré. The party captured the Abbé de Portneuf, the local parish priest, and nine militiamen who had been protecting him and had surrendered to Montgomery's troops. Not content with capturing this party, according to one of the British witnesses, 'the barbarous Capt. Montgomery who commanded us ordered [them] to be butchered in a most inhuman and cruel manner.'[46] Even children were not always spared by British regulars. On 10 July Malcolm Fraser recorded in his journal that a party of rangers had captured a man and his two children. When the men were unable to stop the two children from screaming and crying, the children 'were in the most inhuman manner murdered by those worse than savage Rangers … I wish this story was not fact, but I'm afraid there is little reason to doubt it, the wretches having boasted of it on their return.'[47]

The scope of the destruction meted out by the British army on the St Lawrence was quite remarkable. In a month British troops destroyed nearly all the settlements and about two thousand farms from Kamouraska to Deschambault, a distance of nearly one hundred miles. These raids left the civilian population in dire straits. The bishop de Pontbriand, the Catholic bishop of Quebec, reported that, on both sides of the river, 'about 36 leagues of settlement country have been almost equally devastated; it contained 19 parishes, the greater number of which have been destroyed. All those places … will suffer seriously, and are incapable of assisting any person … [the *habitants*] have no provisions to sell, and will not be restored to their ancient state for more than 20 years.'[48] With no grain, no cattle, and often no shelter, thousands of civilians faced hunger and exposure

as winter approached, and an unknown number died of starvation or disease resulting from malnutrition. Indeed, almost half of the *habitant* population suffered directly at the hands of Wolfe's army. This certainly was not the enlightened warfare British officers envisaged when they arrived on the St Lawrence in June. The raids and the destruction of civilian property that occurred on the St Lawrence were not necessarily outside the established 'rules of war.' Yet the ferocity with which this destruction was undertaken and the enthusiasm with which British troops participated suggest that the raids were of dubious morality at best. French commanders clearly thought this was the case. Governor Vaudreuil wrote to his second in command, Chevalier Lévis, that 'The only resource he [Wolfe] has found in his despair is to pillage, ravage and burn the settlements which are near his army. This proceeding is so contrary to the rules of war.'[49]

There is substantial evidence that British officers also had some concerns about the army's actions. Wolfe's senior officers, Brigadier Generals Monckton, Murray, and, in particular, Townshend, felt unease at the destruction meted out against Canadian non-combatants. This unease soon broke to the surface, and a split developed between Wolfe and his brigadiers that was so deep that Townshend and Murray even prepared a case against Wolfe to be heard upon their return to Britain. Wolfe's untimely death on the Plains of Abraham on 13 September sanctified his memory and ensured that these complaints were never given a full public airing, although reverberations and recriminations from the case continued to be printed in the London press through the winter and spring of 1759–60. Although the dispute between Wolfe and his brigadiers involved more than just the army's conduct towards civilians, and the case focused principally on Wolfe's failure to bring Montcalm to battle, the treatment meted out to civilians and Wolfe's preoccupation with ravaging and plundering the countryside, rather than capturing the town of Quebec, formed a key part of the brigadiers' case.[50] Indeed, it appears that Wolfe himself was concerned about the condemnation that might have awaited him on his return to Europe, for he specifically destroyed the portions of his journal following the defeat at the Falls of Montmorency in which he ordered the descent on civilian settlements.

Other officers also watched the degeneration of the campaign with concern. Captain John Knox, for instance, recorded in his journal:

Fraser's detachment returned this morning, and presented us with more

scenes of distress, and the dismal consequences of war, by a great number of wretched families, whom they brought in prisoners, with some of their effects ... Though these acts of hostility may be warrantable by the laws of nations and rules of war, yet, as humanity is far from being incompatible with the character of a soldier, any man, who is possessed of the least share of it, cannot help sympathising with, and being sincerely affected at, the miseries of his fellow-creatures, though even his enemies.[51]

Perhaps the most compelling evidence that Wolfe's actions sat uneasily with eighteenth-century concepts of the limited nature of war comes from the censorship of his final letter to William Pitt when published in the British press. In his letter written on 2 September, Wolfe had informed Pitt:

At my first coming into the Country, I used all the means in my Power, to engage the Canadians to lay down their Arms, by offers of such Protection & Security for themselves, their Property & Religion, as was consistent with the known Mildness of His Majesty's Government. I found that good Treatment had not the desired Effect, so that of late I have changed my Measures & laid waste the Country, partly to engage the Marquis de Montcalm to try the Event of a Battle to prevent the Ravage, and partly in Return for so many Insults offer'd to our People by the Canadians, As well as the frequent Inhumanitys exercised upon our own Frontiers. It was necessary also to have some Prisoners as Hostages for their good Behaviour to our People in their hands, whom I had reason to think they did not use very well. Major Dalling suprized the Guard of a Village & brought in about 380 Prisoners, which I keep, not proposing any Exchange 'till the End of the Campaign.[52]

When Wolfe's dispatch appeared in the British press, however, this telling passage was completely omitted and did not enter the public domain.[53]

The pillaging and destruction of civilian property also appears in stark contrast to the treatment that civilians received after Wolfe's death. Following the fall of Quebec, Generals Monckton and Murray took every step possible to halt pillaging and plundering by their troops. Those found guilty of plundering the inhabitants' possessions were speedily brought to a court-martial and threatened with execution.[54] Not only were the rank and file discouraged from pillaging and plundering, the strategy of destroying civilian supplies was also changed. When Mur-

ray sent out an expedition to destroy French magazines towards Pointe-aux-Trembles, the commander of the expedition, Colonel Hunt Walsh, was ordered to destroy only grain and forage held by the *habitants* 'over and above what he may deem absolutely necessary for subsistence.'[55] Further, rather than burning the surplus provisions, he was to take what he could back to Quebec, where they were to be distributed to the city's inhabitants who had submitted to the British. Murray went even further to assist the city's inhabitants, ordering one day's provisions to be stopped each week from each officer's and soldier's rations to be redistributed among the city's residents according to their need.[56]

This is not to suggest that Murray was incapable of retribution against the *habitants*. In early 1760 a French party, sent to gather supplies and intelligence, was sheltered and given militarily significant information at the village of St-Michel.[57] When Murray discovered this 'treachery' of villagers who had formerly sworn an oath of loyalty to the British Crown, he recorded in his journal that 'I thought it proper Punishment to burn these houses, at the same time that it put it out of the Enemys Power to make use of them a second time.'[58] He sent out a detachment of Fraser's Highlanders with orders to obliterate the village.[59]

In July 1760, during the advance on Montreal, a party of Murray's men was lured into an ambush near the village of Sorel. The villagers had come down to the shoreline to beg to be allowed to swear an oath of neutrality and to sell supplies and provisions. When the troops landed, however, they were surrounded and attacked, suffering heavy casualties. Murray quickly retaliated. He explained in a letter to William Pitt that 'I was therefore under the cruel necessity of burning the greatest part of these poor unhappy people's houses; I pray God this example may suffice, for my nature revolts when this becomes a necessary part of my duty.'[60] While Murray's actions might now be viewed as reprehensible, they were certainly within eighteenth-century concepts of the 'rules of war,' being clear retribution for specific acts of the enemy. Wolfe's actions the previous summer, however, were more difficult to justify in these terms.

Several forces compelled Wolfe's army to adopt an increasingly savage or 'American' way of war. The first of these was the nature of the opponent, rather than of the terrain. It was French or, rather, Canadian irregular methods of fighting that helped to propel the British to employ such tactics. Particularly on the frontier of the British colonies to the south, the French had developed the strategy they termed *la petite guerre*, whereby aboriginal war parties, guided by French officers,

attacked frontier settlements and skirmished with colonial forces.[61] Although this practice had become an established part of Canadian military strategy, it did not sit easily with French officers – in particular, Montcalm, who sought to wage war in a more European fashion. Indeed, disputes over how to wage war in Canada drove a deep and irreconcilable wedge between Vaudreuil and Montcalm. The *Canadiens* held a huge advantage in irregular skirmishes in the dense woodland, and the Canadian woods essentially became a no-go area for British forces during the campaign. Irregular warfare, and the skirmishes around British camps, formed a fully accepted part of European warfare, and for which Wolfe and his fellow officers were fully prepared. In 'conventional' European warfare, however, such combat was conducted by identifiable combatants. What distinguished the campaign on the St Lawrence from those in Europe was the ease and speed with which Canadian farmers could slip from civilians to soldiers.[62]

Montcalm had four types of troops available for the defence of Canada: the *troupes de la terre*, or regular French forces; the *troupes de la Marine*, who were regular troops but permanently stationed in Canada; the Canadian militia; and his aboriginal allies. The regular forces were concentrated on the north shore of the St Lawrence to oppose any potential British landing, particularly along the Beauport shore between the Falls of Montmorency and Quebec. Elsewhere the militia formed the backbone of defence. Because the militia was composed of all the adult male population, because they often lacked military uniform and insignia, and because most of these operations took place away from the regular army, it was difficult to distinguish between combatants and non-combatants. Vattel, in his *Law of Nations*, had maintained that 'the people ... have nothing to fear from the sword of the enemy. Provided the inhabitants submit to him who is master of the country.'[63] One of Wolfe's justifications for these raids was specifically that the *Canadiens* had not fully submitted to him. Yet the *habitants* were in a dangerous situation: Wolfe's army did not control their villages; he merely sent raiding parties through them. From Quebec, Montcalm and Vaudreuil sent out repeated instructions that the *Canadiens* were to take every opportunity to harass the British. Indeed, during the course of the campaign, nearly every adult male served in some function in the French and Canadian forces. Women, older children, and old men assisted in the movement of supplies and the hiding of food stores from the enemy. The entire Canadian

population was mobilized for warfare in a way that was unthinkable in mid-eighteenth-century Europe.[64] Wherever they went, British forces found it all but impossible to distinguish between combatants and non-combatants, and by early August 1759 the increasingly angry and frustrated British viewed most Canadian civilians with deep suspicion.[65] Under European 'rules of war,' civilians should have remained entirely aloof from the military conflict; their involvement not only blurred the boundary between combatant and non-combatant, but also justified the burning of their farms and the bombardment of their towns and villages.

The second reason for the British army's drift towards a more brutal form of warfare was the activity of France's aboriginal allies. From the start of the campaign, British troops who strayed too far from camp, in particular into the notorious 'woods' that covered most of the St Lawrence River valley, were prone to capture by small 'skulking' parties of aboriginals. John Johnson noted in his journal that, soon after taking possession of Île d'Orléans, three soldiers 'went to a small distance from their Camp, to a wood in the flank, to gather herbs or vegetables ... they no sooner had entered the wood but they were surprized by one of these Skulking parties ... and butchered in the most cruel, and barbarous manner; for besides their killing and scalping them, they ripped them open, and took out their hearts, and left them on the spot where they had committed their horrid barbarity.'[66] While such practices were a recognized part of aboriginal warfare, they were completely anathema to British officers who sought to wage war in the European fashion.[67] As the campaign progressed, the British grew increasingly incensed by aboriginal war practices. In particular, Wolfe and his officers were outraged by the treatment meted out to several grenadiers who were captured by the French on 22 July. Rumours spread rapidly through the British ranks that the grenadiers were to be burned alive in the middle of the French camp. Wolfe's aide-de-camp, Isaac Barré, wrote a heated letter to the French asking whether the rumour had any basis in fact and warning Governor Vaudreuil that 'the British troops are only too much exasperated; the enormous cruelties already committed, and especially the base infraction of the capitulation of Fort William Henry are yet fresh in their minds. Such acts deserve and if repeated will certain meet, in future, the severest reprisals; all distinction will cease between Frenchmen, Canadians and Indians; all will be treated as a cruel and barbarous mob, thirsting for human blood.'[68] Wolfe

himself wrote to Monckton that, if he discovered these reports were indeed true, then 'the country shall be but one universal blaze.'[69]

Governor Vaudreuil was horrified by these threats and attempted to dismiss the rumours as no more than 'soldiers' gossip.'[70] While many such rumours might have been little more than campfire stories told to frighten wary soldiers in the flickering firelight, there was some basis for the British fears. One of the French-Canadian Ursuline nuns of the Quebec hospital wrote candidly in her journal that, after the battle at the Falls of Montmorency, the nuns who were attempting to ferry away the wounded to the hospital had had to face 'the fury and rage of the indians, who, according [to] their cruel custom sought to scalp them.'[71] The Curé Recher similarly noted with some horror in his journal that one British prisoner, who turned out to be Irish and Roman Catholic, had been savagely beaten and tortured by the Indian women and children in their village before being ransomed to the French.[72]

The scalping of prisoners, including women and children accompanying the British army, was certainly carried out by some aboriginal allies of the French. Indeed, Governor Vaudreuil was so concerned by such reports that he ordered Lévis to investigate their accuracy and to attempt to put a stop to such practices immediately.[73] Vaudreuil, however, had unwittingly encouraged this behaviour where it was convenient. For instance, he posted small parties of aboriginals alongside many of the French regulars with orders to capture any soldiers who might attempt to desert. In March he reported to the ministry in Paris that, 'two soldiers of Berry having fallen into this category, our Indians went in pursuit, overtook them, cut the head off one and obliged his comrade to carry it himself to the fort.'[74] If aboriginals were encouraged to scalp even French deserters, British troops must have seemed an inviting target.

The activities of France's aboriginal allies thus served to create a deep hatred of and loathing for aboriginals within the British army. Making the problem even worse was the French practice of using aboriginals alongside Canadian militia, as had occurred successfully in frontier raids against the British colonies to the south. The presence of *Canadiens* among aboriginal raiding parties had seemed to provide the latter with some discipline and order, as they were prone to abandon attacks with the least excuse, or to attack targets that seemed more appealing but that often lacked military importance. Thus, it made sense to use *Canadiens* and aboriginals in this fashion on the St

Lawrence. On 3 July, for instance, Montcalm sent out Le Sieur Legris with a raiding party of thirty farmers and thirty Abenaki warriors against British positions near Point Lévis and Pointe-des-Pères, opposite Quebec.[75] On 18 July, Captain John Knox recorded that 'An Indian was said to be taken on this side the river to-day by some of our outparties: I am told he was quite naked, painted red and blue, with bunches of painted feathers fastened to his head.' Later, Knox corrected his entry, adding that 'the person who was taken to-day, naked and painted, was not an Indian, but a Canadian in disguise; a practice not uncommon among the natives of this country, when detached on any enterprise with the savages.'[76]

The combination of aboriginals and Canadian militia had unfortunate consequences. Because of their frequent contact with aboriginals, the *Canadiens* also might have occasionally followed the practices of aboriginal warfare and treated their British prisoners with some brutality and perhaps even resorted to scalping. Moreover, in these combined parties, it was not unusual for prisoners of the *Canadiens* to be seized by the aboriginals and subjected to torture. Malcolm Fraser's journal reveals how these practices could impinge on British soldiers. At the beginning of July, a detachment of Highlanders found several men who had been killed by the enemy. 'They were all scalped & mangled in a shocking manner. I dare say no human creature but an Indian cou'd be guilty of such Inhuman cruelty.' As an afterthought, Fraser corrected his journal to read 'no human creature but an Indian or Canadian cou'd be guilty.'[77] When John Johnson recorded the scalping of British troops on Île d'Orléans at the end of June, he specifically blamed 'one of these Skulking parties of Savage Canadians.'[78]

Towards the end of July, Wolfe wrote to Montcalm arguing that 'such barbarities were intirely contrary to the Rules of War, highly dishonourable, and disgraceful to a General to suffer, much more so too encourage; and therefore begged the Colonists and Indians might be restrained.' When Montcalm failed to halt such abuses, Wolfe, 'in order if possible, to intimidate these monsters in cruelty, found it absolutely necessary to connive at some irregularities which were committed by our Soldiers in return.'[79] On 25 July he issued another formal proclamation to the Canadian civilians, announcing that they had 'by their conduct, proved themselves unworthy of the advantageous offers he held out to them. Wherefore he has issued orders to the Commanders … to destroy and lay waste what they shall judge proper.'[80] The strategy of combining *Canadiens* and aboriginals in raid-

ing parties might have made strategic sense to French commanders, but it allowed the British to demonize Canadian civilians even more than they did aboriginals. Every eighteenth-century Briton knew that Indians were 'savage'; *Canadiens* were supposed to be European and 'civilized.' By associating themselves with Indian practices of warfare, the *Canadiens* had placed themselves outside civilized European society, justifying their removal by the British from the protection of the rules of war.

Wolfe and his fellow officers had arrived in Canada expecting to fight a regular campaign. Indeed, the campaign on the St Lawrence was almost certainly the most 'European' of all the campaigns fought in North America before the Revolutionary War, and could have been fought on the plains of northern Germany. The Battle of the Plains of Abraham was in all ways a 'regular' European-style contest. Yet, the circumstances the British army encountered on the St Lawrence drove it to fight in a manner more ruthless than in any other campaign.

From the publication of Russell Weigley's *The American Way of War*, historians have argued for a distinctly American manner of waging war that verged on total warfare. Some, such as John Ferling, locate the origins of this form of warfare in the nature of the North American environment; others, such as John Dederer and John Grenier, suggest the impetus for such warfare in America came from the experiences of combat against aboriginals. The Quebec campaign, however, was not the 'wilderness warfare' that other British commanders faced in the interior of North America; it was not the conditions of campaigning, the nature of the Canadian environment, that forced Wolfe's army to fight such a campaign. Wolfe did not have to concern himself to any great degree with securing his supply lines or transporting supplies over the rough terrain of the American interior, Nor was the drift towards brutality the result of 150 years of experience of the 'American way of war,' for this was not an army recruited in North America but a regular army largely recruited in Britain and with little prior experience of campaigning in North America. The brutal pattern of the war they fought lay not in the frontier environment but in the nature of warfare as practised by the *Canadiens* and their aboriginal allies and championed by Canadian-born Governor Vaudreuil. Wolfe, in short, was forced to adopt an 'American way of war' in order to counter his opponents.[81]

Patterns of irregular warfare were not unknown in Europe – indeed, discussions of partisan warfare were becoming increasingly common, as evidenced by the publication in France in 1759 of Jeney's *The Parti-*

san, which would appear the following year in an English translation. The conflict in Quebec, however, was singular for the ways in which the entire Canadian population was mobilized to resist the British attack. Men were farmers one moment and militiamen the next; women and children moved supplies; priests organized the defence and sent reports back to Quebec. In many ways this was total war, and the combination of irregular warfare and total warfare led to the breakdown of the rules of war. Thus, rather than patterned on the seventeenth- and eighteenth-century wars on the frontier of New England, the Quebec campaign in many ways bears more similarity to the irregular warfare of the American Revolution in the campaigns around New York and in the backcountry of the southern colonies, and even to the later Napoleonic Wars in Europe.[82]

Wolfe waged the campaign with an unusual brutality that marked it from others of its time. French and Canadian tactics did not compel British troops to scalp enemies or abandon prisoner exchanges and other Enlightenment military practices, but such brutality reflected the nature of the campaign as one of 'total war.' The entire civilian population of Canada was mobilized for war in a manner that was not seen in western Europe in the mid-eighteenth century and would not be equalled even in the Napoleonic wars. Total warfare, where civilians and military were indistinguishable, was responsible for the transformation of this most regular of eighteenth-century North American campaigns into, in Townshend's words, 'a Scene of Skirmish, Cruelty & Devastation ... War of the worst Shape.'[83] Ultimately, it was not the difficult physical environment of North America but the nature of warfare as practised by the *Canadiens* and their aboriginal allies that incited the British troops to respond in kind.

NOTES

1 'Journal of the Expedition against Quebec,' 18 June 1759, James Murray Collection, Library and Archives Canada (hereafter cited as LAC), MG 23 II (Series 4), C2225.
2 *An Historical Journal of the Campaigns in North America: For the Years 1757, 1758, 1759, and 1760 by Captain John Knox*, vol. 2, ed. Arthur G. Doughty (Toronto: Champlain Society, 1914–16), 77.
3 'General Wolf's [*sic*] Proclamations to the Canadians,' 27 June, 29 July 1759, in *Documents Relative to the Colonial History of the State of New York; Procured*

in Holland, England and France, vol. 10, ed. Edmund B. O'Callaghan and Berthold Fernow (Albany, NY: Parsons Weed, 1853–87), 1046–7.

4 Wolfe to Monckton, 6 August 1759, Monckton Papers, Townshend Collection, LAC, MG18 M, vol. 22.

5 Vaudreuil to Lévis, 18 August 1759, in *Lettres du Marquis de Vaudreuil au Chevalier de Lévis*, ed. Henri-Raymond Casgrain (Quebec: L.J. Demers, 1895), 86.

6 Townshend to Lady Ferrers, 6 September 1759, in *The Siege of Quebec and the Battle of the Plains of Abraham*, vol. 5, ed. Arthur Doughty (Quebec: Dussault and Proulx, 1901), 195.

7 Russell F. Weigley, *The American Way of War: A History of United States Military Strategy and Policy* (New York: Macmillan, 1973). For a similar discussion of how conditions affected the British army, see Stephen Brumwell, *Redcoats: The British Soldier and War in the Americas, 1755–1763* (Cambridge: Cambridge University Press, 2002).

8 John Shy, *A People Numerous and Armed: Reflections on the Military Struggle for American Independence* (Ann Arbor: University of Michigan Press, 1990), 227–54; and Don Higginbotham, 'The Early American Way of War,' *William and Mary Quarterly*, 3rd series, 44 (1987): 230–73.

9 John E. Ferling, *A Wilderness of Miseries: War and Warriors in Early America* (Westport, CT: Greenwood Press, 1980).

10 John Grenier, *The First Way of War: American War Making on the Frontier, 1607–1814* (New York: Cambridge University Press, 2005).

11 D. Peter MacLeod, *Northern Armageddon: The Battle of the Plains of Abraham* (Vancouver: Douglas & McIntyre, 2008); Matthew C. Ward, *The Battle for Quebec, 1759: Britain's Conquest of Canada* (Stroud, UK: Tempus, 2005); and Stephen Brumwell, *Paths of Glory: The Life and Death of General James Wolfe* (London: Hambledon Continuum, 2006).

12 Hew Strachan, *European Armies and the Conduct of War* (London: Allen & Unwin, 1983), 8–9.

13 James Wolfe letter, 18 July 1756, James Wolfe Collection, LAC, MG18 L5, vol. 4.

14 Jeremy Black, *European Warfare, 1660–1815* (Frome, UK: UCL Press, 1994); and M.S. Anderson, *War and Society in Europe of the Old Regime* (London: Fontana, 1988), 190–2.

15 For a discussion of some of the particular problems in Acadia, see John G. Reid et al., *The 'Conquest' of Acadia, 1710: Imperial, Colonial, and Aboriginal Constructions* (Toronto: University of Toronto Press, 2004).

16 John W. Wright, 'Sieges and Customs of War at the Opening of the Eighteenth Century,' *American Historical Review* 39 (1934): 629–44.

17 Emmerich de Vattel, *The Law of Nations: Or the Principles of the Law of Nature Applied to the Conduct and Affairs of Nations and Sovereigns*, trans. Joseph Chitty (Philadelphia: T. & J.W. Johnson, 1863), 351.

18 'General Wolf's Proclamations to the Canadians,' 27 June 1759, 1046–7.

19 *Journal of the Particular Transactions During the Siege of Quebec by an Officer of Fraser's Regiment* (Quebec: Nuns of the Franciscan Convent, 1901), 4.

20 'Operations of the Army under M. de Montcalm before Quebec,' in *Documents Relative to the Colonial History of the State of New York* (see note 3), vol. 10, 1024.

21 Jean-Claude Panet, 'Journal du siège de Québec en 1759,' *Literary and Historical Society of Quebec, Historical Documents*, 4th series, vol. 3 (1875), 9–10; Henri Tétu, 'M. Jean-Félix Récher, curé de Québec, et son journal, 1757–1760,' *Bulletin des Recherches Historiques* 9 (1903): 353.

22 'Operations of the Army under M. de Montcalm before Quebec,' 22 July 1759, 1025.

23 Tétu, 'M. Jean-Felix Récher,' 345; and 'Narrative of the Siege of Quebec,' 21 July 1759, in *Documents Relative to the Colonial History of the State of New York* (see note 3), vol. 10, 999.

24 'Narrative of the Siege of Quebec,' 2 August 1759, 1001; 'Operations of the Army under M. de Montcalm before Quebec,' 22 July 1759, 1025; and Panet, 'Journal du siège de Québec en 1759,' 17.

25 'Precautions taken for the safety of proposed negotiations between Le Mercier & Wolfe ,' 24 July 1759; Admiral Saunders to General Townshend, 25 July 1759, Monckton Papers, Townshend Collection, LAC, MG18 M, vol. 21.

26 Panet, 'Journal du siège de Québec en 1759,' 17; Tétu, 'M. Jean-Felix Récher,' 353; 'Journal of the Siege of Quebec,' Monckton Papers, Townshend Collection, LAC, MG18 M, vol. 30, ff. 53–4.

27 'Journal of the Siege of Quebec,' vol. 30, 54; 'Journal of James Wolfe,' 15 July 1759, James Wolfe Collection, LAC, MG 18 L5, vol. 5.

28 'Journal of the Expedition against Quebec,' f. 14; *Journal of Particular Transactions by an Officer of Fraser's Regiment*, 12; 'Journal of Operations,' 11 August 1759, LAC, MG23 K 34, File 3; Charles Saunders to William Pitt, 5 September 1759, United Kingdom National Archives (hereafter cited as UKNA), Colonial Office (CO) 5/51, f. 40.

29 'General Wolf's Proclamations to the Canadians,' 1047–8.

30 'Journal of James Wolfe,' 2 August 1759.

31 'John Johnson Journal,' Siege of Quebec Collection, LAC, MG18 N18, vol. 3, 33.

32 'Journal of James Wolfe,' 10 August 1759, 4; Vaudreuil to Lévis, 13 August

1759, in *Lettres de Vaudreuil à Lévis* (see note 5), 84; 'Operations of the Army under M. de Montcalm before Quebec,' 1032; Gorham to Wolfe, 19 August 1759, Monckton Papers, Townshend Collection, LAC, MG18 M, Series 1, vol. 21.

33 Gorham to Wolfe, 19 August 1759, Monckton Papers, Townshend Collection, LAC, MG18 M, Series 1, vol. 21.

34 Gorham to Amherst, 30 September 1759, UKNA, War Office (WO) 34/4, f. 1.

35 Gaston Deschênes, *L'année des Anglais: la Côte-du-Sud à l'heure de la Conquête* (Sillery, QC: Septentrion, 1988).

36 'Report of a tour to the South Shore of the River St. Lawrence,' 1–17 September 1759, Monckton Papers, Townshend Collection, LAC, MG18 M, Series 1, vol. 21; Gorham to Amherst, 30 September 1759, UKNA, WO 34/4, f. 1.

37 'Journal of the Expedition against Quebec,' ff. 19–20; James Murray to Admiral Holmes, 11 August 1759, James Murray to Gen. Wolfe, [11] August 1759, James Murray Papers, Correspondence, LAC, MG23-GII1 (Microfilm AG-1992); Tétu, 'M. Jean-Felix Récher,' 386.

38 Henri-Raymond Casgrain, ed., *Journal des campagnes du Chevalier de Lévis en Canada de 1756 à 1760* (Montreal: C.O. Beauchemin et fils, 1889), 193; *Journal of Particular Transactions by an Officer of Fraser's Regiment*, 22; and James Murray to Gen. Wolfe, 25 August 1759, James Murray Papers, Correspondence, 1759, LAC, MG23-GII1 (Microfilm AG-1992).

39 Panet, 'Journal du siège de Québec,' 27; Tétu, 'M. Jean-Felix Récher,' 369–70; and *Journal of Particular Transactions by an Officer of Fraser's Regiment,* 29–30.

40 Vaudreuil to Lévis, 18 August 1759, in *Lettres de Vaudreuil à Lévis* (see note 5), 86.

41 'Journal of the Siege of Quebec,' vol. 13, f. 90 (emphasis in original). See also Aegidius Fauteux, ed., 'Journal du siège de Québec du 10 mai au 18 septembre 1759,' *Rapport de l'Archiviste de la Province de Québec*, 1 (1920–1921): 194; and 'Journal of Wolfe's Campaign of 1759,' 25 August 1759, McCord Museum, M 277.

42 Vattel, *Law of Nations*, 367.

43 'Wolfe's Orders,' Northcliffe Collection, LAC, Microfilm C-370, f. 172.

44 'Bell's Journal,' 30 June 1759, Northcliffe Collection, Separate Items, LAC, MG 18 L5, vol. 5; and *Journal of Particular Transactions by an Officer of Fraser's Regiment*, 29.

45 Wolfe to Monckton, 16 August 1759, Monckton Papers, Townshend Collection, LAC, MG18 M, vol. 22.

46 'Operations of the Army under M. de Montcalm before Quebec,' in *Documents Relative to the Colonial History of the State of New York* (see note 3), vol. 10, 1034; and 'Journal of Wolfe's Expedition,' 23 August 1759, McCord Museum, M 277.

47 'Journal of Wolfe's Expedition,' 10 July 1759, McCord Museum, M 277.

48 'An Imperfect Description of the Misery of Canada,' 5 November 1759, in *Documents Relative to the Colonial History of the State of New York* (see note 3), vol. 10, 1059.

49 Vaudreuil to Lévis, 18 August 1759, in *Lettres de Vaudreuil à Lévis* (see note 5), 86.

50 Townshend to Amherst, 7 October 1759, UKNA, WO 34/46B, 217–18.

51 *Historical Journal of the Campaigns in North America* (see note 2), vol. 1, 443.

52 James Wolfe to William Pitt, 2 September 1759, UKNA, CO 5/51, ff. 72–85; the deleted passage appears ff. 82–3.

53 C.P. Stacey, *Quebec, 1759: The Siege and the Battle* (Toronto: Macmillan, 1959), 184.

54 'Monckton's Orderly Book,' 21 September 1759, Townshend Collection, LAC, MG18 M, vol. 23, 19.

55 'Instructions from Murray to Colonel Hunt Walsh,' 15 November 1759, James Murray Papers, General Murray's Letters, LAC, MG 23 G II1 (Microfilm C2225), vol. 1, f. 9.

56 Murray to Major Hussey, 29 November 1759, James Murray Papers, General Murray's Letters, LAC, MG 23 G II1 (Microfilm C2225), vol. 1, f. 10; and 'John Johnson Journal,' 66.

57 'Journal of the Battle of Sillery and Siege of Quebec,' in *Documents Relative to the Colonial History of the State of New York* (see note 3), vol. 10, 1079.

58 'Journal of the Expedition against Quebec,' f. 80.

59 *Historical Journal of the Campaigns in North America* (see note 2), vol. 1, 349.

60 Ibid., 504.

61 W.J Eccles, *The Canadian Frontier, 1534–1760,* 2nd ed. (Albuquerque: University of New Mexico Press, 1984), 139.

62 Vaudreuil to Lévis, 5 July 1759, in *Lettres de Vaudreuil à Lévis* (see note 5), 64; Martin L. Nicolai, 'A Different Kind of Courage: The French Military and the Canadian Irregular Soldier during the Seven Years' War,' *Canadian Historical Review* 70 (1989): 53–75; and Fred Anderson, *The Crucible of War: The Seven Years' War and the Fate of Empire in British North America, 1754–1766* (New York: Alfred A. Knopf, 2000), 238–9.

63 Vattel, *Law of Nations,* 352.

64 MacLeod, *Northern Armageddon,* 107, 184.

65 'Monckton's Orderly Book,' 14 August 1759.

66 'John Johnson Journal,' f. 10; and *Journal of Particular Transactions by an Officer of Fraser's Regiment*, 2–3.

67 For a discussion of aboriginal war practices, see, in particular, James Axtell and William C. Sturtevant, 'The Unkindest Cut, or Who Invented Scalping?' *William and Mary Quarterly*, 3rd series, 37 (1980): 451–71; and Daniel K. Richter, 'War and Culture: The Iroquois Experience,' *William and Mary Quarterly*, 3rd series, 40 (1983): 528–9.

68 'Operations of the Army under M. de Montcalm before Quebec,' in *Documents Relative to the Colonial History of the State of New York* (see note 3), vol. 10, 1026.

69 Wolfe to Monckton, 25 July 1759, Monckton Papers, Townshend Collection, LAC, MG18 M, vol. 22.

70 'Operations of the Army under M. de Montcalm before Quebec,' in *Documents Relative to the Colonial History of the State of New York* (see note 3), vol. 10, 1028.

71 *Narrative of the Doings During the Siege of Quebec, and the Conquest of Canada; by a Nun of the General Hospital of Quebec* (Quebec: Printed at the Quebec Mercury office, 1855[?]) 7.

72 Tétu, 'M. Jean-Felix Récher,' 329.

73 Vaudreuil to Lévis, 5 July 1759, in *Lettres de Vaudreuil à Lévis* (see note 5), 64.

74 Vaudreuil to Berryer, 25 March 1759, in *Documents Relative to the Colonial History of the State of New York* (see note 3), vol. 10, 947.

75 Panet, 'Journal du siège de Québec en 1759,' 11; Armstrong Starkey, *European and Native American Warfare, 1675–1815* (London: UCL Press, 1998); and Ian K Steele, *Warpaths: Invasions of North America* (Oxford: Oxford University Press, 1994).

76 *Historical Journal of the Campaigns in North America* (see note 2), vol. 1, 428.

77 'Journal of Wolfe's Campaign of 1759,' 2 July 1759; 'Operations of the Army under M. de Montcalm before Quebec,' in *Documents Relative to the Colonial History of the State of New York* (see note 3), vol. 10, 1032

78 'John Johnson Journal,' f. 9.

79 Ibid., ff. 10–11.

80 'General Wolf's Proclamations to the Canadians,' in *Documents Relative to the Colonial History of the State of New York* (see note 3), vol. 10, 1047.

81 For a discussion of the unique nature of early American warfare, see Higginbotham, 'Early American Way of War,' 230–73; Ferling, *Wilderness of Miseries*; and Grenier, *First Way of* War; John Morgan Dederer, *War in America to 1775: Before Yankee Doodle* (New York: New York University Press, 1990).

82 Mr. de Jeney, *The Partisan: Or, the Art of Making War in Detachment, Tr. By an Officer in the Army* (London: R. Griffiths, 1760); Peter Russell, 'Redcoats in the Wilderness: British Officers and Irregular Warfare in Europe and America, 1740–1760,' *William and Mary Quarterly*, 3rd series, 35 (1978): 629–52; and Roger Chickering and Stig Förster, *War in an Age of Revolution, 1775–1815* (Washington, DC: German Historical Institute, 2010).

83 Townshend to Lady Ferrers, 6 September 1759, in *Siege of Quebec* (see note 6), 195.

4

Falling into Oblivion? Canada and the French Monarchy, 1759–1783

FRANÇOIS-JOSEPH RUGGIU[1]

Under the Treaty of Paris in 1763, France ceded New France, with its approximately seventy thousand French Catholic inhabitants, to Britain. In February 1778, by article 6 of its treaty of alliance with the United States, France officially renounced the possibility of recovering Canada. These two well-known facts have sparked an endless flow of interpretations, situated in very different academic contexts. Not surprisingly, French-Canadian historians have scrutinized intensely the choices made by the leading French politicians in order to explain what many still feel as abandonment.[2] British and Anglo-Canadian historians have devoted many studies to the establishment of British rule in Canada during the 1760s and to the role of France in the American War of Independence.[3] American diplomatic historians have focused on the French role in the War of Independence up to the signing of the Treaty of Versailles in 1783.[4] French historians, in contrast, have been the most indifferent. Recent specialists on the reigns of Louis XV and Louis XVI have been interested mainly in the struggle of political factions at the court of Versailles, stressing the supposed roles of Louis XV's mistresses or of Marie-Antoinette, the political and religious opposition of the parliament of Paris to the royal policy, attempts to liberalize the French economy, and, of course, the coming of the French Revolution. As a result, no general accounts of French colonial policy during the last decades of the *ancien régime* have been published in France since the beginning of the 1990s.[5]

During the *ancien régime*, French foreign policy was under the supervision of the Secrétaire d'État des Affaires Étrangères, but the colonies were under the management of the Secrétaire d'État de la Marine. Étienne François, duc de Choiseul, was Secrétaire d'État des Affaires

Étrangères from 13 December 1758 to 13 October 1761 and again from 10 April 1766 to his dismissal by Louis XV on 24 December 1770. From 1761 to 1766, he was Secrétaire d'État de la Marine but continued to oversee French foreign policy through his cousin, César Gabriel de Choiseul-Praslin, the nominal Secrétaire d'État des Affaires Étrangères. On 10 April 1766, César Gabriel became Secrétaire d'État de la Marine until the disgrace of his cousin in 1770. So Étienne François, who was also Secrétaire d'État de la Guerre from 1761 to 1770, and prime minister without the title, enjoyed an exceptional hold on all French overseas affairs. His most important successors as Secrétaire d'Etat des Affaires Étrangères were the duc d'Aiguillon from 1771 to 1774 and Charles Gravier, comte de Vergennes, from 6 June 1774 until his death on 13 February 1787.[6]

The diplomatic actions of both Choiseul and Vergennes have been much studied, of course, but the main principles that guided their actions in the colonial field are difficult to establish and have not attracted a lot of recent attention.[7] This chapter attempts to set the behaviour of Choiseul and Vergennes towards Canada from the Seven Years' War to the American War of Independence in the broader framework of what they thought a metropolis such as France could and should do with its colonies and what it could and should expect from its colonies. In order to understand the attitude of these leading politicians, I focus not only on their actions towards Canada,[8] but also on their general conceptions of what was a colonial empire. I also attempt to place French imperial and colonial history within the domestic political sphere. Specialists on colonial America have recently focused with much success on the colonies as places where local elites endlessly negotiated with the political centre for status, power, and about the definition of policies. But actors at the top of the state were the only ones to have a global perspective when it came to defining strategies and shaping colonial spaces.

Like its predecessors in this field, this chapter draws heavily upon the diplomatic correspondence and public papers of the Secrétariat d'État des Affaires Étrangères. These documents usually relate to specific questions and seldom tackle general issues. It is also true that their contents are biased by the rigid norms of administrative correspondence, the degree of confidence and intimacy between the minister and his agents, and by the short-term tactics of all these actors in consideration of their careers. But the discourses conveyed by this repetitive material reveal a lot about the general assumptions of the different writers. Repeated again and again in different contexts, some major principles

appeared that, over time, came to constitute doctrines. And these doctrines implicitly informed the formation of specific policies and gave the actors tools with which to respond to any situation. In particular, the attitude of French politicians towards Canada shaped an important and particularly lasting colonial doctrine: the 'no territory policy.'[9]

The handover of Canada by France in 1763 is often presented as unavoidable, due to the awful defeats of the Seven Years' War and the indifference of French politicians and the French people to the fate of New France. This contempt is symbolized by the famous and repeated words of Voltaire about *les arpents de neige*, and it seems to have developed from a belief among French administrative elites that there could be no bright future for the colony. Recently, Françoise Lejeune has pointed out that the cession of the colony came after decades of neglect, and she seems to consider its abandonment as inescapable.[10] This point is still open to debate, for it does not appear that French politicians were prepared to surrender Canada easily to the British. Indeed, French policy on this question during the Seven Years' War seems to have been disconnected from the local situation.[11] The fall of Louisbourg (July 1758) and the Battle of the Plains of Abraham (September 1759) do not appear to have changed the position of the French administration, insofar as its policy can be understood through the reports in the foreign ministry archives. Thus, the most pessimistic of five proposals for the peace written in December 1759 assumed only important territorial concessions in Acadia, the loss of the left bank of the Ohio River, and the destruction of Louisbourg's fortifications as well as of some Canadian forts.[12] In September 1759 and even in January 1760, Choiseul still thought that the *guerre de mer* against Britain could be settled through the delimitation of the frontiers between the French and British possessions in Acadia and Ohio.[13] In a letter to Voltaire in the summer of 1760, he appears to have remained confident that Britain would not retain Canada.[14] Only in March 1761 did one of the peace proposals sent by the Most Christian King of France to the British monarch show that the decision to sacrifice New France had been made irreversibly in the face of the rigidity of William Pitt.[15] Whatever his real intentions during this phase of the negotiations (making peace or waiting for Spanish intervention),[16] Choiseul adopted the principle of *uti possidetis* against that of the *status quo ante*, and thus accepted the loss of Canada.

A second reason frequently given to explain why France chose to keep the Caribbean islands of Guadeloupe and Martinique rather than New France is the weight of commercial lobbies and the links of French

aristocrats, especially Choiseul, with the planters of the French West Indies.[17] But this argument is also questionable. Philip Lawson has clearly demonstrated that, despite a considerable controversy in press and print,[18] the discussion about the peace terms inside the British cabinet and among British politicians never took the form of a debate on the respective merits of these two prizes.[19] Indeed, it would be truer to say that Choiseul sacrificed New France for the sake of the French share of the Newfoundland fisheries: the preservation of the right to catch cod on the Banks and in the Gulf of St Lawrence and to dry them on the shores of Newfoundland was a dogma of French colonial policy from the Treaty of Utrecht in 1713, which ended the War of the Spanish Succession, to as late as the twentieth century.[20] Despite the fact that New France had capitulated in 1760 because of the lack of reinforcements from the metropolis, Choiseul was nevertheless able in May 1762 to send a naval squadron, with two men-at-war and a frigate, to capture St John's, Newfoundland.[21] The expedition was an ephemeral success – the town, taken in June, was lost in September – but it clearly demonstrated the importance of the fisheries to the French Crown. Choiseul's action is a reminder that the conservation of the French fisheries, economically important and considered as the nursery of French naval manpower,[22] was a *sine qua non* condition of the peace.[23]

Yet it would be misleading to explain the handover of Canada from such a short-term perspective, and it is worth situating that decision in a broader frame. Choiseul was profoundly convinced that Britain was a major danger not only to France but also to the general balance of power in Europe. In 1765 he declared to Louis XV: 'England is the declared enemy of your power and your state and she always will be. Her eagerness to trade, her haughtiness in diplomatic affairs, her jealousy of your power, and, more than that, the interests of the various factions that govern her in turn, indicate that it will take centuries before we are able to make peace with this state which aims to establish its supremacy in the four quarters of the world.'[24]

The British threat, as seen by French politicians during the 1760s and 1770s, can only be compared to the French threat as seen by English politicians at the end of the seventeenth century. According to Choiseul, Britain was aspiring to a kind of universal hegemony, and its attitude inevitably would lead to a new war with France. His successors, especially Vergennes, shared this view, as well as Choiseul's fatalism about a future war.[25] The violence of the words employed by successive foreign ministers, by their staff, and by the French military hierarchy

matched the denunciations uttered by Junto Whigs when they depicted Louis XIV as a despot aspiring to universal monarchy.[26] The lingering importance of this political discourse, originating in the sixteenth century and first applied by the English and the French Crowns to Spain, is striking. In 1772, Robert Clive used exactly the same language to warn British politicians against any loosening of the British grip on India. The consequences of such a retreat, he said, would lead to the French domination of India and 'would give them "the empire of the sea" and ultimately "universal monarchy."'[27] Strangely, the study of the uses made during the eighteenth century of this powerful (and useful) commonplace has still to be undertaken.

This feeling of Choiseul, expressed many times during the 1760s, was fuelled by the constant aggressiveness that characterized relations among France, Spain, and Britain during this decade. Endless negotiations and diplomatic conflicts were linked to the thorny settlement of the Seven Years' War: over the expenses of French prisoners kept in England during the war, the balancing of the Canadian debt and the millions of dollars the British were promised for not ransacking Manila after capturing it from Spain, the access of French fishermen to Newfoundland shores and the fishing rights attached to St-Pierre and Miquelon, the restoration of French rule in their Caribbean islands captured by the British, and British encroachments for logwood in Honduras Bay and the Mosquito Coast.[28] During the second half of the 1760s, the occupation of the Turks Islands in the West Indies, the incessant debates about the fortifications of Dunkirk, the quarrels about the trade of Senegambia, and, of course, the possession of the Falklands generated short but harsh crises. The last of these even precipitated the fall of Choiseul. Although he seems to have been less bellicose than his desire for revenge predicted, he was convinced that an unavoidable struggle against Britain had to be run at sea and in the colonies.

Indeed, for Choiseul, British hegemony would be realized not by conquests in Europe, as had been the case with Louis XIV, but firstly in America and secondarily in India. He thought that the major aim of Britain was to expel the French from the West Indies in order to be in a position to rule informally the Spanish Empire. In this way, the British would monopolize the Atlantic trade either directly in North America or indirectly in South America, and would afterwards be able to repeat this process in India. This relationship between 'trade' and 'power' is central to understanding the colonial policy of Choiseul, who once wrote, 'We must not deceive ourselves. The true balance of power real-

ly resides in commerce and in America.'[29] A splendid aristocrat, with a brilliant military background, Choiseul's views came close to those developed by British and French traders and economists such as Malachy Postlethwayt (1707–67), who, in *Britain's Commercial Interest Explained and Improved* (1757), insisted that British policy ought to be 'to throw the balance of trade so effectually into the hands of Great Britain as to put the constant balance of power in Europe into her hands.'[30]

The fear of Britain manifested by Choiseul and the French elites was offset by the conviction that Britain's weaknesses would soon overwhelm it. As Edmond Dziembowski has shown,[31] French thinkers had problems understanding the foundations of British power, and they poorly appreciated the benefits of the Atlantic trade for Britain.[32] In their view, the overextension of Britain's trade and the possession of too many settlement colonies, whose trade was competitive and not complementary to that of the metropolis, were liabilities, not assets. They especially thought that the Atlantic trade benefited a few large merchants and not the nation as a whole, which was impoverished by it. And they were therefore confident that the acquisition of new settlements would be a source of trouble for Britain. Inspired by these writings, Choiseul underrated the value of the possession of Canada for Britain. In a famous report to Louis XV written in 1765, he even predicted a separation of the thirteen colonies, now rid of the French threat, from their metropolis because of their 'extent.'[33] This idea, which began to circulate in France at that time, found its origins in history. Colonies were still largely understood in France as they were during Antiquity: a movement of population intended to establish a settlement that, in due course, would separate from the mother country, like Carthage from Tyre or Marseilles from Phocaea. But it was also the product of a traditional mercantilist analysis to which Choiseul strictly adhered.

For Choiseul, as for Colbert a century before, colonies existed solely to enhance the trade of the metropolis, not as territories to be developed. The most perfect colonies were those whose products differed the most from those of the metropolis. This was the case in the French West Indies, which received manufactured goods from the metropolis in exchange for tropical commodities such as sugar, coffee, cotton, and indigo. But this was not the case in New France, whose products were mostly logwoods and cereals besides the insufficient and declining fur trade. In the mind of Choiseul, the settlement colonies, especially in North America, were not only useless but dangerous to the mother country. A letter sent to the French envoy at London, François-Marie

Durand de Distroff – who played an important part in the working out of Choiseul's policy by offering him, in his reports, specific information and detailed advice – pinpointed the lessons Choiseul took from the British example:

> Therefore the northern colonies of America would have to be fully subordinated, so that they operated – even in regard to their basic needs – only in accordance with the will of their metropolis. This is possible as long as one has in America a small amount of territory in which the government invests and maintains troops in order to buttress its despotic authority. But a metropolis which has possessions in North America that are three times the size of France will not be able, in the long term, to prevent them from having manufactures to supply their own needs.[34]

Thus Choiseul, and his staff, thought that a single colonial pattern was suitable for France. It had to possess few small colonies ('*une petite partie de pays*'), strongly attached to the metropolis by trade laws and with the local population strictly controlled by authorities appointed by the Crown. This reasoning explains the thorough (but ineffective) policy applied to St-Domingue (Haiti), where a new governor general, Jean-Baptiste, comte d'Estaing, tried from 1764 to 1766 to reinforce the authority of the central state against the traditional autonomy of the local elites, or the successful transition of the Île de France (Mauritius) and Île Bourbon from the Compagnie française des Indes to the Crown at the end of the 1760s.

In this conception of empire, New France, seen as commercially unproductive and unable to contribute efficiently to the defence of the French West Indies, did not have a place. This belief was not at all new because numerous reports written about North America, especially by the marquis de la Galissonière, governor of New France at the end of the 1740s, had noticed these weaknesses.[35] During the 1740s and 1750s, Canada was commonly identified as a vast territory with a tenuous actual economic worth (even if it might have a strong potential for the future) but with an important military value in the context of the coming global conflict with Britain. So Canada was more valued not for its declining fur trade, but for being the *boulevard de l'Amérique* – a boulevard being a vital element in a system of fortifications.[36] Against strict mercantilist rules, New France was then kept and defended for strategic reasons: it was a military buffer against the domination of Britain in North America and, ultimately, a key element in the preservation

of French colonial commerce. But, at one point, in late 1760 or early 1761, amid the traumatic defeats of the war, Choiseul and his *bureaux* reverted to the alternative view of the French in North America and completely discarded the geopolitical view upon which French policy in this part of world had been based during the 1740s and the 1750s. And if New France should not be retained under French sovereignty, it appeared obvious to the French authorities that Louisiana, with its poorly defined boundaries, which could soon be the pretext for a new war, also should not be retained for strategic reasons and was not worth retaining for commercial reasons.[37] Thus the handover to Spain of New Orleans and of the whole of Louisiana west of the Mississippi on 3 November 1762 was not just compensation for the Spanish losses, as is often said, but the logical result of a complete revision of the French conception of colonization.

So it is not surprising that the French government, despite its desire for revenge, gave up on Canada after 1763 and did not try to maintain contact with members of the French elite remaining there. During the 1760s, Choiseul sent several envoys to North America to assess the possibility of a break between the American colonists and the British Crown. M de Pontleroy in 1764 and 1766, then Johann Kalb in 1768, toured New England but did not try to visit Canada.[38] British authorities were nevertheless afraid of such enterprises. The hand of France was seen behind Pontiac's rebellion in 1763 even though there was no evidence of any official French involvement in the uprising. Rumours of French spies in Canada also circulated widely there and in Britain during the 1760s and 1770s. In 1768, M Francès, the French envoy at London, narrated to Choiseul the none-too-subtle attempts of Lord Hillsborough to unveil French plans in Canada: 'He observed to me that Canada and the neighboring countries were the only tranquil areas, as we must have been told by the agents and intelligence sources he knew that we had in those parts.'[39] Francès stalwartly denied the presence of French agents in the former New France and his refutation sounds genuine, given French policy towards Canada and the whole idea of retaining overseas territories.

Choiseul was still keen to develop the French presence around the world. These projects are often presented in French historiography as a quest for compensation for the losses of the Seven Years' War,[40] and they might be used to refute the idea of the 'no territory policy.' But some of these projects were mere fantasies and not really pursued – for example, the purchase of the Philippines, proposed to Spain in 1764 in

the wake of the diplomatic conflict related to the ransom of Manila.[41] Choiseul also encouraged, or did not discourage, many more significant initiatives. The naval expedition to the Malouines, or Falklands Islands, led by Louis Antoine de Bougainville, was one of them.[42] Others included an attempt to gain a foothold in Madagascar and several efforts in India to secure the remaining French trading posts and to reduce British influence over several Indian princes. The purchase of Corsica, off the French coast, which could offset the possession of Minorca by the British, could be added to this list. But, except for the last example, which occurred for strategic reasons, all these projects were private, led by adventurers, and backed by trade companies, with only remote support from the government. And they were roughly stopped as soon as they began to endanger the peace in Europe or seemed in danger of becoming overextended. Accordingly, the French settlement in Madagascar was abandoned as soon as its promoter, Louis de Modave, started to envision further expansion and asked for more subsidies.[43] These ventures thus should not be seen as a quest for colonial compensation after the trauma of the Seven Years' War.

The main enterprise fostered by Choiseul was the colonization of Kourou, in present-day French Guiana, which has recently attracted considerable attention from scholars.[44] Kourou, close to the old French colony of Cayenne, clearly was conceived as a settlement colony in order to balance the British grasp in the region. But there is no contradiction here. Kourou, and French Guiana, was dedicated to play with respect to the French West Indies the same role that North America played with respect to the British West Indies.[45] Kourou would be a military stronghold, more resembling Louisbourg than New France.[46] From there, the French would be able to send naval and land forces to protect their West Indian islands in the event of a British threat and to do to the British what Admiral Boscawen had done to the French in 1755 when he captured hundreds of French merchant ships and thousand of sailors before the declaration of war. This is why Kourou had to be peopled with Europeans able to serve in the militia, not with African slaves unreliable in case of invasion.[47] Kourou was designed to take on the old military role of buffer that Louisbourg and New France, too close to the thirteen colonies and too disadvantaged by winds and conditions of navigation on the St Lawrence, had demonstrated they could not play. The spectacular failure of the settlement, with the loss of thousands of human lives, put an end to this scheme and strengthened Choiseul's resolution to decline any future territorial schemes.

And this decision was immediately applied to Louisiana. French scholars have observed that Spain waited a long time before taking possession of Louisiana. Ceded in 1762, the colony was reluctantly taken over by the Spaniards in March 1766. Historians have wondered why Choiseul chose to develop Cayenne and did not try to recover Louisiana immediately after the Seven Years' War or even in 1768, when a part of the Creole elites of Louisiana rebelled against Spanish rule and asked for French assistance.[48] But Canada, and its dependency Louisiana, seemed to Choiseul the model of what France must not do in the colonial context. He even wrote in his *Memoirs*, 'I think that I can even say that Corsica is more useful to France in every way than Canada was or ever would have become.'[49] Thus Choiseul never forgot Canada; he even built his colonial policy – the 'no territory policy' – by thinking of this lost country. There is another reason for this stance. As early as 1762, he had written to the marquis d'Ossun, the French ambassador at Madrid, that the *Pacte de Famille*, the French-Spanish alliance, was 'a thousand times more worthy of France's consideration than the colony of Canada.'[50]

Choiseul was a staunch advocate of the *Pacte de Famille*. Signed under his direct supervision on 15 August 1761, it united the two main branches of the Bourbon family. French historians used to scorn the value of this Spanish bond, stressing the poor performance of Spanish naval forces during the conflicts of the second half of the eighteenth century. But the picture is more complex. First, the weaknesses of the Spanish military system in America during the Seven Years' War did not signify that the mutual protection the two powers envisioned to give their colonies did not make sense. Furthermore, beginning in the 1760s, Spain's Carlos III launched a substantial program of reform of the Spanish Empire, which included a strong reinforcement of the American viceroyalties' military capacities.[51] Second, the *Pacte de Famille* was not just a diplomatic and military alliance, but also, and perhaps mainly, a commercial alliance grounded in the old French dream of controlling the Spanish colonial trade. French industry largely supplied Spain with manufactured products, especially textiles (linen, silk, and woollens) and, by re-exportation, the Spanish colonies. This trade legally flowed through the port of Cadiz, where many French merchant houses were active.[52] It grew steadily from the second half of the seventeenth century onwards[53] and continued during the eighteenth century, with the apogee for woollens occurring in the 1750s and 1760s.[54] Spain remained the primary customer of French exports until the 1770s, when

the French textile trade suffered legal competition from British or German products that were of better quality and cheaper.[55] All through the century, moreover, British and American merchants from the thirteen colonies and the West Indies traded directly and illegally with the Spanish colonies and diverted a huge share of Spanish colonial commerce.

The correspondence of Choiseul and the papers of the French commercial agent at Madrid, the Abbé Beliardi, show that the duc was extremely keen to secure for France the largest possible share of this trade. But, as Spain and France were allies, he was obliged to restrain his encouragements to the legal trade. So the *Pacte de Famille* seemed to open the possibility of finalizing a long-desired commercial treaty between France and Spain that would give the former a definitive advantage over Britain in Spain and its empire.[56] Moreover, Choiseul was sure that he enjoyed a deep influence on the working-out of Spanish diplomacy through the French ambassador at Madrid, Pierre Paul, marquis d'Ossun, who was a personal friend of Carlos III, and through the marqués de Grimaldi, Spanish foreign minister until 1776, who formerly had been ambassador at Versailles.[57]

It is now clear that Choiseul deluded himself in both cases.[58] He overestimated his political influence on Spain, and neither he nor his successors fully understood that the colonial interests of France and Spain were divergent, at least in peacetime. They underestimated the fact that the imperial policy of Carlos III would hinder rather than facilitate the legal French trade with Spanish America, while the illegal British trade in that part of the world would continue to flourish.[59] Article XXIV of the *Pacte de Famille* and the commercial convention, signed on 2 January 1768, that developed it proved rather disappointing. They gave to French merchants only the advantages the British already had enjoyed since the commercial treaty of 1667.[60] Moreover, the first *Reglamento del Commercio Libre*, issued in 1765, and the second *Reglamento*, issued in 1778, suppressed the monopoly of Cadiz and liberalized trade between Spain and its colonies.[61] These decrees were intended to enhance progressively the participation of Spanish industry, which was then trivial, in the provisioning of the empire and consequently to reduce, through duties put on re-exports to the colonies, the share of French re-exports to Spanish America.[62] Nevertheless the shaping of French colonial and foreign policies was strongly linked to the enduring and complacent belief that, by the *Pacte de Famille*, Spanish colonies belonged, or would belong, to a kind of informal French economic empire.[63] This belief reinforced the conviction that France did not need territorial colo-

nies, because it had, or would have, free access to the markets of the well-peopled Spanish Empire. It explains both the importance attached by Vergennes to the *Pacte de Famille*[64] and the repeated disdain he displayed for the idea of recovering Canada during the American War of Independence.

Vergennes's position towards Canada prolonged Choiseul's because he had the same perception of the role of trade in Britain's domination and he held the same colonial theory.[65] The French Crown had no interest in expanding or developing a territorial empire; its duty was to protect the most useful colonies – that is to say, the French West Indies, especially St-Domingue. An exchange between Vergennes and the Spanish ambassador, the marqués d'Aranda, testifies that the French 'no territory' discourse was widely diffused in the European circles of power and that this commonplace could even be manipulated against France.[66] Reporting their conversation, Vergennes was shocked when M d'Aranda criticized French policy in St-Domingue: 'We are in Saint-Domingue for no other reasons than for the cultivation of crops and trade. We have no need of naval forces. A few forts and their garrisons are quite sufficient for defence, and our planning and our efforts do not have to extend any further than that. So argues M. d'Aranda, apparently forgetting that the *Pacte de Famille* places on us great responsibilities that he chooses to acknowledge.'[67] Indeed, some people in both Britain and France even began to believe that colonies were not useful at all. Some were physiocrats, who thought that the wealth of France came from agriculture, not from trade. Others, like Adam Smith, were liberals who believed that the establishment of trade relations between independent states could be more fruitful than costly territorial domination.

At the beginning of the American troubles, Vergennes seems genuinely to have feared that Britain could crush the insurgents and then turn all its forces against the French Caribbean territories, or that Britain might make an alliance with the former insurgents, the now-independent Americans, to drive all European powers out of the Caribbean.[68] Joined to a desire to have France once more assume first place in the European diplomatic system, these fears explain the evolution of Vergennes, who wished first to temporize, then agreed to intervene in the Anglo-American conflict. Vergennes's policy towards Canada was clearly explained in the instructions he dispatched to diplomats, such as the marquis d'Ossun, still ambassador at Madrid, the comte de Guines, ambassador at London, and Conrad Alexandre Gérard de Rayneval, French envoy at Philadelphia, or even to military officers such as

Jean-Baptiste, comte d'Estaing.[69] The similarity of these instructions confirms the truthfulness of the French position expressed in article 6 of the treaty of alliance with the United States. France had no territorial ambitions in North America, despite the numerous rumours about French ambitions with respect to Canada that widely circulated in Europe and in North America among the insurgents as well as among the British authorities in Canada.[70]

Vergennes did not wish to recover the territory of the former New France for two main reasons. He did not desire to arouse the suspicion of Americans who could easily see the French as their natural and ancient enemies,[71] and he was strongly convinced that France had nothing to gain commercially by recovering Canada.[72] But Vergennes also did not wish this region to become the fourteenth state of the United States of America,[73] so he was willing to leave it in British hands, thinking that the fear of this British presence on their northern border would keep the Americans allied to France.[74] The arrival of a strong French expeditionary force in North America did not change his resolution. French commanders were instructed not to foil American plans to invade Canada, but to avoid actively taking part in them.[75] And in his letters to Gérard, Charles d'Estaing shows that he grasped perfectly that the reconquest of Canada could not be contemplated.[76] Even Lafayette complied politely.

It is true that this policy stirred up some harsh comments from contemporaries. François de Gaston, chevalier, then duc de Lévis, wrote in his *Memoirs* that 'instead of sending this paltry expedition to the West Indies ... why did he not send a corps of ten or twelve thousand men to Canada? This colony, still entirely French, would have risen up in our favour and today we would be in possession of it.'[77] But Lévis was a former hero of the Seven Years' War and a close friend of a French-Canadian noble, Michel Chartier de Lotbinière, who was then at odds with the governor of Canada, Guy Carleton, and with the British regime.[78] He had been entrusted by Vergennes with an unofficial mission as an observer to the United States, and he hoped that France would take advantage of the conflict to regain possession of its former colony, mostly because he would be able to recover his lost properties. But his fellow French-Canadian nobles did not agree with him, and for the most part supported the British regime.

Vergennes never abandoned this policy. Letters from the inhabitants of Illinois claiming the protection of France were, for example, ignored.[79] During the last phase of the peace negotiations, in October

and November 1782, when all the powers struggled to secure the best terms for themselves and were oblivious of their international obligations, several complicated exchanges of colonial territories were discussed unsuccessfully. France could have received the Spanish part of St-Domingue in return for the cession of Guadeloupe and Dominica to Britain. But these exchanges never concerned the former New France.[80] Eventually, the French peace objectives in North America were just to secure the share of the Newfoundland fisheries they had held since the Treaty of Utrecht.[81]

The lack of interest of either Choiseul or Vergennes in Canada did not reflect simply indifference to the sufferings of the French Canadians, nor did it have its origin in a lack of understanding of the potential wealth of this province or of the prestige that the possession of Canada might bring to the king of France. Some French historians have used these explanations to accuse Choiseul of selling off the first French Empire and Vergennes of dooming the monarchy by fighting an unnecessary war that ruined the royal finances.[82] On the contrary, this lack of interest originated in an ideological belief about colonies: a 'no territory policy' erected as a cogent doctrine that explains the constancy of their position. Thus, Vergennes could write to the French envoy at Philadelphia, La Luzerne, on 14 October 1782: 'You know our approach regarding Canada; it is unchangeable and all the considerations that prevent the conquest of this country are integral to our designs.'[83] This extraordinary uniformity of French policy concerning Canada, in force from Choiseul to Vergennes and beyond, dated back to the early 1760s. The defeat on the Plains of Abraham was proof of the incapacity of the colony to defend itself and to be a part of the new colonial system that Choiseul wished to establish.

So, while Britain was experiencing a huge debate about the nature of empire,[84] France bluntly rejected the possibility of becoming a territorial power outside Europe. It is thus incorrect to state that Choiseul tried, with colonial enterprises such as Kourou, Madagascar, and the Malouines, to build a new French Empire beyond the range of the British grip.[85] Despite his political disagreements with Choiseul and his followers, Vergennes acted exactly in the same way. Indeed, one wonders if the word 'empire,' defined as the domination over vast tracts of territories and the management of diverse peoples who had become subjects of a European king, fits with the model of French colonization as seen by Choiseul and Vergennes.

NOTES

1 I would like to thank warmly Charles-François Mathis and Stéphane Jettot for their generous help during the preparation of this chapter. I am also deeply grateful to Cécile Vidal for her useful critical comments.

2 See, among others, Guy Frégault, *Histoire de la Nouvelle-France*, vol. 9, *La guerre de conquête* (Montreal: Fides, 1970); Marcel Trudel, *La Révolution américaine: pourquoi la France refuse le Canada, 1775–1783* (Sillery: Boréal-Express, 1976); and Françoise Lejeune, 'La France et le Canada du milieu du XVIIIe au milieu du XIXe siècle: cession ou conquête?' in *France-Canada-Québec: 400 ans d'histoire de relations d'exception*, ed. Serge Joyal and Paul-André Linteau (Montreal: Les Presses de l'Université de Montréal, 2008).

3 Philip Lawson, *The Imperial Challenge: Quebec and Britain in the Age of the American Revolution* (Montreal; Kingston, ON: McGill-Queen's University Press, 1989); Hamish M. Scott, *British Foreign Policy in the Age of the American Revolution* (Oxford: Clarendon Press, 1990); Stephen Conway, *The British Isles and the War of American Independence* (Oxford: Oxford University Press, 2000); and Andrew Stockley, *Britain and France at the Birth of America: The European Powers and the Peace Negotiations of 1782–1783* (Exeter, UK: University of Exeter Press, 2001).

4 Edward S. Corwin, 'The French Objective in the American Revolution,' *American Historical Review* 21 (1915): 33–61; C.H. Van Tyne, 'Influences which Determined the French Government to Make the Treaty with America, 1778,' *American Historical Review* 21 (1916): 528–41; John Meng, 'The Place of Canada in French Diplomacy of the American Revolution,' *Bulletin des recherches historiques* 39 (November 1933): 665–87; Alexander Deconde, 'The French Alliance in Historical Speculation,' in *Diplomacy and Revolution: The Franco-American Alliance of 1778*, ed. Ronald Hoffman and Peter J. Albert (Charlottesville: University Press of Virginia for the United States Capitol Historical Society, 1981); Richard B. Morris, *The Peacemakers: The Great Powers and American Independence* (Boston: Northeastern University Press, 1983); Jonathan R. Dull, *A Diplomatic History of the American Revolution* (New Haven, CT: Yale University Press, 1985); Gregg L. Lint, 'Preparing for Peace: The Objectives of the United States, France, and Spain in the War of the American Revolution,' in *Peace and the Peacemakers: The Treaty of 1783*, ed. Ronald Hoffman and Peter J. Albert (Charlottesville: University Press of Virginia, 1986), esp. 35–40; and Jonathan R. Dull, 'Vergennes, Rayneval, and the Diplomacy of Trust,' in ibid., 101–31.

5 Indeed, the best analysis to date of the colonial policy of France after the Seven Years' War is that of Sudipta Das, *Myths and Realities of French Imperi-*

alism in India, 1763–1783 (New York: Peter Lang, 1992). Das brilliantly demonstrates the absence of French imperial activity in India in the second half of the eighteenth century, which she attributes to a lack of interest in India on the part of France's two foreign ministers during the period, the duc de Choiseul and the comte de Vergennes, except for purposes of military diversion. For a general presentation of French foreign policy during the eighteenth century, see Lucien Bély, *Les relations internationales en Europe (XVIIe–XVIIIe siècles)*, 3rd ed. (Paris: PUF, 2001). About French foreign and colonial policy from Choiseul to Vergennes, see Eugène Daubigny, *Choiseul et la France d'Outre-Mer après le traité de Paris: étude sur la politique coloniale au XVIIIe siècle* (Paris: Hachette, 1892); Francis-Paul Renaut, 'Études sur le Pacte de Famille et la politique coloniale de la France (1760–1792),' *Revue de l'Histoire des Colonies Françaises* 9 (1921): 1–52, and 10 (1922): 39–108, 214–64; Jean Tarrade, 'De l'apogée économique à l'effondrement du domaine colonial (1763–1830),' in *Histoire de la France coloniale*, vol. 1, *Des origines à 1914*, ed. Jean Meyer, Jean Tarrade, Annie Rey-Goldzeiguer, and Jacques Thobie (Paris: Armand Colin, 1991); and Pierre Pluchon, *Histoire de la colonisation française*, vol. 1, *Le premier empire colonial* (Paris: Fayard, 1991). The latest general survey is Philippe Haudère, *L'empire des rois, 1500–1789* (Paris: Denoël, 1997).

6 See Jean-Pierre Bois, 'Choiseul, Étienne-François,' and Jean-François Labourdette, 'Vergennes, Charles Gravier,' in *Dictionnaire des ministres des Affaires Étrangères*, ed. Lucien Bély, Laurent Theis, Georges-Henri Soutou, and Maurice Vaïsse (Paris: Fayard, 2005).

7 Guy Chaussinand-Nogaret, *Choiseul: 1719–1785: naissance de la gauche* (Paris: Perrin, 1998); and Jean-François Labourdette, *Vergennes, ministre principal de Louis XVI* (Paris: Éditions Dejonquères, 1990). It is also striking that the foreign policy of such an important figure as the duc d'Aiguillon has been so neglected. See Christophe Dehaudt, 'Aiguillon, Emmanuel Armand de Vignerod du Plessis de Richelieu,' in *Dictionnaire des ministres* (see note 6), 182–7; and Bernard de Fraguier, 'Le duc d'Aiguillon et l'Angleterre,' *Revue d'Histoire Diplomatique* 26 (1912): 607–27.

8 Canada during the early modern period was a rather vague expression that could evoke different places and different problems. See Cécile Vidal and Gilles Havard, *Histoire de l'Amérique française*, 2nd ed. (Paris Flammarion, 2006). One has to draw a clear distinction between three interrelated spaces and issues: the fate of the former New France and its population; the fate of the fishing grounds of Newfoundland, which was by far the most important topic in this part of the world for Choiseul and his successors; and the fate of the Amerindians and European settlers living in the

region of the Great Lakes (*le Pays d'en Haut*) or along the Ohio River (*la Belle Rivière*) and its tributaries.

9 For an attempt to consider the effects of this doctrine regarding India, see François-Joseph Ruggiu, 'India and the Reshaping of the French Colonial Policy (1759–1789),' *Itinerario* 35, no. 2 (2011), 25–43.

10 Lejeune, 'La France et le Canada,' 60.

11 See Jean-Pierre Poussou, Philippe Bonnichon, and Xavier Huetz de Lemps, *Espaces coloniaux et espaces maritimes au XVIIIe siècle* (Paris: Sedes, 1998).

12 M. de Silhouette to Choiseul, Archives des Affaires Etrangères [hereafter cited as AAE], Mémoires et Documents, Angleterre, vol. 41, ff. 396ff.

13 Choiseul to Bernstorff, 23 September 1759, 27 January 1760, in *Correspondance entre le comte Johan Hartvig Ernst Bernstorff et le duc de Choiseul, 1758–1766* (Copenhagen: Librairie de Gyldendal, 1871), 73, 117–24.

14 See Edmond Dziembowski, *Un nouveau patriotisme français, 1750–1770: la France face à la puissance anglaise à l'époque de la guerre de sept ans* (Oxford: Voltaire Foundation, 1998), 225. Philippe Haudrère evokes a *mémoire* of Choiseul to the king, dated November 1760, in which he has already accepted the loss of Canada: Archives Nationales, Marine, B/1, vol. 67, ff. 88–102, quoted in *La Compagnie française des Indes*, vol. 4 (Paris: Librairie de l'Inde Éditeur, 1989), 1083.

15 *Mémoire historique de la négociation de la France et de l'Angleterre depuis le 26 mars 1761 jusqu'au 20 septembre de la même année avec les pièces justificatives* (Paris: l'Imprimerie Royale, 1761), 17. From 26 March 1761:

> *relativement à la guerre particulière de la France et de l'Angleterre, les deux couronnes resteront en possession de qu'elles ont conquis l'une sur l'autre et que la situation où Elles se trouveront le premier de septembre de l'année 1761 aux Indes orientales, le premier de juillet aux Indes occidentales et en Afrique, et au premier de mai prochain en Europe sera la position qui servira de base au traité qui peut être négocié entre les deux puissances. Ce qui veut dire que le Roi Très Chrétien, pour donner un exemple d'humanité et contribuer au rétablissement de la tranquillité générale, fera le sacrifice des restitutions qu'il a lieu de prétendre, en même temps qu'il conservera ce qu'il a acquis sur l'Angleterre pendant le cours de la guerre.*

16 Historians wonder if he was really willing to make peace or just waiting for Spanish intervention. On the negotiation of 1761, see Dziembowski, *Un nouveau patriotisme*, 256ff.; and idem, 'Les négociations franco-britanniques de 1761 devant le tribunal de l'opinion: le duc de Choiseul et la publicité de la diplomatie française,' in *Le négoce de la paix: les nations et les traités*

franco-britanniques (1713–1802), ed. Jean-Pierre Jessenne, Renaud Morieux, and Pascal Dupuy (Paris: Sociétés des études Robespierristes, 2008), 47–67.

17 For a new approach to this debate, based on letters and memoranda especially from French provincial chambers of commerce, see Helen Dewar, 'Canada or Guadeloupe? French and British Perceptions of Empire, 1760-1763,' *Canadian Historical Review* 91 (December 2010), 637–60.

18 William L. Grant, 'Canada versus Guadeloupe: An Episode of the Seven Years' War,' *American Historical Review* 17 (1912): 735–43.

19 Philip Lawson, '"The Irishman's Prize": Views of Canada from the British Press, 1760–1774,' *Historical Journal* 28 (1985): 575–96; and idem, *Imperial Challenge*, 7–24.

20 Charles de La Morandière, *Histoire de la pêche française de la morue dans l'Amérique septentrionale*, vol. 2 (Paris: G.-P. Maisonneuve et Larose, 1962); and J.K. Hiller, 'Utrecht Revisited: The Origins of French Fishing Rights in Newfoundland Waters,' *Newfoundland Studies* 7, no. 1 (1991): 23–39. The links between the fisheries and the French Empire in North America have been emphasized by John G. Reid, 'Imperialism, Diplomacies, and the Conquest of Acadia,' in John G. Reid et al., *The 'Conquest' of Acadia, 1710: Imperial, Colonial, and Aboriginal Constructions* (Toronto: University of Toronto Press, 2004).

21 Georges Cerbelaud Salagnac, 'La reprise de Terre-Neuve par les Français en 1762,' *Revue française d'Histoire d'Outre-Mer* 63 (1976), 211–21. It is true that the plan of the campaign vaguely evoked an operation 'qu'on pourra faire en même temps sur le Canada' the following year (1763).

22 '[U]n commerce qui est le plus riche, le plus aisé, le plus étendu de l'univers, [qui] est plus lucratif que celui des Indes dont les mines s'épuisent et sont funestes à la population ... et qui est la meilleure école pour y former des matelots sans perte d'hommes'; M. Durand to Choiseul, 27 June 1766, AAE, Correspondance Politique, Angleterre, vol. 470, f. 183.

23 'J'ai fini par dire au duc de Bedford: Je ne ferai aucune difficulté pour vous dévoiler notre politique. Nous avons mis pour première condition de la paix la conservation de la pêche de la morue ... Si elle avait été refusée, la guerre durerait peut-être encore'; Choiseul to de Guerchy, French ambassador in London, 14 April 1764, quoted in La Morandière, *Histoire de la pêche*, 872.

24 'L'Angleterre est l'ennemie déclarée de votre puissance et de votre Etat; elle le sera toujours. Son avidité dans le commerce, le ton de hauteur qu'elle prend dans les affaires, sa jalousie de votre puissance, et, plus que cela, les intérêts particuliers des différentes cabales qui tour à tour la gouvernent, doivent nous faire présager qu'il se passera encore des siècles avant que de pouvoir établir une paix avec

cet Etat qui vise à la suprématie dans les quatre parties du monde'; Choiseul, *Mémoire justificatif au roi*, 1765, quoted in Chaussinand-Nogaret, *Choiseul*, 190–1.

25 Orville T. Murphy, 'The View from Versailles: Charles Gravier comte de Vergennes' Perceptions of the American Revolution,' in *Diplomacy and Revolution* (see note 4), 112.

26 The Abbé Jean-Baptiste Dubos attributed to Cromwell the first steps of this project: *'Cromwell ... a toujours songé à la conquête de l'Amérique, comme à l'entreprise la plus utile et la plus honorable où l'Angleterre put employer ses forces. Il voulait la rendre maîtresse de l'Europe par sa navigation et son opulence, de manière que les autres Etats devinssent, pour me servir de l'expression d'un auteur français, à la basse-cour d'Angleterre'*; see *Les intérêts de l'Angleterre mal-entendus dans la guerre présente, traduits du livre anglais intitulé Englands interests mestaken en the present war (sic)* (Amsterdam: George Gallet, 1703), 212.

27 Peter Marshall, *The Making and Unmaking of Empires: British, India and America c.1750–1783* (Oxford: Oxford University Press, 2005), 200.

28 F.-P. Renaut summarizes these successive confrontations, seen through French diplomatic correspondence, in 'Études sur le Pacte de Famille.' In 1762, at the end of a siege led by British troops, the archbishop of Manila promised four million Spanish dollars ransom for the town, but the sum was never fully paid and became the object of a diplomatic conflict between Britain and Spain.

29 Choiseul to Havrincourt, French ambassador in Stockholm, 21 March 1759, quoted in Corwin, 'French Ojectives,' 49.

30 Quoted in Edward S. Corwin, *French Policy and the American Alliance of 1778* (Princeton, NJ: Princeton University Press, 1916), 17.

31 Dziembowski, *Un nouveau patriotisme français*, 227–44.

32 A good illustration of these misunderstandings comes from Choiseul himself:

Je suis fort étonné que l'Angleterre, qui est un point très petit dans l'Europe, domine sur plus du tiers de l'Amérique, que sa domination américaine n'ait pour objet que le commerce, que ce même objet s'étende à celui d'Asie aussi puissamment qu'il nous est présenté par milord Clive, que le Nord de l'Europe soit un des principaux points de l'avidité commerçante anglaise, et que le commerce anglais cherche dans toutes les parties de l'Afrique et du midi de l'Europe à empiéter, de sorte que si chaque individu qui se trouve en Angleterre était occupé au commerce, je ne croirai pas encore que l'Angleterre pût suffire à celui qu'elle entreprend. On me répondra que cela est: j'en conviens,

mais comme cela ne peut pas être j'aurais toujours l'espérance que ce que je ne
conçois pas ne sera pas nuisible.

Choiseul to Durand, 24 August 1767, AAE, Correspondance Diplomatique,
Angleterre, vol. 474, f. 336.

33 '*Il n'y aura que la révolution d'Amérique qui arrivera, mais que nous ne ver-*
rons vraisemblablement pas, qui remettra l'Angleterre dans l'état de faiblesse
où elle ne sera plus à craindre en Europe … L'étendue des possessions anglaises
en Amérique opérera la séparation de ces mêmes possessions avec l'Angleterre';
Pierre-Étienne Bourgeois de Boyne, *Journal inédit 1765–1766*, suivi du *Mé-*
moire remis par le duc de Choiseul au roi, 1765, ed. Marion F. Godfroy (Paris:
Champion, 2008), 457.

34 Choiseul to Durand, French envoy in London, 24 August 1767, AAE, Cor-
respondance Diplomatique, Angleterre, vol. 474, f. 337:

> *Il faut donc que les colonies septentrionales de l'Amérique soient totalement*
> *assujetties, qu'elles ne puissent opérer, même pour leurs besoins, qu'après la*
> *volonté de la métropole ; cela est possible quand on a en Amérique une petite*
> *partie de pays dans laquelle le gouvernement fait de la dépense et y introduit*
> *des troupes au soutien du despotisme ; mais une métropole qui aura dans le*
> *nord de l'Amérique des possessions trois fois plus étendues que la France ne*
> *pourra pas, à la longue, les empêcher d'avoir des manufactures pour leurs*
> *besoins.*

On François-Marie Durand de Distroff, see *Recueil des Instructions données*
aux Ambassadeurs et Ministres de France, XXV-2, Angleterre, t. 3, 1698–1791,
ed. Paul Vauchez (Paris: Éditions du CNRS, 1965), 323–31.

35 See 'Mémoire sur les colonies de la France dans l'Amérique septentrion-
ale,' décembre 1750, ANOM, COL C11A 96, ff. 248–70; and 'Mémoire sur
les colonies de la France dans l'Amérique septentrionale par M. le marquis
de la Galissonière,' 1751, AAE, Mémoires et Documents, Amérique, vol. 24,
f. 110ff. But, finally, he advocated the conservation of the colony: '*L'utilité*
du Canada ne se borne pas à l'objet de conserver les colonies françaises et de faire
craindre les Anglais pour les leurs; cette colonie n'est pas moins essentielle pour
la conservation des possessions des Espagnols dans l'Amérique et surtout du
Mexique.'

36 The *Dictionnaire de l'Académie française* is clear: '*On dit figurément qu'une*
place-forte qui met un grand pays à couvert de l'invasion des ennemis qu'elle est
le boulevar[d] du pays. Malte est le boulevar[d] de la Sicile' (Paris: 1762), t. 1,
201. See also La Galissonière, ANOM, COL C11A 96, f. 252: '*On se bornera*

ici à regarder le Canada comme une frontière infructueuse, comme les Alpes sont au Piémont, comme le Luxembourg serait à la France.'

37 '[L]*'espoir de reconquérir le Canada pendant cette guerre ne peut même pas se présenter à l'imagination, celui de conserver la Louisiane après avoir perdu le Canada ne serait pas beaucoup plus vraisemblable';* Bibliothèque nationale de France, Nouvelles Acquisitions Françaises 1041, f. 48, quoted in Marion F. Godfroy-Tayart de Borms, 'La guerre de Sept ans et ses conséquences atlantiques: Kourou ou l'apparition d'un nouveau système colonial,' *French Historical Studies* 32 (2009), 173. On the importance of fixing the imperial boundaries in North America, see François Ternat, 'Inscrire la paix dans les espaces lointains. Histoire diplomatique d'un entre-deux-guerres: les négociations franco-britanniques de 1748 à 1756' (PhD thesis, University of Paris-Sorbonne, 2009).

38 Vicomte de Colleville, *Les missions secrètes du Général-Major Baron de Kalb et son rôle dans la guerre d'Indépendance Américaine* (Paris: Émile Perrin, 1885).

39 '*Il m'observa que le Canada et ses dépendances étaient les seules parties tranquilles ainsi que nous devions en être instruits par les agents et les intelligences qu'il savait que nous avions dans ces pays-là';* Francès to Choiseul, 19 August 1768, AAE, Correspondance Politique, Angleterre, 480, f. 93. On M. Batailhé de Francès, see *Recueil des Instructions* (see note 32), 323–31, 449–52.

40 Chaussinand-Nogaret, *Choiseul*, 200.

41 Renaut, 'Études sur le Pacte de Famille,' 233–4.

42 The islands, where Bougainville had created a small settlement in 1764, were given back to Spain in 1767. See Louis-Antoine de Bougainville, *Voyage autour du monde* (Paris: PUPS, 2001); and Julius Goebel, *The Struggle for the Falkland Islands: A Study in Legal and Diplomatic History* (New Haven, CT: Yale University Press, 1982).

43 A sarcastic letter from the Secrétaire d'Etat de la Marine to Modave is clear enough: '*Je ne reconnais pas dans ces deux lettres le projet que le Roi avait approuvé et je m'étonne de l'entreprise que vous lui avez substituée. Suivant ce plan, il n'était pas nécessaire pour conquérir Madagascar et s'en assurer la possession d'y envoyer des escadres, des troupes, ni d'y transporter à grands frais une société entière … Le Roi n'a jamais eu l'intention de fonder à Madagascar une colonie de Blancs, occupés de la culture';* Minutes des dépêches et ordres du Roi, Île de France et de Bourbon, 6 August 1769, Archives Nationales, Marine, B 201, ff. 34–5. See also Daubigny, *Choiseul et la France d'Outre-mer*, 130–47; and Tarrade, 'De l'apogée économique,' 222–4.

44 Robert Larin, *Canadiens en Guyane: 1754–1805* (Paris: PUPS, 2006); Emma Rothschild, 'A Horrible Tragedy in the French Atlantic,' *Past and Present* 192 (August 2006): 67–108; and Godfroy, 'La guerre de Sept ans,' 167–91.

45 La Galissonière commented: *'Mais si l'on n'arrête pas les progrès rapides des colonies anglaises du continent … ils auront dans peu … de si grandes facilités pour faire dans le continent de l'Amérique des armements formidables et il leur faudra si peu de temps pour transporter des forces considérables, soit à Saint-Domingue, soit à l'île de Cuba, soit dans nos îles du Vent, qu'on ne pourra plus se flatter de les conserver qu'avec des dépenses immenses'*; 'Mémoire sur les colonies de la France dans l'Amérique septentrionale,' décembre 1750, ANOM, COL C11A 96, f. 253.

46 Godfroy ('La guerre de Sept ans,' 169) explicitly links the fall of Louisbourg and the development of public interest for Kourou. See also Chaussinand-Nogaret, *Choiseul*, 193–4; and R. John Singh, *French Diplomacy in the Caribbean and the American Revolution* (Hicksville, NY: Exposition Press, 1977), chaps. 6 and 7. It was perfectly understood at the time, as demonstrated by a quotation from the Abbé Raynal: *'La perte de ce grand continent détermina le ministère de Versailles à chercher de l'appui dans un autre, et il espéra le trouver dans la Guyane, en y établissant une population nationale et libre capable de résister par elle-même aux attaques étrangères et de voler avec le temps au secours des autres colonies lorsque les circonstances pourraient l'exiger'*; Abbé Guillaume Thomas Raynal, *Histoire philosophique et politique des deux Indes*, avertissement et choix de textes par Yves Bénot (Paris: La Découverte, 2001), 228.

47 Tarrade, 'De l'apogée économique,' 214.

48 Renaut, 'Études sur le Pacte de Famille,' 83, 258–64; Tarrade, 'De l'apogée économique,' 209–13.

49 *'Je crois que je puis même avancer que la Corse est plus utile de toutes manières à la France que ne l'était ou ne l'aurait été le Canada'*; quoted in Trudel, *La Révolution américaine*, 50.

50 '[P]*lus intéressant mille fois pour la France que la colonie du Canada'*; Choiseul to the marquis d'Ossun, ambassador in Madrid, 17 May 1762, AAE, Mémoires et documents, France, vol. 574, f. 76, quoted in Dziembowski, *Un nouveau patriotisme*, 255.

51 John Lynch, *Bourbon Spain, 1700–1808* (London: Basil Blackwell, 1989), 342–4.

52 Besides, Spain was, for centuries, the destination of a huge number of French migrants leaving the southwest of the kingdom to find a better life in Catalonia, Madrid, or Andalusia. See Abel Poitrineau, *Les Espagnols de l'Auvergne et du Limousin du XVIIe siècle au XIXe siècle* (Aurillac: Malroux-Mazel, 1985); and idem, *Les Français en Espagne à l'époque moderne (XVIe–XVIIIe siècles)* (Paris: Éditions du CNRS, 1990). A French ambassador in Spain during the reign of Louis XIV, the marquis de Villard, estimated at

seventy thousand the number of French *'qui tirent de l'argent d'Espagne'*; Marquis de Villars, *Mémoires de la cour d'Espagne de 1679 à 1681* (Paris: Plon, 1893), 6.

53 Michel Zylberberg, *Une si douce domination: les milieux d'affaires français et l'Espagne vers 1780–1808* (Paris: Comité pour l'histoire économique et financière de la France, 1993), 75; François Crouzet states that, during the eighteenth century, French industry provided forty to fifty per cent of Spanish cargoes to America but that this share had fallen at the end of the century; *La guerre économique franco-anglaise au XVIIIe siècle* (Paris: Fayard, 2008), 194.

54 Stanley J. Stein and Barbara H. Stein, *Apogee of the Empire: Spain and New Spain in the Age of Charles III, 1759–1789* (Baltimore: Johns Hopkins University Press, 2003), 315.

55 Crouzet, *La guerre économique*, 192.

56 See the several reports written by the Abbé Béliardi, in Papiers de l'abbé Beliardi, Bibliothèque nationale de France, Fonds Français 10766–10770; Pierre Muret, 'Les papiers de l'abbé Béliardi et les relations commerciales de la France et de l'Espagne au milieu du XVIIIe siècle (1757–1770),' *Revue d'Histoire Moderne et Contemporaine* 4 (1902–1903): 657–72; and Allan Christelow, 'French Interest in the Spanish Empire during the Ministry of the Duc de Choiseul, 1759–1771,' *Hispanic American Historical Review* 21 (1941): 515–37.

57 See, for example, the views of Renaut, 'Études sur le Pacte de Famille,' 102–4, which are shared by many Spanish and American historians.

58 Allan J. Kuethe and Lowell Blaisdell discount the reality of the impact of France on Spanish diplomacy; see 'French Influence and the Origins of the Bourbon Colonial Reorganization,' *Hispanic American Historical Review* 71 (1991): 601–6.

59 Kuethe and Blaisdell, 'French Influence,' consider that the marquis d'Ossun was, in these matters, more perceptive than the Abbé Béliardi; Stein and Stein also evoke the 'guarded optimism' of Edouard Boyetet, commercial agent in Madrid from 1772 to 1784 (*Apogee of the Empire*, 326–9).

60 Christelow, 'French Interest in the Spanish Empire,' 523.

61 Stein and Stein, *Apogee of the Empire*. In 1765 the opening of imperial trade was restricted to Spain's Caribbean possessions. In 1778 it was extended to Rio de la Plata, Chile, and Peru (February), then to Colombia, the Yucatan, and Guatemala (October). Venezuela and New Spain, through Vera Cruz, were excluded.

62 Crouzet, *La guerre économique*, 189–90.

63 Stein and Stein, *Apogee of the Empire*, 321–6.
64 Labourdette, *Vergennes*, 77–82. Jacob Osinga quotes the Instructions of Vergennes, 28 December 1774, to Baron de Breteuil, ambassador in Vienna: '*Il est donc naturel que le roi regarde le Pacte de Famille comme la base de sa politique, et que tant que l'Espagne sera fidèle à l'esprit qui a formé leur union, Sa Majesté s'occupe avant tout du soin de la resserrer*'; see 'The Myth of the Treaties of February 6, 1778: A Case of Beautification of the Reality,' in *La révolution américaine et l'Europe* (Paris: CNRS, 1979), 378. Vergennes continuously supported the *Pacte de Famille*, while Maurepas, the aging king's main adviser, was more reluctant (Labourdette, *Vergennes*, 77–82).
65 Labourdette, *Vergennes*, 74–7; Stockley, *Britain and France*, 131–2.
66 The majority of the reports received by the Secrétaire d'État des Affaires Étrangères about colonial policy showed the same views. See, for example, 'Réflexions sur les moyens de la France et de l'Espagne pour rétablir une balance maritime,' remis à Monsieur le comte de Vergennes le 3 octobre 1774 par le chevalier de Ricard, colonel d'infanterie, AAE, Mémoires et Documents, Angleterre, vol. 56, no. 13, f. 53ff.: '*La France n'ambitionnera plus de vastes colonies mais elle aura beaucoup de comptoirs, d'entrepôts, de ports de relâche, d'établissements dans toutes les mers et surtout beaucoup de vaisseaux; elle préférera le commerce d'échange et de facteurs à tous les autres commerces.*'
67 '*Nous ne sommes à Saint-Domingue que [pour] la culture et le commerce. Nous n'y avons pas besoin de forces navales. Quelques forts et leurs garnisons suffisent à notre défense. Notre prévoyance et nos soins ne doivent pas s'étendre plus loin. C'est ainsi que raisonne M. d'Aranda, paraissant oublier que le Pacte de Famille nous impose de plus grandes obligations qu'il ne veut s'en souvenir*'; Vergennes to the marquis d'Ossun, ambassador to Madrid, 10 January 1775, AAE, Mémoires et Documents, Amérique, vol. 13, Indes Occidentales, Saint-Domingue 1773–77, f. 214.
68 Vergennes told the British ambassador in Paris that the independent colonies could '*se former une grande marine; et comme elles possèdent tous les avantages inimaginables pour construire des vaisseaux, il ne passerait pas beaucoup de temps avant qu'elles eussent des flottes capables de se mesurer avec toutes celles de l'Europe ... en sorte que, finalement, elles ne laisseraient pas une lieue de cet hémisphère dans la possession d'une puissance quelconque de l'Europe*'; Lord Stormont to Lord Rochford, Secretary of State, 31 October 1775, quoted in Henri Doniol, *Histoire de la participation de la France à l'établissement des Etats-Unis d'Amérique*, vol. 1 (Paris: Imprimerie Nationale, 1886), 200.
69 Instructions to Charles d'Estaing, 27 March 1778, article 7, quoted in Trudel, *La Révolution américaine*, 187.
70 Ibid., 130.

71 *'Le Canada est le point jaloux pour eux; il faut leur faire entendre que nous n'y songeons point du tout, que nous sommes loin de leur envier l'indépendance qu'ils travaillent à s'assurer, que nous n'avons nul intérêt à leur nuire ... Quant à de nouvelles acquisitions en Amérique, si le Roi en désirait, ce ne serait qu'autant qu'elles procureraient plus de facilité et d'étendue à ses pêches'*; Vergennes to the comte de Guines, ambassador in London, 7 August 1775, AAE, Angleterre, Correspondance Diplomatique, vol. 511, ff. 228–33.

72 *'Le conseil du roi d'Angleterre se trompe grièvement s'il se persuade que nous regrettons autant le Canada qu'il peut se repentir d'en avoir fait l'acquisition'*; Vergennes to the comte de Guines, ambassador in London, 7 August 1775, AAE, Correspondance Diplomatique, Angleterre, vol. 511, ff. 228–33.

73 Trudel, *La Révolution américaine*, chap. 4.

74 *'[L]e Canada restant au pouvoir de l'Angleterre, cette frontière seule suffirait pour occuper l'inquiétude des colonies septentrionales qui ne pourront jamais être parfaitement tranquilles sur les vues de ce voisin'*; Memoir of Vergennes to the King, 23 July 1777, quoted in Doniol, *Histoire de la participation*, vol. 2, 466–8. See also the Instructions of Vergennes to Mr. Gérard, French minister to the United States, 29 March 1778: *'Mais le roi a considéré que la possession de ces trois contrées* [Canada, Nova Scotia, the Floridas], *ou, au moins du Canada par l'Angleterre, serait un principe utile d'inquiétude et de vigilance pour les Américains, qui leur fera sentir davantage tout le besoin qu'ils ont de l'amitié et de l'alliance du roi'*; quoted in *Despatches and Instructions of Conrad Alexandre Gérard, 1778–1780* (Baltimore: Johns Hopkins University Press, 1939), 129.

75 Trudel, *La Révolution américaine*, 187.

76 *'[E]t qu'enfin les Etats-Unis cèdent et garantissent au roi la souveraineté de l'Isle de Saint-Jean, beaucoup moins utile pour la pêche que pour préparer, consommer et assurer la résolution ou la conquête du Canada, et par conséquent étant plus avantageux dans les mains de la France aux Etats-Unis qui veulent cette résolution ou cette conquête qu'à nous-mêmes qui n'y songeons pas'*; extracts of a text written by the comte d'Estaing, sent by Gérard to Vergennes, 15 July 1778, in *Despatches and Instructions* (see note 72), 152–3.

77 *'[A]u lieu d'envoyer dans les Antilles une expédition mesquine ... que ne faisait-il partir pour le Canada un corps d'armée de dix à douze mille hommes? Cette colonie encore toute française se serait soulevée en notre faveur et nous la posséderions aujourd'hui'*; *Souvenirs et portraits, 1780–1789, par Monsieur le duc de Levis*, nouvelle édition augmentée (Paris: Laurent Beaupré, 1815).

78 Frederick J. Thorpe and Sylvette Nicolini-Maschino, 'Michel Chartier, marquis de Lotbinière,' *Dictionary of Canadian Biography*, www.biographi.ca.

79 Trudel, *La Révolution américaine*, 185.

80 Dull, 'Vergennes, Rayneval and the Diplomacy of Trust,' 122–5.

81 See, for example, Stockley, *Britain and France*, 105–6.
82 Pierre Pluchon, 'Choiseul et Vergennes: un gâchis colonial,' *Négoce, ports et océans, XVIe–XXe siècles: mélanges offerts à Paul Butel*, ed. Silvia Marzagalli and Hubert Bonin (Pessac, France: Presses Universitaires de Bordeaux, 2000), 225–34.
83 '*Vous connaissez notre système à l'égard du Canada ; il est invariable et tout ce qui empêchera la conquête de cette contrée entrera essentiellement dans nos vues*'; quoted in Trudel, *La Révolution américaine*, chap. 4.
84 See, for example, Conway, *British Isles*, 315–45; and Marshall, *Making and Unmaking*, 182–206.
85 Renaut, 'Études sur le Pacte de Famille,' 44–5.

5

1759: The Perils of Success

JACK P. GREENE

The fits of patriotic ecstasy that reverberated throughout the British Empire following the Conquest of Quebec in 1759 and again after the favourable – for the British – conclusion of the Seven Years' War in 1763 disguised from the celebrants the many underlying problems and residual tensions that, over the next few decades, would reduce the size and scope of the empire, radically change its character, and reconfigure global power in the Atlantic and Indian Oceans. Such an outcome seemed unlikely at the time, for, added to the empire's extraordinary economic successes through the first six decades of the eighteenth century, Britain's new military, naval, and diplomatic achievements promised to put the entire British world in a position of such pre-eminence that its future in the early 1760s looked virtually limitless and with no obstacles that could not be easily overcome. To be sure, a few naysayers fretted about the perils of success, worrying that the humiliation of the French might lead to yet another imperial war, that Britain with all its territorial acquisitions had bitten off more than it could chew, or that the elimination of the French from North America would encourage the burgeoning American continental colonies to throw off British trade restrictions and set up for themselves as independent polities. Yet to most ministers, bureaucrats, and other interested members of the metropolitan political nation, Britain's propitious situation seemed to offer opportunities as well as problems. The possibility of a French resurgence could be countered by maintaining British defence capabilities at a high level, while colonial aspirations for independence could be headed off by tightening up imperial governance and trade regulations and better managing aboriginal affairs. Few suspected that these goals would put them on a collision course with sensitive colonial polities, which had

emerged from the war experience with expectations of an expanded role and a more secure political status in the collective and cooperative enterprise that was the British Empire.[1]

Certainly, the last four decades of the eighteenth century witnessed major changes in the European imperial state system, but it is more difficult to determine to what extent those changes can be attributed to the Conquest of Canada in 1759 and, more generally, to the Seven Years' War. While its gains rendered Britain the dominant imperial power in the Atlantic world and enormously enhanced its position in Asia, and while the exchange of Louisiana for Florida potentially strengthened Spain's position by consolidating its North American holdings, French losses in the Americas and in India severely weakened France's imperial standing vis-à-vis both Britain and Spain, despite its retention of Martinique, Guadeloupe, and the economic dynamo of St-Domingue (Haiti), widely regarded as the most successful European colony in America after Mexico and Peru. These developments left France determined to counter Britain's overweening global power and Britain more attentive to imperial defence than it had been in a century and a half of overseas expansion. France's subsequent intervention in the American War of Independence helped to deprive Britain of thirteen of its most valuable colonies, but also contributed to the economic crisis that led to the French Revolution, the French loss of St-Domingue, and another quarter-century of warfare between Britain and France.

Against this broad context, I propose in this chapter to focus on the experiences of the wider *British* world in coping with the problems it encountered in the decades immediately after the Seven Years' War. This focus is not intended to minimize the consequences of the transfers of territories that occurred between 1759 and 1763 upon the polities, societies, and cultures within those territories, many of whose residents faced, at the extremes, the dismal choice of migration or amalgamation and assimilation. Rather, I am merely playing to my own strength, which lies within the eighteenth-century British imperial world. Even within this limited scope, the task of laying out the many changes experienced by the British Empire in the decades after the Conquest of Quebec in 1759 and the Peace of Paris in 1763 and relating them to the results of the Seven Years' War is a daunting one, for the modern historiography on this subject is so rich. This chapter concentrates largely on a few major changes, some of them unanticipated, that dramatically underline the perils that lurked in the great success of 1759.[2]

Along with the acquisition of Quebec, the eastern half of the upper Mississippi Valley, and the ceded islands in the West Indies as a result of the Seven Years' War, the expansion of territorial jurisdiction in India, first over Bengal in the 1760s and then over Madras and Bombay, considerably increased the religious, political, and ethnic diversity of the empire. This diversity profoundly affected the empire's character. If, in David Armitage's succinct formulation, the empire that had developed by the middle of the eighteenth century could be defined as 'Protestant, commercial, maritime and free,'[3] the empire that came into being after the Seven Years' War, while still deeply commercial and maritime, was considerably less Protestant and, by traditional English standards, much less free.

Within the empire, existing precedents for colonial oversight without traditional English consensual governance and legal practices were few and exceptional: Newfoundland, where naval commanders presided over a mixed settler and transitory maritime population mostly using traditions of maritime and customary law; and Minorca, Gibraltar, and Acadia, three acquisitions from the War of the Spanish Succession, whose local Catholic and non-English populations had been permitted to retain their own systems of governance and law – with the notable exception of the Acadians, expelled from Nova Scotia during the early years of the Seven Years' War.[4] Whether Quebec, whose settler population was too substantial to expel, would suffer the fate of Ireland following the Protestant Ascendancy and see its Catholic population subjected to Protestant domination under a minority government enjoying and monopolizing the benefits of English consensual governance and common law culture, or, like Minorca, be permitted to retain its existing political and religious system, was an open question at the end of the war. If allowed to follow the Minorcan model, Quebec promised to introduce a new and, by English standards, considerably more authoritarian mode into imperial governance. India, with its dense population and ancient culture, seemed to offer no option but the authoritarian.

The new conquests not only made the empire more heterogeneous; they also brought vast new territories under British authority. Although Quebec, with its large settler population, presented a special difficulty for metropolitan administrators, they also had to confront the problem of deciding which other new territories in the Americas should be left under the control of indigenous peoples and which should be formally organized into colonies. By forbidding, in the Proclamation of

1763, settlement west of the Allegheny Mountains or around the Great Lakes, metropolitan authorities acknowledged, at least for the short run, indigenous dominance of the vast area to the west of the existing continental colonies. Endeavouring to administer those territories from strategically situated military outposts that doubled as trading centres, metropolitan authorities seemed to promise indigenous groups protection from settler encroachment, a promise they would prove unable to fulfil.[5]

The pressure to divide other conquered area into colonies was considerable, and over the next decade the British established more colonies than they had done at any time since the 1660s: one each in the ceded islands of Dominica, Grenada, St Vincent, and Tobago, two in Florida, East and West, and one on the island of St John (now Prince Edward Island). Unlike Quebec, the small or non-existent settler populations of these colonies presented few impediments to the establishment of traditional English legal culture and consensual governance, but the addition of so many new colonies expanded the total number of American colonies subject to imperial administrative oversight by almost twenty per cent.

At the same time that so much energy was going into the organization and administration of new territories, metropolitan officials embarked upon a desultory and unsystematic series of initiatives designed to enhance state economic, political, and military control over the old settler empire. These initiatives evoked spirited resistance from most of the component parts of that empire and, in 1776, the revolt of those colonies that were not dependent on the metropolis for their defence, internal against their enslaved populations or external against foreign powers. This settler revolt, known as the American War of Independence, was a long and bitter imperial civil war over the secession of thirteen colonies from the empire. Military losses during this second seven years' war also led to the retrocession of the two Florida colonies to Spain and the loss of Tobago to France.

A secondary effect of the American War of Independence was the expansion of settler political authority over internal affairs in polities that did not revolt, from Ireland to the West Indies and North America. Metropolitan concessions designed in 1778 to entice the rebellious colonies back into the empire, specifically the repeal of the Declaratory Act of 1766, produced a significant increase in settler legislative autonomy in the West Indian and Atlantic island colonies as well as in the non-rebelling mainland colonies, and contributed to the political atmosphere

in Ireland that resulted in the early 1780s in the achievement of legisla-
tive independence by the Irish Parliament and the elimination of re-
strictions on Irish trade. Unforeseen at the time was the possibility that
the inability of the Protestant Ascendancy in Ireland to control a restive
Catholic population intent on securing a civic space would lead to the
political union of Ireland and Great Britain in 1800 and the forfeiture of
Irish self-government.[6]

Yet another effect of the American War of Independence was the exo-
dus of Crown supporters from the rebelling colonies during and after
the war, boosting the populations of the Bahamas and of those North
American colonies that did not join the revolt – particularly Nova Sco-
tia, Quebec, and, to a lesser extent, the island of St John, leading to
the creation of settler colonies in New Brunswick and Upper Canada.
Because most of those Loyalists, despite their abhorrence of resistance
to legitimate government, were no less committed to British principles
of consensual governance and the rule of law than the Whig leaders
they had left behind and proved sturdy advocates for the creation or
expansion of the authority of representative assemblies wherever they
settled, they functioned as agents for the extension of British libertarian
traditions in the remnants of the settler empire.

Beyond the Atlantic, other contemporaneous developments were ex-
tending Britain's imperial political jurisdiction. In India, a combination
of territorial expansion, the assumption of political jurisdiction over
Bengal, the inability of the East India Company to control the behaviour
of its servants in any of the Indian presidencies, the growing impor-
tance of the Indian trade for Britain, and the revival of French activi-
ties during the American War of Independence led to the metropolitan
government's increasing oversight over the East India Company and
the conversion of the company into an arm of the state.[7] At the same
time, James Cook's voyages into the Pacific, combined with the need to
find a new outlet for transported British felons, led to the occupation of
Tasmania and New South Wales, thereby laying the foundations for the
eventual creation of new settler colonies in Australia and New Zealand
and, after its conquest, in South Africa.

Finally, the overseas empire received an increasing amount of metro-
politan attention during the closing decades of the eighteenth century.
Especially in association with the prosecution of the Seven Years' War
and the intra-imperial contests of the 1760s, 1770s, and 1780s, metro-
politan officials involved in colonial administration and associates of
those in the higher circles of British government, including members

of Parliament, manifested a profound sense of the weakness of central authority in the outlying segments of the empire, combined with an expanding awareness of the importance of the overseas empire to the commercial well-being and international standing of Britain, percep-tions that were widely shared by the larger public in Britain. At the same time, however, for those critical monitors who thought that the empire should be a humane and civilizing one, enhanced interest in the empire provided an opportunity to scrutinize more closely than earlier generations the behaviour of Britons overseas, producing a heightened understanding of the *costs* of empire for those who were unwillingly subjected to or displaced by it and a more sharply delineated *conception* of empire that differentiated – and thereby distanced – metropolitan Britons from Britons overseas.[8]

Of all these developments, the second – the loss of fifteen of the eigh-teen contiguous North American colonies between 1776 and 1783 – was the most shocking and had the most profound effect upon the empire as a whole. How this hugely successful, increasingly well-integrated, and more densely and closely connected empire so quickly came apart has long been a question of central interest to historians of colonial British North America and the early United States. More recently, it has also attracted the attention of historians of the British Empire and even of Britain itself.[9] Notwithstanding a variety of differing emphases among historians with varying perspectives and interests, a rough consensus seems to have emerged around two general points: first, that metro-politan efforts to enhance state economic, political, and military control over the old settler empire evoked spirited resistance from most of the component parts of that empire and, second, that their resistance and the metropolitan response to it led to the reluctant revolt and eventual independence of those colonies with the capacity for resistance.

To the extent that this story line is serviceable, it raises the more inter-esting questions of why metropolitan authorities sought more control over the old settler colonies, why settler leaders in those colonies resist-ed so strongly, why metropolitans ultimately chose force as the means to try to quell that resistance, and whether the Conquest of Canada and the results of the Seven Years' War had anything to do with those responses. Both contemporaries and modern historians have had a lot to say on these questions.

Historians have stressed two main reasons underlying metropolitan initiatives to tighten up the empire. The first revolves around colonial behaviour during the Seven Years' War in the general areas of defence

responsibility, aboriginal relations, and evasion of trade laws.[10] With regard to defence responsibilities, the difficulties the continental colonies encountered in trying to present a united front against the French during the early years of the war brought the parochial orientation of the component parts of the overseas empire into sharp focus, demonstrated that colonials usually put their own safety and interests ahead of concern for neighbouring colonies or the larger welfare of the empire as a whole, and made it clear that an effective colonial defence would have to be organized by and directed from London and would require the commitment of large numbers of British regulars in America. Unable to send enough troops to repel the French, however, metropolitan authorities continued to seek money and men from the colonies, some of which, including especially Massachusetts, Connecticut, New York, and Virginia, made impressive contributions, while others, notably Pennsylvania and Maryland, got bogged down in internal squabbles and made disappointing returns. Although Pennsylvania did much better during the later stages of the war, its failure to contribute during the early years received considerable attention in the metropolitan press and helped to foster the impression that the colonies were not pulling their share of the load, an impression reinforced by Pitt's policy of encouraging colonial contributions by earmarking metropolitan funds to reimburse colonial treasuries for substantial amounts of their defence expenditures. Notwithstanding significant appropriations for the war effort by the vast majority of the colonies, metropolitan authorities thus understandably emerged from the war with the feeling that the metropolis had shouldered the financial and military burden for a war from which colonials, especially on the continent, had benefited disproportionately. Indeed, over the following decade, many metropolitans claimed that the war had been fought for the benefit of the American colonials alone.

Relations with aboriginals exhibited many of the same problems. Intercolonial rivalries and settler pressure on indigenous lands had led to the development of an unstable relationship with aboriginals, especially in the upper middle and lower southern colonies, severely undermining British efforts to enlist aboriginal allies against the French and Spanish and thwarting attempts to woo their allies away from them. As in the related case of defence, central intervention seemed imperative, and London authorities responded by placing aboriginal diplomacy in the hands of London-appointed commissioners, one for the north and another for the south. Although these appointments by no means re-

moved provincial governments from any jurisdiction over aboriginal affairs, they went a long way in that direction, and aboriginal relations during the war heightened awareness in London of the effects of questionable land transfers and settler pressure on indigenous nations and raised doubts about colonial participation in the direction of aboriginal matters.[11]

The extent of colonial evasion of existing trade laws also came into clearer metropolitan focus during the war. In the decades after Parliament's passage of the Molasses Act in the early 1730s, British West Indian interests had often complained about North American merchant and ship captain evasions of metropolitan restrictions against trading with French and Dutch islands. As these evasions continued and perhaps even increased in scale during the war, and as North American traders developed creative ways to get around existing trade prohibitions, metropolitan officials came to see such behaviour as trading with and strengthening the enemy at the expense of the national interest. This situation became a subject of discussion in the metropolitan press and further underlined for those responsible for colonial governance in London the metropolis's limited capacity to enforce policy on the western side of the Atlantic.[12]

Although all of these problems had earlier manifestations, they were greatly exacerbated and became priority administrative concerns in London as a result of the experiences of the Seven Years' War. Like the decision in the early 1760s to help alleviate the massive war debt by trying to tax the colonies to cover colonial defence and administrative costs, they can all be said to have been direct outgrowths of the war, albeit outcomes that might have produced choices other than the ones made at the time. The same cannot be said for the second main reason that some historians, including this writer several decades ago and, most recently, Peter Marshall,[13] have used to explain the metropolitan decision to try to achieve a tighter rein over the old settler colonies – that is, the increasing awareness of the enormous economic and strategic importance of those colonies to metropolitan Britain. Such an awareness considerably antedated the Seven Years' War. From the 1720s on, economic writers had been celebrating the beneficial effects of Britain's expanding colonial trade and crediting the growing overseas empire – in particular, the American colonies – with the major role in that development. Explaining the many ways in which American plantations had contributed to the economic well-being of metropolitan Britain, these writers emphasized the role of the colonies in providing a place where

those with poor prospects in Britain or elsewhere in the old world could become useful and industrious contributors to the national wealth, in producing valuable commodities that were commercially useful to the metropolis, in stimulating British manufacturing by providing an ever-expanding market for British goods and thereby indirectly accelerating both urban and agricultural expansion and improvement, in providing a field for nurturing British mercantile development and opportunities for capital investment, and in contributing to the augmentation of shipping and sailors. In all these ways, commercial writers and other analysts of the overseas British world emphasized, Britain's overseas possessions had made substantial contributions to the nation's wealth and power at the same time that they were spreading British culture over substantial parts of the Americas.

By the late 1730s and early 1740s, members of Parliament routinely acknowledged that the plantation trades were, as Earl Cholmondeley said in 1739, 'the most valuable branch of our commerce';[14] they were the source, said Sir John Bernard a year later, of 'all our wealth, and that power which is the consequence of wealth.'[15] By mid-century, few could have disputed Malachy Postlethwayt's declaration, in his article on 'Colonies' in his *Universal Dictionary of Trade and Commerce*, that 'our trade and navigation are greatly increased by our colonies' and that the colonies 'really are a source of treasure and naval power to this kingdom, since they work for us, and their treasure centers here.'[16]

Metropolitan recognition that, as one anonymous writer put it in the early 1750s, 'the *Colonies in America*' were 'the *Cornucopia of Great-Britain's* Wealth'[17] extended well beyond a few economic writers and parliamentary orators, and became increasingly evident in the form of rising government expenditures for imperial defence. Budgets for military payrolls overseas doubled between 1728 and 1748 and levelled off over the next six years of peace at a yearly sum just above £70,000, a figure almost double the average annual amount the metropolitan government had spent for military pay in the overseas empire between 1728 and 1734. Not just these escalating sums but also the establishment of buffer colonies at the two ends of the continental chain, creating Georgia in 1734 and augmenting Nova Scotia in 1749, the very first state-sponsored and state-supported colonies in the British Empire, heralded a growing recognition of the economic value of the American colonies and their vulnerability to attack from Britain's principal imperial rivals, Spain and France.[18]

When the French sought to consolidate their hold on the Ohio River

valley in the years after the Peace of Aix-la-Chapelle (1748), they thus seemed, as an anonymous speaker in Parliament charged, to be endeavouring 'to strip us of our most valuable properties.' Knowing 'that the source of power lies in riches, and that the source of English riches lies in America,' the French, he charged, understood that, by weakening the British in North America, they would be undermining the very foundations of Britain's imperial ascendancy.[19] For this reason, French activities in the Ohio, as the author of another London tract reported in 1755, made 'some people think of *American* affairs more than they ever intended,' quickly opening 'the eyes of the whole nation' to 'the extreme danger which now threatens our *American* colonies' and to the fact that whatever threatened them also threatened 'the mother country, since, in whatever fate betides them, she must herself inevitably be involved.'[20] Reviewing public sentiment in Britain 'before and during the war,' a still-later writer emphasized how far the British political nation had taken up such arguments. 'Environed as they were by French encroachments, French forts and French communications; cut off as they were from the fairest riches and best part of the country by French settlements and garrisons on the Ohio, the Mississippi, and the lakes; these very colonies, our last resource,' this writer observed, seemed 'to be in the most imminent danger.' As a consequence, he noted, metropolitan Britons came to believe 'that nothing too great, nothing too expensive, nothing too hazardous could be undertaken in their relief: everything,' he added, 'was to be attempted; for the time was now come to trial, and a trial not to be avoided, whether Great Britain or France excelled as a naval power.'[21]

Well before the full extent of the French challenge had been comprehended in London, however, those in charge of colonial affairs had responded to the rising awareness of the economic importance of the colonies by undertaking measures designed to tighten metropolitan controls over them and to counteract the centrifugal tendencies of an empire in which authority had long been negotiated between the metropolis and provincial polities, and in which those polities had always enjoyed wide latitude in coping with their internal affairs and refashioning English institutions and practices to meet local conditions.[22] For the first time in British imperial history, this reformist impulse stimulated considerable theoretical attention to the problem of imperial relations,[23] but few, if any, of those involved in this exercise seem to have thought in terms of a wholesale reconstruction of the existing system of British imperial governance. Rather, the blueprint for reform, which

could be seen in the new royal governments designed for Nova Scotia and Georgia in the early 1750s, merely looked toward the enhancement of royal power and the restriction of the scope of provincial legislative assemblies. To this end, the Board of Trade, under the Earl of Halifax beginning in 1748, pursued colonial problems more systematically and with far more energy and attention than at any time since the first three or four decades after its establishment in 1696.

The results of this new effort can only have been extremely discouraging for those bent upon enhancing metropolitan supervision over the colonies. Systemic reviews of the situation in colony after colony led to the articulation or revival of a set of restrictive policies designed to shore up metropolitan authority. In most colonies, however, attempts to enforce those policies met stubborn resistance from powerful legislatures that controlled provincial finances and whose consent was often necessary for their implementation. Contrary to metropolitan demands, few legislatures would agree either to be bound by royal instructions issued to colonial governors or to include clauses suspending legislation until they had metropolitan approval. In their opposition to these and a variety of other metropolitan directives they found unsuited to their situations, colonial legislatures justified their opposition as a defence of their constituents' fundamental inherited rights as Englishmen. Threatened by London with dismissal if they did not obey their instructions, a few governors managed to use internal political divisions to forward some Crown policies, but mostly they failed in their efforts or created such deep political troubles that the government had to recall them. In this situation, colonial administrators reviewed colonial legislation more comprehensively and disallowed more laws. Increasingly, in the early 1750s, they also began to threaten the intervention of Parliament in the internal legislative affairs of those colonies that refused to yield to their directives – though actually doing so only once in a case involving Jamaica. Before the Seven Years' War broke out, then, the metropolitan government was deep into an ad hoc and largely unsuccessful effort to revamp the colonial system, while its efforts had revived and given immediacy to ancient colonial anxieties about prerogative threats to long-enjoyed colonial rights.

This stalemate continued during the early years of the war and may even have deepened. Indeed, the early failure of Pennsylvania to contribute to the war effort was largely a result of proprietary insistence, no doubt under direction from Crown authorities in London, upon its governors' adherence to instructions regarding appropriations. As the war

in the Americas went badly for the British in 1757 and 1758, however, metropolitan authorities backed away from their efforts to reform the system of imperial governance, and cooperation against a common enemy replaced contention in transatlantic political relations – albeit most colonial legislatures were quick to take advantage of this situation to extend still further their authority over the internal affairs of their polities. Such 'encroachments' in themselves seemed, in the metropolis, to be sufficient justification for the revival of the reform program in 1759, shortly after the fall of Canada to the British, and, as Bernhard Knollenberg demonstrated a half-century ago, metropolitan authorities pursued it vigorously throughout the early 1760s.[24] No longer constrained by military exigency to placate colonial demands, they demonstrated their clear intention to expand royal authority throughout the colonies through their attention to colonial legislation and other efforts to bring the colonies under closer central supervision. In doing so, they stirred new resentments among colonial leaders, although these often got submerged under the warm glow of British patriotism and the palpable pride that colonials took in being part of such a successful empire.

The Conquest of 1759 and the successful outcome of the Seven Years' War thus did not initiate metropolitan efforts to tidy up the empire. Rooted in a growing awareness of the economic and strategic value of the colonies in a global struggle for imperial supremacy and a determination to head off French efforts to challenge British successes in the Americas, those efforts stretched back to the late 1740s and were well under way before the war began. The war experience strongly reinforced this reformist impulse, while the Conquest of Quebec provided the essential precondition for its revival and extension. At the conclusion of the Seven Years' War, however, the British Empire remained one whose overseas components had been constructed largely by settlers and other private participants on a basis that placed their interests first, and the individual colonies continued, as they had done since their early founding, to enjoy an extraordinary degree of latitude in the management of provincial affairs.

To insist upon tracing the immediate roots of the reform impulse to the pre-war years is emphatically not to de-emphasize the causal importance of the Seven Years' War in the metropolitan decision to pursue that impulse after the war. On the contrary, the successful outcome of the war dramatically reinforced the importance of the colonies in metropolitan thinking, altering even the ways people spoke about empire. No longer was the emphasis so heavily upon trade and economic benefits, as it had

been throughout most of the earlier eighteenth century. Defenders of the treaty that ended the war signalled the change in parliamentary debates in December 1762. 'The value of our conquests ... ought not to be estimated by present produce, but by their probable increase,' one speaker explained, and 'neither ought the value of any country to be solely tried on its commercial advantages.' 'Such ideas,' he said, were 'rather [more] suited to a limited and petty commonwealth, like Holland, than to a great, powerful, and warlike nation' such as Britain. 'Extent of territory and a number of subjects,' he argued, were 'as much consideration to a state attentive to the sources of real *grandeur*, as the mere advantages of traffic.'[25] Indeed, observed the agricultural improver Arthur Young, as important as trade was to a commercial empire like Britain's, it required 'power and dominion ... to support and protect [it].'[26] No longer merely a powerful maritime trading nation, Britain, as a result of the war, had become an *imperial* nation attentive not just to commercial considerations, but also to the 'real grandeur' it had achieved through its overwhelming victories during the war. In this new situation, Britain's extensive overseas possessions became important not only for the great wealth they brought, but also for the extraordinary power they conferred upon the nation. When speaking of empire, the language of imperialism or national grandeur now seemed to be as appropriate as the language of commerce. 'By the additional wealth, power, territory, and influence ... now thrown into our scale' as a consequence of the war, the economic writer Adam Anderson asserted in 1764, Britain would be forever 'enabled to preserve our dearest independence with regard to the other potentates of Europe.' Now that the French had been routed throughout the globe and entirely removed from North America, Anderson looked forward to the creation on the North American continent of a 'vastly more extensive empire' than Britain had previously enjoyed, one 'where our kindred and fellow-subjects' would pave 'the way for the comfortable settlement of many more millions of people than the whole British Empire now contains.'[27]

From this new, post-war perspective on the empire, the colonies could thus be exhibited not merely, in the tradition of earlier analysts, as the prolific seedbeds of a thriving overseas commerce and an amazing stimulus to metropolitan British manufactures and industry, but also as fields for the exertion and display of Britain's expanding, and infinitely expandable, national grandeur. Thus, when the chorographer John Campbell composed his massive two-volume *Political Survey of Britain*, published in London in 1774, he proudly included more than

three hundred pages on 'the Establishments we have made in all Parts of the World.' Heralding those establishments as 'so many distinguishing Testimonies' to 'the commodious Situation of this Island, the Superior Genius of its Inhabitants, and the Excellence of our Constitution, ... so many shining Trophies of our maritime Skill and naval Strength,' Campbell touted the colonies, not just for 'support[ing] the Commerce,' but also for 'extend[ing] the Fame' and 'display[ing] the Power of Great Britain.'[28]

Especially in view of the fiscal and physical exertions made by the metropolis on behalf of its overseas possessions during the Seven Years' War, these many emblems of British fame and power no longer appeared to be the virtually spontaneous and largely self-sustaining products of settler initiative and industry, as so many earlier analysts had suggested, but the consequences of Britain's own careful nurturing and protection, the glorious examples of Britain's own commercial, political, maritime, and military genius.

As they pondered the relationship between empire and national grandeur in the years immediately following the war, however, many metropolitan analysts of empire worried, even more than they had before and during the Seven Years' War, that the empire might lack the internal cohesion and guidance necessary for Britain to fulfil this bold and flattering destiny. If overseas empire was so obviously an essential ingredient in Britain's rise to international power, should it any longer be permitted to function with so little supervision and control? Did not, as Anderson declared, the many valuable extensions of British power overseas now 'demand ... the first and highest regard'?[29] Did they not, as another writer suggested, 'require new regulation'?[30] 'Formerly,' Arthur Young explained, 'it mattered little, whether our statesmen were asleep or awake [in regard to the colonies]: And why? Because the increase of the colonies did the business for them: their increase caused the national trade to increase, and all went on silently, but prosperously.' With the continuously rising *national* significance of the colonies, however, this 'old dilatory sleeping plan,' Young declared, would 'no longer do.'[31] As the ministerial apologist William Knox would observe in the late 1760s, the 'Prodigious extent of the British dominions in America, the rapid increase of the people there, the great value of their trade, all unite in giving them such a degree of importance in the empire, as requires that more attention should be paid to their concerns, by the supreme legislature.'[32] In this view, metropolitan passivity in regard to the overseas empire needed to give way to metropolitan activity.

Recalling the disunited and parochial behaviour of the North American colonies during the early years of the Seven Years' War, some analysts were anxious lest such fissiparous tendencies ultimately should dissipate all the advantages the metropolis derived from the empire. Now that the war and the peace had 'freed [them] from all those terrors of a foreign enemy which so lately agitated' them, such people fretted, the colonists – reflecting upon 'their efforts, during the war, the [new] sense of their security, [their growing] confidence in their own power, [and] the mistaken opinion that independence [was] ... freedom' – might exhibit, as one observer said, 'a restless spirit, which will become more dangerous in proportion as the people who feel it become more powerful.' For an imperial nation to have unruly or uncontrollable colonies was unbecoming. For that reason, he thought, it seemed 'expedient, ... even necessary[,] to lay' the colonies under some appropriate 'restraint now, while' it could still 'be made binding.' To this end, several writers called for measures that would at once maintain 'the dominion of Great Britain' over the overseas empire, secure 'to her the dependence of her colonies,' and mould 'the loose texture of that empire ... into that form which is best calculated for the common good.'[33] Given the failures of Crown authorities using prerogative power alone over the previous decade and a half, many in colonial administration assumed that the achievement of these goals would require parliamentary assistance.

For people with such views, the American Plantation Duties Act of 1764 and the Stamp Act of 1765 represented steps in the right direction. As one contemporary interpreter pointed out, the function of those and other metropolitan regulations adopted in the years immediately after the war was not simply to *regulate the commerce, and improve the revenue of the* British *empire,*' but also to achieve still a third 'great' purpose of empire: to *'secure the dominion'* of the parent state over the colonies. 'By uniting these three objects,' he thought, the American Plantation Duties Act became 'at once a *Bill of Police, Commerce,* and *Revenue.*' As such, it promised to lay a 'deep and broad foundation' on which to reconstruct the empire.[34]

The problem with this strategy was that from the beginning it provoked enormous anxiety throughout the American segments of the empire and met massive resistance from the North American colonies, where it shattered expectations growing out of the Seven Years' War for metropolitan acknowledgment of their long-standing aspirations for explicit metropolitan recognition of the sanctity of colonists' claims to the rights of Britons. Exhibited in pamphlets, newspaper essays, leg-

islative resolutions and petitions, an economic boycott, a general congress, and local riots and intimidation to prevent the enforcement of the Stamp Act, colonial resistance drew upon the traditional language of colonial liberty, as it had emerged over the previous century and a half of the colonies' existence, to claim colonial exemption not only from parliamentary taxation, but also from laws relating to their internal polities. Dismissing metropolitan arguments in favour of the legislation as naked expressions of a language of might or state power that ignored their status as free polities within the empire, colonial protagonists argued that colonists, as Britons, were entitled to all British liberties, that by right they were subject to no laws to which they had not consented through their representatives, and that their representatives sat in their several colonial assemblies, not in Parliament. This response set the terms for a decade-long transatlantic debate over whether the maintenance of Britain's imperial stature required Parliament to hold an incontestable and acknowledged authority over the entire empire.

There is no need here to rehearse once again the slow process by which, over the next decade, thirteen of Britain's American colonies moved from being functional to dysfunctional to revolutionary components of the British Empire, nor the military events that reinforced their decision to go their own way and try to form a national union independent of the empire. Peter Marshall has referred to this unforeseen consequence of the stunning successes of British arms in the Seven Years' War as the 'unmaking' of the British Empire, but it could also be termed the *re*making of the British Empire, a change that would be in full accord with the spirit of his analysis.[35] Britain's old settler empire, with its traditions of self-government and creolizations of the English common law system, was substantially diminished, and the union of Britain and Ireland in 1800 further contributed to this development. And while portions of the empire in North America, the Atlantic, and the West Indies remained to carry these traditions forward, conditions of late establishment, internal weakness, or external vulnerability rendered their situations more susceptible to metropolitan control than had been customary in the older colonies. The metropolitan government even felt it safe to extend those traditions to colonies in which the settler population was substantial, granting consensual government to Quebec in the early 1790s and acquiescing to – in some cases, actually promoting – the transfer of representative institutions and English law to the many settler colonies established in Canada, Australia, New Zealand, South Africa, and East Africa.[36]

Moreover, the new humanitarian standards critics applied to virtually every part of the empire after 1760 eventually led to a variety of reforms that made the empire somewhat less nakedly brutal in its treatment of subordinate peoples, if not usually less exclusionary. East Indian corruption became less rampant, the African slave trade was outlawed, chattel slavery was formally abolished, and Irish Catholics may have suffered less discrimination after Ireland's union with Britain. Indeed, following the abolition of slavery, a creditable argument could be made that the British Empire was considerably freer than it had been before the loss of the American colonies or than the contemporary United States.

Yet, as Peter Marshall and other historians of the non-settler empire have so often reminded us, the beginnings of territorial empire in India and the growing importance of the Indian trade during the closing decades of the eighteenth century provided the foundation for a new kind of imperial structure, one in which large portions of the empire would be governed without a formal consensual element in a far more authoritarian way than had been characteristic of all but a few polities in the old empire, albeit Europeans and their descendants usually enjoyed the benefits of English common-law legal culture. Moreover, Indian precedents informed the creation after 1790 of a new form of governance – Crown colony governance – for newly conquered or planted colonies in which the independent population was small, a form that in the 1860s would be extended to all but a handful of the older colonies in the West Indies, where, after two centuries of consensual governance, colonial establishments chose to do without such governance rather than share it with the formerly enslaved majority. And the spread of settler colonies in the nineteenth and early twentieth centuries was accompanied by the addition of many new colonies in which a small group of European bureaucrats presided over massive indigenous populations, few members of which were incorporated into the administrative world. The British Empire, remaking itself after 1783, was not the empire that the celebrants of 1759 and 1763 envisioned.

NOTES

1 This point is explored more fully in Jack P. Greene, 'The Seven Years' War and the American Revolution: The Causal Relationship Reconsidered,' *Journal of Imperial and Commonwealth History* 8 (1980): 85–105.

2　P.J. Marshall, *The Making and Unmaking of Empires: Britain, India, and America c. 1750–1783* (Oxford: Oxford University Press, 2005), provides the most comprehensive and perceptive study of this broad subject.

3　David Armitage, *The Ideological Origins of the British Empire* (Cambridge: Cambridge University Press, 2000), 173.

4　Jerry Bannister, *The Rule of the Admirals: Law, Custom, and Naval Government in Newfoundland, 1699–1832* (Toronto: University of Toronto Press, 2003). On the Acadian experience, see N.E.S. Griffiths, *From Migrant to Acadian: A North American Border People, 1604–1755* (Montreal; Kingston, ON: McGill-Queen's University Press, 2005). On the expulsion, see Geoffrey Plank, *An Unsettled Conquest: The British Campaign against the People of Acadia* (Philadelphia: University of Pennsylvania Press, 2001).

5　An excellent general discussion is in Colin G. Calloway, *The Scratch of a Pen: 1763 and the Transformation of North America* (New York: Oxford University Press, 2006).

6　For a fuller discussion, see Jack P. Greene, 'Liberty and Slavery: The Transfer of British Liberty to the West Indies, 1627–1865,' in *Exclusionary Empire: English Liberty Overseas, 1600–1900*, ed. Jack P. Greene (New York: Cambridge University Press, 2010); and James Kelly, '"Era of Liberty": The Politics of Civil and Political Rights in Eighteenth-Century Ireland,' in ibid.

7　See Marshall, *Making and Unmaking of Empires*, esp. 205–72.

8　I deal with this subject more fully in a volume I am now writing with the working title, *Speaking of Empire: Confronting Colonialism in Eighteenth-Century Britain, 1730–1785*.

9　Most recently and importantly from Marshall, *Making and Unmaking of Empires*; idem, *'A Free though a Conquering People': Eighteenth-Century Britain and Its Empire* (Aldershot, UK: Ashgate, 2003); and Stephen Conway, *The British Isles and the War of American Independence* (Oxford: Oxford University Press, 2000).

10　See Marshall, *Making and Unmaking of Empires*, 86–118. The already classic account of the war and its relationship to imperial administration is Fred Anderson, *The Crucible of War: The Seven Years' War and the Fate of Empire in British North Americas, 1764-1766* (New York: Vintage, 2000), which, however, tells us little about the profound effects of the war upon the colonial polities caught up in it.

11　See Calloway, *Scratch of a Pen*, 92–111.

12　For example, Merchant of London, *A State of the Trade Carried on with the French, on the Island of Hispaniola, by the Merchants of North America, Under the Color of Flags of Truce* (London: W. Owen, 1760).

13 Jack P. Greene, '"A Posture of Hostility": A Reconsideration of Some Aspects of the, Origins of the American Revolution,' *American Antiquarian Society Proceedings* 87 (1977): 27–68; idem, 'An Uneasy Connection: An Analysis of the Preconditions of the American Revolution,' in *Essays on the American Revolution*, ed. Stephen G. Kurtz and James H. Hutson (Chapel Hill: University of North Carolina Press, 1973); and Marshall, *Making and Unmaking of Empires*, 11–56, 81–3.

14 Speech by Earl Cholmondeley, 4 March 1739, quoted in *Proceedings and Debates of the British Parliament Respecting North America*, vol. 4, ed. Leo F. Stock (Washington, DC: Carnegie Institute of Washington, 1924–41), 689.

15 Speech by Sir John Bernard, 5 February 1740, quoted in *Proceedings and Debates* (see note 14), vol. 5, 25.

16 Malachy Postlethwayt, *Universal Dictionary of Trade and Commerce*, 4th ed., vol. 2 (London: W. Strahan, J. and F. Rivington, J. Hinton, et al., 1774).

17 G.B., *The Advantages of the Revolution Illustrated, By a View of the Present State of Great Britain* (London: W. Owen, 1753), 30.

18 On these developments, see also Elizabeth Mancke, 'Another British America: A Canadian Model for the Early Modern British Empire,' *Journal of Imperial and Commonwealth History* 25 (1997): 1–36.

19 Speech by Anonymous, 21 February 1757, quoted in *Proceedings and Debates of the British Parliaments Respecting North America 1754–1783*, vol. 1, ed. R.C. Simmons and P.D.G. Thomas (Millwood, NY: Kraus International, 1982–86), 195–6.

20 *State of the British and French Colonies in North America, With Respect to Number of People, Forces, Forts, Indians, Trade and other Advantages* (London: A. Millar, 1755), 2, 130.

21 *A Full and Free Inquiry into the Merits of the Peace* (London: T. Payne, 1765), 17–19.

22 This subject is treated more fully in Greene, 'Posture of Hostility.'

23 See Peter N. Miller, *Defining the Common Good: Empire, Religion and Philosophy in Eighteenth-Century Britain* (Cambridge: Cambridge University Press, 1994), 150–212.

24 Bernhard Knollenberg, *Origin of the American Revolution: 1759–1766* (New York: Macmillan, 1960).

25 Speeches by Anonymous, 9 December 1762, quoted in *Proceedings and Debates of the British Parliaments* (see note 19), vol. 1, 422–3.

26 Arthur Young, *Reflections on the Present State of Affairs at Home and Abroad* (London: J. Coote, 1759), 25.

27 Adam Anderson, *An Historical and Chronological Deduction of the Origin of Commerce, From the Earliest Accounts, containing An History of the Great*

Commercial Interests of the British Empire, vol. 1 (London: J. Walter, 1787), xliv–xlv.

28 John Campbell, *A Political Survey of Britain: Being a Series of Reflections on the Situation, Lands, and Inhabitants, Revenues, Colonies, and Commerce of this Island*, vol. 2 (London: Richardson and Urquhart, 1774), 567, n. i.

29 Anderson, *Historical and Chronological Deduction of the Origin of Commerce*, xlv.

30 *The Political Balance. In Which The Principles and Conduct of the Two Parties are weighed* (London: T. Becket and P.A. Dehondt, 1765), 39.

31 Arthur Young, *Political Essays Concerning the Present State of the British Empire* (London: W. Strahan and T. Cadell, 1772), 552.

32 William Knox, *The Present State of the Nation: Particularly with Respect to its Trade* (London: J. Almon, 1768), 39.

33 *Political Balance*, 44–5.

34 Ibid., 46, 48.

35 Marshall, *Making and Unmaking of Empires*.

36 See *Exclusionary Empire* (see note 6), chaps. 6–10.

6

The Slow Process of Conquest: Huron-Wendat Responses to the Conquest of Quebec, 1697–1791

THOMAS PEACE

The lives of the late eighteenth-century Huron-Wendat chiefs Étienne Ondiaraété and Sawantanan, better known in the historical record as Petit Étienne and Louis Vincent, were full of change. In the 1740s, when they were born, their community, Jeune-Lorette, was a Jesuit mission located in the heart of New France, just thirteen kilometres from the Plains of Abraham. By the time they died – in the 1820s – the French Empire and the Jesuits were gone and the community faced increasing pressures from expanding European settlements and declining resources. Their lives both shaped, and were shaped by, the ways that their community experienced and responded to this changing environment. Although the Conquest of Quebec was a contributing factor to many of these changes, the fall of New France reinforced and accentuated transitions that had already been taking place during the decades following the community's move to Quebec. As in their earlier selective adoption of French agriculture and material culture, after the Conquest the community responded to the slow removal of their Jesuit missionaries and decline in political clout by embracing European forms of education and petitioning for land granted to them during the French regime. As in the pre-Conquest period, the changes that took place after the fall of Quebec provided opportunities for the community – and its individual members – to adapt to the new political environment in ways that sought to strengthen or protect Huron-Wendat society.

In this sense, then, the Battle of the Plains of Abraham was not a pivotal event. The changing power structures that it brought about, however, played a determining role in shaping the way that post-Conquest Jeune-Lorette developed. By focusing on this one community, and

some of its key members, this chapter describes one of the contexts in which the experiences of regime change in aboriginal communities can be understood. No aboriginal community had the same experience of the fall of New France. Although there were many similarities between communities, local conditions shaped the outcome of this event in each place. It was not until much later – around the 1830s – that the experiences of the communities around the St Lawrence began to mould together.

By the time Sawantanan and Ondiaraété were young men, their community's relationship with the Jesuits, proximity to *habitant* farmers, and military alliance with the French had brought about a number of cultural adaptations. This process of change had begun nearly a hundred years earlier. After being driven from their homes along the shores of Lake Huron by the Haudenosaunee (Iroquois) Confederacy, the community followed Jesuit missionaries to Quebec. They did not immediately settle at Jeune-Lorette, but chose to live much closer to the French town. However, the threat of further Haudenosaunee attacks, the limited resources near the town, and the pressure of immigrating and expanding French families forced the community to relocate eight times before finally migrating to the seigneury of St-Gabriel. With each of these moves – but particularly after the final one in 1697 – they made adaptations that reflected the community's increasing permanence in the region.

Not surprisingly, given their early encounter with European missionaries, the biggest influence on the community was religious. At the time of their final move, Bacqueville de la Potherie, the French comptroller of the Marine, noted that the Jesuits had made a significant impact on Huron-Wendat culture. In French eyes, the Jesuits had corrected many of the character traits commonly associated with aboriginal peoples; the community was known for its piety, temperance with alcohol, and close relationship with missionaries.[1]

Around the same time, hunting began to play a more important part in meeting the village's subsistence needs.[2] When the community first moved into the St Lawrence valley from early Wendaké, agriculture played a significant role in its economy. The move to Jeune-Lorette marked a transition: rather than seizing an opportunity to move to more fertile land along the St Lawrence, the community moved to a transitional landscape between the rich fertile soils along the river valley and the more sterile soils of the Laurentian Mountains.[3] Indeed the

sandy soil of Jeune-Lorette reduced the potential for agriculture,[4] and less agriculture meant that the community needed to rely more on fishing and hunting.

Although there was a shift in the balance struck between these two aspects of the Huron-Wendat economy, the transition marked neither change in the seasonality of the hunt nor complete abandonment of agriculture. Throughout the eighteenth century, villagers continued the seasonal hunting patterns established in early Wendaké.[5] Fishing was still practised throughout the year, while the fall and late winter continued as the primary hunting periods.[6] Agriculture also continued. Pehr Kalm noted in 1749 that community members grew maize, sunflowers, wheat, and rye, and kept some livestock as well.[7] This illustrates the hybrid nature of Huron-Wendat culture by the middle of the eighteenth century – wheat did not replace maize or sunflowers, nor did livestock replace hunting and fishing; rather, community members integrated European livestock and crops into their economic and subsistence traditions.

Other aspects of their community life similarly straddled European and aboriginal worlds. Like the selective adoption of European agriculture, some elements of their physical world were also becoming similar to that of their French neighbours. Between the 1720s and 1740s, *habitant*-style *pièce-sur-pièce* cabins replaced longhouses, and some members of the community (particularly men) had selectively embraced French fashion, language, and technology. Despite these adaptations, both Kalm and French engineer Louis Franquet, who visited in 1752, noted a number of village traditions that shared more in common with the community's aboriginal heritage than with that of their French neighbours.[8] These traditions continued throughout the later eighteenth century. In their old age, nearly sixty years after Kalm and Franquet made their observations, the traditions taught during Sawantanan's and Ondiaraété's youth continued. They used their maternal language, dressed in distinctive Huron-Wendat fashions, and used technologies descended from their ancestors along Georgian Bay.[9] French influence may have been significant, but it did not bring an end to Huron-Wendat cultural practices.

The community's close proximity to the town of Quebec reinforced the strength of the military alliance that had begun during the seventeenth century. Sawantanan and Ondiaraété grew up in a period of increasing French and English tension. Huron-Wendat men were ac-

Seventeenth- and Eighteenth-century Huron-Wendat Land Use

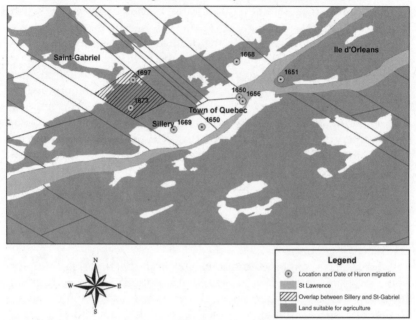

Note: This map is for general reference only. The Canadian Land Inventory uses
 current data. The more heavily urbanized areas of Quebec City, which were
 farmed in the eighteenth century, therefore do not display information about the
 soil.

Sources: Based on maps by Michel Lavoie, "'C'est ma seigneurie que je réclame': le lutte
 des Hurons de Lorette pour la seigneurie de Sillery, 1760–1888' (PhD thesis,
 Université Laval, 2006), appendix; and Canadian Land Inventory – Soil Capa-
 bility for Agriculture, geogratis.cgdi.gc.ca/cgi-bin/geogratis/cli/agriculture.pl, ac-
 cessed 9 November 2009.

tive in fighting alongside the French and their aboriginal allies in many
critical battles during the War of the Austrian Succession and the Seven
Years' War. In 1745, when these men were infants, warriors from the
community joined the French in a failed attempt to retake Acadia; just
over a decade later they were among the troops that successfully took
Fort William Henry.[10] Although never numerically significant relative
to other aboriginal communities or to French troops, the community's
close proximity to Quebec elevated the importance of its fighters and
their involvement in French military actions.[11]

The supplies the Huron-Wendat sold to the French military during the War of the Austrian Succession demonstrate their importance. Between October 1746 and October 1747 the community produced at least 250 snowshoes, 125 paddles, and 25 canoes – essential equipment for quick travel over the North American landscape – for the French military. The French paid the Huron-Wendat handsomely for their service: 5,147 *livres* in total, or 206 *livres* per family, if it had been divided evenly.[12] To compare, in 1756 the Jesuits were owed 1,917 *livres* in rent and back-rent from the French tenants living around Jeune-Lorette;[13] and in 1781 the rent, without back payments, brought in just over 577 *livres tournois*; the annual income from the seigneury in 1790, including the revenue from the mill, was calculated at 4,532 provincial *livres*.[14] Without counting income from agriculture, fishing, hunting, or trading, the community made more in 1746/47 than the local *seigneurs* did in 1790. Although wartime conditions suggest that this income was somewhat irregular, its size relative to seigneurial income suggests it was important to the community.

The military alliance with France gave Ondiaraété a front-row seat when Quebec fell. According to an interview he gave to the *Star and Commercial Advertiser* when he was in his nineties, the village was deeply involved in defending the city. Most of its warriors – about sixty or seventy in number – were at Quebec's principal defences at Beauport, and, when Wolfe's men arrived on 13 September, they joined between a thousand and twelve hundred other aboriginal people from as far west as the Great Lakes at the Plains of Abraham.[15] Little is known about aboriginal participation in the battle. D. Peter MacLeod suggests that the autonomy of aboriginal decision-making about where, when, and how they would fight accounts for some of their absence from the documentary record.[16] Based on their positions in the field – with the Canadian militia on the flanks – he argues that they were in an ideal position 'to fight in their own way.'[17] Louise Dechêne, however, suggests an alternative perspective, downplaying the aboriginal role in the battle. Unlike during earlier conflicts, Dechêne argues, both the militia and regular troops began to take a more dominant role in the fighting during the late 1750s, highlighting the secondary, rather than primary, role aboriginal people played in some of the conflicts of those years.[18] With this in mind, and with many aboriginal peoples having been on the losing side, there is little reason for European accounts to discuss their role in great detail. Indeed, Ondiaraété provides the only aboriginal glimpse of the fighting on 13 September. Although there is

some confluence with the American invasion of Quebec in 1775 in his account, Ondiaraété's memory of the event reinforces MacLeod's interpretation: 'The fire of musketry, was first heard at Cap Rouge. – Our Warriors rushed across the St Charles, leaving Beauport at full speed to take their share in the engagement.'[19] This was all that Ondiaraété saw of the conflict – too young to participate in the battle, he was sent home by his grandfather when the fighting became too intense. Rather than return to the village, however, he remained nearby, but did not see much of the action. In the aftermath of the fall of Quebec, he joined the rest of the community in abandoning Jeune-Lorette and retreated with the French to the Jacques Cartier River, where they spent the winter.[20]

Given that he could recall these events in such detail after nearly seventy years, it is clear that the Battle of the Plains of Abraham was a significant event in Ondiaraété's life. Abandoning the village also meant that it was almost certainly an important event for the rest of Ondiaraété's community as well. In the long term, however, the events of the battle were relatively insignificant. The abandonment of the village coincided with the hunting season, meaning that many of the men would have been away from the village anyway, and the following year the community made peace with the British and returned once more to their village. Longer-term events and opportunities, such as the slow demise of the Jesuit Order and access to education in the American colonies, had a much more significant, if less dramatic, impact on Ondiaraété, Sawantanan, and their community.

The community's support for the French ended with the retreat from Jeune-Lorette in 1759, and during the winter the council of chiefs adopted a policy of neutrality. With Quebec taken, the village was in a highly vulnerable position. The year before, Odanak, an Abenaki community near Trois-Rivières, had been attacked in reprisal for capturing a British messenger sent to seek their neutrality.[21] The only things preventing a similar fate for Jeune-Lorette was the village's location on the other side of the town from the St Lawrence and its abandonment during the winter of 1759. Ondiaraété claimed that the 'council Chiefs thought our force too small to effect much for our own safety, they determined upon being neutral – We knew our weakness and observed that neutrality did not endanger us with the conquerors.'[22] With the fighting so close to their village, they had few other options than a policy that would allow their community to survive regardless of what transpired in 1760.

Mounting tensions between aboriginal and French warriors over military strategy also contributed to this policy of neutrality. Friction had

been building between France and its aboriginal allies throughout the Seven Years' War. Conflict regularly arose between European officers with little North American experience and aboriginal people over the conventions of war. MacLeod's work on the Canadian Iroquois during the Seven Years' War illustrates well how the European preference for fort building and siege warfare conflicted with aboriginal motivations for going to war.[23] By limiting access to captives and material goods after successful battles, European officers reduced the incentives for aboriginal people to join in what were increasingly European conflicts.

European disdain for aboriginal people existed at high levels on both sides of the battlefield. The marquis de Montcalm, who only reluctantly fought alongside aboriginal people, preferred European military strategy and tactics.[24] One of his aides-de-camp famously summarized the view of French officers by writing that aboriginal peoples were a thousand times more annoying than mosquitoes.[25] This was a strong statement considering the insects armies would have encountered as they marched through northeastern forests. The commander-in-chief of British troops in North America, Jeffery Amherst, shared similar views, responding to the suggestion to use aboriginal fighters against Pontiac's 1763 uprising by exclaiming, 'I can by no means think of Employing them upon this Occasion ... by perseverance, & proper measures, I have no Doubt but we shall by our own Strength ... Reduce the Savages ... to Such a Low Ebb, as will Effectually Deter them from Attempting to Disturb Us hereafter.'[26] Although not all Europeans shared these views, the similarity of opinion among both the French and English demonstrates the decreasing value that officers on both sides of the conflict placed on aboriginal people. Although the Huron-Wendat did not abandon the French before Quebec fell, interactions with men such as Montcalm during the late 1750s must have made their decision much easier.

By the autumn of 1760 Britain had gained control of the St Lawrence. On 30 August, even before Montreal capitulated, the Seven Fires, a confederacy of aboriginal communities living in the St Lawrence valley, which included the Huron-Wendat, made peace with the British at Oswegatchie. As Jean-Pierre Sawaya and others have demonstrated, this was neither a capitulation nor a surrender; rather, these meetings began the process of building a new alliance based on the British-Haudenosaunee covenant chain.[27] The Huron-Wendat were not present, but as one of the Seven Fires they were considered part of this new alliance. On 5 September, after the preliminary peace with the British had been

established, but before an alliance was finalized at Kahnawaké eleven days later, they had a meeting with General James Murray, who wrote them a short note granting safe passage home from Montreal and guaranteeing the preservation of their religion, customs, and trade.[28] Today, after a ruling by the Supreme Court of Canada in 1990, this document is known as the Murray Treaty.

The Supreme Court's decision that the Murray Treaty was indeed a treaty has sparked extensive historiographical debate. One group of historians, best represented by Denis Vaugeois, argues against seeing the document as a treaty, claiming that it did not correspond with other British-aboriginal treaties. Denys Delâge, the leading historian supporting the court's decision, focuses on the alliance-based relationship between the Huron-Wendat and the French and British colonial governments.[29] Twelve years after the Supreme Court's decision, Alain Beaulieu used Ondiaraété's account in the *Star and Commercial Advertiser* to shed new light on the debate.[30] Although he argued that the document was not a treaty, he also noted the importance given to the document by the community. Indeed, the Murray Treaty was still kept in the council house and used in petitions to the Crown during the late 1820s.[31] Beaulieu concluded that, while not a treaty, the document symbolizes the community's integration into the British Empire.[32]

This view, however, does not warrant discounting the document's legitimacy as a treaty. The work of William C. Wicken and John G. Reid demonstrates that written agreements between the British and aboriginal peoples during this period often misrepresent the oral agreements at their foundation. As with all symbols, the meaning and interpretation of a document are liable to shift over time as the views of society and individual decision-makers change.[33] In the absence of abundant source material, Wicken's and Reid's work should caution scholars from narrowly reading the document. When placed in the context of the British alliance with the Seven Fires and its symbolic importance for the community, it seems clear that its intention was to embody the new peace and developing alliance between the British and the Huron-Wendat. Although stylistically different from other treaties, the ideas that it embodies seem to have been the same.

For men such as Sawantanan and Ondiaraété, however, much of this debate would have been moot. Although they carefully preserved the Murray Treaty, the Huron-Wendat rarely made reference to it during the eighteenth century. Legal titles to lands the community held around their village were of far greater importance. The debate over the mean-

ing of the Murray Treaty is principally a twentieth-century issue and does not seem to have been a point of contention until then.[34]

Despite the turmoil of 1759 and 1760 and the Murray Treaty, Sawantanan and Étienne Ondiaraété would have noticed few immediate changes in their everyday lives. Travellers to the village describe a scene similar to that reported by those who had visited during the French regime – marriage and birth patterns reinforced their observations, and the seasonality of the hunt continued as it had before. Although stable on the more day-to-day level, the new British regime slowly brought about broader changes in the community: the Jesuits were not replaced as missionaries died or left the colony, the community's political influence waned with its integration into British-aboriginal alliance structures, and the door was opened for some members of the community to access higher education in New England.

By the 1790s, the nature of the community had been transformed. It was no longer a Jesuit mission and it no longer played an important military role. In response to these changes, the community began a series of petitions for the legal title to the nearby seigneuries of Sillery and St-Gabriel. These petitions, which appealed to the king's promise in the Royal Proclamation to protect aboriginal land, sought a steady income from seigneurial rents and access to education to balance out declining yields from hunting, fishing, and agriculture. In a fashion similar to the changes that took place after they moved to the Quebec area in the 1650s, the Huron-Wendat were confronted with a new political environment that would require an innovative strategy for the community's long-term cultural and political survival.

Visitors after the Conquest made similar observations to those of La Potherie, Kalm, and Franquet. During his visit to the community during the American Revolution, the chaplain to the Duke of Brunswick's Dragoon Regiment, F.V. Melsheimer, emphasized the 'foreign' nature of Huron-Wendat culture, especially in its fashions and physical appearance, but in the end arrived at a conclusion not all that different from Kalm's descriptions: 'The Hurons deserve the name of Savages solely from their physiognomy, their dress and language; while, as regards their morals, they are surely just as good, if not better, than the best Christians.'[35] Few earlier or later observers, however, would have disagreed with John Lambert, who, in the early nineteenth century, echoed many of Kalm's and Franquet's descriptions, noting that 'the Indians, though so closely allied by intermarriages, have never entered fully into the European mode of living; ... All the domiciliated Indians in Lower

Canada employ themselves either in hunting or fishing; or are engaged by the merchants in the North-west fur trade; very few attend much to agriculture.'[36] Thus, in the aftermath of significant geopolitical change, the Huron-Wendat continued to embrace European culture selectively.

Despite Lambert's dismissal of Huron-Wendat agriculture, evidence suggests that a balance continued to be struck between agriculture, hunting, and fishing. George Heriot, who passed through the village in the early nineteenth century, was one of the few people who described the geographic extent of Huron-Wendat agriculture. He observed that the community had 240 *arpents* (about two hundred acres) sown with corn[37] – most likely within the sixteen hundred *arpents* that had been conceded by the Jesuits in the 1740s. In 1847 the village's priest observed that most Huron-Wendat agriculture took place on this land, rather than in the village.[38] Taken together on a per-family basis, this suggests that, if each family in the community participated in agriculture equally, each household would have used about seven and a half *arpents* of land at the turn of the nineteenth century.[39] As a point of contrast, in 1781 the two hundred and twenty families in St-Gabriel each cultivated an average of twenty-two *arpents* of land; about 10 per cent had seven *arpents* or less of arable land.[40] Although it is clear that, relative to many of their neighbours, the Huron-Wendat farmed less land, there seems to have been enough land for agriculture to have continued as part of some people's daily lives.

These apparent retrenchments in agricultural production, however, did not reflect only the relative importance of agriculture to the community's economy; they also betrayed the gender bias of eighteenth- and nineteenth-century observers. Unlike their *habitant* neighbours, for the Huron-Wendat agriculture continued, as it had in early Wendaké, to be women's work. With the exception of Kalm and to a lesser extent Heriot, most other travellers to the community used gendered language to dismiss agriculture as relatively inconsequential to the Huron-Wendat economy. In 1776 Melsheimer summed up the perspective of European visitors when he noted: 'In the summer they are idle, doing nothing, unless it may be to aid their wives and children in the cultivation of their fields and gardens – for to the squaws is delegated this business, as well as all the domestic economy of the household.'[41] These views were echoed by Lambert, who, although more descriptive about agricultural production, spent little time focusing on women's and children's work.[42] Agriculture may have diminished in importance relative to hunting and fishing, but the male-dominated nature of

the source material and the female-oriented nature of Huron-Wendat agriculture should caution us about devaluing this aspect of Jeune-Lorette's economy.

By the 1820s, however, it was clear that agriculture had ceased to be a viable and sustainable way of supporting the entire community. Although visitors to the community still commented on agricultural practices, community members made it clear that farming yielded too little produce to support the community. In his 1824 testimony before a committee of the Lower Canadian Assembly, Grand Chief Tsawan-honhi (Nicolas Vincent) made this apparent: 'Such of the Indians as have Lands, plant Indian Corn, Sow Potatoes, and a little Corn, but the number is very small. The others live on the produce of Hunting and Fishing, because they have no Lands.'[43] The shift away from agriculture towards hunting and fishing was neither wholesale nor dramatic; rather, the changing economic patterns in Jeune-Lorette reflected the community's access to land and the cultural influence of its neighbours. The relative importance of hunting, fishing, and agriculture may have changed, but the mixed economy still shared much in common with that of the community's ancestors from early Wendaké.

Culturally, however, a preliminary survey of post-Conquest marriage and baptismal records demonstrates that, in their day-to-day lives, the Huron-Wendat closely followed Roman Catholic traditions and shared many similarities with their *habitant* neighbours.[44] This is best seen in the Lenten and Advent abstentions from marriage. Both groups – and people in much of the St Lawrence valley – were most likely to marry in November and January; marriage was least likely in March and December (Lent and Advent). The seasonality of births reflects this pattern. One of the most popular times for childbirth was nine months after the peak in marriages. The other peak for childbirth reflects Louise Dechêne's observation that late spring was the high season for conception in turn-of-the-eighteenth-century New France.[45]

Part of what helped to continue the close relationship between the Huron-Wendat and the Roman Catholic Church was the continued presence of the Jesuits. Although the religious rights of Catholics and access to missionaries for aboriginal people were maintained in the Capitulation of Montreal and Treaty of Paris, the continuation of the Jesuit Order in the aftermath of the Conquest was far from certain.[46] The global political-religious winds were changing during the Seven Years' War. Hostility to the order's political influence had been rapidly building in European countries on both sides of the conflict. These tensions cul-

minated in the Jesuit expulsion from Portugal in 1759, from France in 1764, and from Spain in 1767. In 1773 Spanish influence pressured the new anti-Jesuit pope, Clement XIV, into suppressing the order outright. Globally, the Jesuits were to be disbanded and removed from positions of influence; their affairs fell into the control of local bishops.

Given the global rejection of the Jesuits, one would expect that the British – long haters of Catholicism and Jesuits – to have seized the international anti-Jesuit climate as an opportunity to cleanse the new colony of their religious influence. Indeed, much of the official correspondence crossing the Atlantic throughout the post-Conquest period called for an end to the order. Michel Lavoie's recent work on this period of Jeune-Lorette's history demonstrates, however, that the British policy of indirect rule, whereby the British retained many French regime institutions while overseeing their administration, coupled with the Jesuits' weak numbers (there were only sixteen priests and five brothers left by 1764[47]) created an environment in which the order's influence was tolerated but not encouraged.[48] Rather than banishing the few remaining priests, the policy enacted by Governor James Murray and championed by his successor, Guy Carleton, and bishop of Quebec, Jean-Olivier Briand, prevented new religious appointments in the colony while allowing those Jesuits already there to carry on with their work. In most of the Roman Catholic world, the Jesuits were disbanded, but in Quebec they were allowed a limited existence. This created a situation in which Jesuit influence slowly diminished with the death of the few remaining missionaries.[49] By the 1790s they only had a weak presence in Jeune-Lorette, and by 1801 they had completely disappeared from Lower Canada.

As the number of Jesuits decreased, discussion and debate increased about what to do with their land. Jeffery Amherst sought title to it as a personal reward for his service as commander-in-chief in North America, but residents of Quebec argued that the Jesuits had held their seigneuries only in trust for the good of the colony as a whole, and petitioned for the revenues from these lands to be used to support education.[50] The Huron-Wendat had a similar but more direct claim. Their community was not just a Jesuit mission; it was also located in a Jesuit-run seigneury. With the Jesuits gone, the administration of the seigneury was in question.

Many of the aboriginal people living in the St Lawrence valley had had a unique legal relationship with the French Crown. Unlike elsewhere in New France, where relationships were solidified through

gift-giving and reciprocity, or in New England, where relationships were framed by peace and friendship treaties and legal title 'purchased' by the British Crown, the mission communities along the St Lawrence were anchored in legal seigneurial title. The seigneuries of Sillery (Kamaskda)[51] and Sault St-Louis (Kahnawaké) were granted by the French Crown to their respective aboriginal communities; the sole caveat was that they were to be administered through guardianship by the Jesuits. This aboriginal seigneurial title was quickly recognized after the Conquest in Sault St-Louis. Montreal governor Thomas Gage ruled in the Mohawks' favour after they recommenced unsuccessful French regime petitions to prevent the Jesuits from ceding their land.[52] Although problems with settlers and the colonial administration continued to arise there, the community's claim to seigneurial title was not disputed by the British.[53] After the Conquest, seeking confirmation of their seigneurial title was a critical way for the Mohawk to ensure a continuous presence on land to which they had held title for decades.

The process was considerably more complex in Jeune-Lorette. Unlike in Sault St-Louis, the Huron-Wendat claim to seigneurial title was complicated by overlapping boundaries between the seigneuries of Sillery and St-Gabriel, both of which were Jesuit seigneuries, Sillery having been granted in 1650 to immigrant Algonquin, Abenaki, and Huron-Wendat communities, while St-Gabriel had been donated to its Jesuit guardians nearly two decades later. The core of the problem lies in the date of concession. The title to St-Gabriel was originally made to Robert Giffard in 1647 for an area east of Quebec near Beauport. The grant of Sillery was made west of the town three years later. Giffard's grant conflicted with a pre-existing seigneury and was moved north of Sillery, with the result that the northern two leagues of Sillery overlapped with the southern two leagues of St-Gabriel. Seigneurial grants were made in Europe with only cartographic knowledge of the landscape, but since few Europeans had settled in the region during this period, the overlapping seigneuries were not initially identified as a problem. In 1667 Giffard made the issue even less likely to arise by donating St-Gabriel to the Jesuits. As the de facto *seigneurs* of both seigneuries, the Jesuits were assured that there would be no conflict over the boundary's location.

By the turn of the century, however, the problem had become more complicated. Not only did the Jesuits control both seigneuries, but the Abenaki and Algonquin had moved closer to Trois-Rivières and the Huron-Wendat, after a series of migrations, had moved to Jeune-

Lorette, which was located in the overlapping space. According to eighteenth-century seigneurial geography, however, the village was well inside the boundaries of St-Gabriel, not Sillery. Two years after the Huron-Wendat moved into St-Gabriel, and without their knowledge, the Jesuits successfully argued that their aboriginal wards had moved away from Sillery and that the seigneury should be granted directly to them. Thus, according to French legal title, Sillery was no longer an aboriginal seigneury like Sault St-Louis.

In the 1790s, nearly a century later, when the scarcity of land and resources became a major issue for the Huron-Wendat, they discovered that – according to the paperwork left behind by the French – they were not the principal holders of the land. The British refused to accept responsibility for these errors or to intervene in the situation.[54] Unlike in Sault St-Louis, the Huron-Wendat were ultimately unsuccessful at convincing the British that they had seigneurial title to this land. The British policy of indirect rule, in maintaining the Jesuit presence, had prevented the Huron-Wendat from learning the convoluted history of St-Gabriel and Sillery until it was too late. Had they acted earlier, the Huron-Wendat might have been able to capitalize on the anti-Jesuit spirit that underlay Thomas Gage's decision regarding Sault St-Louis, but by the 1790s they required a different strategy to maintain and sustain their community.

The threat of lost local influence was compounded by the diminishing influence of the Huron-Wendat with the British administration. Unlike during the French regime, Jeune-Lorette was no longer an active part of the colony's defence. As Sawaya demonstrates in his work on the Seven Fires, the community was now part of a much more institutionalized and hierarchical world of 'Indian Affairs,' the focus of which was the British-Haudenosaunee Covenant Chain;[55] rather than being at the heart of an empire, the Huron-Wendat were increasingly on the margins. Instead of dealing directly with military officials and the governor at Quebec, they were encouraged to address Daniel Claus, the deputy superintendent of the Indian Department, with their problems and needs. During the French regime, Jeune-Lorette had participated in many critical events affecting northeastern North America, but by the close of the American Revolutionary War their military value had greatly diminished. In 1783, at the end of the war, John Johnson, the head of the Indian Department in Quebec, argued against a proposal to end the British practice of giving gifts to the community. Rather than highlighting Jeune-Lorette's value as a military supplier or ally, as the

French might have, Johnson argued that the community should continue to receive gifts because it was critical to maintaining the relationship of the British with the distant relatives of the Huron-Wendat in the west, the Wendat living at Detroit.[56] Although the community still maintained some military value, the influence it had wielded during the French regime was significantly reduced.

While incorporation into the Anglo-American world reduced Huron-Wendat influence in the northeast, it also created new opportunities. In the early 1770s Sawantanan left the St Lawrence valley for Eleazar Wheelock's Dartmouth College, eventually graduating in 1781 – a rare feat since, in the entire early American college system, only fifty aboriginal students attended a colonial college and by 1800 only five had graduated.[57] Not only did this make Sawantanan unique among most aboriginal people in the northeast, but his high level of education would have put him in a unique position among the rural *habitants* as well.

Sawantanan's experience at Dartmouth was similar to that of other aboriginal students at colonial American colleges. In the late seventeenth century, for example, Wowaus, a Nipmuc who had received a basic education and lived and worked in Cambridge, Massachusetts, left his job at a local print shop to fight the British alongside Metacomet and his Nipmuc relatives. When the war was over, Wowaus returned to work in Cambridge, printing religious texts for aboriginal communities. Despite his close ties and deep connections with British society, neither education, nor trade, nor place of residence replaced Wowaus's allegiance to his community. In a much later period, Samson Occom, the well-known Mohegan preacher and student of Eleazar Wheelock, became a tireless crusader for the education of aboriginal people. Occom travelled as far as England raising funds for Wheelock's Indian Charity School – the forerunner of Dartmouth College. Over time Occom and Wheelock drifted apart, but Occom continued to focus on the well-being of northeastern aboriginal communities. For him, education was a tool that aboriginal communities could use to sustain themselves – and their culture – in the face of increasing European domination. Wheelock, on the other hand, had a much more assimilationist and evangelical goal, and, by the end of the eighteenth century, given the few successes among his aboriginal pupils, his focus shifted to the education of colonial children.

Men like Wowaus and Occom were pre-cursors of Sawantanan, and sought to use their European education to serve as cultural brokers and

work against some of the sharper edges of early American colonialism.[58] Indeed, it was the idea of creating cultural brokers in aboriginal communities that most appealed to Wheelock when he began recruiting aboriginal people to attend his school. Although his ultimate goal was assimilation, his more immediate aim was to send aboriginal students back into their communities as evangelical teachers, to convert their friends and relatives to Protestant Christianity and to persuade them to become allies – if not subjects – of the British Crown.[59] This is exactly what Sawantanan set out to do after his graduation. The annual meeting of Dartmouth's board of trustees for that year noted that Sawantanan and a colleague, Hugh Holmes, were 'desirous to return to their friends in Canada and then enter on some literary employment honorable to themselves as Graduates at this University and useful to mankind.'[60] Initially, in the 1780s, Sawantanan assisted a school master in the Montreal area.[61] In 1791, after having also taught in the newly established Mohawk community on the Bay of Quinte, he returned to Jeune-Lorette to start a school.[62] Coupled with the end of the Jesuit presence and the noticeable decline in their influence with the British, his return marked the beginning of a new strategy for cultural survival that built on the community's past experiences.

Like earlier transitions in this community, the changes that took place with Sawantanan's return reshaped, rather than replaced, the community's focus on education. The community's literacy rate in the years after he returned demonstrates that Sawantanan was building on a local culture of European-based education. In the early 1790s, Huron-Wendat men signed a petition to the bishop of Quebec regarding the shared use of their church with their *habitant* neighbours.[63] Following Allan Greer and Michel Verrette, whose separate studies define literacy in New France as the ability of individuals to sign petitions and parish registers, the signatures on this document suggest that adult Huron-Wendat men had a literacy rate of around twenty-two per cent.[64] To a certain degree this probably reflects the influence of Jesuit scholasticism on the community.[65] Although there is no evidence from this community that sheds light on practices of education during the eighteenth century, it is likely that Sawantanan filled and further enriched a pre-existing culture that engaged aspects of European education. This was a culture of education that was specific to Jeune-Lorette, however. Although the community's literacy rate was in keeping with the average in the St Lawrence valley, it was likely higher than its *habitant* neighbours in St-Gabriel. For example, only three of 128 neighbours

managed to sign their names on a 1795 petition to create a new parish separate from the mission church,[66] and one of these three was English and another was the notary; the rest marked with an 'x,' suggesting that the *habitant* literacy rate in the area was only about two per cent.

The fact that there was a schoolhouse in Jeune-Lorette at all at the turn of the nineteenth century also made this community uncommon – a formal education system did not develop in Lower Canada until well into the nineteenth century. According to Verrette, the development of a school system was a slow process that involved more than the writing of reports and the passing of legislation to change people's perceptions of education.[67] Neither the 1789 report for promoting the means of education, which called for a bilingual university supported by free elementary and secondary education, nor the 1801 Education Act, which hinged on local acceptance of a unified system, had a significant impact on access to schools in the colony. The 1824 Fabriques Act and the 1829 and 1832 Syndics Acts provided more support for an education system and encouraged the slow growth of local schools, but, according to Anthony Di Mascio, the 'watershed' moment was the 1841 Common School Act, which lay the foundation for a divided Protestant-Catholic school system.[68] While a formal school began in Jeune-Lorette in the early 1790s, it was not until the late 1820s that local schools became the norm in neighbouring French communities.

The community also felt the pressures that the increasing European population was placing on its church, as the *habitant* and Huron-Wendat petitions make clear.[69] In the absence of the Jesuits, conflict in the shared mission church arose over who would determine church policy and how and when the church was to be used. By 1795, the bishop had agreed to the *habitants'* request for a new parish and, after a century of shared worship, the *habitant* population obtained a church of its own.

The increased French presence also placed pressure on the Huron-Wendat hunting territory. Most directly, the southern edge of that territory was being ceded for farms; indirectly, French farmers and other Europeans also began to compete for the land's animal and other natural resources. Migration into the northern areas of the newly formed United States further complicated the situation by constricting Abenaki hunting territory, pushing them further north onto Huron-Wendat hunting grounds.[70] As the nineteenth century dawned, resources formerly widely available to the community were diminishing significantly.

By this time Ondiaraété and Sawantanan had joined the village's council of chiefs. In 1791 Ondiaraété and three other chiefs sent a peti-

tion to Lord Dorchester (Guy Carleton), governor of Lower Canada, asking for title to their lands and education for their children. Although signed by Ondiaraété and the other chiefs, there is a tradition among many people familiar with this community, and most popularized a century ago by sociologist Léon Gérin, that Sawantanan was its principal author.[71] Although there is no definitive proof, the date of his arrival in the community and his prior cultural experiences at Dartmouth College and among the Mohawk in the Bay of Quinte lend support to this community tradition.

The petition marked the beginning of more than forty years of Huron-Wendat engagement with the governor and assembly of Lower Canada, British parliamentarians, and the Crown for title to the seigneury of Sillery, interactions that were fundamentally different from earlier ones with European powers. The contrast is best observed by comparing the claims after 1791 with a 1773 complaint about settler encroachment near the Huron-Wendat village.[72] The 1773 claim, addressed to Deputy Superintendent Daniel Claus of the Indian Department, focused on specific grievances related to settler encroachment on village land. Petitions after 1791, however, rather than reacting to such narrow issues, were directed to the colony's governor and referred to overall title of the land, often invoking the 1763 Royal Proclamation. In them, the Huron-Wendat sought the seigneurial income from Sillery and St-Gabriel – in effect, claiming rights to land granted during the French regime to hundreds of French farmers, not just objecting to recent encroachments on village lands.[73]

The claims after 1791 also differed in form. Unlike earlier claims, which were orally presented and followed aboriginal protocols, petitions increasingly used conventions that reflected the community's access to European-based education – they were written, signed, and, by the early nineteenth century, accompanied by supporting written documentation.[74] The difference between the two approaches symbolized the changes that had taken place since the Conquest. In ways similar to earlier adaptations to aspects of French agriculture, architecture, and language, the Huron-Wendat selectively used European diplomatic conventions to address the community's changing geopolitical position in the St Lawrence valley.

The world in 1791 was considerably different from the one in which Sawantanan and Ondiaraété had grown up. As life along the St Lawrence changed, the Huron-Wendat adapted and learned from their new colonial relationship with the British. But change came slowly – it took nearly thirty years for the full effect of the Conquest to be felt in Jeune-

Lorette, and it continued a process that had begun with the arrival of the Jesuit missionaries in early Wendaké. From the mid-1620s onwards, there was seldom a decade that was not marked by adaptations to a new European-dominated environment. By the time the British appeared on the Plains of Abraham, the Huron-Wendat were accustomed to adapting to new contexts. Although the events of 1759 could have had a dramatic effect – as when the community migrated east to Quebec – the British policy of indirect rule slowed the process of change and allowed the community to develop new tools, such as Sawantanan's Dartmouth College education, to help ensure its survival.

The Conquest of 1759 was not a conquest of the Huron-Wendat. Although the Battle of the Plains of Abraham clearly left its mark on individuals such as Etienne Ondiaraété, it was, at its core, a European event. The fall of New France might have changed the community's trajectory, but it did not change the processes at play. As in so many aboriginal communities in the northeast, dramatic change had occurred in Jeune-Lorette decades before Wolfe and Saunders floated up the St Lawrence River; European diseases and missionary-caused cultural erosion had rendered the community vulnerable to Haudenosaunee attack and the eventual destruction of the Huron-Wendat homeland. If there was a 'conquest' for the Huron-Wendat, this was it. From 1650 onwards the community faced the political, cultural, and economic challenges of living in a different landscape from early Wendaké and alongside *habitant* farmers. After 1759 the tenor of these challenges changed, but their influence on the community did not. In the *longue durée* of Huron-Wendat history, the Conquest brought about subtle changes that built on the community's experiences during the French regime. More wholesale structural change would follow the Conquest nearly a half-century later, when changes in the management of the Indian Department would fundamentally alter their relationship with the colonial – and later Canadian – state. Although the Conquest placed the community onto a trajectory where these changes became increasingly likely, the event itself was relatively minor.

This was not the case for other aboriginal communities in the northeast. For some, France's defeat in North America brought about a radical redefinition of their relationship to European imperial power. The 1710 British conquest of Acadia, for example, redefined the Mi'kmaw relationship to European power. For the first time, after the Treaty of Utrecht, they discovered that their absence from European negotiations radically altered the geopolitical landscape of their land. The Great Lakes communities had a similar experience in 1763. In both cases, ab-

original peoples could not believe that their land had been ceded by France to Britain without their consultation and approval; in both cases they fought and resisted British claims to their lands. Where, in Jeune-Lorette, the Conquest brought changes similar to those already taking place during the early eighteenth century, here the disruption was swift and violent.

The fall of New France did not affect all aboriginal peoples in the northeast in the same way. Even among the Jesuit mission communities in the St Lawrence valley, there were fundamental differences in the experience of regime change. For example, Odanak was the only aboriginal village to be attacked by the British, while Kahnawaké was deeply involved in trying to achieve full title to the seigneury of Sault St-Louis. For both communities, however, the nearly twenty years between the Conquest and the outbreak of the American Revolution was a period in which Europeans no longer considered their territories an imperial borderland. Although these aboriginal communities were confronted with an influx of British settlers, this change brought about a pause in tensions between the French and British and later between the Americans and British in the region.

The different experiences of aboriginal communities after the fall of New France provide important insights into the dynamics of the eighteenth-century northeast. As a primarily European conflict that took place in what was still primarily an aboriginal landscape, the Seven Years' War deeply affected nearly every aboriginal community in the region. Whether change took place rapidly or slowly, no community was able to avoid the long-term effect of this political change. In the century that followed, the diversity of relationships between the British and aboriginal communities became increasingly narrow as the purview of the Indian Department grew in geographic and bureaucratic scope and European immigrants flooded onto aboriginal lands. By the 1830s many aboriginal communities in the northeast were in a similar position: their lands and economic resources reduced and their options for recourse few. In this sense, perhaps, the Conquest laid the framework for the creation of Canada.

NOTES

1 Bacqueville de la Potherie, 'Letter IX: Description of the River St. Lawrence up to Quebec, the Capital of New France. How the French discovered this

Continent, and the Progress that has been made in its Evangelization,' in *Documents relating to the early history of Hudson Bay*, ed. Joseph Burr Tyrrell (Toronto: Champlain Society, 1931), 289–91.

2 Jocelyn Tehatarongnantase Paul, 'Le territoire de chasse des Hurons de Lorette,' *Recherches Amérindiennes au Québec* 30, no. 3 (2000): 6.

3 Léon Gérin, 'Le Huron de Lorette,' in *Les Hurons de Lorette*, ed. Denis Vaugeois (Sillery, QC: Septentrion, 1996), 22.

4 Jean Tanguay, 'Les règles d'alliance et l'occupation huronne du territoire,' *Recherches Amérindiennes au Québec* 30, no. 3 (2000): 23.

5 Paul, 'Territoire de chasse,' 6; and Tanguay, 'Règles d'alliance,' 23.

6 Paul, 'Territoire de chasse,' 6; and Bruce Trigger, *Children of Aataentsic: A History of the Huron People to 1660* (Montreal; Kingston, ON: McGill-Queen's University Press, 1976), 41–3.

7 Peter Kalm, *Travels into North America*, trans. John Reinhold Forester, 2nd ed., vol. 2 (London: T. Lowdens, 1772), 308–9.

8 Ibid., 307–9; Franquet, *Voyages et mémoires sur le Canada* (Quebec: A. Côté, 1889), 102–8.

9 *Eighth Report of the Committee of the House of Assembly, on that part of the speech of His Excellency the Governor in Chief which relates to the settlement of the crown lands with the minutes of evidence taken before the committee* (Quebec: Neilson & Cowan, 1824), particularly 11, 22. See also *Three Chiefs of the Huron Indians, Residing at La Jeune Lorette, Near Quebec, in Their National Costume*, 1825, Library and Archives Canada, W.H. Coverdale collection of Canadiana, R3908-0-0-E.

10 William Pote, *The Journal of Captain William Pote Jr.* (New York: Dodd, Mead, 1896); Ian K. Steele, *Betrayals: Fort William Henry & the 'Massacre'* (Oxford: Toronto, 1990), 83.

11 Louise Dechêne has argued that aboriginal people played a much more important role in military actions under the French regime than they have been given credit for in either primary or secondary accounts. In her estimation, French settlers had neither the skill nor the endurance for these actions, and there were too few regular troops to carry them out. See Louise Dechêne, *Le Peuple, l'État et la Guerre au Canada sous le Régime français* (Montreal: Boréal, 2008), 27–8, 194–6.

12 'État des munitions qui ont été fournies par les particuliers ci-après nommés pour munir les magasins de Québec à l'occasion de la guerre depuis le 20 octobre 1746 jusqu'au 10 octobre 1747,' 15 October 1747, Centre des archives d'outre mer (hereafter cited as CAOM), General Correspondance, Canada, C11A/117, ff. 95–116. The amount per family is based on Franquet's estimate that there were twenty-five families in the village; see

Franquet, *Voyages et mémoires*, 107. Greg Kennedy, whose work focuses on farming societies in Acadia and the Loudonais, has compiled annual budgets for these regions that provide a good point of comparison. In the 1760s, revenue for an average day worker in the Loudonais was 349.8 *livres* and for a ploughman 1,872.47 *livres*. In Acadia, the income in 1707 of a small farmer was 776.33 *livres* and for a large farmer 1,647.07 *livres*. It is important to remember that this is their total income, rather than just a portion. The Huron-Wendat did not pay for their land and therefore had fewer expenses than their French contemporaries. See Gregory Kennedy, 'French Peasants in Two Worlds: A Comparative Study of Rural Experience in Seventeenth and Eighteenth Century Acadia and the Loudunais' (PhD thesis, York University, 2008), appendix A.

13 'Dépouillement fait les 8, 9 et 10 mars 1756 des sommes dues tant pour les arrérages de cens et rentes que des droits de lots et ventes, 1755 compris,' 1756, Bibliothèque et archives nationales du Québec à Québec (hereafter cited as BANQ-QUE), E21, S64, SS5, SSS6, D1419.

14 'Registre avec index contenant l'État général des biens des Jésuites dans la province de Québec, comprennant l'aveu et dénombrement de 1781,' BANQ-QUE, E21, S64, SS5, SSS1, D284; 'Recapitulation of the foregoing Fiefs and Seigniories heretofore held and Claimed by a certain Religious Community known by the Name of the Order of the Jesuits,' 18 May 1790, United Kingdom National Archives (hereafter cited as UKNA), CO 42/74, f. 75.

15 D. Peter MacLeod, *Northern Armageddon: The Battle of the Plains of Abraham* (Vancouver: Douglas & McIntyre, 2008), 73.

16 Ibid., 164.

17 Ibid., 165–7.

18 Louise Dechêne, *Peuple, l'État et la Guerre*, 386.

19 'Indian Lorette,' *Star and Commercial Advertiser/L'Étoile et Journal du Commerce*, 13 February 1828.

20 Ibid.; and 27 February 1828.

21 Amherst to Pitt, 22 October 1759, UKNA, CO 5/ 56.2, ff. 1–26.

22 'Indian Lorette,' *Star and Commercial Advertiser/L'Étoile et Journal du Commerce*, 27 February 1828.

23 D. Peter MacLeod, *The Canadian Iroquois in the Seven Years' War* (Toronto: Dundurn Press, 1996), 114.

24 Steele, *Betrayals*, 131–2; MacLeod, *Canadian Iroquois*, chap. 2.

25 MacLeod, *Canadian Iroquois*, 120.

26 Jeffery Amherst to William Johnson, 30 September 1763, UKNA, CO 5/63, ff. 383–383v.

27 Jean-Pierre Sawaya, *Alliances et dépendance: comment la couronne britannique a obtenu la collaboration des Indiens de la vallée du Saint-Laurent entre 1760–1774* (Sillery, QC: Septentrion, 2002), chap. 1; Cornelius Jaenen, 'Rapport historique sur la nation huronne-wendat,' in *Les Hurons de Lorette*, ed. Denis Vaugeois (Sillery, QC: Septentrion, 1996), 208; Denys Delâge and Jean-Pierre Sawaya, *Les Traités des Sept-Feux avec les Britanniques* (Sillery, QC: Septentrion, 2001), chap. 3.

28 James Murray to Hurons of Lorette, 5 September 1760, Séminaire du Québec, Faribault, no. 256.

29 For more information, see Denis Vaugeois, *Les Fins des alliances* (Sillery, QC: Septentrion, 1995); idem, *Les Hurons de Lorette* (Sillery, QC: Septentrion, 1996); and Delâge and Sawaya, *Traités des Sept-Feux avec les Britanniques*, chap. 4.

30 Alain Beaulieu, 'Les Hurons et la Conquête: un nouvel éclairage sur le "traité Murray,"' *Recherches Amérindiennes au Québec* 30, no. 3 (2000): 59–61.

31 'Indian Lorette,' *Star and Commercial Advertiser/L'Étoile et Journal du Commerce*, 27 February 1828; *Eighth Report of the Committee of the House of Assembly*, 24.

32 Beaulieu, 'Hurons et la Conquête,' 61.

33 William C. Wicken, *Mi'kmaq Treaties on Trial: History, Land, and Donald Marshall Junior* (Toronto: University of Toronto Press, 2002); John G. Reid, *Essays on Northeastern North America: Seventeenth and Eighteenth Centuries* (Toronto: University of Toronto Press, 2008), chaps. 7 and 9.

34 Delâge and Sawaya, *Traités des Sept-Feux avec les Britanniques*, 56.

35 F.V. Melsheimer, *Journal of the Voyage of the Brunswick Auxiliaries from Wolfenbuttel to Quebec* (Quebec: 'Morning Chronicle' Steam Publishing Establishment, 1891), 167.

36 John Lambert, *Travels through Canada, and the United States of North America, in the years 1806, 1807, & 1808 to which are added, biographical notices and anecdotes of some of the leading characters in the United States*, 2nd ed. (London: C. Cradock and W. Joy, 1813), 356.

37 George Heriot, *Travels through the Canadas, Containing a description of the picturesque scenery on some of the rivers and lakes; with an account of the Productions, Commerce and Inhabitants of those provinces* (Philadelphia: M. Carey, 1813), 93.

38 *Appendice du Quartrième volume des journaux de l'Assemblée Législative de la Province du Canada du 28 Novembre 1844, au 29 mars 1845, ces deux jours compris et dans la Huitième année du Règne de Notre Souveraine Dame La Reine Victoria: Première session du second Parlement Provincial du Canada* (Montreal: L. Perrault, 1845), EEE-23; *Appendix to the sixth volume of the Journals of the*

Legislative Assembly of the Province of Canada, From the 2nd Day of June to the 28th Day of July 1847 (Montreal: R. Campbell, 1847), T-82, T-83.

39 This calculation is derived by dividing Heriot's estimation of the land under cultivation by the thirty-two families observed by Joseph Bouchette in 1821; see 'A Topographical Dictionary of the Province of Lower Canada,' in Joseph Bouchette, *The British Dominions in North America; or a topographical and statistical description of the provinces of Lower and Upper Canada*, vol. 2 (London: Longman, Rees, Orme, Brown, and Green, 1831).

40 'Registre avec index contenant l'État général des biens des Jésuites dans la province de Québec, comprennant l'aveu et dénombrement de 1781,' BANQ-QUE, E21, S64, SS5, SSS1, D284.

41 Melsheimer, *Journal of the Voyage*, 166.

42 Lambert, *Travels through Canada*, 356.

43 *Eighth Report of the Committee of the House of Assembly*, 19.

44 The evidence used in this section of the chapter reflects my on-going research on Jeune-Lorette using the post-Conquest parish registers for Charlesbourg, Ste-Foy, and Jeune-Lorette. Unfortunately, the pre-Conquest parish records for Jeune-Lorette no longer exist. I am very grateful to Bertrand Desjardins at the Research Program for Historical Demography, Université de Montréal, for access to their extensive database.

45 Louise Dechêne, *Habitants et marchands de Montréal au XVIIe siècle* (Montreal: Boréal, 1974), 114.

46 'Articles of the Capitulation of Montreal,' in *Documents relating to the Constitutional History of Canada, 1759–1791*, ed. Adam Shortt and Arthur G. Doughty, 2nd ed. (Ottawa: J. deL. Taché, 1918), 7–24; 'Treaty of Paris 1763,' in ibid., 97–112.

47 Roy C. Dalton, *The Jesuits' Estates Question 1760–1888: A Study of the Background for Agitation of 1889* (Toronto: University of Toronto Press, 1968), 6.

48 Michel Lavoie, *'C'est ma seigneurie que je réclame': le lutte des Hurons de Lorette pour la seigneurie de Sillery, 1658–1890* (Montreal : Boréal, 2009).

49 Dalton, *Jesuits' Estates Question*, 7.

50 Ibid., 34.

51 *Eighth Report of the Committee of the House of Assembly*, i.

52 *Indian Treaties and Surrenders from 1680 to 1890*, vol. 2 (Ottawa: B. Chamberlin, 1891), 298–304.

53 'Registry of seigneurial titles from the French regime,' n.d., UKNA, CO 42/28, ff. 258–96; 'List and State of Seigniories in the hands of New Subjects not signers to the Petition to His Majesty of October 1788,' 5 December 1788, UKNA, CO 42/63, ff. 28–9v; 'List of seigniors old and new,' UKNA, CO 42/72, ff. 159–64.

54 *Eighth Report of the Committee of the House of Assembly,* 43–4.

55 Sawaya, *Alliances et dépendance,* 40.

56 John Johnson to R. Matthews, 3 April 1783, British Library, Haldimand Papers, 21775, f. 88. When the Huron Confederacy dispersed in 1650, one group – the Huron-Wendat at Jeune-Lorette – went east and another group – those living at Detroit – went west. Loose connections were maintained between these communities throughout the seventeenth and eighteenth centuries.

57 Cary Michael Carney, *Native American Higher Education in the United States* (New Brunswick, NJ: Transaction Publishers, 1999), 38.

58 Margaret Connell Szasz, *Indian Education in the American Colonies 1607– 1783* (Lincoln: University of Nebraska Press, 1988; 2007), 115–20, 197–200, 263.

59 James Axtell, *The Invasion Within: The Conquest of Cultures in Colonial North America* (Toronto: Oxford University Press, 1985), 208.

60 'At an annual meeting of the honorable board of trustees of Dartmouth College at said College,' 17 September 1782, Archives du Conseil de la Nation Huron-Wendat (hereafter cited as ACNHW), Collection François Vincent, FV/34/3/h4.

61 Louis Vincent to President Wheelock, 20 February 1784, ACNHW, Collection François Vincent, FV/37/3/K.

62 For more information on Sawantanan's time along the Bay of Quinte, see Église d'Angleterre, BANQ-QUE, P1000, s3, d2735, f. 30; State of religion in Canada, n.d., CO 42/72, f. 234; John Wheelock to John Forrest, 15 June 1785, Dartmouth College Archives, doc. 785365; 'From Quebec to Niagara in 1794: Diary of Bishop Jacob Mountain,' in *Rapport de l'archiviste de la province de Québec* (Quebec: Roch Lefebvre, Imprimeur de Sa Majesté la Reine, 1959–60), 164–5; John Wheelock to Jedidiah Morse, 25 February 1811, Dartmouth College Archives, doc. 811175.1. Reference is also made to Sawantanan's teaching at the Bay of Quinte and helping translate the Gospel of Matthew in C.M. Johnston, 'John Deserontyon (Odeserundiye),' in *Dictionary of Canadian Biography,* www.biographi.ca.

63 'Précis des conventions entre les Hurons du village de Lorette et une partie des habitants de Charlesbourg,' 11 November 1793, Archives de l'Archidiocèse de Québec (hereafter cited as AAQ), 61, Loretteville, CD I-177A–E.

64 Allan Greer, 'The Pattern of Literacy in Quebec, 1745–1899,' *Histoire Sociale/ Social History* 11, no. 2 (1978): 295–335; Michel Verrette, *L'alphabétisation au Québec, 1660–1900* (Sillery, QC: Septentrion, 2002).

65 The Jesuits created a Huron-Wendat orthography in the late seventeenth

century that continued to be used well into the nineteenth century, long after the Jesuits had ceased to have any influence in the community.

66 'Requête des habitants de la Jeune Lorette,' 22 April 1795, AAQ, 61, Loret-teville, CD I-5A–E.

67 Verrette, *L'alphabétisation au Québec*, 107.

68 Anthony Di Mascio, 'Forever Divided? Assessing the "National" Question and the Governance in Education through a Re-examination of Quebec's 1789 Report on Education,' *McGill Journal of Education* 42, no. 3 (2007): 470.

69 'Précis des conventions entre les Hurons du village de Lorette et une partie des habitants de Charlesbourg,' 11 November 1793, AAQ, 61, Loretteville, CD I-177A–E; 'Requête des habitants de la Jeune Lorette,' 22 April 1795, AAQ, 61, Loretteville, CD I-5A–E.

70 Colin G. Calloway, *The Western Abenakis of Vermont, 1600–1800: War, Migration, and the Survival of an Indian People* (Norman: University of Oklahoma Press, 1990), 187, 233. For the impact this had on the Huron-Wendat, see also *Eighth Report of the Committee of the House of Assembly*, 20.

71 'Timeline of the Huron community,' n.d., ACNHW, Collection François Vincent, FV/104/6/b6; see also Denis Vaugeois, *The Last French and Indian War: An Inquiry into a Safe-conduct Issued in 1760 that Acquired the Value of a Treaty in 1990* (Montreal; Kingston, ON: McGill-Queen's University Press, 2002), 74.

72 Milton W. Hamilton, ed., *The Papers of Sir William Johnson*, vol. 13 (Albany: University of the State of New York, 1962), 623–6.

73 A good summary of these claims can be found in the *Eighth Report of the Committee of the House of Assembly* and the *Continuation of the Appendix to the XLIInd Volume of the Journals of the House of Assembly of the Province of Lower Canada, session 1832–3*, appendix OO.

74 *Eighth Report of the Committee of the House of Assembly*, 12.

7

The Consequences of the Conquest: Quebec and British Politics, 1760–1774

STEPHEN CONWAY

To British contemporaries, 1759 was the 'year of victories.' Successes in Germany, India, the Caribbean, and North America, and on the seas off Portugal and western France, were celebrated widely and enthusiastically.[1] This, the loyal address of the borough of New Windsor proudly proclaimed that December, was now 'the Brilliant Period of the British Annals.'[2] That Quebec was 'subjected to Brittish [sic] dominion,' according to Liverpool's corporation, was the cause of particular pleasure.[3] In fact the war in North America was not yet over; the continued resistance of the French, and their defeat of a British army on the Plains of Abraham in the spring of 1760, served as a reminder that New France had not been fully conquered.[4] But despite the alarms caused by the French counterattack, it was generally assumed that the numerical superiority of the British and colonial troops, and the Royal Navy's cutting off the beleaguered and depleted French army from Europe, meant that it was only a matter of time before the remaining French military forces in Canada were obliged to acknowledge defeat.[5] Montreal at last surrendered in September 1760 and with it the whole of the French colony. Celebrations in Britain were somewhat more muted than when news arrived of the fall of Quebec, as British victory by this stage seemed inevitable; but celebrations there were nonetheless.[6]

If, for the British public, the capture of New France was a great triumph that helped to enhance national standing, for British ministers the consequences of conquest were less certain. Three sequential questions required an answer. The first was whether to retain Canada or return it in the negotiations leading up to a comprehensive peace settlement. Once the British government decided to annex the former French colony, the next question was what to do with the francophone popu-

lation, which modern scholarship reckons to have been about sixty-seven thousand, but contemporaries estimated to be anything between sixty and one hundred and fifty thousand strong.[7] Would they be encouraged to stay or compelled to leave? Expulsion might seem a drastic and unlikely policy, but it was far from unprecedented. Finally, if the *Canadiens* were to remain, how were they to be governed? They were almost all Catholics, and this made the immediate introduction of the kind of system of government that operated in the older British colonies – based on representative institutions, English law, and Protestant churches – highly problematic. Catholics were assumed by most British and Irish Protestants to be unreliable subjects, who owed allegiance to the pope and would persecute Protestants if given the chance to exercise any political authority over them.[8] In Britain and Ireland, Catholics were accordingly subject to a range of penal laws, restricting their land-ownership, denying them access to political and military office, and even making the free exercise of their religion hazardous.[9]

The objective of this chapter is to explore the issues raised by these three questions confronting British ministers from 1760, and to attempt to explain why they reached the decisions they did, giving the greatest attention to the final question: the form of government to be employed in the new British province. This issue is best considered in relation to the previous experience of the British state in exercising authority over a largely Catholic population. To devote attention to such matters no doubt will appear to some as quirkily old-fashioned. Modern historiography is more interested in popular reactions than in ministerial decision-making. Imperial history also tends now to focus more on the experience of empire for the peoples subject to British or other European control than on what was happening in London, or Paris, or Madrid. A decentred approach – both domestically and imperially – undoubtedly has much to recommend it, and has acted as a welcome corrective to an excessive concentration in older historical studies on the ideas and actions of the metropolitan political elite. Policy-making did not take place in a vacuum, but was a reflection of, or at least was influenced by, a wide range of domestic and imperial interests and perspectives. There was a world of difference, too, between the policies of ministers and the practice on the ground in distant territorial dependencies. Even so, we cannot understand developments in Canada after the Seven Years' War unless we are aware of the thinking of policy-makers in the imperial centre as well as those who sought to implement British policy in Quebec.

It was by no means a foregone conclusion that Canada would be kept in 1763, and there were powerful arguments for giving it back.[10] As the peace negotiations began, it became clear that there would be no speedy settlement unless the French were allowed to regain at least some of their lost possessions. In the last conflict – the War of the Austrian Succession of 1740–8 – British overseas gains had to be traded in to secure French withdrawal from the Low Countries, a strategically vital area from where an invasion of Britain could be launched with the greatest chance of success. As the Seven Years' War reached its closing stages, British conquests in the wider world were again used as bargaining counters to check French power in Europe. In 1761 and 1762 the requirement was to induce the French government to evacuate its troops from western Germany, where the war had reached the point of stalemate, and no amount of additional manpower or money seemed able to tip the scales in favour of the allies.[11] But if something had to be given back, if only to persuade the French to leave western Germany, what should it be: Canada or the French islands in the Caribbean?

The economic case for keeping the Caribbean conquests seemed strong: the French islands produced sugar more cheaply than did the British, and adding one or more of them to the British Crown's possessions would enable sugar from the new acquisitions to penetrate the continental European markets that up until then had been dominated by the French. On the other hand, sections of the powerful West India lobby feared that additional sugar islands would mean that more sugar entered the protected British market, lowering prices for existing planters, and so depressing their profits. As the earl of Breadalbane noted sourly shortly after the capture of Guadeloupe, the British West Indians would press for its return at the peace, 'for certainly such an addition of Sugar from our own Colonies must lower the value of a Jamaica Estate considerably.'[12] But influential though the West Indian interests undoubtedly were – a high level of absenteeism meant that many plantation owners resided in Britain and were able to ensure their voices were heard at Westminster and Whitehall[13] – the final decision seems to have rested more on the virtues of Canada than on the pros and cons of retaining West Indian conquests.

This is not to say that Canada was assumed to be economically valuable. While there was some speculation in Britain about the potential for sales to the new colony,[14] British ministers were under no illusions about Quebec's intrinsic economic importance. They had taken their lead from the French government, which clearly regarded Canada more

as a millstone than an asset, and which was certainly not keen to see it returned.[15] In the final analysis, British ministers chose Canada over Guadeloupe, or any of the other French islands returned in 1763, for the simple reason that its retention increased the security of the older British colonies to the south. It was to protect these old colonies that the British government had fought the Seven Years' War in the first place, and so we should not be surprised that the desirability of the permanent removal of the French threat was a major consideration in British thinking at the end of the conflict. There were, to be sure, those who suggested it would be a mistake to keep Canada, on the grounds that, without the French looming in the north, the ties between Britain and the old colonies inevitably would loosen as the colonies no longer felt the need for British protection. The duke of Bedford made very much this point to his cabinet colleagues (even though in the previous war he had been an advocate of removing the French threat permanently),[16] and historians, from Sir Lewis Namier and Lawrence Henry Gipson to Linda Colley, have developed it into a background explanation for the American Revolution.[17] In the early 1760s, however, the majority of ministers appear to have been less concerned by the prospect of American independence than by the possibility that a continuing French military presence in Canada would mean that the British colonies remained vulnerable to attack.[18]

Once it was decided to annex the French colony, the second question came into play: put simply, what was to be done with its francophone and Catholic *Canadien* inhabitants? One possible solution – hard-hearted but not inconceivable – would have been expulsion. Social engineering of such a radical kind might seem an extreme and unlikely approach, but it was certainly not without precedent. Forcible expulsion had been the fate of the Acadians of Nova Scotia as recently as 1755.[19] Ten years earlier, during the Jacobite rebellion in Scotland, British ministers had toyed with the idea of deporting the disaffected Highland clans to the West Indies and colonizing the vacated territory with Protestants brought in from France and Switzerland.[20] In the end, convicted Highland rebels were transported to the West Indies and the North American colonies as indentured servants, but the numbers involved were much smaller than ministers appeared to be envisaging while the rebellion was at its height.[21] In 1760 there were no transportations. Indeed, there is no evidence that such an approach was even considered by British ministers. On the contrary, the following year, the earl of Egremont, the secretary of state for the southern department, and so

the British politician responsible for the colonies at that time, explained to General Amherst, the British commander-in-chief in North America, the necessity for 'humanely & kindly' treating the *Canadiens*, in order to avoid their departing for territories still under the control of the French Crown. Egremont even expressed the hope that British troops would avoid offending local religious sensitivities.[22] The French population, in short, was encouraged to stay, rather than obliged to leave.

With large numbers of *Canadiens* opting to stay in their homeland, the final and most tricky question had to be answered: how were they to be governed? The thorny problem of ruling an alien people, unaccustomed to English law, representative institutions, and Protestantism has, of course, been studied by many historians, and may seem to be a settled subject. It is now twenty years since the publication of Philip Lawson's authoritative book on the twists and turns of British policy development between the Conquest in 1760 and the passage of the Quebec Act in 1774.[23] The work of Lawson, and of Peter Marshall, who wrote two insightful essays on the same process,[24] is so thorough and thoughtful that it might reasonably be imagined that there is nothing left to say. Lawson, in particular, covers exhaustively the minutiae of policy formulation, and both he and Marshall base their studies on extensive archival research. Their assessments are judicious and in nearly all aspects difficult to fault.

There is at least one area, however, where one might question their arguments. Both Lawson and Marshall suggest that Canada posed unique problems for British politicians, problems that they had no experience in trying to solve. According to Lawson, 'Quebec presented the sort of social, economic, and constitutional challenges that defied empirical palliative.'[25] Marshall says much the same: 'No precedent existed for the effective Imperial absorption of a non-British population.'[26] Both claims are, strictly speaking, correct: there was no exact parallel with Quebec, no precisely matching precedent on which British politicians could call. But it surely would be wrong to imply that those same politicians were working in the dark, groping their way to solutions without any models to guide them. As another Peter Marshall – the eminent imperial historian P.J. Marshall – has pointed out, mid-eighteenth-century British ministers had experience of governing large numbers of Catholics nearer home – most notably in Ireland and also in the Mediterranean island of Minorca, where the vast majority of the people were Catholic Catalans.[27] On a schematic level, the transition from the form of government that British ministers envisaged for Can-

ada at the end of the Seven Years' War to the arrangements enshrined
in the Quebec Act of 1774 can be understood as the move from the Irish
to the Minorcan model. At least some contemporaries seemed to be
thinking in terms of these models, and referred to them during debates
and discussions about Canada. Right to the end, Irish-style government
was preferred, and the Minorcan alternative was embraced only with
considerable reluctance.

Ireland in the middle of the eighteenth century was a predominantly
Catholic country. In eastern Ulster there was a concentration of Protes-
tants, many of whom were Presbyterians who could trace their origins
back to Scotland, from where they had migrated in the early seven-
teenth century. Leinster also had a significant Protestant population,
nearly all of whom were members of the established Anglican Church,
descended from the Elizabethan plantations. In Dublin and its hinter-
land, the area first settled by the English in the Middle Ages, there were
also large numbers of Anglicans. But in most of the country there was
an overwhelming Catholic majority – in the west and south, Catho-
lics might have outnumbered Protestants by as much as nineteen to
one.[28] Despite the numerical preponderance of the Catholics, Ireland
was ruled through its well-entrenched Protestant minority, which prob-
ably constituted no more than twenty per cent of the whole population.
Protestants – in all but a few cases Anglicans – held the vast majority
of the cultivatable land: after the Williamite settlement at the end of the
seventeenth century, about eighty-six per cent of Ireland was owned by
Protestants.[29]

The Protestant landowning class dominated government and ad-
ministration throughout the country; indeed, the Irish Test Act of 1704
formally debarred non-Anglicans from holding all but the most minor
public office. Magistrates were Anglican landowners, and English-style
quarter sessions and assize courts operated in the counties. In Dublin
there were courts of king's bench, common pleas, chancery, and exche-
quer, based on the English originals. English law was used in all these
courts, even in the lowest; Gaelic Irish or *brehon* law ceased to be recog-
nized by Irish judges from the beginning of the seventeenth century.[30]
The central instrument of Protestant rule was the Irish Parliament at
Dublin. Membership was confined, in theory at least, to Anglicans, who
were voted into office by their fellow Protestants; Catholics were de-
barred from the franchise by an Irish statute of 1727.[31] The Irish legisla-
ture modelled its procedures on its British counterpart at Westminster,
and enjoyed the same control over domestic taxation.[32] For the most

part, however, the Irish Parliament was managed by the Irish government at Dublin Castle, working through a small number of influential Irish Protestant landowners, who undertook to secure parliamentary majorities for the Castle's favoured measures, and therefore acquired the name of 'undertakers.'[33] Much as Irish Protestants might regret it, the Dublin Parliament was not the equal of its British cousin – its ability to initiate legislation was limited, and its activities were supervised by the British Privy Council. The Westminster Parliament, furthermore, claimed legislative superiority over the Dublin assembly in the Irish Declaratory Act of 1720, and though Westminster never attempted to tax Ireland, it did regulate the country's overseas trade and pass legislation to discipline the British army based in Ireland. The key to British control of the country, then, was working through a local Protestant elite, the dominance of which was secured by landownership, office holding, the establishment of the Anglican Church, English law, and a representative institution open only to Anglicans and subordinate to the Westminster Parliament.

Minorca, under British rule for a much shorter period, offered a very different example of how a predominantly Catholic people might be governed.[34] The island was captured by the British in 1708, during the War of the Spanish Succession. As most Minorcans supported the Habsburg claimant to the Spanish throne, who was a British ally, the initial period of occupation was less fractious than it might have been. The British garrison administered the island on behalf of the Habsburgs until 1712, when the governor claimed sovereignty for Queen Anne. In 1713, at the Peace of Utrecht, Minorca was formally ceded to Britain. Members of the local elite requested the continuation of the existing religious dispensation, established privileges, and the legal system.[35] The first British governor announced that he would respect existing property rights, retain the services of local magistrates and other public officers in the *universidads*, or oligarchic town councils, and allow the island's Roman Catholic establishment to remain in place. The one new development was hardly visible to the inhabitants: the revenues of the bishop of Majorca, who had enjoyed authority over the church in Minorca, were now collected for the British Crown and added to its other local revenues.[36] The transition to British rule, in short, involved little more than a change at the top – Minorcans were now subjects of Queen Anne, and then King George – and to all intents and purposes the fabric of local government, landownership, and religion remained unaltered. The Catholic inhabitants of the island, in other words, were

to a considerable extent ruled by their own local Catholic elite. In January 1755, the British government even acceded to the request of the Spanish Crown that the bishop of Majorca be allowed to undertake a visitation of his clerics on Minorca.[37]

Nonetheless, to British ministers Minorca appeared far from a success story. The early years of British occupation were marked by frequent complaints about the arbitrary behaviour of British governors and lieutenant-governors, and the 'Licentiousness [of the garrison] with regard to Women.'[38] Richard Kane, the first lieutenant-governor, and subsequently a long-serving governor, particularly enraged the local Catholic clergy, who resented his attempts to reduce the oversight of the bishop of Majorca. During and after the Anglo-Spanish war of 1739–48, British politicians had been convinced that the population of the island remained Spanish in orientation and that the Minorcans were therefore unreliable subjects. There had been calls for a concerted effort to protestantize the people and to introduce new settlers almost from the start of the British occupation; from the 1740s these calls became louder and more frequent. In January 1742, with Minorca under threat from Spanish attack and its garrison known to be weak, the duke of Argyll, a former governor, told the House of Lords that the Minorcans 'would certainly join the Spaniards in case they should invade the island.' Local disaffection, Argyll argued, was a natural consequence of the Catholicism of the islanders. It had been a great error, he went on, not to have adopted a policy of active protestantization. 'If we had done this,' Argyll maintained, 'most of the inhabitants might by this time have been true members of the church of England.'[39] The earl of Hardwicke, the lord chancellor, replying for the government, pointed out that a policy of active conversion would have been inconsistent with the terms of the transfer of the island to British sovereignty. But, in a revealing aside, he conceded that 'it would have been a very desirable thing' if large numbers of the people had indeed become Protestants.[40] Lord Tyrawley, governor just before the outbreak of the Seven Years' War, was an Irish Protestant with a strong animus against Catholics. He wrote of the Minorcans that 'Such is the Power of Education and the Influence of Priests, and Such their Attachment to Spain that they doe not disguise their Wishes to return under its Dominion.'[41] British governors and lieutenant-governors, furthermore, regularly fell out with the local population. The elderly General William Blakeney, lieutenant-governor from 1748 to the fall of the island to the French in 1756, was particularly unpopular. Another Irish Prot-

estant, with a deep suspicion of the Catholic religious establishment on the island, Blakeney did little to endear himself to the inhabitants. After the French capture of Minorca, Blakeney complained bitterly of the failure of the local population to offer assistance to his troops: 'they are a disaffected people,' he told the southern secretary, '[in] no way attached to his Majesty's government.'[42]

By contrast, recent history suggested that Ireland was less disaffected and that the system of government that had developed there had been successful. Such a claim might seem improbable, given what we know about the persistence of a Gaelic counterculture, prominently featuring songs and poems longing for deliverance from Protestant oppression.[43] But, as Sean Connolly pointed out some years ago, we need to avoid the temptation to read back from the great uprising of 1798 and assume that throughout the eighteenth century Ireland was a seething cauldron, ready to boil over at the first increase in the heat.[44] From the perspective of 1763, when the British government formulated its policy for the governance of Quebec, Ireland must have appeared to ministers in London as a far better model than Minorca. This is not to say that Ireland was calm and quiet: at the end of the Seven Years' War there were rural disturbances in the south and in Ulster.[45] Nor were Protestants unconcerned about the threat posed by the Catholic majority: far from it – Ireland's Protestants (and some British Protestants, too) were in a state of anxiety about Catholic loyalty every time international conflict threatened an invasion. But the unrest at the end of the Seven Years' War was to some extent put down to the dislocations and disruptions of the struggle itself, and at least some British politicians appear to have been much less worried than were the Protestant Irish about the insurrectionary potential of Ireland's excluded.

In 1745, when the Scottish Highlands erupted into rebellion in favour of the deposed Stuart claimants to the British throne, Ireland's Catholic population remained unmoved. The lord-lieutenant, the earl of Chesterfield, was convinced that there was nothing to fear; he even discouraged Protestants keen to form paramilitary units to keep the Catholics in check, and urged them to concentrate on improving the economy instead.[46] Chesterfield, it must be said, was unusually relaxed about the Catholic threat; later lords lieutenant showed themselves to be more receptive to local Protestant fears.[47] Even so, from the perspective of ministers in London, the experience of the Seven Years' War must have suggested that Ireland's potential for large-scale insurrection had been successfully contained. In 1760, when there was a small French

landing in Ireland, the Catholics, as in 1745–6, showed no disposition to rise up and cut the throats of their Protestant neighbours.[48] On the contrary, Catholic merchants and gentry drew up petitions of loyalty in the aftermath of the French incursion, and paraded their adherence to the existing regime again when George III succeeded his grandfather later that year.[49] Ireland was not to be immune from the changes that swept through the British Empire after the Seven Years' War; indeed, the undertaker system was very soon to be replaced by a more direct method of managing Irish politics through a resident lord lieutenant and a chief secretary sitting in the Irish House of Commons.[50] But in 1763, as British ministers considered what to do with the former New France, Ireland would surely have appeared the most relevant and encouraging guide.

The Frenchness of the *Canadiens*, it might be objected, made any comparison with the seemingly quiescent Irish Catholics less than exact. The French, after all, had been British rivals and enemies for much of the preceding quarter of a century, and the recently concluded war had done little to diminish British animosity.[51] Surely, in a future British conflict with the Bourbon monarchy, the French Canadians would prove to be more unreliable, and less easy to overawe, than the Irish Catholics, for the simple reason that they were ethnically and culturally French? This assumes, however, that contemporaries regarded ethnicity as more important than religion. Some, as we will see later, certainly doubted whether a people of French origins could ever be truly loyal to the British Crown. But for other British decision-makers, ethnic background was clearly less important than religious affiliation, as witness the plans to bring Protestant French settlers into the Highlands of Scotland after the 'Forty-five rebellion and the successful penetration into British public life of Huguenot refugees, such as Jean-Louis Ligonier, who rose to become commander-in-chief of the British army. If religion did indeed trump ethnicity, we can surmise that, for British ministers, the distinction between the French Canadians and the Irish Catholics was probably not very significant. Fears about Irish Catholic mutiny, encouraged by French or Spanish military intervention, had been very real for much of the first half of the eighteenth century. The success of the Irish model of government in containing the threat of a Catholic uprising, exemplified by the passivity of the Catholics in 1760, despite a French landing, could easily have encouraged British politicians to believe that the approach adopted in Ireland had every chance of working in the same manner on the potentially rebellious French Canadians.

The famous Royal Proclamation of 7 October 1763, establishing the framework for governance in all the new British acquisitions in North America and the Caribbean, can be seen as an attempt to introduce an Irish-style solution to the Quebec problem. Historians, particularly American historians, have tended to focus on the Proclamation's attempt to halt westward expansion of the old British mainland colonies and preserve the wilderness between the Appalachians and the Mississippi for the aboriginal peoples.[52] But the temporary prohibition on movement into the west (and it was only temporary) was not designed just to avoid trouble with the Amerindians; it was also intended to encourage the movement of Protestant settlers in other directions. To the south lay the new provinces of East and West Florida, territory ceded by the Spanish Crown at the Peace of Paris. The Floridas needed to be rapidly re-peopled as the Spanish inhabitants had for the most part departed. To the north was Quebec, where the much larger Catholic population remained, but a counterbalancing Protestant presence was urgently required if anything like the Irish form of government were to be introduced in the near future.

To promote Protestant settlement, especially in Quebec, an assembly was promised, 'so soon as the state and circumstances ... will admit.'[53] But the prerequisite for an assembly, at least in Quebec, was itself large-scale Protestant settlement. To achieve this objective, land grants were offered to soldiers who had served in the recently concluded war. The careful calibration of the grants to reflect military rank conveys the impression that the intention was to create a ready-made Protestant land-owning class. Subalterns were entitled to two thousand acres, captains three thousand, and field officers, five thousand. These officers, presumably, were envisaged as the large landowners through whom the new province could be governed – men of substantial property who would become magistrates and representatives in the colonial assembly promised in the Proclamation. The private soldiers, offered fifty acres each, we can surmise were intended to play the part of yeoman freeholders who would form the bedrock of the voters who returned the new Protestant landowning elite to the benches of the assembly, just as their counterparts in Ireland elected the Ascendancy landowners who dominated the Dublin Parliament.[54]

Further parallels with Ireland suggest themselves. The promotion of military veteran settlement in Quebec can be seen as an attempt to form a Protestant landowning class experienced in using firearms, and able therefore to constitute an effective militia to keep the local Catholic

population in check. If Quebec could be so controlled, the regular British garrison in the St Lawrence valley might safely be redeployed when required elsewhere, in much the same way as a large part of the British army in Ireland was dispatched abroad at the start of eighteenth-century wars.[55] The Proclamation also promised the introduction of English criminal and civil law into Quebec – in other words, the same system that operated throughout Ireland, including those parts of the south and west with an overwhelming Catholic majority.

The Proclamation's architects, it might be added, were politicians with strong Irish connections. The young earl of Shelburne, first lord of trade from April 1763, left office before the Proclamation was issued, but was effectively one of its authors.[56] His family dominated County Kerry, and Shelburne himself had served briefly as an Irish as well as a British MP before he inherited his peerage. His successor at the Board of Trade was the earl of Hillsborough, an important Irish landowner, who possessed a large estate in County Down. As a grandee in Protestant Ulster, Hillsborough was perhaps more accustomed to dealing with Presbyterians than with Catholics, but his knowledge of Irish politics was extensive. The same was true of the earl of Halifax, who, as secretary of state for the southern department from September 1763, took charge of bringing forward the Proclamation. He had recently served as lord lieutenant of Ireland, where he had shown a shrewd appreciation of the dynamics of power.[57]

The Irish model of ruling a Catholic majority through a Protestant landowning minority clearly influenced the instructions sent to James Murray, the first governor of the new colony.[58] Issued in the king's name on 7 December 1763, the instructions ordered Murray, 'so soon as the Situation and Circumstances of Our Said Province will admit,' to 'summon and call a General Assembly of the Freeholders,' but recognized that 'it may be impracticable for the present to form such an Establishment.' Not until there was a large enough Protestant minority, it was implied, would it be possible to bring in the promised elected legislature. Though the instructions made no mention of how a Protestant interest was to be created, we can surmise that at this stage it was still expected that land grants would encourage the arrival of new Protestant settlers, particularly demobilized soldiers. But some hope was also pinned on conversion of the existing Catholics – much as in Ireland, where it met with only limited success.[59] The authors of the instructions expected that 'the Inhabitants may by Degrees be induced to embrace the Protestant Religion.' They anticipated that the Church

of England would be established and Protestant schools and clergy-men supported by land grants – again, the parallels with Ireland are striking. Murray was required to report on what further steps might be taken to promote 'the Protestant Religion.' All the governor's advisory councillors, meanwhile, were to be drawn from the Protestant part of the population.[60]

If the Proclamation and Murray's instructions represented the desire of British ministers to impose an Irish solution onto Canadian prob-lems, why, eleven years later, did the British government turn its back on the Irish model and embrace something very like the Minorcan al-ternative? The Quebec Act, as is well known, abandoned the commit-ment to calling an assembly when the time was right, and accepted that government should proceed without an elected body. The gover-nor's advisory council was to be open to the local Catholic elite, who were further conciliated by the adoption of French civil law (which guaranteed their property rights) and a special, semi-established posi-tion for their church. In addition, the boundaries of the province were vastly extended, taking in the wilderness between the Mississippi, the Great Lakes, and the Ohio. While many opposition MPs at Westminster viewed the Quebec Act as a betrayal of the promises made in 1763 and an indication of the despotic tendencies of Lord North's government, we might best see it as a belated recognition that the Irish model for governing a significant Catholic population could not be applied in Canada.

The perception that the Quebec Act's provisions represented a move to Minorcan-style government is not simply an historical judgment – contemporaries saw the parallels only too clearly. Thomas Townshend, Jr, an opponent of the Quebec legislation, brought up Minorca on the second reading of the bill in the House of Commons on 26 May 1774. In raising the issue of the British inhabitants in the newly enlarged Que-bec, who were now to be subject to French civil law, Townshend asked: 'Has this been the policy of this country with regard to any other ac-quisition whatever, except one, with regard to Minorca?' He went on to point out what he believed to be the inevitable consequences of a failure to anglicize the colony: 'The Minorceens remain Spanish. The Canadians will in that respect be in the same situation as the Minor-ceens. When Minorca was attacked, had you one Minorceen that did not join the French? Will the Canadians be less Frenchmen than the Mi-norceens?'[61] On the other side of the debate, William Knox, undersecre-tary for the colonies in North's government, claimed after the Quebec

Act became law that ministers had knowingly embraced 'a plan of lenity and indulgence' based on the system that operated in Minorca. He added that they had at the same time rejected Irish methods, and suggested that one reason for that rejection was that harshness in Ireland had not achieved the desired results.[62]

Knox's claim that the British government had become less enamoured of the Irish model, and was therefore disposed to look at the alternative more favourably, fits well with recent scholarship pointing to a change in British elite attitudes towards Catholicism after the Seven Years' War. The conflict had been interpreted in some quarters as a religious contest, with the Catholic allies France and Austria (later joined by Spain) locked in a titanic struggle with the Protestant states of Britain, Hanover, and Prussia. Such an interpretation required contemporaries to overlook the fact that the Protestant Swedes and the Orthodox Russians were part of the anti-Prussian alliance, and that Catholic Portugal was protected by British troops in 1762. Nevertheless, there is plenty of evidence to suggest that the war was seen as a great showdown between Protestantism and Catholicism. There could be no doubt, furthermore, that the Protestant side had won. After the war, even the pope gave up on the Catholic Stuart claimants to the British throne; in 1766, on the death of James Francis Edward Stuart, or James III, the pope refused to regard his successor as the legitimate ruler of Britain and Ireland. With the Jacobite threat effectively over, there was much less reason for British political elites to feel nervous about Catholicism.[63]

But to take Knox's comments at face value and to assume that growing scepticism about the Irish model led to the adoption of a new policy of toleration in Quebec would surely be a mistake. There are good grounds for believing that concessions to Catholicism in Quebec (and elsewhere in the empire) led to changes in Ireland,[64] but not so much evidence to suggest that the prerequisite for change in Canada was disillusionment among British ministers with the Irish model for governing Catholics. The move to Minorcan-style rule in Quebec might be better understood as a process of gradual, and very reluctant, facing up to the reality of the impracticality of adopting the Irish solution in Canada.

The existing historiography suggests something rather different: that the problems associated with the form of government envisaged in the Royal Proclamation of 1763 became apparent very quickly, and that British ministers and imperial officials adjusted accordingly. Indeed, at least one Canadian historian implies that Governor Murray sought

to undermine the Proclamation from the very beginning, and that his efforts helped to persuade ministers in London to abandon the policy they had championed at the end of the Seven Years' War.[65] The Quebec Act, according to most recent accounts, was anticipated in many respects by the proposed reforms of the Rockingham government in 1766 – reforms that were scuppered at the last minute by the insistence of the lord chancellor that changes to the system of government in Quebec could not be introduced under the prerogative powers of the Crown, but required an act of Parliament.[66] Under Rockingham's successors, the same accounts tell us, a great deal of time was then spent in canvassing opinion and gathering information. Only in 1773, under Lord North, did ministers finally decide to act, and then only under pressure from legal judgments that meant that the status quo was no longer an option and influenced by the looming crisis with the old British North American colonies, which suggested that some concessions to the French Canadians would be timely.[67]

Plenty of evidence, it must be said, appears to support the view that British politicians rapidly accepted the need to abandon the system outlined in the Proclamation, and that their slowness in bringing forward legislation reflected nothing more than the distractions of other business and the limited importance they attached to Canadian issues. British ministers were certainly soon enough alerted to the problems inherent in following the Irish model. In December 1764, the lord chief justice of the King's Bench, Lord Mansfield, told the first minister George Grenville of his considered views on the Royal Proclamation. Mansfield was convinced that it had been an egregious mistake to take away the 'laws, and customs, and forms of judicature' of the French inhabitants. He appears to have recognized the influence of the Irish model on ministerial thinking, by arguing that the changes introduced there were 'the work of great length of time, many emergencies, and where there was a pale of separation between the conquerors and the conquered,' with only the conquerors ruled 'by their own laws at first.' Ireland, in short, could not provide the model for what to do in Quebec, as its system of government had emerged gradually, over centuries of English dominance. Mansfield went on to demonstrate that in other instances the conquered were allowed to retain 'their own municipal laws.' His examples were historical, but, as if to clinch the argument, he pointed out that 'Minorca does now.'[68]

By the time that Mansfield expressed these concerns, Murray had already recognized that some acknowledgment of local legal traditions

was necessary; the wholesale importation of English laws and judicial structures was simply not possible given the paucity of Protestants in the new colony. In an ordinance of 17 September 1764, he established a court of King's Bench in Quebec, in which criminal and civil causes would be heard 'agreeable to the Laws of England' and to any ordinances that he or his successors might pass for the province. But, in what is usually seen as an important concession, he admitted Catholics as well as Protestants as jurymen. A further concession was offered in the inferior court of Common Pleas. While French laws and customs were no longer to be valid after 1 October 1764, even in cases between French Canadians, at least 'Canadian Advocats, Proctors, &c' were to be allowed to practise in the court. Justices of the Peace were to be Protestants, but the ordinance made provision for the election by the Catholic inhabitants of each existing parish of bailiffs and sub-bailiffs to oversee routine functions of local government and to arrest accused parties.[69]

British ministers soon recognized, too, that it was not going to be practicable to convert significant numbers of Canadiens to Protestantism. The free exercise of the Catholic religion had been guaranteed at the surrender and in the subsequent peace, and by early 1766 the Rockingham government had accepted the need to fill the vacant bishopric of Quebec.[70] More important, so far as the introduction of an Irish style government was concerned, it was quickly apparent that attracting Protestant settlers – the key to the Irish solution – was going to be very difficult. Disbanded soldiers were not inclined to apply for land grants in Quebec, with its long winters and short growing season, when land was available in the backcountry of the older British colonies further south. The take-up for land grants in Quebec was disappointingly small. The few British merchants and traders who had set up business since the fall of New France were not considered to be suitable material for the construction of a Protestant voting and ruling class. Not only were they too few in number; they were disqualified by virtue of their background and occupation. Murray, who clashed bitterly with the British merchants in Quebec, regarded them as 'chiefly adventurers of mean education.'[71] This was not simply a matter of personal animosity; Murray's views were shared by many members of the British political elite. Merchants were not regarded as committed to their communities in the same way as landowners were, for the simple reason that merchants possessed moveable capital, whereas landowners were literally tied to their property and could not take it with them if they decided to leave.[72]

Yet despite the very real difficulties in trying to adopt the Irish model, British politicians were deeply reluctant to abandon it. Murray's concessions in the ordinance of September 1764 were not as great a departure from the Irish model as might be assumed: as Toby Barnard has explained, parish-level public offices in Ireland were open to Catholics, and Catholics often served as jurymen in those areas of the country where Protestants were very thin on the ground.[73] Furthermore, the desirability of introducing English law into Canada continued to be much trumpeted, even by those who supported concessions to the local situation. In what might have been an answer to Mansfield's claim that it was despotic to do away with French law overnight, Lord Hillsborough argued in March 1768 that it had never been the intention of the authors of the Proclamation of 1763 – of which he was one – that French civil law traditions should be totally eliminated: 'it never entered into Our Idea,' he wrote, 'to overturn the Laws and Customs of Canada, with regard to Property.' English law, he explained, respected local customs in England itself, and that was how they had anticipated its operating in Canada.[74] Even when the Quebec bill was being debated in the House of Commons, the solicitor-general, Alexander Wedderburn, denied that it had been the intention of the Proclamation to extinguish French civil law. Wedderburn seemed to suggest that, far from abandoning the Irish model, the government was still endeavouring to follow it faithfully. Ireland, he argued, did not have English law from the first English settlement; it was introduced as the system of the whole country only in the reign of James I. His implication, presumably, was that the government's conceding the continued use of French civil law in Canada was merely a temporary expedient: sooner or later, English law would supersede it.[75] Perhaps still more surprisingly, in a debate in the House of Commons on 8 May 1770, General Henry Seymour Conway, who had been a minister in the Rockingham government that brought forward proposals to allow French civil law to be used in Quebec, revealed his true preferences. Conway told his fellow MPs that 'it was meant to be a benefit to them [the French Canadians] that the laws of this country were given to them in lieu of their own. When they know them better,' Conway continued, English norms would 'not be repugnant' to the Canadians.[76]

Nor was there any rapid recognition that an assembly was not going to be possible in Quebec. Despite the problems in securing Protestant settlers, the vision of an Irish-style legislature, through which Quebec could be ruled, proved remarkably difficult to abandon for

British politicians. In June 1767 the Privy Council still hoped that, as soon as 'there can be found a sufficient number of Protestant Subjects duely [sic] qualified,' an assembly would be called in the province.[77] During the Chatham administration, Shelburne, now the southern secretary, even considered (but did not pursue) allowing Catholics to vote in elections as a means of honouring the commitment to calling an assembly. The precedent for Catholic enfranchisement had been set in Grenada, another acquisition at the Peace of Paris, where from 1766 the French planters were permitted not only to vote but also given limited representation in the assembly itself.[78] But the parallels with Grenada were far from close: the island had a French population of about three thousand five hundred, living alongside new British settlers; in Quebec there were hardly any Protestant landowners and, according to contemporary belief, perhaps more than a hundred thousand Catholics. Nor were the Grenada parallels particularly encouraging, from a ministerial point of view. The island's assembly became the scene of bitter fighting between French and British factions, and the divisions within the planter class in Grenada led, in the words of a recent historian of the West Indies at the time of the American Revolution, to 'a state of virtual paralysis between 1768 and 1774.'[79]

Minorca offered a much nearer approximation to Quebec than did Grenada. Like Quebec, the Mediterranean outpost had virtually no Protestant residents, apart from the troops of the garrison. Its Catholic population was smaller than Quebec's, but much larger than Grenada's – in 1713 it had been just over sixteen thousand; by 1756, according to a contemporary survey, 30,652.[80] Even so, the Minorcan model remained deeply problematic. After the restoration of British rule in 1763, many of the difficulties identified before the island's capture in 1756 continued to manifest themselves.[81] Relations between the garrison and the local population were still fractious, and those British military men placed in charge of the island continued to clash with local elites. Lieutenant-Governor James Johnston confirmed the rights and privileges of the Minorcans in 1764, but within a couple of years Minorcan critics were using connections in Britain to lobby for an end to 'his arbitrary proceedings.'[82] The Minorcans, for their part, were condemned in British publications as 'slothful' and 'naturally listless,'[83] and their being allowed to continue with their own systems of law and government after 1713 was seen as 'their heaviest Misfortune.'[84] The Rev. Edward Clarke, secretary to Lieutenant-Governor Johnston, acknowledged that there were some loyal Minorcans, but was dismissive of the 'magistrates and

some of the clergy,' whom he believed had far too much power.[85] The extent of the tensions became very apparent in the summer of 1773 in the famous legal case of *Fabrigas v. Mostyn*, when a Minorcan merchant launched proceedings in the Court of Common Pleas in London against the governor for wrongful imprisonment.[86] Knox's suggestion in 1774 that Minorca was content, and therefore was the most promising model to adopt, was probably no more than making a virtue out of a necessity. British ministers did not succumb to the attractions of 'lenity and indulgence,' as Knox put it; they reluctantly adopted the Minorcan solution after their preferred option – the Irish model – proved unworkable in the setting of post-Conquest Quebec.

British ministers, considering what to do about the government of the new province of Quebec, were not working in the dark, with no precedents or models to guide them. On the contrary, they consciously tried to apply to the Canadian situation the method of governing a large Catholic population that had been pursued – and pursued, from the perspective of mid-eighteenth-century British politicians, with some success – in Ireland. Only with the greatest reluctance did they finally embrace the alternative Minorcan model. We cannot understand political and constitutional developments in Canada after the Conquest without recognizing not simply the key role of decision-makers in London, but also the extent to which they were influenced by the experience of governing other areas of the British Empire.

NOTES

1 For a description of the celebrations in London following the arrival of news of the victory at Minden, see John Clavell to William Filliter, 9 August 1759, Dorset Record Office, Filliter Family Papers, D/FIL/F 23.
2 Berkshire Record Office, Windsor Borough Records, Minute-book W 1/AC 1/1/2, 323.
3 Sir James A. Picton, ed., *City of Liverpool Municipal Archives and Records* (Liverpool: Edward Howell, 1907), 119. See also J.H. Gilbert and R.M. Gilbert, eds., *Calendar of the Ancient Records of Dublin*, vol. 10 (Dublin: Joseph Dollard, 1889–1944), 389–90.
4 For an expression of anxiety about the British position in Canada, see Sir Robert Wilmot to Richard Rigby, 18 June 1760 (copy): 'It is apprehended that the Next Ship will bring an acct. that we have lost Quebec.' Derbyshire Record Office, Wilmot Horton of Catton Collection, D 3155 C 2396.

5 See, for example, John Calcraft to James Robertson, 19 August 1760, Cal-craft Letter-book, British Library, Additional MSS, 17,495, f. 115.

6 See, for example, *Records of the Borough of Nottingham*, vol. 7 (Nottingham, UK: Thomas Forman & Sons, 1882–1956), 3; and Angus J.L. Winchester, ed., *The Diary of Isaac Fletcher of Underwood, Cumberland, 1756–1781* (Kendal, UK: Cumberland and Westmorland Antiquarian and Archaeological Society, 1994), 91.

7 For contemporary estimates, see P.D.G. Thomas, *Tea Party to Independence: The Third Phase of the American Revolution 1773–1776* (Oxford: Clarendon Press, 1991), 89. For modern assessments, see John A. Dickinson, *A Short History of Quebec: A Socio-Economic Perspective* (Toronto: Copp Clark Pitman, 1988), 73.

8 See Colin Haydon, *Anti-Catholicism in Eighteenth-Century England, c.1714–1780: A Political and Social Study* (Manchester: Manchester University Press, 1993).

9 For the view that Irish Protestant hostility to Catholics might actually have increased in the years preceding relief, see Louis Cullen, 'Catholics under the Penal Laws,' *Eighteenth-Century Ireland* 1 (1986): 23–36.

10 For studies of the controversy, see George L. Beer, *British Colonial Policy 1754–1765* (London: Macmillan, 1907), 152–9; Charles W. Alvord, *The Mississippi Valley in British Politics*, vol. 1 (Cleveland: A.H. Clark, 1917), 52–62; Lewis Namier, *England in the Age of the American Revolution*, 2nd ed. (London: Macmillan, 1961), 273–82; Jack Sosin, *Whitehall and the Wilderness: The Middle West in British Colonial Policy 1760–1775* (Lincoln: University of Nebraska Press, 1961), chap. 1; and Philip Lawson, *The Imperial Challenge: Quebec and Britain in the Age of the American Revolution* (Montreal; Kingston, ON: McGill-Queen's University Press, 1989), 9–23.

11 See Matt Schumann and Karl Schweizer, *The Seven Years' War: A Transatlantic History* (London: Routledge, 2008), 84–5, 88, 89.

12 Bedfordshire Record Office, Lucas of Wrest Park Papers, L 30/9/17/19.

13 See Lewis Namier and John Brooke, *The History of Parliament: The House of Commons 1754–1790*, vol. 1 (London: Her Majesty's Stationery Office, 1964), 156–9.

14 See, for example, Wyndham Beawes, *Lex Mercatoria Rediviva: Or, The Merchant's Directory*, 2nd ed. (London: R. Baldwin, 1761), 649.

15 Lawson, *Imperial Challenge*, 17.

16 For Bedford's views at the end of the Seven Years' War, see, for example, British Library, Newcastle Papers, Additional MSS, 32,922, ff. 449–51. For his earlier, and very different, opinion that the French must be driven from North America if the British colonies were to have any security, see John

Russell, ed., *Correspondence of John, Fourth Duke of Bedford*, vol. 1 (London: Longman, 1842–6), 182.

17 Namier, *England in the Age of the American Revolution*, 281–2; for Gipson, see John Shy, *A People Numerous and Armed: Reflections on the Military Struggle for American Independence* (Oxford: Oxford University Press, 1976), chap. 5; and Linda Colley, *Britons: Forging the Nation, 1707–1837* (New Haven, CT: Yale University Press, 1992), 135–6.

18 For the primacy in official thinking of the security of the old British North American colonies, see Peter N. Miller, *Defining the Common Good: Empire, Religion and Philosophy in Eighteenth-Century Britain* (Cambridge: Cambridge University Press, 1994), esp. 173.

19 See Geoffrey Plank, *An Unsettled Conquest: The British Campaign against the Peoples of Acadia* (Philadelphia: University of Pennsylvania Press, 2001).

20 For the proposal to import foreign Protestants into the Highlands, see Newcastle University Library, Newcastle of Clumber MSS, NeC 1534/1–2.

21 Christopher Duffy, *The '45: Bonnie Prince Charlie and the Untold Story of the Jacobite Rising* (London: Cassell, 2003), 537.

22 Egremont to Amherst, 12 December 1761, United Kingdom National Archives, CO 5/214, Pt II, 241–2.

23 Lawson, *Imperial Challenge*.

24 Peter Marshall, 'The Incorporation of Quebec in the British Empire, 1763–1774,' in *Of Mother Country and Plantations: Proceedings of the Twenty-seventh Conference in Early American History*, ed. V.B. Platt and D.C. Skaggs (Bowling Green, KY: Bowling Green State University Press, 1971), 42–62; and 'British North America, 1760–1815,' in *The Oxford History of the British Empire*, vol. 2, *The Eighteenth Century*, ed. P.J. Marshall (Oxford: Clarendon Press, 1998), 372–93.

25 Lawson, *Imperial Challenge*, 25.

26 Marshall, 'British North America, 1760–1815,' 372. Earlier, in his essay on 'The Incorporation of Quebec,' 43, Marshall acknowledged that there were precedents – he identified Acadia and Minorca – but argued that they were not influential. He made no mention of Ireland.

27 P.J. Marshall, *The Making and Unmaking of Empires: Britain, India, and America c. 1750–1783* (Oxford: Oxford University Press, 2005), 182.

28 See R.B. McDowell, *Ireland in the Age of Imperialism and Revolution 1760–1801* (Oxford: Clarendon Press, 1979), 156.

29 David Dickson, *New Foundations: Ireland 1660–1800*, 2nd ed. (Dublin: Irish Academic Press, 2000), 47.

30 The process whereby English institutions and practices were introduced is

traced in Nicholas Canny, *Making Ireland British 1580–1650* (Oxford: Oxford University Press, 2001).

31 Irish statute 1 Geo. II, c.9, § vii.

32 See C.I. McGrath, *The Making of the Eighteenth-Century Irish Constitution: Government, Parliament and the Revenue, 1692–1714* (Dublin: Four Courts Press, 2000).

33 See Eoin Magennis, *The Irish Political System 1740–1765: The Golden Age of the Undertakers* (Dublin: Four Courts Press, 2000).

34 For an overview of the British on Minorca, see Desmond Gregory, *Minorca, the Illusory Prize: A History of the British Occupation of Minorca between 1708 and 1802* (Rutherford, NJ: Farleigh Dickinson University Press, 1990).

35 British Library, Papers relating to Minorca, Additional MSS, 17,775, ff. 36–7.

36 British Library, Hardwicke Papers, Additional MSS, 35,885, f. 166.

37 Ibid., f. 220.

38 [Anon.], *The Distress'd Condition of Minorca, Set Forth in Answer to the Vindication of Colonel Kane* (London, 1720), 7, 13.

39 William Cobbett and John Wright, eds., *The Parliamentary History of England*, vol. 12 (London: Longmans, 1806–20), 380–1.

40 Ibid., 389.

41 British Library, Tyrawley Papers, Additional MSS, 23,638, f. 100.

42 Quoted in Geoffrey Plank, *Rebellion and Savagery: The Jacobite Rising of 1745 and the British Empire* (Philadelphia: University of Pennsylvania Press, 2006), 147.

43 See Éamonn Ó Ciardha, 'The Stuarts and Deliverance in Irish and Scots-Gaelic Poetry, 1690–1760,' in *Kingdoms United? Great Britain and Ireland since 1500: Integration and Diversity*, ed. S.J. Connolly (Dublin: Four Courts Press, 1999), 78–94; idem, *Ireland and the Jacobite Cause, 1685–1766: A Fatal Attachment* (Dublin: Four Courts Press, 2002), esp. chap. 7; and Vincent Morley, *Irish Opinion and the American Revolution 1760–1783* (Cambridge: Cambridge University Press, 2002), esp. 1–14.

44 S.J. Connolly, 'Varieties of Britishness: Ireland, Scotland and Wales in the Hanoverian State,' in *Uniting the Kingdom? The Making of British History*, ed. Alexander Grant and Keith J. Stringer (London: Routledge, 1995), 204–6.

45 See J.S. Donnelly, Jr, 'The Whiteboy Movement, 1761–5,' *Irish Historical Studies* 21 (1978–9): 20–54; and Eoin Magennis, 'A "Presbyterian Insurrection"? Reconsidering the Hearts of Oak Disturbances of July 1763,' *Irish Historical Studies* 31 (1998–9): 165–87.

46 John Ainsworth, ed., *The Inchiquin Manuscripts* (Dublin: Irish Manuscripts

Commission, 1961), 160. For local Protestant unease at Chesterfield's attitude, see John Ryder, bishop of Down and Connor, to Sir Dudley Ryder, 19 December [1745], Public Record Office of Northern Ireland, Harrowby MSS, T 3228/1/19.

47 See, for example, the views of the duke of Devonshire at the beginning of the Seven Years' War: Derbyshire Record Office, Wilmot Horton of Catton Collection, D 3155 WH 3450.

48 For the views of one Catholic gentleman, who hoped that Thurot would be 'Nabb'd, to pay for his impudence,' see Owen Callanan to Dominick Sarsfield, 29 February 1760, National Library of Ireland, Sarsfield Papers, MS 17891.

49 Dickson, *New Foundations*, 152.

50 For the changes, see esp. Magennis, *Irish Political System*, chap. 7; and Martyn J. Powell, *Britain and Ireland in the Eighteenth-Century Crisis of Empire* (Basingstoke, UK: Palgrave, 2003), chap. 4.

51 For Anglo-French relations, see Jeremy Black, *Natural and Necessary Enemies: Anglo-French Relations in the Eighteenth Century* (London: Duckworth, 1986). The British elite, it should be added, could be as much francophile as francophobe; see Robin Eagles, *Francophilia in English Society, 1748–1815* (Basingstoke, UK: Palgrave Macmillan, 2000).

52 The Proclamation as a barrier to westward expansion and the divisions within the old British colonies about the merits of expansion are central themes in Marc Egnal, *A Mighty Empire: The Origins of the American Revolution* (Ithaca, NY: Cornell University Press, 1988). For recent general accounts that emphasize the Proclamation as a barrier to westward expansion, see Francis D. Cogliano, *Revolutionary America 1763–1815: A Political History* (London: Routledge, 2000), 8–9; and Steven Sarson, *British America 1500–1800: Creating Colonies, Imagining an Empire* (London: Hodder Arnold, 2005), 184–5.

53 Merrill Jensen, ed., *English Historical Documents*, vol. 9, *American Colonial Documents to 1776* (London: Eyre & Spottiswoode, 1969), 640.

54 Ibid., 641, for the land grants.

55 For the army in Ireland, see Alan J. Guy, 'The Irish Military Establishment, 1660–1776,' in *A Military History of Ireland*, ed. Thomas Bartlett and Keith Jeffrey (Cambridge: Cambridge University Press, 1996), 211–30.

56 See the still valuable article by R.A. Humphreys, 'Lord Shelburne and the Proclamation of 1763,' *English Historical Review* 49 (1934): 241–64.

57 See National Library of Ireland, Halifax's Journal, MS 8064, esp. entries of 10 and 25 November 1761.

58 For a sympathetic account of Murray's governorship, see Linda Kerr,

'Creation of Empire: James Murray in Quebec,' in *Hanoverian Britain and Empire: Essays in Memory of Philip Lawson*, ed. Stephen Taylor et al. (Woodbridge, UK: Boydell & Brewer, 1998), 229–47.

59 The convert rolls suggest about five thousand eight hundred converts from Catholicism in the eighteenth century; see Michael Brown et al., eds., *Converts and Conversion in Ireland, 1650–1850* (Dublin: Four Courts Press, 2005), 15. See also S.J. Connolly, *Religion, Law and Power: The Making of Protestant Ireland 1660–1760* (Oxford: Clarendon Press, 1992), 294–307.

60 Quoting from W.P.M. Kennedy, ed., *Documents of the Canadian Constitution 1759–1915* (Toronto: Oxford University Press, 1918), 28, 32.

61 R.C. Simmons and P.D.G. Thomas, eds., *Proceedings and Debates of the British Parliaments respecting North America, 1754–1783*, vol. 4 (Millward, NY: Kraus International Publications, 1982–), 445.

62 [William Knox], *The Justice and Policy of the Late Act of Parliament, for making more Effectual Provision for the Government of the Province of Quebec, Asserted and Proved; and the Conduct of Administration respecting that Province, Stated and Vindicated* (London: J. Wilkie, 1774), 20, 26, 28.

63 See Haydon, *Anti-Catholicism*, chap. 5, for the increasing divergence between elite and popular attitudes.

64 See Jacqueline Hill, 'Religious Toleration and the Relaxation of the Penal Laws: An Imperial Perspective, 1763-1780,' *Archivum Hibernicum* 44 (1989): 98–109.

65 See Hilda Neatby, *Quebec: The Revolutuonary Age, 1760–1791* (Toronto: McClelland and Stewart, 1966), 53–4.

66 Lawson, *Imperial Challenge*, chap. 4.

67 Ibid., chaps. 5–7; Marshall, 'British North America,' 377–9; and P.D.G. Thomas, *Lord North* (London: Allen Lane, 1976), 78–9.

68 William James Smith, ed., *The Grenville Papers*, vol. 2 (London: Murray, 1852–3), 476–7.

69 *Documents of the Canadian Constitution* (see note 60), 37–40.

70 Lawson, *Imperial Challenge*, 78.

71 Murray to the Board of Trade, 2 March 1765, William L. Clements Library, Shelburne Papers.

72 See Paul Langford, *Public Life and the Propertied Englishman 1689–1798* (Oxford: Clarendon Press, 1991), chap.5, for the traditional distinction between landed and other forms of property, and the gradual decline in the importance of landed property in the course of the eighteenth century.

73 Toby Barnard, *The Kingdom of Ireland, 1641–1760* (Basingstoke, UK: Palgrave, 2004), 104–5, 106, 120–1, 134.

74 *Documents of the Canadian Constitution* (see note 60), 57.

75 *Proceedings and Debates* (see note 61), vol. 4, 465–6.

76 Ibid., vol. 3, 282.

77 James Munro, ed., *Acts of the Privy Council of England. Colonial Series*, vol. *1766–1783* (London: His Majesty's Stationery Office, 1912), 28.

78 Ibid., 8–9.

79 Andrew Jackson O'Shaughnessy, *An Empire Divided: The American Revolution and the British Caribbean* (Philadelphia: University of Pennsylvania Press, 2000), 30–1, 124–5.

80 For 1713, see British Library, Papers relating to Minorca, Additional MSS, 17,775, f. 18; for 1756, see *London Magazine* 25 (1756): 104.

81 See Gregory, *Minorca*, chaps. 3 and 4.

82 [Anon.], *An Account of the Deplorable State of the Island of Minorca, and the Many Injuries Done to the Inhabitants under the Command of Lieutenant-Governor Johnston* (London, 1766), 11.

83 Malachy Postlethwayt, *The Universal Dictionary of Trade and Commerce*, 4th ed., vol. 2 (London: J. & P. Knapton, 1774), sub 'Minorca.'

84 John Campbell, *A Political Survey of Britain being a Series of Reflections on the Situation, Lands, Inhabitants, Colonies, and Commerce of this Island*, vol. 2 (London: Richardson & Urquart, 1774), 583.

85 Edward Clarke, *A Defence of the Conduct of the Lieutenant-Governor of the Island of Minorca. In Reply to a Printed Libel, secretly dispersed, without a Name, and which is Annexed to this Account* (London: T. Becket & P.A. De Hondt, 1767), esp. 19, 49.

86 The case was transferred to the King's Bench in November 1774, where Fabrigas was eventually awarded damages in a landmark judgment.

8

Commercial Interest and Political Allegiance: The Origins of the Quebec Act

HEATHER WELLAND

The British Empire before the American Revolution is usually characterized as 'Protestant, commercial, maritime, and free.'[1] Once possessed of the long-coveted New France, however, the British sought instead to keep it Catholic, agrarian, and feudal. In the words of one of its chief justices, Canada was 'the darkest corner of the dominion,'[2] and not every Briton joined in the elevation of General James Wolfe to near-sainthood after his victorious death on the Plains of Abraham in 1759.[3] 'A frozen region in the state of nature,' Quebec's first governor, James Murray, declared.[4] 'A place fit only to send exiles to, as a punishment for their past ill lives,' agreed one of his relatives.[5] The colony's attorney-general declared himself ready to accept even a Welsh judgeship to be free of a province so 'dull and disagreeable.'[6] 'Why in the name of sense should our ministry be so fond of Canada?' ranted Colonel Samuel Martin from his Antiguan plantation, lamenting its exchange for the more obviously lucrative Guadeloupe. '[It] has been of no value to the French, the whole trade of it not being worth more than a hundred thousand pounds per annum, and the expense to France much more money.'[7] France was inclined to agree; it was eager to give up its settler colonies there and in Louisiana to focus on its sugar plantations and the North Atlantic fisheries.[8]

Yet British politicians and the public had long been excited by New France's reported natural resources, and the colony strategically linked the isolated British settlement in Nova Scotia with the thirteen colonies to the south. During the War of the Spanish Succession, it had been considered as important as the West Indies.[9] The 1710 capture of Port-Royal and the unsuccessful expedition against Quebec in 1711 were initiated by 'projectors' seeking an expansion of British colonial inter-

ests.[10] A fleet destined for Quebec in 1746 was diverted to Portugal, but in 1748 the popular press asserted 'the necessity of *reducing that place*, in order to make the *British empire in America complete and secure*, and to repay us the expenses of the war in *fishing* and *fur* trades.'[11] At the peace table in 1761 and again in 1763, Britain sought Canada 'entire and unmutilated.'[12]

Like that of India, the Conquest of New France in 1759–60 represented a significant territorial acquisition, complicated by the presence of a population with different political and cultural traditions; and like the fate of the East India Company, Quebec's fate hinged on questions of parliamentary authority and the best way to extract revenue from these new subjects. The Quebec Act of 1774 placed Canada, Labrador, and the Ohio region under the authority of a governor and an appointed 'legislative council.' It left the Catholic Church intact, albeit cut off from France and Rome, and re-established French civil law except in criminal cases. Its failure to make provisions for the Church of England or for any representative institutions provoked public outrage over 'arbitrary government' and drew comparisons with depriving the East India Company of its chartered rights, shutting the port of Boston, and silencing the patriot opposition in Ireland.[13]

This chapter situates the Quebec Act in this wider context of empire, arguing that the Act had its origins in pre-war debates about imperial political economy. The long process of drafting legislation for the colony was complicated less by the problem of governing a French and Catholic population than by broader disagreements about economic integration and the role of the imperial government. There were two versions of British imperialism during the 1760s: one that looked to create relatively autonomous colonies bound to the metropolis by commercial ties, and one that sought to keep colonies politically and economically dependent on the metropolis and separate from one another. After the Conquest of Quebec, the British merchant community there allied itself with the American cause and with powerful interest groups in the City of London. They lobbied to institute English common law and a representative assembly in Quebec to protect their business investments. The Whig administrations of Rockingham and Chatham were sympathetic to these lobbyists, but they were ultimately frustrated by Lord North's Tory ministry and its Whig allies – the 'neo-Tories.' The Quebec Act of 1774 was part of a larger 'neo-Tory' imperial policy that drew on established tenets of political economy to privilege government regulation and captive markets.[14] Both versions of imperialism had roots in

the projects and deliberations of the 1740s and 1750s, when commercial and territorial expansion undermined traditional arguments for the Protestant interest abroad and sharpened economic disagreements about the future of the empire.

Historiographical debates surrounding the Quebec Act have centred on its causal role in the American Revolution, its implications for Catholic toleration, and the extent to which it created fundamental inequalities between French and English populations in Canada. Since American revolutionaries in 1775 labelled the Quebec Act one of the 'Intolerable Acts,' historians of American history have confined themselves to examining whether or not it was.[15] A contrasting story of the Act as forward thinking and conciliatory was enshrined in work of historians such as Reginald Coupland, who presented the bill as a blueprint for the Commonwealth ideal.[16] Canada, it was assumed, stayed British because it was French: religious concessions to the colony won its loyalty even in the face of the Franco-American invasion in 1775, guaranteeing its immunity from revolution and laying the foundations for gradual institutional change and a wholesome, Burkean respect for tradition.

The assertion that the 1760s was a turning point for the toleration arguments among upper-class Britons found reinforcement in the work of Philip Lawson and, more recently, Peter M. Doll. Lawson revived the suggestion that 1774 was a landmark for secularism and toleration; Doll argues that the Act aimed at religious reformation and assimilation, but he presents it within the context of a revived Anglican tradition of sympathy for the Gallican church.[17] The assertion that the 1760s represented a new direction for Catholic policy in 'polite' society has also been given credence by Irish historians.[18]

Canadian historiography has been more critical of the Quebec Act's intentions and consequences. Coupland's Whiggish account was challenged by Hilda Neatby, who drew attention to the ways in which the Act aimed at covert anglicization.[19] During the 1960s, Quebec historians of the 'Montreal school' backed their political claims for greater autonomy with a historical narrative in which Quebec never fully recovered from the political, economic, and cultural impositions of the Conquest. For some historians of the Montreal school, the Act was part of the process by which the British channelled the wealth of the colony to themselves, preventing French Canadians from realizing the same measure of material progress as their English-speaking counterparts.[20] What this nationalist history shares with accounts of British imperial-

ism broadly conceived is the premise that economic nationalism was linked inextricably with religion: that commercial success, Protestantism, and English constitutional 'liberties' were inseparable components of symbolic patriotism and imperial policy.[21]

This chapter contends that, despite the anti-papist rhetoric that dominated the public press in London and New England, the Tory Quebec Act and its abortive Whig predecessors conformed in important ways to pre-war thinking about the necessity of colonial toleration and the role of commercial prosperity in securing imperial allegiance. If Whigs in the 1760s hoped to remake Quebec in the image of the other Atlantic colonies, North's concessions to French religion and law in 1774 masked a policy designed to keep the population isolated, bound to the land, and dependent upon British manufactures. Prosperity, not Protestantism, would secure French loyalty. Attributing the Quebec Act primarily to debates over political economy, rather than over religion, I thus question the traditional linkage of trade, liberty, and Protestantism in the construction of eighteenth-century British imperial patriotism.

'It is very singular how this poor Roman Catholic religion has been treated,' noted Isaac Barré drily during parliamentary debates on the Quebec Act. 'In Maryland it has been tolerated, in Ireland persecuted, in Canada you choose to give it an establishment.'[22] Given demographic realities, however, toleration of Catholics and Dissenters in the colonies had long been the only practical option. When Thomas Sherlock, bishop of London, attempted to transfer the office's traditional responsibility for the colonies to a new, American bishopric in 1748, he was thwarted by Parliament; first minister Henry Pelham thought it would prove too controversial for colonists who worshipped at dissenting churches.[23] The following year, the Board of Trade ignored arguments for the Protestant interest abroad, upholding the Catholic franchise and property ownership that were contested in both Montserrat and Nevis. The Board ruled that, since the pope's authority was no longer considered to extend to temporal matters, allegiance to the Roman Church was thus not in conflict with allegiance to the British Crown. Colonial Catholics could be trusted as loyal subjects so long as their property and economic interests were protected.[24]

In Ireland, too, arguments for Catholic allegiance rested increasingly on their economic stake in the British nation. The penal laws had not uniformly brought about economic deprivation, and by the mid-eighteenth century there was a well-off Catholic merchant class with solidly established business networks in France and a 'hidden interest'

in Irish property. This growing wealth, in combination with divisions among Protestant elites and in turn between these elites and Westminster, allowed for the formation of an effective Catholic lobby. The Catholic Association in Dublin, founded in 1756, was composed largely of merchants and shopkeepers who argued against the penal laws on the ground they had done economic damage to Ireland.[25]

Arguments for political loyalty that favoured commercial and propertied interests over religious ones were made possible by the mid-century expansion of the British Empire and the decline of Jacobitism as a real political threat. By the late 1730s and particularly by the 1740s, a narrowing re-export market and an intensification of European competition saw Britons advancing a program of territorial and commercial expansion in the Atlantic. Colonial merchants and those associated with 'improving' circles in agriculture and manufacture hoped to create captive labour and consumer markets overseas, where they might acquire raw materials and sell finished commodities. Various initiatives from the 1730s through the 1750s looked to the colonies to supply the materials for the manufacture of everything from silk to wine, substituting domestic goods for costly foreign imports. 'What a boundless wealth might be brought into this kingdom, by supplying our plantations with everything they want, and all manufactured within ourselves,' suggested Joshua Gee, a North American merchant, economist, and favoured commercial consultant for the Board of Trade.[26] His colleague, the Whig Member of Parliament and Irish landowner Arthur Dobbs, hoped foreign import substitution would 'put difficulties upon the consumption of wasting and luxurious imports, and give proper encouragement to increase our exports, and to plant, and manufacture at home, that we may lessen our imports from abroad.'[27]

Underscoring these projects was the extension and consolidation of Britain's political control over its territories – what agent John Hanbury called 'the extension of Britain's mild government.'[28] In 1735 Martin Bladen of the Board of Trade informed the duke of Newcastle that there was increasing support for colonial projects, which, like the newly established Georgia, were dependent on Parliament for their charter and subsidies: 'It would seem, by the vast number of papers called for at the latter end of the sessions, that some gentlemen fancy, they should be able to make wonderful discoveries, or at least to bring the whole economy of the plantations out of their ordinary channel, under the immediate inspection of Parliament.'[29] The proposals laid before the Board of Trade and Parliament tended to favour central-

ized metropolitan control of land use and revenue. Retired sea captain Thomas Coram contracted with the Board of Trade to reserve tracts of land for naval stores in the colony of Nova Scotia; when Dobbs and John Hanbury joined forces to establish the Ohio Company, they bypassed the Virginian council, which had traditionally managed land grants for settlement.[30]

Increasingly, projects aimed at creating British wealth relied on non-British variables. The subsidized settlement of North America with skilled foreign Protestants, a growing understanding of the possibilities of African free labour, a diversified interest in aboriginals as a consumer market, and a very public debate over the merits of naturalizing foreign Protestants and Jews to boost British manufacturing and finance all found political economists looking more than ever to the productive and consumptive activities of non-Britons. 'All states which are liberal of naturalization, are fit for empire,' declared one pamphleteer. 'Let us endeavour to increase and multiply and replenish the earth with every stranger who shall choose to reside amongst us.'[31]

Dobbs criticized the Spanish exile of the Jews and Muslims who composed its commercial classes.[32] When the Whig government sought to pass bills for the naturalization of foreign Protestants and Jews in Britain, it cited the improvement of manufacture through new techniques imported from abroad and an increased population whose consumption would provide tax revenue to fund the national debt.[33] When Parliament sought to settle Nova Scotia in 1749, the ministry instructed the Board of Trade to oversee the process of sending agents to Europe to recruit Protestant settlers skilled in 'useful handicraft trades and employments.'[34]

Gee and Dobbs were both keen to make aboriginals 'industrious inhabitants' of the colonies. Dobbs proposed a policy of intermarriage,[35] while Gee praised French policy: 'They persuade as many as possible to be of the French religion; they oblige their people to marry with the Indians, and where they cannot draw them into French customs, they fall into theirs ... in short, they take all measures to become one people.'[36] By the onset of the Seven Years' War in 1756, then, imperial policy was already defined by the pursuit of British economic interests under an increasingly interventionist Parliament to promote foreign import substitution and captive markets.

During the 1740s and 1750s, a constellation of interest groups linked to the independent slave trade was also engaged in projects that extended British commercial influence, but without extending British

territory or British government. When the decaying Royal Africa Company finally ceded its forts and its charter in 1750, it was replaced by a regulated company administered by merchants from London, Bristol, and Liverpool. Where the old company had operated as a joint-stock corporation, trading for itself as a 'body politic and corporate,' the new one simply managed government subsidies to maintain the fort. It was open to any independent slave trader and could not trade on its own account.[37] The British slave trade was becoming less profitable by mid-century, affected by European competition and the narrowing re-export market for British plantation goods. After 1748, a post-war slump in sugar prices affected the demand for slaves and, in turn, the livelihood of slave traders.[38] Thus, the same economic constraints that led some interest groups to propose expansion and settlement as a means to acquire new markets provoked those involved in the African trade to consider alternative avenues for profit. This did not result in a questioning of slave labour on moral grounds, or even necessarily on economic ones, for these traders did not abandon their slaving ventures. But it did cause some to look at the possibility of using African free labour within Africa. Restructuring the slave trade was linked to the same issues of labour and 'industry' that fuelled imperial expansion projects, but unlike these, made settler colonialism and captive markets a secondary concern.

The new African Committee saw possibilities for foreign import substitution even though the forts did not mark any kind of official British colony. The Committee approved an attempt by Thomas Melvil, chief factor at Cape Coast Castle, to plant cotton and indigo. Melvil reported that Manchester textiles sold as well in the region as Indian ones, 'and many more might be introduced had they the material of their manufacture cheaper ... I have ever since I came ashore, been preaching up to the Negroes the advantages which might accrue to them from planting cotton; they have hearkened to my doctrine, and have already begun to clear away the bush about this town, so that next year I expect to see all hands employed in that commodity... In short from the eagerness the Negroes show in planting cotton, I foresee that we may in a few years if we please annihilate the French colonies.'[39] The Committee thought that manufacture might be boosted further if Britain imported the African cotton duty free.[40] Cape Coast Castle should be 'like a fair or marketplace,' agent Thomas Boteler told Melvil. 'If a French ship offers me a good barter am I to tell him, "Sir, you are a foreigner, I can't trade with you, but my neighbour at the Dutch fort is within a pistol

shot of me, I want to recommend you to him"?'[41] Boteler suggested that the superiority of British goods ultimately would put profits in the national favour.[42]

The Committee's proposal assumed a commercial influence in African nations that did not constitute formal colonialism, yet still reaped economic benefit from African free labour and consumption. Indeed, in defending its projects to the Board of Trade, the Committee suggested that Africans could grow crops already produced by British colonies in North America and the West Indies.[43] Many of these merchants collaborated with Arthur Dobbs on his North-West Committee, which sought to end the Hudson's Bay Company monopoly in the same way as it had replaced the Royal Africa Company, thus opening trade to the Hudson Bay region.[44]

These efforts in Africa and in Hudson Bay pointed to the emergence of a new political economy that challenged the traditional 'supply-side' explanations of wealth accumulation.[45] These had focused on supply as the engine of economic growth: a cheap supply of labour was the only means by which British goods could be produced in large and inexpensive enough quantities to undersell their competitors; and the very quantity and availability of goods was the key to their consumption. Foreign import substitution had always privileged availability over taste, assuming that tea brewed from English herbs or wine made from Carolinian grapes was as appealing as the foreign product it replaced. The experiments in Africa and in Hudson Bay proposed something different: that demand was the key to market success. The Manchester textile industry would thrive as long as it sought out African cotton and Africans desired the finished product; there was no need to bring Africans under the regulation of the British government either to boost production or to guarantee consumption.

Political economy had previously operated on the assumption that people would not labour unless necessity forced them to. Joshua Gee, for example, considered it was natural for an individual to work as little as possible so long as his own comfort was ensured, and observed that when corn was cheap, labourers had little incentive to work hard.[46] Political economists had previously assumed that the state needed to devise strategies to force its subjects to work, and in turn to interest them in the commodities that were the produce of this work. If the state aimed at the increase of national wealth, political economists simultaneously feared a prosperous country might become an idle and unproductive one. The government must continue to keep the 'wheel of

commerce' in perpetual motion by keeping as many as possible at work – and buying the fruits of this work.[47]

When John Hardman of the African and North-West Committees testified before Parliament that the goal of the fur trade was to create 'imaginary wants' and 'desires' among aboriginals, however, he was articulating a reversal of this formula: consumption, or demand, was the engine of labour, for these wants and desires would never be satisfied, but 'increase in proportion to his property.'[48] Not only was there something limitless about the capacity of consumer demand, but it would translate into an incentive to be industrious. The merchants on the North-West and African Committees did not assume an inherent idleness; people would labour even when necessity did not force them to. This constituted a shift away from the 'make-work' projects of settler colonialism to an emergent focus on universal demand as the engine of commercial expansion.

The activities of the African and North-West Committees pointed to the emergence of a new political economy that de-emphasized colonial possession under the 'immediate inspection of the state.'[49] These merchants were still slave traders; they were not anti-imperialists. Yet their focus had shifted from colonization to commerce, focusing on free trade, consumer demand, and commodity circulation rather than on captive markets. In the years leading up to the Seven Years' War, those who espoused this new political economy would find leadership under William Pitt the Elder, the wartime secretary of state. Pitt's 'Patriots' outlined their program in the *Monitor* in 1755: the maintenance of British maritime, and hence commercial, supremacy, and a proper definition of the relationship between Britain and its colonies. They embraced a federal union of the North American colonies that would shift colonial regulation away from Westminster.[50]

If the 'Protestant interest' was rendered secondary by these mid-century projects, it was further diminished by the decline of Jacobitism. After the defeat of the Jacobite uprising in 1745, Catholics no longer necessarily posed a threat to the king's supremacy. Certainly the Young Pretender carried little weight in Britain or France at the onset of the Seven Years' War; British Jacobites renounced him and France refused to grant him assistance.[51] Foreign correspondents reassured William Pitt that 'he is not thought of, even by the exiles.'[52] When British politicians learned of French invasion plans from The Hague in 1759, they were assured that the French ambassador considered it 'an affair purely military ... neither the Pretender nor the Protestant religion were con-

cerned in it.'[53] With the Stuarts abandoned by their French and British supporters, the Catholic menace was represented by stateless Jesuits, not Stuart exiles; the Catholic gangs that operated in the Irish country-side during the 1760s, for example, were attributed to the 'swarms of Jesuits' from Rome 'daily flowing into this kingdom.'[54]

The force of anti-Catholicism was thus considerably diminished by the time of the Conquest, and certainly by the time the British government began to work out what to do with Quebec during the 1760s. The waning of anti-Catholicism was aided after the war by a renewed sympathy from the Church of England for the Gallican Church and the decline of papal authority on the Continent.[55] The strident anti-popery trumpeted in the London papers and in parts of America during the Quebec Act debates reflected growing tensions between Protestants as much as animosity towards Catholics. The opposition press may have widely publicized that the Quebec Act was passed on the Pretender's birthday, but it had cautioned before that 'the obsolete name of Jacobitism' had 'too often furnished pretences for extending the powers of the crown, and exposing the liberties of the people to real danger.'[56] In America, dissenting New Englanders preached from the pulpits of Harvard and Yale that the Episcopal Church was a plague on the holy people,[57] taking aim at the Church of England as much as at the Church of Rome. Their increasing political radicalism meant Dissent, not Catholicism, was the breeding ground for sedition: 'It is well known that both in doctrine and discipline, the church is the firmest basis of monarchy and the English constitution; while the various denominations of independents, Quakers, and other Dutch and German sectaries in our colonies are more republican in their principles.'[58] Subversion of state authority, once the preserve of popery, was now potentially Protestant. Catholicism was no longer a special threat.

By the time Wolfe and Montcalm immortalized themselves on the Plains of Abraham in 1759, the various positions that would inform British imperial policy for Quebec were already in place. The decline of Jacobitism and the demographic realities of empire had conspired to weaken arguments for the Protestant interest, underscoring instead the importance of commercial interests in the constitution of political allegiance. Yet the process of imperial expansion had also uncovered different ways to guarantee these interests. Establishment Whigs and Tories wished to create captive markets under the regulation of an interventionist state. Their opposition, linked by the late 1750s to Pittite Whigs and the radical London Toryism of those like planter and politician Wil-

liam Beckford, were committed to British commercial expansion, but emphasized the binding ties of commerce over direct rule. Although these positions would sharpen and harden after 1763, the debates over Quebec demonstrated a fundamental continuity from them.

The initial reports on Canada's economic potential were extremely favourable. General James Murray, the interim military governor and later the colony's first civil governor, reported in 1762 that the region's natural resources and agricultural potential might be 'an inexhaustible source of wealth and power to Great Britain.' He suggested that France had not realized the full commercial potential of the province by allowing most of its trade to be carried on under monopolies and by diverting its population for military manoeuvres. Murray warned that the *Canadiens* were 'very ignorant and extremely tenacious in their religion; nothing can contribute so much to make them staunch subjects to his Majesty as the new government giving them every reason to imagine no alteration is to be attempted in that point.'[59] The 1763 Proclamation accordingly did not touch the Canadian church, but it did encourage settlement and investment by granting the immediate protection of British law until more permanent arrangements might be made.

Despite Murray's caution, initial problems in Canada had little to do with the Catholic population. They were caused instead by tensions between the British inhabitants. The English-speaking population of Canada following 1763 was composed of military men and merchants; Murray described them, respectively, as 'a conquering army who claim a sort of right to lord it over the vanquishees' and 'a set of free British merchants, as they are pleased to style themselves, who with the prospect of great gain have come to a country where there is no money, and who think themselves superior in rank and fortune to both the soldier and the Canadian, deeming the first voluntary and the second born slaves.'[60]

These 'free British merchants' felt their business interests and investments unprotected, first by military courts and later by French civil law.[61] They took Murray's civil commission of 1764 as a continuation of military rule, as it established no representative institutions in the province, and they had the backing of a powerful London interest group: the City and its merchants, who joined them in insisting that only a civil establishment along the lines of the American colonies could reassure merchants of a secure return on their ventures and provide the means of recovering debts.[62] Their joint petitioning campaign of 1765 insisted that Murray and his officers had acted to discourage commerce, thus

impoverishing the province, and the precarious nature of trade there required large extensions of credit.[63] The unrepresentative nature of authority in the colony rendered property insecure and damaged the chances of commercial development.[64]

The Rockingham administration, and the Chathamite one that followed, took the colonial and metropolitan lobbyists seriously and were sympathetic to the idea that Quebec should be given the institutions of its southern neighbours. The rapid turnover of ministries during the 1760s, the alliance between Rockingham and the duke of Newcastle, and the personal conflicts of William Pitt, should not obscure broad arenas of agreement between these 'new Whigs.' This umbrella accommodated politicians attentive to the limits of state and sceptical that colonial dependence was the only profitable economic relationship for Britain and its overseas territories. They were dedicated to British institutions but comfortable with colonial political autonomy, agreeing that commercial ties were sufficiently binding. The earl of Shelburne termed this 'negative government' – a Parliament cautious in its exercise of authority.[65]

The economic commitments of this new Whiggery owed much to mid-century interest groups that had moved away from ideas about colonial dependence. Both ministries preferred to recognize colonial autonomy in Quebec rather than exercise direct parliamentary authority. They looked to establish a representative assembly and to implement British common law to protect credit and realize the commercial potential of the colony. The Rockingham government's key advisor on Quebec was the colony's attorney general, Francis Maseres, the son of French Huguenots and in favour of a legislative assembly composed of both French and English inhabitants.[66] When Shelburne drafted a revised plan for Quebec in 1767 under Chatham, he deviated very little from the recommendations Maseres had made to Rockingham.

During the Stamp Act controversies in 1765 and 1766, Shelburne became convinced that the most important ties between America and Britain were commercial, not political, and he accordingly paid attention to making Quebec commercially viable. Though he acknowledged 'the power of Parliament to be supreme,' he asked his political opponents that 'the expedience of the act be considered in a commercial view, regard being had to the abilities of the Americans to pay this tax [the Stamp Duties], and likewise the consequences likely to proceed.' The Romans, he argued, had 'planted colonies to increase their power; we to extend our commerce. Let the regiments in America, at Halifax

or Pensacola, embark at once upon the same destination, and no inter-
vening accident disappointing the expedition, what could be effected
against colonies so populous and of such magnitude and extent? The
colonies may be ruined first, but the distress will end with ourselves.'[67]

When framing his legislation for Quebec, Shelburne sought to cater
to demands of the merchant communities in London and Montreal –
specifically by supporting an open trade with the aboriginals, and more
generally by establishing an assembly and a court system that would
encourage and protect investments in the colony.[68]

Proposed legislation for Quebec under the Whig administrations of
the 1760s, then, aimed to integrate Quebec into what was hoped would
become a typical British Atlantic colony and to cater to the demands of
the merchant community and its metropolitan supporters, who looked
to British institutions to secure property and credit. Their recommenda-
tions to establish English law were calculated to lay the foundations for
a prosperous and autonomous commerce.

Political shuffling, however, stalled the passage of any Quebec leg-
islation until Lord North's Tories came to power in 1770. North com-
missioned his stepbrother, Lord Dartmouth, to draft a bill for Quebec
in 1772. Dartmouth's act differed in significant respects from the plans
introduced in the 1760s. It made no provision for Protestant clergy, re-
stored French civil law in all but criminal cases, and greatly extended
the province's boundaries to include much of what is now Ohio. It also
took no account of the petition Maseres had presented to Dartmouth
and to the king that January on behalf of the 'freeholders, merchants,
and traders' of the colony, which called for an assembly of French- and
English-speaking inhabitants to facilitate 'the extension of its trade and
navigation.'[69] Dartmouth opted instead for a legislative council, com-
posed of Catholics and Protestants but appointed by, and sitting at the
pleasure of, the governor.

The Quebec Act did not aim, as its abortive predecessors had done, at
encouraging the colony's commercial integration into Britain's Atlantic
empire, but at keeping it isolated – and thus politically and economi-
cally dependent upon the metropolis. The engineers of the 1763 Procla-
mation line had been motivated by fear that distant settlements might
begin manufacturing for themselves, lessening their economic and, in
turn, their political dependence on Britain. They hoped that settlers,
restricted by the Proclamation, would now 'emigrate to Nova Scotia or
to the provinces on the southern frontier, where they would be useful
to their mother country, instead of planting themselves in the heart of

America, out of the reach of government, and where, from the great difficulty of procuring European commodities, they would be compelled to commence manufactures, to the infinite prejudice of Britain.'[70] Similarly, Lord Hillsborough worried that new westerly colonies that began manufacturing 'might lay the foundation of a power in the heart of America which might be troublesome to the other colonies and prejudicial to our government over them';[71] in 1772 he would resign over just this issue.

This was 'neo-Tory' imperialism. If new Whigs like Shelburne were cautious about exercising the rights of Parliament and preferred to maintain a reciprocal commercial relationship with the colonies, their opponents considered the only beneficial commercial relationship to be one in which colonies supplied raw materials and purchased finished goods. In the 1760s, George Grenville had spoken of 'new "toryism"' to distinguish the emerging party from Tories who followed Pitt.[72] Neo-Tories included Whigs like Hillsborough and Grenville himself, who looked to maintain American dependence; their political economy was rooted in the establishment tradition of captive markets and an interventionist Parliament.

Indeed, the East India Company controversies of the 1760s and 1770s stemmed from similar disagreements about the exercise of parliamentary authority. The right of the Company to the territorial revenues it collected in Bengal sparked debate about where the rights of the state ended and corporate rights began. In the aftermath of the Seven Years' War, concern over abuses of power by Company servants prompted calls for a parliamentary enquiry. By 1773, Westminster's move to control Indian revenue provoked accusations that Parliament was using Company mismanagement as an excuse for interfering with the Company's private property. North's opponents in the popular press warned that the preservation of property should be the end of government and that, if 'the weight and influence of the East India Company be wholly thrown into the scale of government, it may be the means of entirely overturning the English constitution.'[73]

As with the Stamp Act, the question was not so much if Parliament had the authority to collect revenue, but whether and when it should exercise that right. In 1773 a letter in the *Public Ledger* explained, 'We are not enquiring what a Parliament may arbitrarily, but what it can constitutionally perform. It is a sophism to confound the legality with, if I may so speak, the constitutionality of a proceeding. An Act may be legal, as having passed the necessary forms of the legislature, but in its

principles and tendency it may be contrary to the fundamentals of the constitution.'[74] Thus Pitt (now Lord Chatham) supported the East India Company's right to retain a portion of the revenues it collected.[75] He and Shelburne agreed that parliamentary sovereignty should manifest itself as 'guardian of charters, whose objects must ever be held sacred ... in the case of the India Company, an honest administration of the exclusive trade.'[76] Indeed, Quebec and India were twinned in the public imagination: the popular press drew on criticisms of Indian policy when it denounced the Quebec Act as an act of arbitrary government and encroachment on private property.[77]

For neo-Tories, an interventionist Parliament was also a paternal one, using its authority to define the public interest. The increasing dissent of the American colonies during the 1760s made the very practice of petitioning and lobbying contentious, as did domestic issues like the arrest of MP John Wilkes and uncertainty about the legality of his subsequent re-election in Middlesex.[78] Edmund Burke might point out that the House of Commons was 'the child of resistance,' but for neo-Tories, resistance was dangerous: 'the people have a right to petition, but no part of the people have a right to petition in libellous terms upon the parliament.'[79] In the case of Quebec, their assertions were justified by the way in which public interest groups increasingly identified themselves with extra-parliamentary power. The Quebec Grand Jury, for example, comprising the most vocal members of the colony's commercial lobby, declared itself an actual representative institution and in 1764 granted itself political authority on the strength of its claims to represent the public interest. If Whigs continued to try to work with these groups throughout the 1760s, neo-Tories looked to counter what they considered a dangerous rival to parliamentary sovereignty.

Neo-Tory policy in Quebec was of a piece with controlling East India Company revenues and curtailing the local autonomy of the other American colonies. It discouraged British settlement and commercial traffic with the other colonies, hoping to prevent manufacturing competition and reinforce metropolitan authority by keeping Quebec isolated, sparsely populated, and dependent on British manufactures. William Knox, former colonial agent and pamphleteer for the Grenville and North administrations, thought the French should remain 'as much as possible separate people, and without any great intercourse with the old colonies, for the intermixing with them can serve no commercial purpose.'[80] Four years earlier Governor Guy Carleton had expressed to Hillsborough his concern that British merchants might use Eng-

lish law to take advantage of the *Canadiens*; and when Shelburne had drafted his act, Carleton had advised leaving Canadian laws intact.[81] Dartmouth agreed, but he further intended that French civil law and religion should prove an effective deterrent to British emigration. The English-speaking population would be forever a deliberate minority: 'it is not wished that British subjects should settle that country. Nothing can more effectually tend to discourage such attempts.'[82]

Concessions to French traditions thus masked the goal of keeping Canada politically and economically dependent: North took seriously Murray's prediction that 'turning the thoughts of the people towards the cultivation [of hemp and flax]' would remake Canadians into industrious subjects and consumers. Agriculture would distract them from their previous military lives and the rudimentary manufactures they engaged in. They would then become dependent upon 'those of a better sort manufactured and imported from Great Britain.'[83] North was quick to suggest that increased commerce in the province was due not to the activities of British merchants, but to an intensification of agriculture. When witnesses were called before Parliament during the Quebec Act debates in 1774, North asked Carleton if Canadians were not 'happier' since they had been freed of their military commitments to France and given leisure to properly cultivate their land.[84]

For the opposition, the failure to establish common law was the most contentious part of the Act. With property disputes both landed and commercial at the discretion of judges with no jury, Whigs considered the bill an endorsement of arbitrary authority and a threat to commercial expansion. When the Bill reached the House of Commons in May 1774, Burke called the legal settlement the 'most material part of the bill,' and the opposition was quick to name juries as the most important part of the constitution.[85] Bound up with the charge of arbitrary government was the powerless, un-elected legislative council. 'We find the King's pleasure twisting itself about every fibre of this bill,' declared Burke.[86] Divisions fell out along the expected party lines, with Chathamite and Rockingham Whigs forming the bulk of the opposition in both houses.

The opposition found support out-of-doors. After the second reading, Herbert Mackworth presented a petition from the London merchants trading to Quebec that protested that any capital hazarded or property purchased was now to be decided upon without benefit of a jury. The merchants' counsel, James Mansfield, testified before the House that the trade of the province had steadily increased since 1763, but would

now be threatened by the reintroduction of French law.[87] 'Two-thirds of the whole trading interest of Canada are going to be deprived of their liberties, and handed over to French law and French judicature,' Burke asserted. 'No English merchant thinks himself armed to protect his property, if he is not armed with English law.'[88] Serjeant Glynn suggested that the loyalty of the *Canadiens* could be inspired only through their full integration into British institutions: 'Without they possess the highest sense of civil rights, they can never be good friends with us, or good subjects of the King.'[89]

The problems of civil law were compounded by the new boundary, which extended the province's jurisdiction far beyond the French settlements at Quebec City, Montreal, and Trois-Rivières. Burke called it 'a line which is to separate a man from the right of an Englishman.' George Johnstone more prosaically warned North that he was 'going to extend a despotic government over too large a surface.'[90]

The Quebec Act passed, but the controversy it stirred up did not. In January 1775 the Quebec merchants prepared a petition that Francis Maseres presented to the king and to Lord Camden and Sir George Savile, who put it before the Lords and the Commons, respectively.[91] These merchants claimed that, by 'purchasing houses and lands, and carrying on extensive trade, commerce, and agriculture,' the 'value of the lands and wealth of its inhabitants are more than doubled.'[92] They called for the Act's repeal on the grounds it failed to protect their livelihoods: to be under French law 'was disgraceful to them as Britons, and ruinous to their properties, as they thereby lost the invaluable privilege of trial by jury.'[93]

There were two distinct British imperialisms after 1763: the neo-Tory ideal of an empire bound by metropolitan authority and paternal politics, and the new Whig vision of an empire bound by mutual commercial relationships and functioning through the mechanisms of interest politics. Both owed their origins to pre-war debates over political economy. The former based its economic considerations on the traditional mechanisms of foreign import substitution and captive markets, conducted under the auspices of an interventionist Parliament. The latter argued against economic dependence, believing Britain might still derive economic benefit from colonies that reserved a measure of political and economic autonomy. In Quebec, new Whig attempts to create a colony integrated into Atlantic commerce and to maintain the support of mercantile interest groups at home and abroad were ultimately superseded by neo-Tory legislation that kept Canada isolated and dependent.

The Quebec Act's significance lay in its success at enforcing a particular political economic vision of empire. In this chapter, I have sought to articulate the origins of this legislation: to present it as one product of a long-term and ongoing debate about empire. New Whigs might downplay the economic dependence that neo-Tories sought to enforce, but arguments for the Protestant interest abroad had long been replaced by arguments for commercial interest as the foundation of political allegiance. The state's encouragement and protection of economic participation in the empire guaranteed loyalty in a way that transcended any article of religion. This idea gained further currency as the political threat of Catholicism receded after 1745. The assumption that commerce, liberty, and Protestantism were inseparable components of British imperial patriotism becomes untenable when it is considered that both Whig and Tory visions of Quebec's future were predicated on its prosperity, not its Protestantism.

NOTES

1 This phrase was coined by David Armitage in *The Ideological Origins of the British Empire* (Cambridge: Cambridge University Press, 2000), 8.

2 Quoted in Hilda Neatby, 'Chief Justice William Smith: An Eighteenth Century Whig Imperialist,' *Canadian Historical Review* 48 (1947): 49.

3 Philip Lawson, '"Sapped by Corruption": British Governance of Quebec and the Breakdown of Anglo-American Relations on the Eve of Revolution,' in Philip Lawson, *A Taste for Empire and Glory: Studies in British Overseas Expansion, 1660–1800* (Great Yarmouth, UK: Variorum, 1997), 303.

4 Governor Murray to the Board of Trade, 2 September 1764, United Kingdom National Archives (hereafter cited as UKNA), CO 42/1/2, f. 401.

5 Water Murray to James Murray, 15 March 1767, Library and Archives Canada (hereafter cited as LAC), Murray Papers, MG 23 G II 1.

6 *The Maseres Letters, 1766–1768*, ed. W. Stewart Wallace (Toronto: Oxford University Press, 1919), 74, 97.

7 Colonel Samuel Martin to Samuel Martin, Jr, 12 February 1762, British Library Additional Manuscripts (hereafter cited as BL Add. Ms.) 41347, f. 122.

8 Louis-Joseph de Montcalm to M. Berryer, Ministre de la Marine, 4 April 1757, LAC, MG 23 A1, vol. 2, ff. 1400–1. The French determination to keep some toehold in the fisheries – 'which they were ready to receive on almost any terms that England would prescribe' – only convinced British officials of their value; see Hans Stanley to William Pitt, 6 August 1761, BL Add. Mss. 36798, f. 154.

9 William Thomas Morgan, 'The South Sea Company and the Canadian Expedition in the Reign of Queen Anne,' *Hispanic American Historical Review* 8 (May 1928): 161.

10 J.D. Alsop, 'The Age of the Projectors: British Imperial Strategy in the North Atlantic in the War of the Spanish Succession,' *Acadiensis* 21, no. 1 (1991): 34.

11 *London Evening Post*, 23–25 February 1748, emphasis in original.

12 Charles Yorke to Lord Hardwicke, 17 April 1761, BL Add. Ms. 35351, f. 181.

13 *Gazetteer and New Daily Advertiser*, 30 May 1774; *London Evening Post*, 4–7 June, 14–18 June 1774.

14 I owe the term 'neo-Tory' to conversations with James Vaughn (University of Texas, Austin). The term is based on George Grenville's distinction between Tories such as the earl of Bute and Tories such as William Beckford, who supported William Pitt. I use it here to describe not only Tories like Bute or Lord North, but also politicians with Whig credentials and background who supported an interventionist Parliament – Whigs like Grenville himself.

15 For the Quebec Act as a cause for the American Revolution, see Carl Bridenbaugh, *Mitre and Sceptre: Transatlantic Faiths, Ideas, Personalities and Politics, 1689–1775* (Oxford: Oxford University Press, 1962); and Charles H. Metzger, *The Quebec Act: A Primary Cause of the American Revolution* (New York: United States Catholic Historical Society, 1936), 202–6.

16 Reginald Coupland, *The Quebec Act: A Study in Statesmanship* (Oxford: Clarendon Press, 1968).

17 Philip Lawson, 'A Perspective on British History and the Treatment of Quebec,' in Lawson, *Taste for Empire and Glory*, 266; idem, '"Sapped by Corruption,"' in Lawson, *Taste for Empire and Glory*, 309–10; and Peter M. Doll, *Revolution, Religion, and National Identity: Imperial Anglicanism in British North America, 1745–1795* (Cranberry, NJ: Associated University Presses, 2000), 22–30, 137–40, 149–53.

18 See Thomas Bartlett, *The Rise and Fall of the Irish Nation: The Catholic Question, 1690–1830* (Dublin: Gill and Macmillan, 1992), 66–73.

19 Hilda Neatby, *Quebec: The Revolutionary Age, 1760–1791* (Toronto: McClelland and Stewart, 1966), 139–41, 262–3.

20 The 'Montreal school' positioned itself against the 'Laval school,' which disagreed with the need for greater political autonomy and emphasized that Quebec had created its own problems. The Church, not the Conquest, doomed French Canadians to enjoy a lesser share of Canadian prosperity and political reward. See Ronald Rudin, *Making History in Twentieth-Century Quebec* (Toronto: University of Toronto Press, 1997), 93–6. Historians of

the Montreal school included Guy Frégault, Maurice Séguin, and Michel Brunet. Brunet argued that the Quebec Act was part of the process by which British merchants stripped a conquered people of its wealth; see *Les Canadiens après la Conquête, 1759–1775* (Ottawa: Fides, 1969), 288–9.

21 See Linda Colley, *Britons: Forging the Nation 1707–1837* (New Haven, CT: Yale University Press, 1992), esp. chaps. 1 and 2; and Kathleen Wilson, *The Sense of the People: Politics, Culture, and Imperialism, 1715–1785* (Cambridge: Cambridge University Press, 1998), chap. 3.

22 *Debates of the House of Commons in the Year 1774, on the Bill for Making More Effectual Provision for the Government of the Province of Quebec. Drawn Up From the Notes of Sir Henry Cavendish*, ed. J. Wright (1839; Toronto: S.R. Publishers, 1966), 41.

23 See 'Some considerations humbly offered by Thomas Bishop of London, relating to Ecclesiastical Government in his Majesty's Dominions in America, to the King in Council,' Lambeth Palace Library (hereafter cited as LPL), Society for the Propagation of the Gospel (SPG) Papers, vol. 10, ff. 112–13. For Henry Pelham's reaction, see his letter to his brother the duke of Newcastle, 21 May 1750, BL Add. Ms. 35423, f. 94.

24 For arguments in favour of Catholic loyalty, see the defence of colonial agents and solicitors from Montserrat and Nevis in *Journal of the Commissioners of Trade and Plantations*, vol. 9 (London: His Majesty's Stationery Office, 1938), 234, 239, 243; for the Board's agreement, see 279, 450.

25 Bartlett, *Rise and Fall of the Irish Nation*, 46–8, 53.

26 Joshua Gee, 'Preface," in *The Trade and Navigation of Great Britain Considered* (London: Samuel Buckley, 1729).

27 Arthur Dobbs, *Essay on the Trade and Improvement of Ireland* (Dublin: A. Rhames, 1729), 13.

28 'Petition of John Hanbury to the Privy Council,' 9 February 1748, UKNA, CO 5/1327/1, f. 27.

29 Martin Bladen to the duke of Newcastle, 10 June 1735, Calendar of State Papers Colonial (hereafter cited as Cal. S.P. Col.), 41, 458.

30 'Petition of John Hanbury to the Privy Council.' See also Alfred James, *The Ohio Company: Its Inner History* (Pittsburgh: University of Pittsburgh Press, 1959), 11.

31 *Reflections Upon Naturalization, Corporations, and Companies, by a country gentleman* (London: M. Cooper, M. Cook, and J. Barnes, 1753), 6, 15–17.

32 Arthur Dobbs, 'On making new settlements,' n.d. [1748?], Public Record Office of Northern Ireland (hereafter cited as PRONI), D/162/45. Toleration was not strictly new as an economic argument; see William Petty, *Political Arithmetic* (1690), in *The Economic Writings of Sir William Petty*, vol.

1, ed. Charles Henry Hull (New York: Augustus M. Kelley, 1963), 262–3. Petty argued that liberty of conscience was a stimulus to wealth because Dissenters were naturally industrious people and because the heterodox of a nation were always the most commercial – Jews in Venice, Christians in Turkey, Huguenots in France. He further argued that the employment of large numbers of clergy to enforce uniformity diverted hands from other more productive activities.

33 *Cobbett's Parliamentary History of England, From the Earliest Period to Year 1803*, vol. 14 (London: T.C. Hansard, 1819), 135–6, 1378, 1386–7, 1396, 1416.

34 *Journal of the Commissioners of Trade and Plantations* (see note 24), vol. 9, 51.

35 Dobbs to Sir Robert Walpole, c. 1727, PRONI D/162/21; Dobbs, 'On making new settlements,' n.d. [1748?], PRONI D/162/45.

36 Gee, *Trade and Navigation of Great Britain Considered*, 36.

37 'Representation of the London merchants to the Board of Trade,' 7 December 1749 and 8 January 1750, UKNA, CO 388/44, Cc 53, 60; 'Representation of the Liverpool merchants to the Board of Trade,' 24 October 1749, UKNA, CO 388/44, Cc 54; and 'A Scheme for Securing, Improving, and Extending the Trade to Africa for the Benefit of All His Majesty's Subjects, from the merchants of Bristol to the Board of Trade,' 1 November 1749, UKNA, CO 388/44, Cc 58.

38 Richard B Sheridan, *Sugar and Slavery: An Economic History of the British West Indies, 1623–1775* (Epping, UK: Robert MacLehose, 1974), 439.

39 Thomas Melvil to the Committee of the Company of Merchants Trading to Africa, 23 July 1751, UKNA, CO 388/45/1, f. 137.

40 Thomas Boteler to Thomas Melvil, [1751], UKNA, CO 388/45/2, f. 1.

41 Thomas Boteler to Thomas Melvil, 23 July 1751, UKNA, CO 388/45/1, f. 126.

42 Ibid., f. 128.

43 Ibid., f. 271.

44 For an account of Dobbs's relationship with the Hudson's Bay Company and his search for the Northwest Passage, see E.E. Rich, *The Hudson's Bay Company, 1670–1870*, vol. 1 (Toronto: McClelland and Stewart), 564–71.

45 Recent attempts to marry the changing cultural meanings of consumption – in the British context, generally a focus on social mobility and 'politeness' – with economic growth during the period have concluded that the engine of this growth was demand, or desire; see Jan deVries, *The Industrious Revolution: Consumer Behaviour and the Household Economy, 1650 to the Present* (Cambridge: Cambridge University Press, 2008). Maxine Berg has demonstrated that imitation and innovation were entwined in the eighteenth-century cycle of consumption and production: the demand for cer-

tain kinds of luxury goods spawned new technologies of production, new commodities, and new definitions of fashion and desirability; see *Luxury and Pleasure in Eighteenth Century Britain* (Oxford: Oxford University Press, 2005).

46 Gee, *Trade and Navigation of Great Britain Considered*, 38.

47 For the 'wheel of commerce' and its distribution of wealth, see 'Preface,' in ibid.

48 'Report from the Committee Appointed to Inquire into the State and Condition of the Countries adjoining to Hudson's Bay, and of the Trade Carried on There,' 1749, Beinecke Library, Yale University, Transcript of the examination of witnesses, 55–6.

49 Dobbs, 'On making new settlements,' [1748?], PRONI D/162/45.

50 *Monitor*, 16 August 1755.

51 Thomas Birch to Viscount Royston, 22 August 1761, BL Add. Ms. 4234B, f. 73.

52 Hans Stanley to William Pitt, 12 June 1761, BL Add. Ms. 36798, f. 44.

53 'Dispatch from The Hague, encl. Hardwick to Viscount Royston,' 8 June 1759, BL Add Ms 35351, f. 70.

54 William Henry to Archbishop Thomas Secker, 16 April 1765, LPL, Secker Papers, vol. 2, ff. 241, 243–4.

55 Archbishop William Wake, who framed the Minorcan settlement in 1713, had hoped with his correspondents at the Sorbonne for intercommunion and a mutual recognition of ministry between 1717 and 1720. In 1766 Archbishop Thomas Secker defended Wake's vision by stressing the Church of England's essential continuity with the pre-Reformation church; see Doll, *Revolution, Religion, and National Identity*, 22–7. Papal power seemed to be giving way to state power when the Jesuits were expelled from Spain, Naples, and Sicily in 1767 and papal estates annexed in France in 1768.

56 *London Evening Post*, 9–11 June 1774; *Monitor*, 16 August 1756.

57 Metzger, *Quebec Act*, 32–4.

58 'A brief account of the state of the Church of England in the British Colonies of North America,' Dr. Smith for the Bishop of London, 1762, LPL, SPG Papers, vol. 10, ff. 165–6.

59 'General Murray's Report of the State of the Government of Quebec in Canada,' 5 June 1762, BL Add. Ms. 21667, ff. 22–3, 25, 27–8.

60 Murray to the Board of Trade, 24 April 1764, UKNA, CO 42/1/1, ff.152-3.

61 Francis Maseres to Richard Sutton, 14 August 1768, in *Maseres Letters* (see note 6), 113.

62 See *Lloyd's Evening Post*, 1 April 1765; *London Chronicle or Universal Evening Post*, 2 April 1765; *Gazetteer and New Daily Advertiser*, 3 April 1765; 'Memo-

rial and Petition from the Merchants and traders of the City of London trading to Canada on behalf of themselves and others,' 19 April 1765, UKNA, CO 42/2, f. 102; 'Petition of British merchants and traders in behalf of themselves and their fellow subjects, inhabitants of your Majesty's Province of Quebec,' 10 June 1765, UKNA, CO 42/2, f. 127; and 'Petition of the merchants and others now residing in London interested in and trading unto the Province of Canada in North America,' 10 June 1765, UKNA, CO 42/2, f. 130.

63 Ibid.

64 'Memorial of Fowler Walker to the Board of Trade, agent on behalf of the merchants, traders, and others the principal inhabitants of the cities of Quebec and Montreal,' 10 June 1765, UKNA, CO 42/2, f. 113.

65 *Life of William, Earl of Shelburne, Afterward First Marquess of Lansdowne. With Extracts from his Papers and Correspondence*, 2nd ed., vol. 1, ed. Lord Fitzmaurice (London: Macmillan, 1912), 253.

66 Maseres to Charles Yorke, 27 May 1768, in *Maseres Letters* (see note 6), 91.

67 *Life of William, Earl of Shelburne,* (see note 65), 253.

68 Ibid., 187, 302–3.

69 See Francis Maseres, *An account of the Proceedings of the British, and other Protestant inhabitants, of the Province of Quebec, in order to obtain a House of Assembly in that Province* (London: B. White, 1775), 11–12, 19.

70 James Harris, 'Hints relative to the division and government of the newly conquered and acquired countries in America,' 1 June 1763, William Clements Library, University of Michigan, Shelburne Papers 48/45.

71 Quoted in *Life of William, Earl of Shelburne* (see note 65), 303.

72 Quoted in John Brewer, *Party Ideology and Popular Politics at the Accession of George III* (Cambridge: Cambridge University Press, 1976), 102.

73 *Morning Chronicle, and London Advertiser*, 7 May 1773.

74 *Public Ledger*, 10 March 1773.

75 Lucy S. Sutherland, *The East India Company in Eighteenth-Century Politics* (Oxford: Clarendon, 1952), 152.

76 Quoted in *Life of William, Earl of Shelburne* (see note 65), 451.

77 *London Evening Post*, 14–18 June 1774.

78 Alison Gilbert Olson, *Making the Empire Work: London and American Interest Groups, 1690–1790* (Cambridge, MA: Harvard University Press, 1992), 149.

79 Quoted in the diary of Sir Henry Cavendish, 24 January 1770, British Library, Egerton Manuscripts, 3711, ff. 83–4, 14.

80 William Knox, 'Hints respecting the settlement of our American colonies,' 1763, William Clements Library, University of Michigan, Shelburne Papers, 48/42.

81 Carleton to Hillsborough, 28 March 1770, UKNA, CO 24/7, f. 131; Carleton to Shelburne, 24 December 1767, UKNA, CO 24/7, f. 55

82 Dartmouth to Hillsborough, 7 May 1774, LAC, Dartmouth Papers, vol. 2, MG 23 A1, f. 2038.

83 'General Murray's Report,' f. 26.

84 *Debates of the House of Commons in the Year 1774* (see note 22), 104–6.

85 Ibid., 217, 233; see also arguments by Serjeant Glynn and William Johnstone, 260, 283.

86 Ibid., 217.

87 Ibid., 98.

88 Ibid., 288.

89 Ibid., 259.

90 Ibid., 192, 186.

91 Maseres, *Account of the Proceedings*, 238–9. French Canadians were solicited to join in the preparation of this petition; according to Thomas Walker, a number did in fact back English law as giving 'free scope to their industry,' but were discouraged by their superiors (133–4).

92 Ibid., 239.

93 *Debates of the House of Commons in the Year 1774* (see note 22), iv–v.

9

The Conquered and the Conqueror: The Mutual Adaptation of the *Canadiens* and the British in Quebec, 1759–1775

DONALD FYSON

In much of the historiography of post-Conquest Quebec, the period from 1759 to 1775 is often presented as an unfortunate interlude leading up to the Quebec Act. The 1759–64 military regime, for example, while often mentioned, has been the subject of relatively little detailed study and no satisfactory overview,[1] while the first decade of civil rule is presented largely as a time of confusion and conflict, only resolved by the Act itself and the subsequent recasting of politics and governance in the colony. This chapter re-evaluates those critical years from the perspective of the European settlers in the new colony of Quebec, both *Canadien* and British.[2] By focusing on everyday practices and structures rather than on political discourse, it highlights the practical and utilitarian nature of the mutual adaptation that characterized the newly conquered society. Above all, it seeks to strike a balance between what one might call the jovialist and the miserabilist schools of interpretation that have hitherto dominated the discussion.

That the British Conquest of Quebec was a traumatic event for the *Canadien* population is beyond doubt. And that it is still seen today as a traumatic event by some is also evident. Perhaps because of this, academic historians in Quebec have tended to avoid the Conquest in recent years. Though it is perhaps an overstatement to assert that 'There are no longer any Conquest specialists in the major Quebec universities,'[3] there are some elements of truth to this. Take studies of the period immediately following the Conquest, before the Quebec Act. On the one hand, in the two decades from 1989 to 2008 (before the current crop of publications associated with the anniversaries of 1759 and 1760), almost forty Quebec-based academic scholars published studies based on original research that dealt to a significant extent with the effects of

regime change during this crucial first period of British rule. However, the total production amounted to perhaps twenty books (most of which dealt only in part with the period), fifteen articles, and ten theses, or about two studies per year. Further, of these various studies, only about ten dealt exclusively with the period 1759 to 1775. To these Quebec-based scholars and writings, one might add a little under half as many again from outside Quebec.[4] Further, it is revelatory that over a third of these fifty-five or so scholars were not francophones but anglophones, mostly from outside Quebec. As well, only three of the Quebec authors were permanent faculty in Quebec history departments, the others being either graduate students or faculty from other disciplines such as literature or law. It really does seem as if Quebec historians have largely (though not entirely) lost interest in the period.

This relative reticence of Quebec academic historians to engage in detailed studies of the post-Conquest period has partly to do with the intense popular politicization of the history of the Conquest, which, as others have shown, has carried on down to this day.[5] But equally important, there may well be the impression that the subject has already been done to death, in the epic battles between the Montreal and Laval schools over the bourgeoisie and the effects of the Conquest.[6] As the major protagonists in the Montreal-Laval controversy have left the stage, the scholarly debate has largely died out.

And yet, there is still a great deal we do not know about the post-Conquest period, and a great many misconceptions still circulate, even in scholarly circles. Consider the following recent statements regarding the relationship between state and society in the post-Conquest period, taken from various syntheses published in the last two decades: 'Language of the administration and the clergy under the French régime, written French had nothing more, from 1760, than a private existence.'[7] 'The language of the law was therefore exclusively in English, and French henceforth only existed as a language of translation.'[8] 'The legislative, administrative, and judicial branches of [the pre-Conquest] legal order collapsed, for the most part, as a matter of law, with the change of sovereignty in 1763 and, as a matter of fact, had already ceased to function during the military government that preceded it (1760–64).'[9] 'The province's inhabitants resisted ... the new judicial structure by having massive recourse to arbitration so as to resolve their disputes.'[10] 'The Test oath was imposed on anyone who wanted to exercise an official function in the colony. Catholic, the Canadiens were thus ... automatically excluded from all administrative and judicial functions.'[11]

'Catholicism technically precluded jury service, thus excluding Ca-
nadiens from a fundamental element of English justice.'[12] 'Canadien
society was not yet participant ... Politics, apart from very sporadic dis-
obedience, was beyond the ken of the habitant.'[13] 'The group selected to
serve as the intermediaries between the occupying power and the pop-
ulation was not the British settler minority in French Canada but the
French-speaking Catholic clergy.'[14] All of these statements are at best
misleading and at worst entirely false. And they are not simply the sort
of ordinary empirical errors to which all historians are subject. Rather,
they are the basis for broad conclusions regarding the nature of the re-
lationship between state and society in post-Conquest Quebec. Still, it
is generally not their authors who are at fault, for most are simply syn-
thesizing previous work. Instead, it is the basic empirical research that
has largely gone by the wayside, as few scholars have been interested
in revisiting the historiography or even the archives.

One way to renew the Conquest debate is to move beyond the sorts
of polar opposites that have tended to dominate the debate, especially
in public but also within the scholarly community: binaries such as con-
tinuity/change, tolerance/intolerance, generosity/oppression, domi-
nation/subordination, and the like. These are often inadequate to take
into account the vast complexities of a regime change that involved
not just the replacement of one crown by another, or the substitution
of one ruling group by another and subsequent simplification of *Cana-
dien* society (as the classic decapitation thesis would have us believe).[15]
This chapter is thus built around the notion of mutual adaptation, as
it allows for a richer, more nuanced view of the process by which the
Canadien and British populations reacted to and attempted to shape the
new realities that followed the military conquest of 1759–60 and the
diplomatic cession of 1763. Mutual adaptation fundamentally implies
compromise, which implies complexity. It thus inevitably undermines
the simplistic conflict perspective that has dominated much of the long-
popular miserabilist take on the Conquest that comes out of contem-
porary nationalist politics.[16] But mutual adaptation should also not be
taken to imply the sort of happy fusion of the races that one finds in the
jovialist take of much older mainstream historiography, both franco-
phone and anglophone, epitomized by works such as Abbé Maheux's
Ton histoire est une épopée,[17] and which in turn drew on contemporary
anti-nationalist or avowedly federalist political leanings. For, to para-
phrase the old Chicago school schema proposed by Robert Park (with-
out adopting its laissez-faire and sometimes uncritical perspective), the

mutual adaptation of different groups can include varying degrees of conflict, cooperation, accommodation, and assimilation.[18]

A further binary opposition that has often hindered analysis of the post-Conquest period is the simplistic division between French and English (or British) that underlies much analysis. Of course, there were two 'national' European groups in Quebec following the Conquest, along with the various native groups, as well as two main European languages and two main strains of Christianity, so the distinction is not entirely unwarranted (even if the 'English' or 'British' were in fact a much more complex group, composed of people born in England, Scotland, Ireland, the American colonies, and so on). Even if one accepts the distinction, these two groups were not in any way unified, with the *Canadiens* divided between elites (themselves fragmented into overlapping seigneurial, clerical, and commercial groups) and ordinary inhabitants (both urban and rural), while the British colonists were fractured between colonial administrators (supported by the army) and civilians, the latter in turn composed not only of merchants, as is often erroneously asserted, but also a wide range of others.[19] It is perhaps not necessary to adopt a sociological approach and apply a fine analysis of the different fragments of the post-Conquest population.[20] But in considering mutual adaptation following the Conquest, one must at the least take into account three main collective actors – the colonial administration (including the military), the *Canadien* civilian population, and the British civilian population – while being aware of the further divisions within these groups. It is the failure to address all of these groups adequately, and especially the *Canadiens*, that led political historians such as A.L. Burt, Hilda Neatby, or, more recently, Philip Lawson to pay little attention to mutual adaptation: their overwhelming focus on British political actors in the immediate post-Conquest period too often led them to present relatively simplistic views of the *Canadiens* as essentially conservative and passive actors.[21]

The period from the fall of Quebec in 1759 to the coming into force of the Quebec Act in 1775 is an excellent laboratory for studying the possibilities and limits of mutual adaptation between people of two formerly antagonistic national groups. It was, after all, a time when the effects of the war were still being felt directly, when anti-Catholic provisions such as the Test Acts were theoretically in force, when – again in theory at least – English public and private law had entirely replaced French, and when the British (both colonial administrators and civilians) generally thought they could easily anglicize (or perhaps more

accurately, 'Briticize') the *Canadiens*. But this was only the theory. This chapter, drawing on several of my earlier studies as well as new research,[22] focuses briefly on three areas in which mutual adaptation became a necessity for both the *Canadien* and British population of the colony: the Catholic question, political praxis, and the law.

One of the thorniest issues in the immediate post-Conquest period was that of the civil rights of Catholics. The apparent exclusion of Catholics from public life following the Conquest is one of the most-often publicly cited 'facts' regarding the period, proof of the ill designs of the Conqueror.[23] And indeed, the limited toleration of Catholicism in Quebec agreed to in the 1763 Treaty of Paris and the theoretical imposition of English penal laws, such as the Test Acts and their accompanying oaths and declarations (most notably the Oath of Supremacy and the Declaration against Transubstantiation, both objectionable to Catholics), marked a radical policy shift from the military regime. Following the terms of capitulation of both Quebec City in 1759 and Montreal in 1760, there was apparent broad toleration of Catholicism. To the extent that military government allowed it, Catholics were also appointed to significant positions of trust, with prominent *Canadien* merchants in Montreal, for example, serving as judges in the town's principal civil court, that of the militia captains, while *Canadien* militia captains elsewhere took on similar roles.[24] With the beginning of civil government, the rules of the Protestant supremacy applied, and continued to apply through to the emancipatory Quebec Act. Or did they?

The ideological debates and political discussions within the British community and the imperial government regarding the Catholic question have been fairly well explored by scholars, as have the legal arguments as to whether the penal laws applied to a newly conquered colony – the opinion of British law officers from 1765 was that they did not.[25] What has been less well explored is the actual application of the anti-Catholic provisions explicit and implicit in the transfer of sovereignty in 1763. One problem stems from a general misunderstanding of the scope and nature of the penal laws and their application to Quebec. The legal situation was fuzzy at best. For example, if the penal acts formed part of the public law of Britain applicable to the colony, as colonial administrators in Quebec initially assumed and were more or less told by their superiors in London,[26] they should have come into force immediately on Quebec's becoming a British colony, in February 1763, following the signing of the Treaty of Paris. These laws at the very least would have disabled Catholics from acting as judges and holding

other remunerated government positions, following the provisions of the original Act of Supremacy of 1559. And yet, in the colony, nothing changed through to the establishment of civil government in August 1764, eighteen months later. For example, *Canadiens* continued to act as judges in the militia courts, in apparent direct contradiction of the Act of Supremacy. Already, then, the strict application of the penal acts was dubious.

There were other misapprehensions concerning penal laws in the colony as well. Take the often-cited Quebec grand jury presentment of October 1764. In it, the British grand jurors objected to the presence of Catholic jurors as 'an open Violation of our most sacred Laws and Libertys, and tending to the utter subversion of the protestant Religion and his Majesty's power authority, right, and possession of the province to which we belong.' They supported this by citing both the Treaty of Paris and British law:

> By the Definitive Treaty the Roman Religion was only tolerated in the province of Quebec so far as the Laws of Great Britain admit, it was and is enacted by the 3d Jams 1st Chapr 5th Section 8th no papist or popish Recusant Convict, shall practice 'the Common Law, as a Councellor, Clerk, Attorney, or Sollicitor nor shall practice the Civil Law, as Advocate or proctor, nor practice physick, nor be an apothecary, nor shall be a judge, Minister, Clerk or Steward of or in any Court, nor shall be Register or Town Clerk or other Minister or Officer in any Court ... but be utterly disabled for the same.'[27]

Reading this, one might conclude, as many have done, that, under British law, Catholics were indeed excluded from juries and essentially from all administrative positions. The problem is that the grand jury or, rather, the author of the presentment appears deliberately to have misrepresented the law. The act in question referred only to 'popish recusant convicts,' not to papists in general as the wording of the presentment suggested. Hence, as long as Catholics were not convicted of being popish recusants, there was no bar, under this act at least, to their serving as jurors or in any of the other positions noted.[28] Further confusion can be found in the precise terms of the 1763 commissions and instructions to Murray as governor. These explicitly imposed the full range of anti-Catholic oaths and declarations only on members of the Council, on any future Assembly, and, arguably, on judges, justices of the peace, sheriffs, 'and other necessary Officers and ministers' for the administration of justice.[29]

The legal situation was thus in no way clear-cut, and this left much room for manoeuvre by colonial administrators such as Murray and Carleton in adapting themselves to the local situation. And in this respect, they had much adapting to do. In essence, it was impossible for the colonial administration to draw its personnel only from among the colony's Protestant adult males, who numbered perhaps two hundred at the end of the military regime, excluding the army, and perhaps seven hundred and fifty in 1775.[30] From a purely practical perspective, Murray and Carleton had to look elsewhere to compose the state apparatus necessary for running a colony of perhaps sixty-five to seventy thousand European inhabitants at the beginning and ninety thousand at the end of the period under consideration here. And the only possible pool was the *Canadien* population.

As a result, colonial administrators seem to have interpreted the restrictive provisions in as narrow a sense as possible, and the imposition of the various provisions of the penal laws appears to have been limited essentially to those instances specifically laid out in the commissions and instructions. The difference can be eloquently illustrated by the following extract from the Council minutes in 1768:

Hector Theophilus Cramahé and Walter Murray Esqrs, not being present in Council on Wednesday the 26th day of October last, when the other Members of his Majesty's Council took the Oaths; the Oaths of Allegiance, Supremacy and Abjuration, the Oaths of a Counsellor and the Declaration against Popery, were this day taken and subscribed by them in Council ...

Read a Letter from M. Courval, Bailiff of the Town of Three Rivers, who had desired permission to resign the said Office, having already served two years and up wards, reporting that Augustin Paradis has been nominated by the Inhabitants of the said Town to succeed him, provided that such Nomination met the Approbation of this board.

Approved, and Ordered that the said Augustin Paradis, be substituted Bailiff, in the stead of Mr Courval for the said Town of Three Rivers; and that the Secretary cause his Name to be published in the next Gazette.[31]

Evidently, officials such as town bailiffs had no need to take the oaths and make the declarations required of councillors such as Cramahé and Murray and could thus be Catholics, as indeed were both Courval and Paradis.

In practice, there was no general bar to Catholics in the public service. In the legal system, Murray apparently believed that his commission required him to appoint only Protestants as justices of the peace, as did influential members of his council,[32] but he did not apply the same criteria to court clerks, bailiffs, and the like, even though a strict reading of his commission would have required that as well. Thus, Catholics were excluded only from the magistracy; all other positions, such as court clerks and court bailiffs, along with judicial auxiliaries such as notaries and lawyers, were not subject to the penal act exclusions. As a result, in the legal system, which was the one significant part of the colonial administration specifically targeted by the instructions, while the judges and magistrates were all Protestants (though not all British), the clerkships of the Common Pleas, the most active of the two higher courts, initially were split between British and French clerks, and the bailiffs attached to these courts were about three-quarters *Canadien*. Further, no limits were placed on Catholics acting as lawyers or notaries, such that about 50 per cent of the former and 90 per cent of the latter, were *Canadiens* in the period under question. In sum, the penal laws were no bar to the creation of a legal system that, rather than being entirely dominated by Protestants, was instead a hybrid.[33] This flexibility was carried to the point of directly contradicting the explicit provisions of the governors' commissions: in the late 1760s, Governor Carleton appears to have appointed at least two Catholic *Canadiens*, Guillaume Guillimin in Quebec City and Louis-Joseph Godefroy de Tonnancour in Trois-Rivières, to act as judges of the Prerogative Court, essentially an administrative instance for the settling of inheritances, guardianships, and the like.[34]

Why this recourse to Catholics? Partly it was a question of numbers. But partly, as well, it was the need for colonial administrators to rely on local knowledge. Guillimin and Godefroy de Tonnancour had both held high judicial appointment in New France, the first as a judge and the second as king's attorney. The first two *Canadien* clerks of the Common Pleas, Jean-Claude Panet in Quebec City and Pierre-Méru Panet in Montreal, had also been legal professionals under the French regime; equally important, both had been the clerks of the equivalent military regime courts in their respective districts and thus could ensure judicial continuity. A significant number of the *Canadien* bailiffs employed by the courts in the 1760s, especially in Quebec City, had been bailiffs under the French regime. And as for the notaries and the lawyers, since there was considerable continuity in the law as actually practised, at

least on the civil side, it was natural that many of those who had prac-
tised before the Conquest, especially among the notaries, and had con-
tinued to practise under the military regime simply continued after the
new system was set up in 1764. In many senses, they had far less adapt-
ing to do than the colonial administrators and new British subjects.

Nor were Catholics ever systematically excluded from juries. Under
the 1764 ordinance setting up the courts, they could be jurors in the
superior Court of King's Bench. There was confusion as to their ca-
pacity to act as jurors in the other courts (the Common Pleas and the
Courts of Quarter Sessions of the Peace), until a July 1766 ordinance
declared them able to act. However, the ordinance was clearly only
declaratory of a de facto situation, since *Canadiens* had been acting as
jurors since the very beginning of the operation of the civil courts. The
1764 Quebec Quarter Sessions grand jury presentment, given above, is
one indication; but so too is the first jury listed in full in the Montreal
Quarter Sessions register, in April 1765, which consisted of six British
and six *Canadien* jurors. Similarly, the first jury listed in Quebec City's
Common Pleas register, in January 1766, well before the ordinance,
was composed of ten *Canadiens* and one British juror, along with one
ambiguous case.

Beyond the legal system, Catholics also occupied many other posi-
tions in the colonial administration. Catholics were generally absent
from the ranks of those with salaried and highly lucrative positions.
But this was not a question of Catholic exclusion, but rather of metro-
politan domination, much as under the French regime. Even then, at
least two lucrative positions, those of the chief road inspectors, or *grand
voyers*, were filled by *Canadiens*, with salaries of £100 each. The rationale
given by the Council for these posts, which were in direct contradic-
tion of the provisions of the Act of Supremacy, are instructive. The ap-
pointments were described as being 'the more necessary as the persons
presently employed in that office are men who can be trusted to furnish
government with Intelligence from the distant parts of the province;
all the Protestants and people of property and Understanding residing
in the great Towns;' more specifically, 'they will be able to give from
time to time an Account to the government of the State and Situation
of the Canadian Inhabitants.'[35] In other words, British colonial admin-
istrators needed the local knowledge that the *grand voyers* could pro-
vide. The *Canadien* presence among the lower ranks of the colony's civil
employees thus derived from mutual adaptation and mutual interest,
rather than the altruism that has been postulated by some apologists of

the British colonial administration.[36] But the apparent ready integration of Catholics into a supposedly Protestant and anti-Catholic state suggests a great deal of religious pragmatism on both sides – the sort of pragmatic approach to religion extensively explored by those who have examined the fate of the Catholic Church itself in the early years of British rule.[37] Overall, the religious issue was not at all omnipresent in the daily administration of the colony, whatever its place in transatlantic discourse and debate. And *Canadiens* were happy to accept the positions open to them, not the least because most were lucrative to a greater or lesser degree, or at the very least were a source of power.

A similar examination of everyday practices can also refresh our understanding of the nature of politics in the colony. Generally, political analysis of the period following the Conquest focuses on high politics, such as the debates around the calling of an assembly, with a tripartite struggle between British colonial administrators, British merchants, and, to a lesser extent, *Canadiens*. There is no denying that this was a highly conflictual period, with the many shifting groups in the new colony jockeying for position. But broadening our view beyond high politics reveals a series of intertwined adaptive processes: *Canadiens* adapting to new British political institutions, British institutions being adapted to *Canadien* practices, and the British population adapting to *Canadien* institutions.

At a macro level, authoritarian political structures were retained both under the military regime and under civil government, as an adaptation of political and administrative structures inherited from New France. Under the military regime, Murray presided over a paternalistic, intrusive, and controlling government, much as under the French regime. Consider the following order promulgated by Murray in 1761 against hunting by workers and artisans: 'We have been informed that the passion that they have for hunting makes them forget the duty of their profession, which is prejudicial to their family and to private citizens who want to build.' Or, again, his ban on credit extended by tavernkeepers, 'which cannot but increase the debauchery of the workers by the ease with which they find credit, and which leads to the ruin of their family.'[38] And while this sort of moralistic paternalism largely disappeared under civil government, authoritarianism remained. In this context, it was the British civilian population that appears to have had the greatest difficulty adapting to this situation, especially that part of it used to the relative political liberty of the American colonies. Conflicts between British merchants and colonial administrators got the better of

Murray, among others, and led to many of the merchants supporting
the revolutionaries during the invasion of 1775–6.

But the continuing use of French structures ran deeper than the fla-
vour of authoritarianism. On a symbolic level, for example, post-Con-
quest colonial administrators, both military and civilian, continued to
occupy French-regime loci of power such as the Château St-Louis, the
Jesuit college, or the Recollet church in Quebec City, drawing on sym-
bolic capital built up by their French predecessors – all very familiar
to the colony's *Canadien* inhabitants, but potentially disconcerting to
British colonists who, for example, might find themselves being judged
in former Catholic religious buildings.[39] As well, the British colonial
administration based its spatial conception of the colony's territory es-
sentially on the Catholic parish. Already under the military regime, the
Catholic parish was firmly established as the territorial referent used
by governors.[40] And despite the governors' instructions explicitly di-
recting them to have the colony 'accurately surveyed, and divided into
Townships, Districts, Precincts or Parishes' and also divided into coun-
ties,[41] the Catholic parish remained the colony's fundamental adminis-
trative structure under civil administration, at least outside the towns.
This was ironic for an imperial state based on Protestant supremacy,
as the Catholic parish was defined essentially by the Catholic Church,
without significant intervention by the colonial administration. Once
again, the British colonial administration adapted itself to the struc-
tures already in place, rather than creating its own.

Consider as well the language of everyday administration. Despite
the very common misconception, scholarly as well as popular, that
French lost all status following the Conquest, it remained as much the
language of the state in Quebec as English, at least at the everyday level
experienced by the colony's population. Under the military regime, for
example, the linguistic adaptations were not of the Conquered to the
Conqueror, but the opposite: orders and ordinances were published in
French, records such as those of the military courts or the order books
of the governors were kept in French by French-language clerks and
secretaries, and in general it was the British who talked to the French in
their own language, rather than vice versa. This stemmed not from any
particular charitable desire to do justice to the king's new subjects, but
from the simple necessity of communicating with these subjects and the
more basic fact that far more British knew French than the *Canadiens*
knew English, at least among the elites.

The military regime was of course a particular time, before the British could be sure they were going to retain the colony and while the British population was very small. And yet, de facto bilingualism continued after the establishment of civil government in 1764. Legislation, proclamations, and other official documents were published in both English and French in the *Quebec Gazette* and in handbills and broadsides, giving a continued boost to official translation.[42] In the legal system, while surviving criminal court records are mainly in English, the main civil court, the Common Pleas, kept dual French and English registers and produced documents such as summons and the like in both English and French. And notarial records, the basis for most landed property transactions in the colony, remained almost entirely in French. In sum, French continued to be very much a language of officialdom, regardless of its official status, and the British population simply had to adapt.

The examination of the phenomenon of interpreters, fundamental to mutual adaptation, adds to this impression. While interpretation has yet to be studied in any detail in the immediate post-Conquest period, it seems that both British and *Canadiens* acted in this capacity: in a small sample of twenty-four interpreters mentioned in the *Parchemin* database of notarial records between 1760 and 1769, thirteen were apparently francophones and eleven anglophones. At the same time, in all cases where this is explicitly mentioned in notarial records, the interpreter was acting for the anglophone rather than the francophone party, indicating British linguistic adaptation rather than vice versa.

Another example of mutual adaptation, in the sphere of very local politics, was the institution of parish bailiffs.[43] Under the military regime, the British military governors had maintained the pre-existing French system of militia officers, though shorn of their military role so as to leave only their administrative functions. Thus, the main representatives of the military state in the countryside were the *Canadien* militia captains, to whom governors such as Murray, Gage, and Haldimand directed their orders for firewood or hay provisioning, impressment of labour, arrest of deserters, and the like.[44] In this respect, the military regime did not depart in any significant fashion from the French regime that preceded it. Under the civil government put in place in the colony from 1764, however, the militia was abolished, and colonial administrators were faced with the necessity of establishing some sort of structure to allow them to maintain a degree of administrative presence and control in the countryside. This was not possible through

the normal English mechanism of justices of the peace, as magistrates had to be Protestants and there were few Protestants established outside the two main towns. The solution was to adapt another English structure, the parish constable, although renaming them as 'bailiffs,' or *baillis* in French. Thus, under the 1764 ordinance setting up the courts, each parish in the colony was to have a bailiff and two sub-bailiffs, with a variety of administrative and judicial duties, notably with regard to road maintenance and the execution of court orders. On the whole, they were to serve as replacements of the militia captains under the military regime, though with more limited functions; at the same time, they represented the English model of decentralized local governance.[45]

The importance of the bailiffs for the political life of the *Canadien* population after the Conquest stems from the fact that, under the terms of the ordinance, these local officials were to be elected annually by an assembly of the parish householders, at least outside the main towns (where the bailiffs were generally appointed by the resident justices of the peace). The assembly elected six candidates and sent the list to Quebec, where the colonial administration selected three – in practice, almost always the first three on the list, thus reproducing the parish assembly's choice. Here we thus have a form of local 'democracy' (in the limited eighteenth-century sense of the word) and interplay between the colonial administration and the population that went directly against the more centralizing spirit of the French regime. And yet, the *Canadien* population adapted very well to this newly opened political field. The positions, especially those of head bailiff, were often sought after, as they brought power and prestige – bailiffs, for example, had a special pew in the parish church, much like the militia captains before them. And there were contested elections, conflicts between different elite factions, interventions by *seigneurs* and clergy, and petitions and counterpetitions sent in to the central administration – in short, all the characteristics of developed electoral politics, but played out on such a local level that it has entirely escaped the attention of historians.

In this instance, the *Canadiens* adapted themselves very well to this new British institution, but in some respects that institution was also adapted to them. The use of parish assemblies, for example, tapped into local traditions of participatory 'democracy' already in place under the French regime. In some parishes at least, parishioners met to elect church wardens or to make other decisions regarding parish affairs; the French regime *grand voyers* regularly assembled parish inhabitants to make decisions regarding road layout and repairs, with matters some-

times put to a vote; and under the French civil law system, issues such
as the election of trustees for minor children were decided by a family
assembly composed of relatives and friends.[46] The new British system
of elected local officials no doubt functioned partly because of these
pre-existing traditions, which also continued after the Conquest. Simi-
larly, after the system of parish bailiffs was in theory abolished with
the coming into force of the Quebec Act in 1775, the launching of the
American invasion, and the restoration of the militia by Carleton, the
Americans in some of the occupied parishes instituted a system of local
elections for militia captains, to replace those appointed by the British
governor. They, like a number of historians, might have thought they
were introducing the *Canadiens* to local democracy for the first time
and were thus instrumental in their political education.[47] But they were
wrong: parish elections already had been going on for a decade, and
local democracy for much longer.

A final example of mutual adaptation in the political sphere comes at
the other end of the spectrum: the use by elites of collective represen-
tation to the colonial administration. This took two main forms, both
grounded in British practices and having no real precedent under the
French regime or indeed the military regime that followed it: grand
jury presentments and collective petitions. Following English and colo-
nial practice, the grand juries of the criminal courts in Quebec not only
decided on the course of criminal complaints, but also had an advisory
role. At the end of each court session, they prepared a general represen-
tation, called a presentment, that gave their views on the current state
of the district they represented, on both judicial and administrative
matters, and made suggestions for change. This made the presentment
a particularly useful vehicle for collective political representation, es-
pecially in the absence of representative institutions such as an assem-
bly. Indeed, the first Quebec grand jury considered itself to be the only
truly representative body in the colony (even though it had in fact been
packed by unscrupulous political operators). As for collective petitions,
they had been subjected to severe restrictions under the French regime,
and British colonial administrators also initially attempted to put limits
on the sorts of mass meetings by Catholics that were often necessary for
collective political action, imposing prior notification and the presence
of a councillor and/or magistrate.[48] But this seems not to have applied
to more run-of-the-mill collective petitions, and was soon abandoned
altogether.[49] The registers and records of the colonial administration
are thus replete with petitions and, to a lesser extent, presentments.[50]

Despite the novelty of such practices for *Canadien* elites, they adapted rapidly to these useful forms of political expression. For example, *Canadiens* in professional groups ranging from lawyers to bakers used collective petitioning to advance their particular aims, such as modifying working conditions or increasing state regulation of their trade.[51] Further, grand jury presentments and, to a lesser extent, collective petitions regularly brought together *Canadien* and British civilian populations that often are seen as irretrievably opposed when scholars focus only on the relatively limited number of collective representations that were part of the broader debate over the fate of the Quebec polity.[52] Thus, one of the first collective petitions in the registers of the Council, concerning the expropriation of a lot near Quebec City's port, was signed by Beaubien, A. Dumas, Per[re]ault, and Moore & Finlay: a combination of *Canadien* Catholic, Huguenot, and British Protestant merchants.[53] And while the first Quebec grand jury presentment, discussed above, was a notable failure of adaptation and accommodation, with the British jurors first seeking their *Canadien* counterparts' accord on items of mutual interest and then demanding that Catholics be disqualified as jurors, later grand jury presentments included both British and *Canadien* signatories, with some even being written in French. It is true that, in collective petitioning, there did develop a more ethnically based practice of preparing separate but parallel petitions from British and *Canadiens* – as, for example, the petitions by the British and *Canadien* inhabitants of Montreal for assistance following the disastrous fire there in 1765, or the petitions from British and *Canadien* fur trade merchants for changes to the trade regulations.[54] At the same time, joint petitioning continued, as in the 1773 petition, in French, by thirty-two prominent *Canadien* and British inhabitants of Montreal, joined together in a union fire-prevention company, complaining of the fire hazard created by the butchers' stalls in the market.[55]

Collective representations might thus be a source of conflict, as when British merchants petitioned for the establishment of a Protestant-dominated assembly, or when *seigneurs* sought to meet so as to constitute themselves as representatives of the *Canadien* population without inviting the commercial elites.[56] But when the issues at stake concerned mercantile or bourgeois interests, they might also cut across linguistic lines so as to solidify class cohesion. And in all cases, they represented yet another example of the complexities of mutual adaptation in the period after the Conquest.

A final example of mutual adaptation concerns the relationship of the *Canadien* and British populations to the law, and to each other through the law. The legal situation following the Conquest was complicated. The military regime saw the de facto preservation of French civil law, which continued to be applied in the military courts, while courts martial and military law were used for more serious criminal offences. The Proclamation of 1763 was taken by some to have swept away all of French law and replaced it with English law, while others supposed this change to have concerned only public law, including criminal law. Finally, the 1764 ordinance that set up a new court system, modelled on English precedents, allowed partial continuation of French law and said nothing of important aspects of the legal system such as notaries, who continued as before.[57] In this ever-shifting environment, mutual adaptation was a fundamental necessity, since right from the Conquest the colony experienced a mix of both French and British laws, legal structures, and legal practices. It thus involved both the adaptation of the *Canadien* population to English law – notably English criminal and public law – and to British-style courts, and the adaptation of the British population to French civil law and practice.

Adaptation, however, is not the usual historiographical approach to this period. Instead, analyses have concentrated on the concept of national confrontation around both the criminal and civil law. On the civil side, it has long been asserted that, in the decade following the Conquest, *Canadiens* boycotted the state justice put in place by the British colonial administration. In family matters, for example, they supposedly resorted to arbitration and infra-justice, rather than submit their differences to the new system and its foreign judges. Their boycott of the criminal justice system was even more profound, it is asserted, since everything was in English.[58] This, however, is a historiographical illusion. With regard to the civil law, the *Canadiens* actually had relatively little adapting to do since, despite the apparent replacement of French civil by English common law, the former remained largely in effect throughout the period. Under the military regime, civil and minor criminal cases in Montreal and Trois-Rivières were judged by the merchants who were militia captains, while in Quebec City the court was composed of British military officers.[59] The courts in the two main towns, however, applied French civil law, aided by their clerks, the Panets.[60] The work of the courts was also taken up almost entirely by cases brought by *Canadiens*. Even before the Quebec City court, run by British

military officers, virtually every case concerned *Canadiens*, and in 90
per cent of them they were the only parties.[61] As Murray remarked in
one of his orders, 'We are pained to see that for trifles the *habitants* pur-
sue one another in cases that make them lose more time in their labours
than the subject of the case.'[62]

The shift to civil government produced no particular change in this
situation: the vast majority of plaintiffs and defendants before the
courts continued to be *Canadien*. Even in the criminal courts, if we look
at the level of the justices of the peace where most cases were heard, *Ca-
nadiens* made up about two-thirds of plaintiffs in the Montreal Quarter
Sessions between 1765 and 1773, and one-half in the Quebec City court;
furthermore, most of the cases in which they were involved concerned
only other *Canadiens*. British plaintiffs were certainly overrepresented,
given that they made up only a tiny proportion of the population, but
there was no *Canadien* boycott. As for the civil courts, *Canadiens* were
involved in perhaps 90 per cent of the cases in the superior sessions of
the Common Pleas in Montreal and 80 per cent in Quebec City; and
in 70 per cent of the Montreal cases and 60 per cent of those in Que-
bec City, all parties were *Canadien*. Given that *Canadiens* appear to have
been even more dominant in the inferior terms of the court,[63] the notion
of a boycott is not at all tenable.

Take also the example of juries, a new feature introduced under Brit-
ish rule. *Canadiens* are often portrayed as having mistrusted this new
structure: elites because it was too democratic and ordinary *Canadiens*
because it took too much time. But there is no evidence of anything but
a rapid adaptation to the jury system. On the criminal side, *Canadiens*
were as assiduous in acting as jurors as their British counterparts, and
perhaps more so.[64] And in civil cases, where jury use was optional, thus
reflecting the willingness of at least one party to have recourse to it, *Ca-
nadiens* were regularly involved in jury cases, and not only at the behest
of British opponents. Of a sample of fifty-three jury cases in the Quebec
City Common Pleas records between 1764 and 1775, twenty-five appar-
ently concerned only British parties, fifteen only *Canadien* parties, and
thirteen were mixed – hardly evidence of *Canadien* reticence to have
recourse to juries, even though British parties were evidently far more
likely than *Canadiens* to submit their differences to juries.

All in all, it is clear that *Canadiens* adapted to the new judicial realities
that followed the Conquest, though whether or not this was an easy
process remains to be studied in depth, at least for the civil courts. But
what of the British population? The attitudes of the new British colo-

nists towards the law and the courts have been examined in depth, and especially the political discourse of that part of the British population that clamoured for the full and exclusive introduction of English civil law.[65] In terms of the criminal law, there was, of course, little adaptation to make, since it largely followed British forms. But the civil law was a different story, and shows to some extent both the willingness of the British population to adapt and the limits of that adaptation.

Take, for example, British attitudes towards the notarial system, which was relatively alien to them, given the usual English system of private deeds and registration. Using the *Parchemin* database, which contains descriptions of all extant notarial acts in Quebec up to the 1780s, I have constructed a sample of 273 notarial acts apparently involving the new post-Conquest British population under the military regime.[66] Despite the preliminary nature of the sample, it allows for some observations. First, during the initial occupation of Quebec City, while the military fate of the colony was not yet decided, the new British colonists made no use of the notarial system, even though it manifestly continued to operate.[67] Once the final capitulation of Montreal was signed in September 1760, however, it took very little time for British colonists to begin to interact with the *Canadien* population via the notarial system. The first notarial document described in the database that involved a British party was the lease of a house in Montreal by the widow of a *Canadien* merchant to Edward Best, an English merchant, on 18 September, only ten days after the capitulation of the city. This was followed by a number of others soon afterwards. Based on a systematic sample of the notarial acts in the database, one can estimate that, between 1761 and 1764, there were in all something over seven hundred acts involving British parties.[68] Given a British adult male civilian population of a couple of hundred, that would have meant three or four notarial acts each, on average, suggesting that it is far too simple to talk of British dislike and avoidance of this fundamental aspect of French civil law.

At the same time, there is every indication that, for the British, the notarial system served almost exclusively as an interface with the *Canadiens*, since only seven among the 273 identified acts involved agreements exclusively between British parties. The situation was similar for the military regime courts, where British parties were involved in about 10 per cent of the four thousand or so cases in the Quebec City court, but almost all of these cases involved *Canadiens* as well. One might thus be tempted to conclude that, with a few exceptions, the new British colonists avoided the justice system when possible, and were drawn into it

only in instances, such as notarial transactions, involving *Canadiens* who demanded the security of their familiar practices. This seems especially clear in property matters: while over half of the 273 acts involving British parties were of *Canadiens* selling or leasing property to British, only a tiny handful involved British vendors or lessors, suggesting that this was a case of *Canadien* proprietors imposing their conditions before giving up their property. However, two other major categories of notarial acts, *obligations* and *engagements*, which accounted for something over a quarter of the acts involving British parties, suggest that this is an oversimplification. In both *obligations* (essentially, mortgages for various types of debt) and *engagements* (hiring contracts, notably of *voyageurs* for the fur trade), it was almost always the British party who was in the 'dominant' position and who thus presumably could have demanded that these agreements follow forms more familiar to them. And yet, at least in some cases, the new British colonists chose instead to follow French forms. Further, there are indications that, for fur trade engagements at least, private agreements generally far outweighed notarized ones not only for British but also for *Canadien* merchants.[69] Similarly, before the military regime courts, the British party was the plaintiff in about three-quarters of the cases involving both groups, suggesting no reticence on their part to go before these courts. Determining why this was the case is difficult without further study. Nevertheless, right from the beginning, British colonists in no way systematically avoided either the French notarial system or military courts that applied French law in French; rather, they adapted themselves to French practices while carrying out legal interactions among themselves through other means, such as private deeds.

As for the period of civil government, though much remains to be examined, an impressionistic survey suggests that, even when English law was imposed in the colony and a few anglophone notaries began practising according to English forms, British parties still did not desert the French notarial system. The same is true of British recourse to the Court of Common Pleas, which at least in part applied French law and forms, notably in cases involving *Canadiens*.[70] Had the British been entirely averse to adapting to French civil law, they might have been tempted to direct all of their cases to the King's Bench, which apparently applied English law exclusively, or perhaps to the justices of the peace (whose application of civil law has yet to be studied). And yet, this does not seem to have been the case. Again using the samples of Common Pleas cases, British parties were involved in 30 per cent of

cases in Montreal and 40 per cent in Quebec City, they were about as likely to be plaintiffs as defendants, and between 10 per cent and 20 per cent of all cases involved British parties only. While many of these cases were decided according to basic rules of equity that conformed to English practice, especially those that concerned only British parties, other cases involved British suitors in complex arguments around French civil law. In some, it was the British parties who appealed to French law. Evidently, the relationship of British colonists with French civil law was more complex than simple avoidance.[71]

All of the above suggests once again a simple conclusion: the process of mutual adaptation of the *Canadien* and British populations of Quebec in the immediate post-Conquest period, between 1759 and 1775, was far more complex than indicated by simplistic miserabilist and jovialist interpretations, and involved more than overriding ethnic conflict or the harmonious fusion of races. The *Canadien* and British populations in general, and their elites in particular, seem to have adopted the philosophy that, on a practical level, 'adaptation is the better part of valour,' even while continuing their political fights to shape post-Conquest Quebec state and society to their liking. How else to explain the colonial administration's partial relaxation of the penal laws, and the *Canadien* population's willingness to fill the space thus provided; or the complexity of the political sphere when one extends one's vision down to the local, everyday level; or the evidently supple approach to law and justice by the two groups. Pragmatism, utilitarianism, and instrumentalization played a part that was at least as important as the ideological debates historians have so often retained.

NOTES

1 Marcel Trudel's *Histoire de la Nouvelle-France X: le régime militaire* (Montreal: Fides, 1999), while providing a wealth of (sometimes misleading) information, is too far removed from and apparently unaware of current and even past historiography on more detailed aspects of the military regime, especially unpublished theses.

2 I do not deal here with the meanings of the Conquest for the aboriginal population of Quebec or with its effects on the Western interior; my focus is on the European population of the St Lawrence settlements. On the Conquest and Quebec's aboriginal population, see, for example, Jean-Pierre Sawaya, *Alliance et dépendence: comment la Couronne britannique a obtenu la*

collaboration des Indiens de la vallée de Saint-Laurent entre 1760 et 1774 (Quebec: Septentrion, 2002).

3 '*On ne trouve plus de spécialistes de la Conquête dans les grandes universités québécoises*'; Christian Rioux, 'Cachez cette histoire que je ne saurais voir!' *Le Devoir*, 13 September 2009.

4 My analysis excludes duplicates (such as theses later published as books), works that only synthesize existing studies, works covering a longer period where the years 1759–75 are treated in passing, and works concerned only with the war itself and the subsequent diplomatic negotiations. The analysis has, of course, some degree of subjectivity.

5 See, for example, *Remembering 1759: The Conquest of Canada in Historical Memory*, ed. Phillip Buckner and John G. Reid (Toronto: University of Toronto Press, 2012).

6 For a useful overview, see S. Dale Standen, 'The Debate on the Social and Economic Consequences of the Conquest: A Summary,' *Proceedings of the Annual Meeting of the French Colonial Historical Society* 10 (1984): 179–93.

7 '*Langue de l'administration et du clergé sous le Régime français, le français écrit n'a plus, à partir de 1760, qu'une existence privée*'; Maurice Lemire et al., *La vie littéraire au Québec*, vol. 1, *1764–1805: la voix française des nouveaux sujets britanniques* (Quebec: Presses de l'Université Laval, 1991), 108.

8 Michael Dorland and Maurice Charland, *Law, Rhetoric, and Irony in the Formation of Canadian Civic Culture* (Toronto: University of Toronto Press, 2002), 92.

9 John E.C. Brierley and Roderick A. Macdonald, eds., *Quebec Civil Law: An Introduction to Quebec Private Law* (Toronto: Emond Montgomery, 1993), 11.

10 '*Les habitants de la province résistent ... à la nouvelle structure judiciaire en ayant massivement recours à l'arbitrage afin de régler leurs litiges*'; Luc Huppé, *Histoire des institutions judiciaires du Canada* (Montreal: Wilson & Lafleur, 2007), 52.

11 '*Le serment du Test fut imposé à quiconque voulait exercer une fonction officielle au sein de la colonie. Catholiques, les Canadiens se virent donc ... exclus d'office de toute tâche administrative et judiciaire*'; Danièle Noël, 'Une langue qui ne capitule pas (la justice et les tribunaux)' in *Le français au Québec: 400 ans d'histoire et de vie*, ed. Michel Plourde (Montreal: Fides/Publications du Québec, 2000), 72. She does note an exception for jurors and lawyers.

12 John G. Reid and Elizabeth Mancke, 'From Global Processes to Continental Strategies: The Emergence of British North America to 1783,' in *Canada and the British Empire*, ed. Phillip Buckner (Oxford: Oxford University Press, 2008), 37–8.

13 David Chennells, *The Politics of Nationalism in Canada: Cultural Conflict since 1760* (Toronto: University of Toronto Press, 2001), 58, 67.

14 Garth Stevenson, *Parallel Paths: The Development of Nationalism in Ireland and Quebec* (Montreal; Kingston, ON: McGill-Queen's University Press, 2006), 49.

15 For especially succinct expressions, see, for example, Hubert Guindon, 'The Social Evolution of Quebec Reconsidered,' *Canadian Journal of Economics and Political Science* 26, no. 4 (1960): 536; or Marcel Rioux, *La Question du Québec* (Paris: Éditions Seghers, 1969), 41–53.

16 As in the work of Michel Brunet, such as *Les Canadiens après la Conquête 1759–1775: de la révolution canadienne à la révolution américaine* (Montreal: Fides, 1969); or that of Gilles Bourque, notably *Question nationale et classes sociales au Québec, 1760–1840* (Montreal: Parti Pris, 1970).

17 Arthur Maheux, *Ton histoire est une épopée*, vol. 1, *Nos débuts sous le régime anglais* (Quebec: Charrier & Dugal, 1941).

18 For the same reason, I avoid using the term accommodation, linked as it is with potentially jovialist theories such as consociationalism; for the application of the latter to the post-Conquest period, see Chennells, *Politics of Nationalism in Canada*.

19 On the splits within the British population, see notably A.L. Burt, *The Old Province of Quebec*, vol. 1 (Toronto: McClelland and Stewart, 1968). On the diversity of the British civilian population, see, for example, Honorius Provost, *Les premiers anglo-canadiens à Québec: essai de recensement, 1759–1775* (Quebec: IQRC, 1984).

20 As Gilles Paquet and Jean-Pierre Wallot did for a slightly later period; see *Un Québec moderne, 1760–1840: essai d'histoire économique et sociale* (Montreal: Hurtubise HMH, 2007), 505–71.

21 Burt, *Old Province of Quebec*; Hilda Neatby, *Quebec: The Revolutionary Age, 1760–1791* (Toronto: McClelland and Stewart, 1966), 30–124 passim; and Philip Lawson, *The Imperial Challenge: Quebec and Britain in the Age of the American Revolution* (Montreal; Kingston, ON: McGill-Queen's University Press, 1989).

22 Notably *Magistrates, Police, and People: Everyday Criminal Justice in Quebec and Lower Canada, 1764–1837* (Toronto: Osgoode Society/University of Toronto Press, 2006); 'La paroisse et l'administration étatique sous le Régime britannique (1764-1840),' in *Atlas historique du Québec: La paroisse*, ed. Serge Courville and Normand Séguin (Ste-Foy, QC: Presses de l'Université Laval, 2001); 'Judicial Auxiliaries Across Legal Regimes: From New France to Lower Canada,' in *Entre justice et justiciables: les auxiliaires de la justice du Moyen Âge au XXe siècle*, ed. Claire Dolan (Quebec: Presses de l'Université

Laval, 2005); 'The Canadiens and British Institutions of Local Govern-
ance in Quebec, from the Conquest to the Rebellions,' in *Transatlantic
Subjects: Ideas, Institutions and Social Experience in Post-Revolutionary British
North America*, ed. Nancy Christie (Montreal; Kingston, ON: McGill-
Queen's University Press, 2008); and 'Domination et adaptation: les élites
européennes au Québec, 1760–1841,' in *Au sommet de l'Empire: les élites
européennes dans les colonies (XVIe–XXe siècle)*, ed. Claire Laux et al. (Berne:
Peter Lang, 2009).

23 For example, letters from Christian Dufour, *Le Devoir*, 11 November 2000
and Claude G. Charron, *Le Devoir* 5 May 2005.

24 José Igartua, 'The Merchants and Négociants of Montréal, 1750–1775: A
Study in Socio-Economic History' (PhD thesis, Michigan State University,
1974), 174–99; and Trudel, *Régime militaire*, 155–84, are the only detailed
examinations of the operation of these courts.

25 See notably Burt, *Old Province of Quebec*, vol. 1, 66–159 passim; Vincent
T. Harlow, *The Founding of the Second British Empire, 1763–1793* (London:
Longmans, 1952–64), 664–714 passim; Neatby, *Quebec*, 30–124 passim;
Lawson, *Imperial Challenge*, 43–52, 96–103; and Peter M. Doll, *Revolution,
Religion, and National Identity: Imperial Anglicanism in British North America,
1745–1795* (Madison, WI: Fairleigh Dickinson University Press and As-
sociated University Presses, 2000). On the applicability of the penal laws,
see also S. Morley Scott, 'Chapters in the History of the Law of Quebec,
1764–1775' (PhD thesis, University of Michigan, 1933), 89–95.

26 As in Egremont to Murray, 13 August 1763, in *Documents Relating to the
Constitutional History of Canada, 1759–1791*, 2nd ed., ed. Adam Shortt and
Arthur G. Doughty (Ottawa: Historical Documents Publication Board,
1921), 169. See also William Knox, *The Justice and Policy of the Late Act of
Parliament, for Making More Effectual Provision for the Government of the Prov-
ince of Quebec ...* (London: J. Wilkie, 1774), 12–13; and Francis Maseres, *An
Account of the Proceedings of the British, and Other Protestant Inhabitants, of the
Province of Quebeck ...* (London: B. White, 1775), 131–201.

27 *Documents Relating to the Constitutional History of Canada* (hereafter cited as
DRCHC), 214–15.

28 This was pointed out in the *Report to the Lords of the Committee for Plantation
Affairs* of 2 September 1765, in *DRCHC*, 241–2. For an overview of the law
and the oaths as they would have stood in Quebec between 1763 and 1774,
see Richard Burn, *The Justice of the Peace and Parish Officer*, 8th ed., vol. 1
(London: H. Woodfall and W. Strahan, 1764), 167–8, 326–43.

29 *DRCHC*, 173–7 (Commission), 182–3 (Instructions).

30 The lists of Protestant householders prepared in October 1764 show 144

in Quebec City and 56 in Montreal (United Kingdom National Archives, CO 42/2, ff. 45–6); there were very few elsewhere. In 1775, according to an analysis of the names presented in Provost, *Premiers anglo-canadiens à Québec*, there were about 325 civilian adult male anglophones in Quebec City; allowing for a similar number in Montreal and perhaps a hundred elsewhere, that would give perhaps 750 altogether.

31 Library and Archives Canada (hereafter cited as LAC), State Minute Books (minutes of Council), R10808-5-1 (formerly RG1 E1), 3 November 1768. My thanks to Christian Blais of the Assemblée nationale du Québec for providing me with a preliminary version of his transcription of the minutes.

32 Murray to Halifax, 15 October 1764, *DRCHC*, 210; Adam Mabane to Council, LAC, R10808-5-1, 6 February 1766.

33 On these issues, see Fyson, *Magistrates, Police, and People*, chaps. 1–4; idem, 'Judicial Auxiliaries'; idem, 'Canadiens and British Institutions'; and idem, 'Jurys, participation civique et représentation au Québec et au Bas-Canada: les grands jurys du district de Montréal (1764–1832),' *Revue d'histoire de l'Amérique française* 55, no. 1 (2001): 85–120.

34 There is no official record of their appointment, but they are identified as judges of the prerogative court in various sources, including notarial records. On Guillimin's activity, see Jean-Philippe Garneau, 'Droit, famille et pratique successorale: les usages du droit d'une communauté rurale au XVIIIe siècle canadien' (PhD thesis, Université du Québec à Montréal, 2003), 245–8.

35 LAC, R10808-5-1, 27 November 1765 and 2 December 1765.

36 Maheux, *Ton histoire est une épopée*, 52–80; and Albert Anthony Wetherell, 'General James Murray and British Canada: The Transition from French to British Canada, 1759–1766' (PhD thesis, St John's University, 1979), 168–70.

37 For example, Marcel Trudel, *L'Église canadienne sous le régime militaire 1759–1764* (Quebec: Presses universitaires Laval, 1956–57).

38 'Nous avons été informé que la Passion qu'ils ont pour la Chasse leur fait oublier Le devoir de leur Profession, ce qui est préjudiciable à leur famille, et aux particuliers qui font Bâtir' and 'ce qui Ne peut qu'augmenter La Débauche des ouvriers par La facilité qu'ils ont à trouver Crédit, et Ce qui entraîne La Ruine de Leur famille'; 'Ordonnances, ordres, reglemens et proclamations durant le gouvernement militaire en Canada, du 28e oct. 1760 au 28e juillet 1764,' Université de Montréal, Collection Melzack (hereafter cited as Murray Melzack), 28 July 1761 and 13 September 1761; available online at http://calypso.bib.umontreal.ca/cdm4/index__murray.php?CISOROOT=/_murray.

39 See Fyson, *Magistrates, Police, and People*, 313–19.

40 See, for example, Murray Melzack, 11 December 1762.
41 *DRCHC*, 192, 194, 311, 313.
42 Patricia Dumas, 'La naissance de la traduction officielle au Canada et son impact politique et culturel sous le gouvernement militaire et civil du général James Murray, Québec (septembre 1759 à juin 1766)' (MA, York University, 2004); Michel Brisebois, *The Printing of Handbills in Quebec City, 1765–1800: A Listing with Critical Introduction* (Montreal: McGill University, Graduate School of Library and Information Studies, 1995).
43 This is explored in Fyson, 'Paroisse et l'administration étatique,' 25–37; idem, *Magistrates, Police, and People*, 141–2; and idem, 'Canadiens and British Institutions of Local Governance,' 58–66.
44 For a summary overview of their role, see Trudel, *Régime militaire*, 85–116.
45 Historians of the period have tended to content themselves with repeating Carleton's assertion as to the bad qualities of the bailiffs, which, in fact, was an obfuscation on his part that confused (perhaps deliberately) the parish bailiffs with judicial bailiffs operating for the courts; see, for example, Scott, 'Chapters in the History of the Law of Quebec,' 291–4.
46 Allan Greer, 'L'habitant, la paroisse rurale et la politique locale au XVIIIe siècle: quelques cas dans la vallée du Richelieu,' *Société canadienne d'histoire de l'Eglise catholique, Sessions d'études* 47 (1980) : 19–33; Manon Bussières, 'De la voie de passage au chemin public. Le réseau routier et ses représentations dans la Province de Québec: l'exemple du Centre-du-Québec, 1706–1841' (PhD thesis, Université du Québec à Trois-Rivières, 2009), 34–6; and Jean-Philippe Garneau, 'Le rituel de l'élection de tutelle et la représentation du pouvoir dans la société canadienne du XVIIIe siècle,' *Bulletin d'histoire politique* 14, no. 1 (2005): 45–56.
47 Pierre Tousignant, 'La genèse et l'avènement de la Constitution de 1791' (PhD thesis, Université de Montréal, 1971), 19, citing Gustave Lancôt and Marcel Trudel.
48 LAC, R10808-5-1, 25 April 1765.
49 There is as yet no study of the overall phenomenon of collective petitioning in Quebec following the Conquest. But see Steven Watt, '"Duty Bound and Ever Praying": Collective Petitioning to Governors and Legislatures in Selected Regions of Maine and Lower Canada, 1820-1838' (PhD thesis, Université du Québec à Montréal, 2006).
50 Notably the registers of Council, LAC, R10808-5-1, and the correspondence files of the Civil Secretary, LAC, RG4 A1.
51 LAC, RG4 A1, vol. 12, 4571–4; LAC, R10808-5-1, 16 January 1766, 30 July 1766, and 5 May 1768.
52 As in Tousignant, 'La genèse et l'avènement de la Constitution de 1791,'

or Mary Ann Fenton, 'Petitions, Protests, and Policy: The Influence of the American Colonies on Quebec, 1760–1776' (PhD thesis, University of New Hampshire, 1993).

53 LAC, R10808-5-1, 3 September 1764.

54 LAC, R10808-5-1, 27 June 1765, 5 April 1769.

55 LAC, RG4 A1, vol. 20, pp. 6999-7001.

56 Elizabeth Arthur, 'The French-Canadian under British Rule, 1760–1800' (PhD thesis, McGill University, 1949), 111–13.

57 For useful overviews, see Michel Morin, 'Les changements de régimes juridiques consécutifs à la Conquête de 1760,' Revue du Barreau 57, no. 3 (1997): 689–98; and John A. Dickinson, 'L'administration chaotique de la justice après la Conquête: discours ou réalité?' in Canada: Le rotte della libertà, ed. Giovanni Dotoli (Fasano, Italy: Schena, 2005), 117–27. For a guide to the courts, see Donald Fyson with the assistance of Evelyn Kolish and Virginia Schweitzer, The Court Structure of Quebec and Lower Canada, 1764 to 1860, 2nd ed. rev. and corrected (Montreal: Montreal History Group, 1997, 2009), http://www.hst.ulaval.ca/profs/dfyson/courtstr/. On martial law, see Douglas Hay, 'Civilians Tried in Military Courts: Quebec, 1759-64,' in Canadian State Trials, vol. 1, Law, Politics, and Security Measures, 1608–1837, ed. F. Murray Greenwood and Barry Wright (Toronto: University of Toronto Press, 1997).

58 The classic statement on the civil side was by André Morel: 'La réaction des Canadiens devant l'administration de la justice de 1764 à 1774: une forme de résistance passive,' Revue du Barreau 20, no. 2 (1960): 55–63. For an overview of the arguments regarding criminal justice, see Fyson, Magistrates, Police, and People.

59 For an overview of the court structure, see Trudel, Régime militaire, 155–84.

60 On the law applied in the Montreal courts, see Igartua, 'Merchants and Négociants of Montréal,' 174–99, which is, as far as I know, the only detailed examination of the actual operation of the courts.

61 From an analysis of an index of parties appearing before the Quebec Military Council, Bibliothèque et archives nationales du Québec (hereafter cited as BAnQ), Instrument de recherche 303016, kindly supplied to me in electronic form by Rénald Lessard. Of a little over four thousand three hundred cases, only ten appear to have involved British parties exclusively. Some British parties appear to have taken a number of potentially civil disputes before courts martial instead of submitting them to the regularly established military regime courts, but the number seems to have been quite small. See Frederick Bernays Wiener, Civilians under Military Justice:

The British Practice since 1689, Especially in North America (Chicago: University of Chicago Press, 1967), 46–52.

62 *'Nous avons vu avec peine que pour des bagatelles les habitants se suscitent Les uns les autres des procès qui leur font perdre plus de temps dans leurs travaux, que l'objet devant'*; Murray Melzack, 14 October 1762.

63 The figures for the superior sessions are based on an analysis of a sample of the case descriptions of Superior Court dossiers: for Montreal, as presented in the *Thémis 3* database by Archiv-histo, and for Quebec, as in BAnQ's *Pistard* database, kindly provided to me by Rénald Lessard. See also the more limited analyses presented in Evelyn Kolish, 'Changements dans le droit privé au Québec Bas-Canada entre 1760 et 1849: attitudes et réactions des contemporains' (PhD thesis, Université de Montréal, 1980), appendix A. The figures for the inferior sessions are based on a database concerning the Montreal court for 1771, kindly supplied to me by Jean-Philippe Garneau. These are evidently very preliminary observations.

64 Of 102 trial jurors identified in the Montreal Quarter Sessions register between 1765 and 1769, 58 were apparently *Canadiens*.

65 See, for example, Evelyn Kolish, *Nationalismes et conflits de droits: le débat du droit privé au Québec, 1760–1840* (LaSalle, QC: Hurtubise HMH, 1994), 29–43.

66 The sample was constructed based on examining all descriptions in the database from the fall of Quebec (September 1759) to the end of 1760; all acts passed the 15th day of the month for the period 1761–4; all descriptions that explicitly mentioned that one of the parties was English, Irish, Scottish, etc.; all acts whose descriptions mentioned an interpreter; and a search for the names William, John, James, Edward, and Peter, as well as names beginning with Mc. This is, of course, only a preliminary working sample, which needs to be extended and made more systematic, a large-scale undertaking ideally involving examining each and every one of the several thousand descriptions of acts passed each year.

67 There were a couple of marriage contracts involving men described as English or Irish between the fall of Quebec and the capitulation of Montreal, but as both were in parts of the colony still controlled by the French, these must have been part of the small pre-Conquest British population of the colony, composed notably of prisoners of war.

68 Based on a systematic sample of all acts passed on the 15th day of the month for the period 1761–4; given the relatively small sample size (a little under 4 per cent of all acts), this figure should be treated with caution.

69 In the immediate post-Conquest period, notarized *engagements* apparently represented only a small minority of fur trade hiring contracts overall; see

Fernand Ouellet, 'Dualité économique et changement technologique au Québec (1760–1790),' *Histoire sociale/Social History* 9, no. 18 (1976): 256–96; and Brian D. Murphy, 'The Size of the Labour Force in the Montreal Fur Trade, 1675–1790: A Critical Evaluation' (MA thesis, University of Ottawa, 1986), 130. This was not due, however, to differing practices of English merchants, as French merchants continued to dominate the fur trade up to the mid-1770s; see Dale Bernard Miquelon, 'The Baby Family in the Trade of Canada, 1750–1820' (MA thesis, Carleton University, 1966), 134–58.

70 Scott, 'Chapters in the History of the Law of Quebec, 1764–1775.'

71 A research team composed of Michel Morin, David Gilles, and Arnaud Decroix is examining the records of the post-Conquest civil courts and their role in dispute settlement, with a book expected soon: *Les tribunaux et l'arbitrage en Nouvelle-France et au Québec, 1740–1784* (Montreal: Éditions Thémis). For an initial reflection, which also uses the notion of adaptation, see David Gilles, 'Les acteurs de la norme coloniale: entre adaptation et appropriation (Québec XVIIe–XVIIIe siècle),' *Clio@Themis* 4 (2011); my thanks to Professor Gilles for giving me access to this.

10

'Delivered from all your distresses': The Fall of Quebec and the Remaking of Nova Scotia

BARRY M. MOODY

In 1761, his London agents wrote to John Easson of Annapolis Royal, Nova Scotia, that they 'do sincerely congratulate you upon your being delivered from all your distresses by the surrender of Quebec,'[1] a comment that while particularly appropriate for Easson was also applicable for the entire British population of Nova Scotia. Certainly few men in the colony would have been more aware of how his own life and that of his family and community had been altered by events hundreds of kilometres away. Having come to Nova Scotia in 1734 as an employee of the Board of Ordnance, Easson had lived through numerous aboriginal and French attacks on the fort and town of Annapolis, both benefited and suffered from the French presence in North America from a business perspective, and, in 1758, finally been captured by a Mi'kmaw raiding party and carried off to Quebec, to be present there when that town fell to the British in 1759. Over the years, he had witnessed the attempts of the British government to deal with the Acadian and aboriginal populations of the colony, and had seen at first hand the largely futile efforts to establish an English-speaking, or at least Protestant, population in Nova Scotia. Obviously for Easson himself, the fall of Quebec meant personal freedom and the ability to return to family, community, and business, but he was also perceptive enough to realize just how radically these distant events would reshape the colony he had called home for more than twenty-five years. Over his remaining thirty years in Nova Scotia, he would witness its transformation from a colony inhabited largely by Mi'kmaq and Acadians, as it had been for most of his residency so far, to one with a solid British population, with British institutions and culture.[2]

In 1710, Port-Royal, the capital of the French colony of Acadia, was seized by a joint British and New England force and renamed Annapolis Royal. By the terms of the Treaty of Utrecht in 1713, France surrendered an indeterminate portion of the colony to Britain, although retaining Île Royale (Cape Breton Island) and Île St-Jean (Prince Edward Island).[3] For the next fifty years, Britain would struggle in its efforts to retain and develop the colony, while France expended considerable effort and vast sums of money in its attempts to rebuild its strength in the east and dislodge the British from their foothold. The fate of the region was not finally determined until the fall of the French strongholds of Louisbourg, Quebec, and Montreal. Throughout this period, Nova Scotia/Acadia remained very much a borderland, a region of conflict and contention; neither nation could confidently call the area its own.[4] The aboriginal peoples of the region, especially the Mi'kmaq, pursued their own agenda, which did not correspond precisely with that of the French and not at all with that of the English.

For the first half of the eighteenth century, both Britain and France, through their action and their inaction, had a profound impact on the area variously known as Nova Scotia and Acadia (essentially today's mainland Nova Scotia and New Brunswick), as did their colonies of Canada, Île Royale, and Massachusetts. In the twentieth century, however, far more attention was paid to New England's (especially Massachusetts's) role in the colony. The story of New England's thrust into Nova Scotia and consequent influence in the shaping of its neighbour would be chronicled brilliantly by American historian J.B. Brebner with the publication in 1927 of his influential *New England's Outpost: Nova Scotia before the Conquest of Canada*, which, despite efforts at revision and rebuttal, has remained the standard work on the topic. By contrast, French efforts to build a presence, and even reassert dominance, in old Acadia have been studied only sporadically, so that the significance of the French influence on the region has been largely forgotten.

For the historians of New France, Nova Scotia/Acadia has too often been seen as insignificant and incidental to the larger study of the French in America.[5] Nor did eastern involvement ever have the romantic and economic appeal of the western thrust, with its *coureurs de bois*, exploration, aboriginal alliances, and martyred missionaries. In fact, one is left to wonder how much would have been written about French activity in the Maritimes in the eighteenth century if it had not been for the reconstruction of Fortress Louisbourg by the federal government

of Canada, leading to the remarkable productivity of the Louisbourg historians.[6] Otherwise, for many historians of eighteenth-century Nova Scotia, Quebec's involvement in the region, while troubling, and important for the Mi'kmaq and Acadians, ceases to be of any consequence in the broader development of a *British* Nova Scotia, after both the Acadians and the Mi'kmaq are removed from centre stage in the 1750s. The history of Nova Scotia becomes the story of triumphant British imperialism against defeated French imperialism, with the latter quickly losing its significance and so – justifiably in this view – of little enduring interest. However, to ignore or downplay the role of France in Nova Scotia during this period is to miss significant aspects of the development of the colony, particularly the importance of the changes of the 1760s. French activity, and even *fear* of French activity, was one of the key determining factors of this era.

Even a very brief glance at the activities and influences of the French in Nova Scotia before 1759 underscores French importance in a number of areas, and here again John Easson can be our guide. The Nova Scotia to which he came in the mid-1730s was a marginal colony on the periphery of Britain's North American empire. Although it had been a British possession for a quarter of a century, little progress had been made in making it British in anything more than name. A largely forgotten garrison in a decrepit fort was all that protected the tiny population of the colonial capital, Annapolis Royal. An even smaller garrison, in a flimsy blockhouse, announced a weak British presence at the fishing station of Canso. Aside from the soldiers and their dependents, only a handful of families in the colony could call themselves British. The bulk of the population was made up of the aboriginal population, the Mi'kmaq, long tied to the French by bonds of religion, mutual interest, and friendship, and the much larger Acadian population, whose numbers doubled every generation through natural increase. Neither group was seen by the British as either loyal or dependable. Much of the suspicion of these people that pervaded the period, and would lead eventually to the expulsion of the Acadians, was driven in part by the perceived threats to the region by the French forces in North America, as well as by the weakness and inefficiency of the British presence.[7]

The Mi'kmaq had never accepted the terms of the Treaty of Utrecht, in which the French had handed over a large portion of Mi'kma'ki to the British. In the decades to follow, they would periodically demonstrate their displeasure at the British presence by raids on both Annapolis Royal and Canso and attacks on New England traders operating

in the Bay of Fundy.[8] Easson – who engaged in local trade as well as holding a position with the Board of Ordnance – and all of the British merchants of Annapolis suffered periodic seizure of their trading vessels when they moved beyond the range of the cannon of the fort. Throughout the decades, French Roman Catholic missionaries, funnelling into the colony through either Louisbourg or Quebec, would play a controversial role in encouraging anti-British sentiment and action by the Mi'kmaq.[9]

As master carpenter at the fort, Easson was well aware of the weakness of the British position in Annapolis Royal and of the almost hopeless, last-minute attempts to repair the fort to prepare for the onslaught that everyone knew was coming with the declaration of war between France and Britain in 1744. The initial threats, in the spring and fall of that year, came from Louisbourg, with the capture of Canso and two attacks on Annapolis Royal, the second of which nearly succeeded in taking the fort.[10] With the fall of Louisbourg the following year, however, the source of military difficulty for the British shifted to Quebec itself, as a force of regular colonial troops under the leadership of Lieutenant Pierre-Paul Marin de la Malgue was dispatched to join forces with the Mi'kmaq in harassing the British. The resulting attack on Annapolis was lifted by a combination of support from Boston and the arrival of the news of the siege of Louisbourg by the New Englanders.[11] Although the attack on Annapolis came to nothing, it marked a new involvement by Quebec in the affairs of Nova Scotia. Up to that point, Quebec had usually been content to pursue non-military intervention, and to encourage Louisbourg to take the initiative when a more forceful role was needed. The fall of Louisbourg to the New Englanders in June of 1745 forced Quebec into a more active role in the east; far from securing the safety of Nova Scotia, the taking of the fortress destabilized the mainland colony even further. From 1745 onward, it would be Quebec that posed the more serious threat and influenced more significantly affairs in Nova Scotia, even after the return of Louisbourg to the French at the end of the war. In 1746 both Quebec and France itself launched offensives aimed at Nova Scotia and Louisbourg, with the former sending a land force of six hundred *Canadiens* under Captain Jean-Baptiste-Nicolas-Roch de Ramezay to join a huge naval expedition under the duc d'Anville that sailed from France in the spring of that year.[12] Through incredible good luck, rather than military superiority, the British retained control of the region, although it is clear that French forces could roam at will through the countryside without fear of inter-

ference; *Canadien* forces would be present in Nova Scotia continuously from 1746 to the eve of the fall of Quebec.

Seventeen forty-seven proved to be the worst year thus far for the British presence in Nova Scotia. Late in 1746 a New England detachment of approximately five hundred troops was dispatched to Grand-Pré, the centre of the most populous Acadian region. A determined Quebec force, wintering at Chignecto, made an arduous overland trek through difficult terrain and heavy snow to attack an unsuspecting and ill-prepared New England contingent. The New Englanders were completely routed, losing their commanding officer and approximately seventy troops (or one hundred and forty, according to whose numbers one uses) with nearly a hundred wounded or captured; it was the most serious loss for the British in Nova Scotia during the war. The 'Grand-Pré Massacre,' as it was promptly named by the losers, infuriated New England, raising passions against Quebec and the Acadians (who were blamed for treachery) to new heights.[13] The attack at Grand-Pré made it painfully clear how powerful the Quebec presence in Nova Scotia really was and the extent to which it controlled the agenda in the region.

The war years of the 1740s had shown the precariousness of the British position in Nova Scotia. Beyond the small town of Annapolis Royal, the colony really was under the control of the Mi'kmaq and whatever Quebec forces might be present. The success of the French intervention in Nova Scotia lay not in what the Quebec militia was able actually to capture and hold, but in the way in which it kept the colony off balance. In this it appears to have been very effective, despite recent comments on the efficiency and efficacy of the Quebec militia.[14] The end of the War of the Austrian Succession in 1748 and the return of Louisbourg to the French shortly thereafter, however, led not to a diminution but to an acceleration of Quebec's role; leadership for French involvement in Nova Scotia would never return to the hands of those governing Louisbourg.

In 1749 came the first serious attempt by Quebec in forty years to establish a permanent base in the colony, from which French military power, manipulation of the Acadian population, and influence over the Mi'kmaq could be exercised. By 1751 Quebec forces had built Fort Beauséjour, at the head of the Bay of Fundy, on the southern edge of what they claimed was French territory but well within what Britain was certain had been ceded in 1713.[15] Within a very short time, the British had countered with the establishment of Fort Lawrence almost within cannon shot. For the first time, British and French forces faced

each other from fortified positions within sight, each contending for control of the region and the people who occupied it.[16] But it should be kept in mind that this was a Quebec initiative, instituted by the colonial regime, to serve Quebec interests as well as imperial concerns. From Fort Beauséjour, Quebec would play a significant role in involving the Acadians in the struggle between the French and British for the colony and in further destabilizing British Nova Scotia. Even the capture of Beauséjour and the beginning of the expulsion of the Acadians in 1755 failed to diminish significantly Quebec's military involvement in the east, both directly and through support of the Mi'kmaw and Acadian forces. Not until the fall of Louisbourg in 1758 and the threats against Quebec in 1759 did the pressure lessen and then cease. Only the capture of Quebec finally brought it to a close.[17]

Quebec's direct military involvement in Nova Scotia was troublesome and destabilizing, but it seldom posed a serious threat to the continuation of actual British possession of the colony, as the French were never able or willing to devote sufficient forces to bring about the colony's fall. Difficulties of overland access and provisioning from Quebec also added to the problems. Quebec's influence over and impact on the Mi'kmaq and the Acadians, however, would create other serious issues for the peoples of the colony.

Since the arrival of French settlers in Mi'kma'ki (or Acadia as they would call it) at the beginning of the seventeenth century, an usually warm relationship had developed between the French and the aboriginal peoples of the region. The latter, however, were by no means dominated or controlled by the former, despite close ties of trade, religion, and even kinship, and could pursue a completely separate agenda in the region.[18] The conquest of Port-Royal in 1710, and especially the terms of the Treaty of Utrecht of 1713, altered substantially the relationships of the peoples of the region. With the exception of Île St-Jean and Île Royale, France no longer possessed much of the Mi'kmaw homeland (although what is now eastern New Brunswick would remain contested territory between France and Britain). The extent to which the French were able to influence Mi'kmaw policy over the succeeding decades is under dispute, but without question French support and encouragement were important factors in Mi'kmaw success in controlling much of the countryside well into the late 1750s. That support and encouragement usually flowed through either Quebec or Louisbourg, and often originated there. Either alone, or in concert with the French from Louisbourg or Quebec, the Mi'kmaq were a potent force in the

life of the region. Despite several attempts at formal peace between
the British and the aboriginal peoples, conflict was more frequently
the case. Attacks on Canso and Annapolis Royal, the seizure of New
England and Nova Scotian trading vessels, and assaults on the New
England fishery all threatened to disrupt the fledgling economic life of
the colony and even to dislodge the British completely.[19] Although by
no means the only reason, the hostility of the aboriginal peoples was
one of the causes of the infinitesimal growth of an English-speaking
population in the colony in its first forty years and its confinement to
the two communities of Annapolis Royal and Canso.

Even with the new push for a substantial English-speaking, Protes-
tant population in the decade after the founding of Halifax in 1749, ab-
original opposition to new settlements was a determining factor in the
failure of the British initiative. The new communities of Halifax and
Dartmouth both suffered extensively from Mi'kmaw attacks, as the lat-
ter sought to prevent or at least slow further British settlement in their
territory. British plans for the planting of new communities of settlers
from the Germanic states among the Acadian villages (part of a plan of
assimilation) were a complete failure when it became clear that, in the
face of Mi'kmaw opposition, it would be unsafe to attempt. The set-
tlers had to be housed within the walls of Halifax and then eventually
settled in their own community of Lunenburg far from the Acadians.[20]

These raids, with their fire, killing, and scalping, were greatly feared
by the settlers of the colony, and that fear would reverberate down
through the decades, long after the Mi'kmaq had ceased being any
threat at all. Some of those who lived through these attacks would sur-
vive for another half-century or more, telling and retelling the stories
of these turbulent times, moulding and shaping perceptions of the ab-
original peoples for several succeeding generations of Nova Scotians.
Reflecting this oral tradition, Nova Scotia's first real historian, T.C. Hal-
iburton, while extremely sympathetic to the Acadians, in 1829 wrote
harshly of the Mi'kmaq:

> Strangers can form no estimate at all, and the present generation of Ameri-
> cans but a very inadequate one of the nature of a war with the savages,
> and the horrors of an Indian captivity. Their mode of making war was
> altogether different from that of Europeans; it was a desultory, murder-
> ous, and predatory excursion, conducted by detached parties; who killed,
> scalped, and plundered their enemy ... If time and opportunity permitted,
> they carried off their prisoners, to glut their appetite for vengeance by in-

flicting a lingering and cruel death, or to extort an exorbitant ransom from their friends and relations.[21]

Not only were Mi'kmaw raids on Nova Scotia towns much feared by the settlers, but the intense dread of capture during such a raid was directly connected in the minds of Nova Scotians with Quebec. Beginning in the 1740s, increasing numbers of settlers, traders, and soldiers were taken prisoner by raiding parties. Some of the captives were ransomed and returned to their families and communities, sometimes through the intervention of the Acadians, but others had to endure long months of captivity, and often suffered the gruelling overland trek to Quebec, where additional months or years of imprisonment awaited them.

In New England literature and historiography, the captive and the captivity narrative are familiar fixtures,[22] but little attention has been paid to the topic in Nova Scotian history. This is probably related to the fact that it was a phenomenon of short duration (unlike the much longer experience of New Englanders), and none of the captives is known to have produced a surviving extensive narrative of his or her ordeal. The seizure of British subjects in Nova Scotia, holding them in prolonged captivity, and/or transporting them to Quebec appears to have been an activity almost exclusively restricted to the 1740s and 1750s. That those taken to New France were held in Quebec City, often for years before their release, made Quebec complicit in this greatly feared practice. Many of these captives were civilians, often women and children, and some had been captured when peace officially existed between France and Britain. Nonetheless, Quebec usually proved very reluctant to release them. In 1756, the home of Huguenot settlers Louis and Marie-Anne Payzant, living near Lunenburg with their four children, was attacked by Mi'kmaq; Louis was killed and his wife and children taken prisoner. Two of the children were kept to be adopted by their captives, while the rest were sent on to Quebec. Eventually reunited, the family remained in Quebec until freed by the victorious British forces, over three years later.[23] On 6 December 1757, a wood-gathering party near Annapolis Royal was fired on; one man was killed and six soldiers, along with master carpenter John Easson, were taken prisoner.[24] Easson was taken overland to Quebec, where he would be held until its fall. John Weatherspoon likewise was taken near Annapolis, and suffered a similar fate to Easson's. Weatherspoon's journal, kept during his captivity and later imprisonment at Quebec, gives a graphic account of the experience, as well as details about many other captives.[25] The

1750s are replete with such stories, the details of which would have been told and retold in the years thereafter – one Payzant child did not die until 1834, for example – indelibly implanting in the minds of several generations of Nova Scotians the image of a savage aboriginal population and a complicit Quebec. Nova Scotia had certainly become a much more dangerous colony in which to live, and consequently even less attractive to British settlers.

The extent to which the French, and especially those in Quebec, either influenced or encouraged the Mi'kmaq in this activity and in their overall strategy is not clear. What does appear certain is that continuing Mi'kmaw opposition played a significant role in the retardation of British settlement in the colony to 1760. With remarkably small numbers of warriors, they effectively controlled most of the countryside outside the few British settlements, often making it deadly for new settlers even to go outside the town limits. This activity by the Mi'kmaq was made possible at least partially by the encouragement, supplies, and presents received from the French. This became clear when that support ceased after 1759. Certainly this was the perception by the British, both in Nova Scotia and in New England, who tended to see the Mi'kmaq more as tools of French policy than as independent agents.

The fall of Louisbourg in 1758 and especially that of Quebec the following year dramatically altered the dynamics of the region and its peoples. Freed from the threats to its security that these external forces posed, and from much of the internal danger from the now-weakened Mi'kmaq, British Nova Scotia belatedly began to experience the kind of development it had long been denied. The end of the French-British conflict in North America had both positive and negative impacts, as the colony sought a new *raison d'être* and new directions.

News of the fall of Louisbourg and Quebec was received with relief and joy by the British residents of Nova Scotia; a cloud had been lifted, and it now seemed possible for the colony to develop as never before. As Governor Charles Lawrence pointed out in his address to the House of Assembly on the capture of Quebec, 'If we rightly improve the opportunity, we cannot fail to be as much an object of Envy as we were before of Compassion.'[26]

The most obvious and almost immediate result of the removal of the French threat was a new wave of settlement in the colony. For decades, various schemes to bring settlers to the colony had failed, not only because of the fear of French and aboriginal attacks, but also because of government inaction. Moreover, Halifax had not been seen as a desir-

able place to live, and waves of earlier British and European settlers had passed the colony by despite an increasing shortage of good farmland in many of the British colonies to the south. By 1759, after half a century of British control, Nova Scotia's 'British' population was still fewer than ten thousand, at least a third of whom were actually recent Germanic immigrants.[27]

Charles Lawrence realized fully the opportunities for settlement presented by the removal of the French threat. Following up on earlier schemes, in October 1758 he issued a proclamation directed at the people of New England, offering free land and subsidized transportation. The reasons given for the timing of this offer are telling: 'Whereas by the late Success of His Majesty's Arms in the Reduction of Cape Breton ... a favourable Opportunity now presents for the peopling and cultivating, as well the lands vacated by the French [the Acadians], as every other Part of this valuable Province.'[28] The capture of Louisbourg earlier in the year had relieved much of the French pressure on the colony, although, as Lawrence would have been well aware, real dangers persisted. By the fall of 1758, however, he also knew that a major expedition was planned against Quebec for the following summer, one that should remove for good any threat from that quarter as well. The time for the settlement of Nova Scotia had arrived.

Although the proclamation stirred great interest in New England, where land had become scarce and free land virtually non-existent, colonials there were cautious. They were too familiar with Nova Scotia's unsettled past to rush into hasty decisions they might live to regret. Halifax received many enquiries during 1759, but it was not until after the arrival of the news of the fall of Quebec that many New Englanders were prepared to commit themselves. Beginning with a trickle in 1759 and then a major rush in 1760, approximately eight thousand settlers streamed into the colony, taking up the vacated Acadian farmland and occupying harbours on the South Shore conveniently situated for fishing and trade. The New England Planters, as they became known, constitute the first major permanent English-speaking migration into what is now mainland Canada.[29] And it is clear that the removal of the French threat, specifically from Louisbourg and Quebec, was a necessary precondition to their arrival.[30] Indeed, many of the new arrivals remained fearful that the threat had not disappeared completely.[31] Others, such as the youthful Henry Alline, having heard stories of past attacks, feared the continuation of Mi'kmaw opposition to settlement in what the aboriginal peoples still viewed as their territory. His early

joy at living in the countryside was eclipsed 'when it was frequently reported, that the Indians were about rising to destroy us; and many came out among us with their faces painted, and declared that the English should not settle this country.'[32] The removal of the French threat notwithstanding, the Planters had moved into what was still contested territory.

This migration, which lasted until approximately 1768, when the flow of settlement turned westward, nearly doubled the population of the colony and led to the building of many new communities on the colony's South Shore, throughout the Annapolis Valley and Isthmus of Chignecto, and up the valley of the St John River. The numbers of settlers alone, however, was not the most significant aspect of this migration. For the first time in the history of the region as a British possession, newcomers felt secure enough to settle outside the centres of Halifax, Annapolis Royal, and Lunenburg, and in the process the landscape of much of peninsular Nova Scotia would be transformed.

The area around Annapolis Royal serves as a good case study of the way in which the countryside was altered in a few short years. Until 1755, the region consisted of the small British town of Annapolis Royal, with a civilian population usually numbering fewer than a hundred, and the surrounding Acadian population of approximately three thousand scattered along both banks of the Annapolis River. Although there had been a little intermarriage between the two groups in the years immediately after the conquest of 1710 – the Maisonnat/Winniett and de Sainte-Étienne de la Tour/Bradstreet unions being the most prominent – this did not become a widespread practice in subsequent years.[33] Although the British and Acadians traded extensively, and some of the latter worked in the town on occasion, especially on the fort, in essence they remained very much two solitudes, occupying their own separate spaces. There is no record of a single British resident living outside the confines of the tiny town at any point before 1760.

In 1755, of course, the townspeople became even more isolated when the Acadians along the river were expelled or fled into the woods. Most of their homes and farm buildings were put to the torch, and Annapolis Royal became a British island in a desolate and eerily quiet countryside. Escaped Acadians, occasional *Canadien* militia, and passing Mi'kmaq were all that remained, while the fields and orchards of the formerly prosperous Acadian farms began to revert to wilderness.[34]

With the lifting of the barriers of fear and armed opposition, however, the area began to take on a new population and a new appear-

ance. In 1760 and 1761, hundreds of New Englanders, mostly from Connecticut and Massachusetts, arrived to settle the new townships of Granville on the north bank of the river and Annapolis on the south, settling on the former dyked marshlands of the dispossessed Acadians and the surrounding uplands and dramatically altering the western end of the Annapolis Valley. Although a few families would give up and move on during the next few years, the overwhelming majority remained and were joined by others, not all of them necessarily from New England, who took the place of those departing. Within less than a decade, a permanent, English-speaking population of significant size had been established, many of whose descendants still reside in the county today.[35] Over the next several generations, a new society emerged, strongly influenced by its New England origins, but unmistakably different nevertheless.

From the vantage point of nearby Annapolis Royal, the transformation of the surrounding countryside could not have been more dramatic. In a little more than half a decade, the town, once surrounded by a French-speaking, Roman Catholic population (the Acadians) of questionable loyalty, found itself in the midst of an English-speaking, Protestant population whose loyalty to the British Crown was assumed (though not necessarily entirely accurately). Ironically, the change had come about at a time in the fifty-year history of this British town when such an alteration was least needed. For half a century, a British population had been desperately needed to help protect the town and provide a secure source of supplies. Now, however, the forces that had threatened the security of the town and the stability of the region seemed to have been largely removed. At almost the same time, an apparently dependable population had moved in and now surrounded the town. The landscape, moreover, was transformed not just by the mere replacement of one population (French) with another (British). The lifting in 1759 of much of the previous fear and uncertainty now dictated the way in which settlement would take place – the very shape the new communities would assume – which, in turn, would greatly influence the way in which these townships and their inhabitants would evolve. Although the newcomers apparently were happy to have a British fort – even a small and dilapidated one – nearby, it is clear from their settlement patterns that they had little real fear of attack. Rather than build their homes within or clustered just outside Annapolis Royal itself, where they could live under the protection of the fort's guns, they chose to settle on five-hundred-acre lots laid out along both sides of the

river for more than sixty kilometres, creating a solid line of settlement more in the style of rural Quebec than of earlier British North American colonies. Up to this point, the three communities of Annapolis Royal, Halifax, and Lunenburg were tightly settled towns, shaped by the need for mutual protection, and even the Acadians had chosen to establish small villages along the edge of their marshlands. The Planter farming townships, however, broke this pattern, as the settlers spread across the landscape on their separate farms. Clearly, from a defensive point of view, this pattern offered little protection, but it had the immense advantage of allowing each family to live on its own land, rather than in a town some distance away. The implications of this for the future social, political, economic, and religious evolution of these people were immense.

This same reluctance to settle in towns is evident in a number of other farming townships, even those where a formal town with small, half-acre town lots was laid out with gardens, farms, dyked marshes, and woodlots surrounding it. In townships such as Horton and Cornwallis, the settlers preferred to live on their own scattered farms in defiance of the Halifax-imposed plan of a tightly settled town.[36] This pattern did not prevail, however, in the fishing and trading communities of the South Shore. There, villages and towns were more common. Communities such as Liverpool and Yarmouth were established within months of the settlers' arrival, and good waterfront property and access to a wharf were of more immediate concern than potential farmland.[37]

Freedom from external threats also allowed these newcomers to develop a relationship with the land that was significantly different from that of either their Mi'kmaw or Acadian predecessors. Unlike the Mi'kmaq, the Planters did not rely primarily on the products of the forest for their livelihood, but chose to clear increasingly large areas of wooded uplands for agricultural purposes. The long-term impact of this on the lives of the aboriginal population would be far-reaching, as no provision was made in any of the hundred-thousand-acre townships for an aboriginal presence, and a shrinking forest seriously affected their ability to survive.[38] Although the Acadians had been primarily farmers, their use of the land was very different from that of their successors. While the Planters also used the rich dyked marshlands that had been cultivated for a century before their arrival, they were never able to use them as effectively as had the Acadians.[39] Increasingly, they turned their attention to the surrounding uplands, transforming the environment over the succeeding generations, and changing the rela-

tionship between the land and its human occupants as well.[40] Even two hundred and fifty years after the arrival of these new settlers, the impact of their land-use patterns remains clear: satellite images of Granville Township, for example, clearly reveal the superimposition of the Planter farms on the landscape, a template that no future waves of migration into the townships, not even the Loyalists, eradicated or seriously altered. Such decisions could not have been made in the climate that pertained prior to the autumn of 1759.

The long-term consequences of the new-found freedom of the Planters to settle the land and shape their environment as they saw fit played a significant role in the evolution of much of rural Nova Scotia. While it lies well beyond the scope of this chapter to explore these consequences fully, it can be noted, for example, that the development of villages and towns was much delayed in some regions – in the combined townships of Annapolis and Granville, only one other town, Bridgetown, would emerge over the next two hundred and fifty years.[41] One result was the deferred creation of religious and educational institutions. Levels of literacy among second-generation Planters declined in many areas, while the scarcity of churches and settled ministers seems to have played a part in the spread of the New Light revival of the 1770s and 1780s and the subsequent strength of the Baptist and Methodist movements; both would play significant roles in the evolution of Maritime society. It has been suggested that the scattered nature of rural Nova Scotia society played a role in the failure of a revolutionary movement to develop in the colony in the 1770s. Were town and village centres an essential component for the development of a sense of community – an aggrieved community – and a sense of common cause? While it is certainly too much to claim that the fall of Quebec alone created such developments in these and other areas, it is clear that the connections can be made. The shape of the Nova Scotian landscape, with all its implications for community and family development, was tied directly to the removal of the military threats that had long held the colony in thrall, providing the settlers the freedom to choose the manner of their settlement.[42]

If the where, why, and how of Planter Nova Scotia settlement are important factors to explore, so too is the when. For fifty years, the French imperial presence in North America, at both Louisbourg and Quebec, had ensured that Nova Scotia would remain a potential or actual battlefield between two empires, seriously retarding its evolution as a British colony. Indeed, without a strong English-speaking, Protestant population, Nova Scotia could not develop the governmental infrastructure

common to the other British colonies in North America. An elected form of assembly was introduced not after the British conquest of the colony, in the second decade of the century, but only in the latter part of the sixth decade, after the French Empire in North America began to crumble, and then only grudgingly on the part of the governor. With the capture of Quebec and the coming of the New Englanders shortly thereafter, the British approach to the governance of this colony could then take shape, with the emergence of a very different type of colonial government as the result. In her provocative study, *Fault Lines of Empire*, Elizabeth Manke looks at the impact of 'attempts by the British metropolitan government to redefine center-periphery relations in the British Atlantic world.'[43] For a crucial half-century, Nova Scotia's development as a colony had been curtailed by a combination of French and aboriginal hostility, British governmental opposition and indifference, and Massachusetts obstruction.[44] Britain now forcefully shaped a new colony in which civil and judicial governance was largely removed from the local level. Or, phrased another way, 'The British knew that the frontier in Nova Scotia presented an opportunity to reform and refashion New England practices and to eliminate the excesses they thought New England represented.'[45] Clearly, the shape of the new Nova Scotia was directly related to the fact that the fall of Quebec and the coming of the New England Planters took place when they did, not earlier, or possibly much later. The creation of modern Canada thus was the result not just of Britain's acquisition of a large land mass formerly part of the French Empire, but also of the practices and principles put in place in Nova Scotia in the wake of, and made partially possible by, the capture of Quebec in 1759.

The removal of the French threat and much of that posed by the aboriginal nations also had a significant impact on the residents of the few existing towns and villages of the colony. Using Annapolis Royal as an example, it is clear that the fall of Quebec to a large extent lifted the state-of-siege mentality that had characterized the town for half a century. Until the threats that had been posed repeatedly by both Louisbourg and Quebec forces were finally removed, not a single English resident of the town had been willing to move beyond the confines of the palisade that encircled the community, and Annapolis Royal remained a tiny enclave huddled in the shadow of the fort. After 1759, for the first time in its history, Annapolitans were prepared to contemplate life beyond the town's protective walls. The Planter grants of the 1760s included virtually every significant Annapolis family name as well, as

a scramble took place for land, both for speculation and for farms and country residences. The restrictions on movement and living space, and the almost daily threats to life, that for so long had characterized the community had now been lifted, opening up new opportunities for the people of the colony's former capital.[46] Beginning in 1759, extensive lands were set aside for the elite of Halifax, and in 1764 a new township, Windsor, was created; these prominent Haligonians would develop the area into country retreats for their families, an idea unthinkable a scant decade before, when it was unsafe to leave the security of Halifax's defences even to gather firewood.[47]

It was not merely the layout of farms and country estates that transformed the landscape of much of rural Nova Scotia. The homes of the Acadians were swept away in the aftermath of expulsion as their villages were put to the torch. In the countryside, while some of the houses without question survived this destruction, not a single documented house of the Acadian period has survived to the present day.[48] After 1755, the landscape was not just barren of people. Only in the town of Annapolis Royal itself is there a lone house that can be dated to partial Acadian ownership.[49] For all intents and purposes, the built landscape of rural Nova Scotia had been wiped clean. The new settlers of the post-1759 period would impose a different appearance on the land they possessed, building houses more reflective of those they had left behind in New England.[50] Indeed, a few Planters brought their disassembled houses with them from New England. The houses, together with barns, outbuildings, and, later, churches and schools would give the landscape a very different look from that which had prevailed a mere decade or so before.

If it can be said that, in general, the impact of 1759 was positive for British Nova Scotia, the same was not true for the aboriginal inhabitants of Mi'kmaki. For many years, historians, led by Brebner, argued that the collapse of the French in North America had an immediate and devastating impact on their aboriginal allies in the region, removing their main support and leaving them at the mercy of the victors. More recently, this probably simplistic view has been challenged by those who argue that the Mi'kmaq were a stronger, more independent force, able to control more of the situation than has sometimes been admitted.[51] However, whether the Mi'kmaq were left as a demoralized and defeated people or instead entered another phase of their relationship with the British, it must be recognized that the context within which they operated, and that would help determine the direction of the col-

ony, had now changed irrevocably. Despite some continued tensions, the Mi'kmaq and the British entered a period of treaty negotiation and signing in the early 1760s that brought to an end a half-century of conflict. In 1773, a report suggested that 'The Indians ..., since the French have been expelled from the Neighbourhood of this Province ... have become quiet and at present are well disposed.' If, as John Reid probably rightly suggests, this is an oversimplification of the state of affairs, it does nonetheless give voice to the view that there had been a major shift in the relationship between the two and that a new era of peaceful, if not always amicable, relations had been ushered in.[52] As far as most of the European settlers of the colony were concerned, the aboriginal population largely ceased to be a factor of significance.

Even for European Nova Scotians, not all of the consequences of the fall of Quebec were positive ones. For a small fortified place such as Annapolis Royal, the French and Mi'kmaw threats of the past half-century had become virtually its *raison d'être*. Although London had seldom been generous, even in wartime, in sending money for the garrison and fortifications, the fort remained the town's major source of revenue. Commanding officers at the fort had long lamented the untrustworthiness of the surrounding Acadians, and wished ardently for a loyal, supportive civilian population in the region and an end to the hostilities posed by the enemy, both aboriginal and French.[53] By the early 1760s, they had what they had wished for. After 1763, however, with no enemy in sight and an impoverished government at home, little money would flow towards such small outposts in a colony that had lost much of its military and strategic significance. All work on the fortifications ceased in 1766, and two years later the garrison was entirely withdrawn; two local men were instructed to mothball the fort in case it should be needed at some future date.[54] An important source of income was thus lost to the local economy, at least until trouble with the rebellious colonists to the south arose. Aside from the economic impact, what the blow did to the sense of importance and identity of the townspeople can only be guessed at. In 1767 Thomas Gage, commander-in-chief of British forces in North America, summed up the situation well in noting that 'One company [of troops] is posted at Annapolis Royal because it is [*sic*] a Fort of Consequence when built, but Affairs are so much changed since, by the Removal of the Acadians and settling the Country with British Subjects, not to mention the Conquest of Canada, that it does not seem to require Attention, to answer the Expence of supporting it.'[55]

The same was true, on a larger scale, for the colony as a whole. The

twin threats of Louisbourg and Quebec had made Halifax and Nova Scotia of considerable significance in the struggle for North America; that importance was now largely at an end. Seeing no further threat to Britain's supremacy in North America, a strapped British government cut back on military expenditures in Nova Scotia on a massive scale.[56] For the next fifteen years, Nova Scotia's positioning between two contending forces – a situation that had prevailed for nearly a hundred and fifty years – had been eradicated, and the colony's significance much reduced in consequence. Only the loss by Britain of most of its North American colonies would re-establish Nova Scotia, and especially the port of Halifax, to some of the strategic prominence that it had held before the fall of Quebec.

One of the more obvious consequences for the region, but one that has been little commented upon, was that Nova Scotia remained a British colony rather than becoming a French one. The fall of Louisbourg and especially Quebec finally brought to an end any chance of the restitution of Acadia. So conditioned have we become to accepting the British fate of the region that it is just assumed as somehow inevitable, because that is how the story ends. The outcome of the previous fifty years of conflict was by no means certain or inevitable, however, and to forget it is to miss a fundamental truth about that period. Until 1758–9, the region remained the ragged outer eastern edge of the French Empire in North America, as well as the northern borderland of the British. The 1740s and 1750s saw the most intense and prolonged conflict in the area's history, the outcome of which was by no means certain. The events on the St Lawrence in 1759, followed by the terms of the peace treaty four years later, brought to an end to that uncertainty, and committed the region to a British future. One hundred and fifty years of conflict and change of ownership was at an end, and Nova Scotia, not *Acadie*, would emerge when the gunfire had ceased.

NOTES

1 Lane & Booth to John Easson, 24 February 1761, http://www.gov.ns.ca/nsarm/virtual/easson/introduction.asp?Language=English.
2 For details of Easson's life, see Barry Moody, 'The Eassons: A Nova Scotia Family,' at http://www.gov.ns.ca/nsarm/virtual/easson/introduction.asp?Language=English. This site reproduces more than a thousand documents generated by the related Easson and Hoyt families.

3 John G. Reid, 'The "Conquest" of Acadia: Narratives,' in John G. Reid et al., *The 'Conquest' of Acadia, 1710: Imperial, Colonial, and Aboriginal Constructions* (Toronto: University of Toronto Press, 2004).

4 John Bartlet Brebner, *New England's Outpost: Acadia before the Conquest of Canada* (New York: Columbia University Press, 1927) and N.E.S. Griffiths, *From Migrant to Acadian: A North American Border People, 1604–1755* (Montreal; Kingston, ON: McGill-Queen's University Press, 2005) are the best explorations of this theme.

5 Some exceptions are George F.G. Stanley, *New France: The Last Phase, 1744–1760* (Toronto: McClelland and Stewart, 1968); and W.J. Eccles, *France in America* (Vancouver: Fitzhenry & Whiteside, 1972). Even Eccles pays scant attention to Acadia/Nova Scotia in this period in his *The Canadian Frontier 1534–1760* (New York: Holt, Rinehart and Winston, 1969).

6 See, for example, A.J.B. Johnston, *Endgame, 1758: The Promise, the Glory, and the Despair of Louisbourg's Last Decade* (Sydney, NS: Cape Breton University Press, 2007); B.A. Balcom, *The Cod Fishery of Isle Royale, 1713–1758* (Ottawa: Parks Canada, 1984); and Kenneth Donovan, 'Slaves and Their Owners in Île Royale, 1713–1758,' *Acadiensis* 25, no. 1 (1995): 3–32.

7 Brebner, *New England's Outpost*; Griffiths, *From Migrant to Acadian*, especially 315–46; John Mack Faragher, *A Great and Noble Scheme: The Tragic Story of the Expulsion of the French Acadians from Their American Homeland* (New York: W.W. Norton, 2005), 179–208; and Geoffrey Plank, *An Unsettled Conquest: The British Campaign against the Peoples of Acadia* (Philadelphia: University of Pennsylvania Press, 2001), 68–105.

8 Plank, *Unsettled Conquest*, 74–8; see the many references to Mi'kmaw attacks on English traders in *Original Minutes of His Majesty's Council at Annapolis Royal, 1720–1739*, ed. Archibald MacMechan (Halifax: McAlpine, 1908); and *Minutes of His Majesty's Council at Annapolis Royal, 1739–1749*, ed. Charles Bruce Fergusson (Halifax: Public Archives of Nova Scotia, 1967).

9 Plank, *Unsettled Conquest*, 95, 98–9, 111; Gérard Finn, 'Jean-Louis Le Loutre,' in *Dictionary of Canadian Biography*, vol. 4, http://www.biographi.ca.

10 Plank, *Unsettled Conquest*, 108–9; Faragher, *Great and Noble Scheme*, 214–20; and Barry M. Moody, '"A Just and Disinterested Man": The Nova Scotia Career of Paul Mascarene, 1710–1752' (PhD thesis, Queen's University, 1976), 213–40.

11 Moody, '"Just and Disinterested Man,"' 257–63; Faragher, *Great and Noble Scheme*, 223–4; *The Journal of Captain William Pote Jr. During His Captivity in the French and Indian War from May 1745 to August 1747* (New York: Dodd, Mead, 1896), 1–5; and W.J. Eccles, 'Paul Marin de la Malgue (La Marque),' in *Dictionary of Canadian Biography*, vol. 3, http://www.biographi.ca.

12 Moody, '"Just and Disinterested Man,"' 271–2; Faragher, *Great and Noble Scheme*, 234–6; and Jean Pariseau, 'Jean-Baptiste-Nicolas-Roch de Ramezay,' in *Dictionary of Canadian Biography*, vol. 4, http://www.biographi .ca. For a full discussion of d'Anville's expedition, see James Pritchard, *Anatomy of a Naval Disaster: The 1746 French Naval Expedition to North America* (Montreal; Kingston, ON: McGill-Queen's University Press, 1995).

13 Moody, '"Just and Disinterested Man,"' 287–9; idem, 'Arthur Noble,' in *Dictionary of Canadian Biography*, vol. 3, http://www.biographi.ca; and Griffiths, *From Migrant to Acadian*, 363–5.

14 Jay Cassel, 'The Militia Legend: Canadians at War, 1665–1760,' in *Canadian Military History Since the 17th Century: Proceedings of the Canadian Military History Conference, Ottawa, 5–9 May 2000*, ed. Yves Tremblay (Ottawa: Department of National Defence, 2001), 59–67.

15 Plank, *Unsettled Conquest*, 130–1.

16 Griffiths, *From Migrant to Acadian*, 395; John G. Reid, *Six Crucial Decades: Times of Change in the History of the Maritimes* (Halifax, NS: Nimbus, 1987), 34; and Dominick Graham, 'Charles Lawrence,' in *Dictionary of Canadian Biography*, vol. 3, http://www.biographi.ca.

17 See, for example, John Knox, *An Historical Journal of the Campaigns in North America for the years 1757, 1758, 1759*, ed. Arthur G. Doughty (Toronto: Champlain Society, 1914–16), 31–329, for events in Nova Scotia while he was posted there.

18 Griffiths, *From Migrant to Acadian*, 11, 13–14, 20–2, 84–5, 259–60; Reid, '"Conquest" of Acadia,' 21–2; and William Wicken, 'Mi'kmaq Decisions: Antoine Tecouenemac, the Conquest, and the Treaty of Utrecht,' in *'Conquest' of Acadia, 1710* (see note 3), 95–8; and Plank, *Unsettled Conquest*, 30–1.

19 Barry Moody, 'Making a British Nova Scotia,' in Reid et al., *'Conquest' of Acadia* (see note 3), 150–1; Plank, *Unsettled Conquest*, 77–8 ; Moody, '"Just and Disinterested Man,"' 215–21; and *Boston Weekly News Letter*, 19 July 1744.

20 Plank, *Unsettled Conquest*, 131–4; Winthrop Pickard Bell, *The 'Foreign Protestants' and the Settlement of Nova Scotia* (Toronto: University of Toronto Press, 1961), 502–18; and John G. Reid, *Essays on Northeastern North America, Seventeenth and Eighteenth Centuries* (Toronto: University of Toronto Press, 2008), 180–1.

21 Thomas C. Haliburton, *An Historical and Statistical Account of Nova-Scotia*, vol. 1 (Halifax: Joseph Howe, 1829), 154–5.

22 John Demos, *The Unredeemed Captive: A Family Story from Early America* (New York: Knopf, 1994); Kathryn Zabelle Derounian-Stodola and James Arthur Levernier, *The Indian Captivity Narrative, 1550–1900* (New York:

Twayne, 1993); and *Held Captive by Indians: Selected Narratives, 1642–1836*, ed. Richard VanDerBeets (Knoxville: University of Tennessee Press, 1973).

23 B.C. Cuthbertson, 'John Payzant,' in *Dictionary of Canadian Biography*, vol. 4, http://www.biographi.ca. Payzant's own brief account of the attack on his family and his subsequent captivity at Quebec is found in *The Journal of John Payzant*, ed. Brian C. Cuthbertson (Hantsport, NS: Lancelot Press, 1981), 15–6.

24 Knox, *Historical Journal*, 115, 122–8.

25 'Journal of John Weatherspoon,' in *Report and Collections of the Nova Scotia Historical Society for the Years 1879–80*, vol. 2 (Halifax, NS: Nova Scotia Historical Society, 1881).

26 Quoted in John Bartlet Brebner, *The Neutral Yankees of Nova Scotia: A Marginal Colony during the Revolutionary Years* (Toronto: University of Toronto Press, 1969), 1.

27 Moody, 'Making a British Nova Scotia,' 139–45.

28 The proclamation was published in the *Boston Gazette*, 31 October 1758.

29 Margaret Conrad, 'Introduction,' in *They Planted Well: New England Planters in Maritime Canada*, ed. Margaret Conrad (Fredericton, NB: Acadiensis Press, 1988), 9–12.

30 For many years, Brebner's *The Neutral Yankees of Nova Scotia*, first published in 1937, was the standard work on the Planters and their settlement in Nova Scotia. Since the mid-1980s, a great deal more work has been done on this group. See, for example, *They Planted Well* (see note 29); and *Making Adjustments: Change and Continuity in Planter Nova Scotia*, ed. Margaret Conrad (Fredericton, NB: Acadiensis Press, 1991). For a visual representation of the Planter migration, see *Historical Atlas of Canada: From the Beginning to 1800*, vol. 1, ed. R. Cole Harris (Toronto: University of Toronto Press, 1987), plate 31.

31 See for example, the account of David Perry, http://homepages.rootsweb .ancestry.com/~dagjones/captdavidperry/captdavidperry.html; and R.S. Longley, 'The Coming of the Planters to the Annapolis Valley,' in *They Planted Well* (see note 29), 22.

32 *The Life and Journal of the Rev. Mr. Henry Alline*, ed. James Beverley and Barry Moody (Hantsport, NS: Lancelot Press, 1982), 33.

33 See Charles Bruce Fergusson, 'William Winniett,' in *Dictionary of Canadian Biography*, vol. 3, http://www.biographi.ca; Hector J. Hébert, 'Marie-Madeline Maisonnat,' in *Dictionary of Canadian Biography*, vol. 3, http:// www.biographi.ca; W.G. Godfrey, 'John Bradstreet,' in *Dictionary of Canadian Biography*, vol. 4, http://www.biographi.ca; and Moody, 'Making a British Nova Scotia,' 130.

34 Barry Moody, 'Town with a Past: Annapolis Royal, 1749–2010,' ms in prep-
 aration, in possession of the author; and Knox, *Historical Journal*, 117–27.
35 W.A. Calnek and A.W. Savary, *History of the County of Annapolis including
 old Port Royal and Acadia* (Toronto: W. Briggs, 1897), 465–640; and Barry
 Moody, 'Land, Kinship and Inheritance in Granville Township, 1760-1800,'
 in *Making Adjustments* (see note 30).
36 A.W.H. Eaton, *History of Kings County* (Belleville, ON: Mika Press, 1972),
 72–89; and Debra McNabb, 'The Role of the Land in the Development of
 Horton Township, 1760–1775,' in *They Planted Well* (see note 29), 151–3.
 For a visual representation of the town in Horton Township that was not
 developed, see *Historical Atlas of Canada* (see note 30), plate 31.
37 J.R. Campbell, *A History of the County of Yarmouth, Nova Scotia* (Saint John,
 NB: J & A McMillan, 1876), 32–8; and Elizabeth Manke, *The Fault Lines of
 Empire: Political Differentiation in Massachusetts and Nova Scotia, ca. 1760–
 1830* (New York: Routledge, 2005), 10–14.
38 As yet, there has been no significant study of the long-term impact on the
 Mi'kmaq of the suddenly changed farming practices after 1759.
39 The best study of the use of the marshlands is Sherman Blakney, *Sods, Soil,
 and Spades: The Acadians at Grand Pré and their Dykeland Legacy* (Montreal;
 Kingston, ON: McGill-Queen's University Press, 2004).
40 A.R. MacNeil, 'The Acadian Legacy and Agricultural Development in
 Nova Scotia, 1760–1861,' in *Farm, Factory and Fortune: New Studies in the
 Economic History of the Maritime Provinces*, ed. Kris Inwood (Fredericton,
 NB: Acadiensis Press, 1993), 1–16; idem, 'Early American Communi-
 ties on the Fundy: A Case Study of Annapolis and Amherst Townships,
 1767–1827,' *Agricultural History* 62, no. 3 (1989): 101–19; and Moody, 'Land,
 Kinship and Inheritance,' 165–6.
41 Calnek and Savary, *History of Annapolis County*, 222–4.
42 Manke, *Fault Lines of Empire*, 3–4, 132–3, 152.
43 Ibid., 1.
44 See *'Conquest' of Acadia, 1710* (see note 3), for an exploration of these
 themes in post-1710 Nova Scotia.
45 Manke, *Fault Lines of Empire*, 136.
46 Grant, Granville Township, 30 October 1765, Fort Anne National Historic
 Site, Annapolis Royal, NS; List of Granville proprietors, n.d. [c. 1774–5],
 Nova Scotia Archives and Records Management (hereafter cited as
 NSARM), Halifax, RG 20 Series C, vol. 225; and Calnek and Savary, *History
 of Annapolis County*, 160, 196–7.
47 L.S. Loomer, *Windsor, Nova Scotia: A Journey in History* (Windsor, NS: West
 Hants Historical Society, 1996), 59–63.

48 Almost certainly a few of these houses have survived, hidden inside later additions and alterations, though none has yet been verified. Dendrochronology, the new technique of dating, holds great promise for identifying such structures.

49 The Sinclair Inn, a designated National Historic Site, was built in early 1710 in Port Royal (Annapolis Royal) by Jean Soullard, a Quebec silver and gunsmith, and his Acadian wife, Louise Comeau. The 1710 date indicated by the documents has been verified with dendrochronology.

50 See, for example, Allen Penney, 'A Planter House: The Simeon Perkins House, Liverpool, Nova Scotia'; Daniel Norris, 'An Examination of the Stephen Loomer House, Habitant, Kings County, Nova Scotia'; and Heather Davidson, 'Private Lives from Public Artifacts: The Architectural Heritage of Kings County Planters,' all in *They Planted Well* (see note 29).

51 Reid, *Essays*, 174.

52 Ibid., 185.

53 See Moody, 'A Just and Disinterested Man'; and Brebner, *New England's Outpost*, passim, for many examples of this.

54 Michael Franklin to [among others] Colonel Winniett and Jonathan Hoar at Annapolis, NSARM, 28 July 1768, RG 1, vol. 136.

55 Quoted in Brenda Dunn, *A History of Port-Royal/Annapolis Royal 1605–1800* (Halifax: Nimbus, 2004), 220.

56 Brebner, *Neutral Yankees of Nova Scotia*, 3, claims that the parliamentary grant for Nova Scotia was reduced from £50,000 to £5,000 per annum over a five-year period.

11

'Cutting heads from shoulders': The Conquest of Canada in Gaelic Thought, 1759–1791

MATTHEW P. DZIENNIK[1]

One of the more powerful and enduring images of the Quebec campaign is that of the plaid-clad Highland regiment, the 78th (Fraser's) Foot, being released in the closing stages of the battle to ensure the rout of the French-Canadian defenders. *Les sauvages sans culottes*, as the French reputedly termed them, inspired considerable fear and respect, both at the time and later, largely due to gross exaggerations of their apparent brutality and their willingness to neglect their muskets in favour of the broadsword.[2] The image seemed to encapsulate Britain's imperial expansion: formidable, dominant, assured, but paradoxical. The antiquated charge of the 78th Foot on the Plains of Abraham marked not only an imperial victory over French Canada, but a victory for the perceived progress of British imperialism. Instead of being a threat to internal stability, the martial prowess of the Highlands was now being employed to conquer foreign parts for settlement and cultivation, and to deny hegemony to Catholic France. There was something here to be celebrated, even if it occasionally expanded beyond the bounds of some Englishmen to accept. One critic objected to Joseph Wilton's design for a statue of the death of James Wolfe in Westminster Abbey on the grounds that his last moments would be in the arms of a Highlander. '[F]or what reason Highlanders,' he queried, 'above any other people, are made the only attendants ... there were surely English as well as Scotch regiments present when that gallant officer was kill'd.'[3]

In emphasizing the apparent primitiveness of the charge of the 78th Foot, the ability of the Highland soldier to represent modernity, as it was understood in the eighteenth century, was lost. It was drowned by the fears of English-speaking Scots, who, in the early nineteenth century, feared their nation would become no more than an indistinctive

cultural protrusion of Englishness, and who needed an icon that could represent a distinctively Scottish contribution to empire.[4] They found it in the Highland soldier, not by changing racist attitudes towards him, but by changing the meaning of these racist attitudes to fit a new political expedient.[5] Nineteenth-century 'Highlandism' created a contextual space for the development of a romantic image of the Highland soldier, an image that drew reductive and ahistorical parallels between the products of early-modern clan society and those who fought in Britain's colonial wars in the late eighteenth century. Consequently, Highland soldiers came to represent ancient ideals, mere tools in the expansion of the empire, not active agents with their own agendas and agency in the projection of imperial thought. It is revealing, then, that one Highland officer who was present at the Plains of Abraham noted that the regiment had charged only on the orders of General James Murray, and complained that the decision had saved many French-Canadian lives since it was impossible for the artillery to do its work for fear of hitting the Highlanders.[6]

Recent scholarship has seriously challenged, and largely overturned, romanticized eighteenth-century readings of the Highland soldier. For landowning elites in the Highlands, military service was a lucrative diversification of estate economies, only marginally different from other improvements such as sheep farming or the establishment of fish and kelp industries. In a more direct sense, Highland elites colonized various levels of the fiscal-military state as military officers, extracting benefits that conformed to individual or familial interests. By using the burgeoning public purse of the British imperial state, military service proved a means of engaging with a thoroughly modern commercial empire, but on terms that suited the interests of regional elites. It gave them opportunities for contacts and connections across the empire, as well as an entrenchment of their interests in the Highlands.[7] Many lesser sections of Highland society also adapted to changing socio-economic conditions and the imperatives of imperial expansion. The poor, particularly the landless cottars or subletters on Highland estates, adeptly used military service as a lever to secure landholding, often creating tensions as families that were willing to provide men for the army were privileged in tenancy agreements over other subtenant groups. On an individual level, enlisted Highland soldiers commanded large sums for their enlistment, conceiving of military service as a labour market and carefully protecting their value as labourers.[8] There was a normality to Highland military service. Military out-migration for a variety

of European powers had been a basic structural fact of the Highlands since at least the medieval period.[9] The socio-economic interpretation of Highland soldiering, tied to localized conditions and predicated on individual and familial interest, is a vital corrective to a problematic historiography.

This chapter, while accepting the interpretive framework of recent scholarship, argues that the privileging of socio-economic interpretations and the downplaying of the cultural ramifications of military service provides only a partial picture of Highland engagement with the imperial state. Socio-economic revisionism tends to obscure the enormous cultural impact of military service, and divorces the Highland soldier from important political contexts, which were different in the late eighteenth century. Political, commercial, and military connections between elites in the Highlands and the fiscal-military state had a long and complex history of reciprocal tension and amity.[10] But the imposition of imperial authority over the Highlands following the suppression of the 1745 Jacobite rebellion did create a different dynamic. In a fit of climactic violence, the Hanoverian regime resolved the dynastic challenge to its control of the kingdom and the British state cemented itself as the only viable political authority in the Highlands. Highland self-imagery at this critical stage was redefined within the context of an expanding empire, rather than within the confines of not-inconsiderable domestic issues in the Highlands themselves. Imperial expansion, and Highlanders' participation in that enterprise, was used to inject a confidence into Gaelic self-expression, reinvigorating a martial identity that allowed full licence to expressions of agency, masculinity, and conquest. The British victory at Quebec was a central feature of the realignment of Gaelic political thought towards accommodation with the British Empire as a cultural body politic. Between the fall of the town and the Constitution of 1791, Quebec served as explicit proof of the merits of fashioning a self-imagery around the empire that helped many Highlanders to embrace the triumphalist discourse of imperial hegemony. Quebec marked an important step in the equation of Highland interest with British imperial expansion.

This chapter begins with an exploration of the political and cultural contexts of Gaelic identity in the post-Jacobite Highlands, and demonstrates how Gaels interpreted the Conquest of Canada and how this affected Gaelic self-perception. It shows that the empire did not fundamentally alter the nature of identity, but created an autonomous space in which confident Gaelic identities were allowed to emerge and de-

velop without much overt inconsistency. This does not mean, however, that the imperial context was incidental. Adjusting the internal points of reference for their own self-imagery was relatively simple, but Gaels were also extremely proactive in the expansion of imperial authority and control over newly won territories. This required not simply a re-moulding of self-imagery to a new imperial context, but identification with the aims of the British Empire. Using post-Conquest Quebec as a case study, the rest of the chapter highlights the way Highlanders embraced imperial hegemony in a number of respects and held thoroughly 'modern' views of the rights of the colonizers. The undoubted centrality of private interest in individuals' motivations did not preclude a large-scale Highland impact on Quebec, precisely because private interest was shaped by the political context. The interpretation offered here is not a challenge to recent socio-economic scholarship, nor does it rehabilitate an older scholarship of false romanticism. Rather, it demonstrates that cultural benefits were part of how military service was conceived, and argues that political frameworks, not simply socio-economic agendas, defined private interest in the British Empire. Cutting heads from shoulders with a broadsword, an *a priori* assertion of archaic values, was in fact, a statement of support for imperial progress and change, simply expressed in a traditional form.

The intuitive perception of the post-Culloden Highlands is of a region broken by the repression of a vengeful Hanoverian regime. The initial success of the 'Highland army' in the '45 provoked an excessive response from the British state. The vicious cultural imperialism imposed upon the Highlands is well known in a vast historiography, and continues to strike a popular chord with the public at large across the global Scottish diaspora.[11] As John Roy Stuart, a colonel in the Jacobite army and erstwhile poet of the Jacobite cause, described the calamity that befell his people:

> With no joy, pleasure or luck,
> But grief, evil and plague
> As befell the seed of the Children of Egypt.[12]

The post-1746 Highlands saw social engineering on an unprecedented scale, a 'punitive civilising' of the region, carried on with what has been called 'genocidal intent.'[13] Even staunch Hanoverian Gaels, men such as the poet and militiaman Donnchadh Bàn Mac an t-Saoir (1724–1812), were deeply troubled by the assault on Gaelic culture that

accompanied the suppression of the rebellion. Mac an t-Saoir expressed the bitterness felt by many in biting satire, most clearly in *Orain do'n Briogais*, or *Ode to the Breeches*.[14]

Gaelic culture did not, however, retreat into a morose and pessimistic stupor under the weight of these assaults. There were a number of important reasons for this. First, as much as popular opinion in Georgian England was ready to associate all Scots, particularly Highlanders, with Jacobitism, the Jacobite rebellion had been a political contest, not an ethnic one, whose lines of demarcation had settled on a myriad of religious, national, and dynastic factors convoluted beyond simple examination by poverty, poor government administration, and local rivalries – three-fifths of the Highland clans had either supported the government or remained neutral.[15]

Second, so complete had the failure of the rebellion been that, while the government in London remained nervous about a rising well into the 1750s, by that point the idea of any popular rebellion was highly unlikely.[16] Jacobitism in the Highlands after the '45 was dependent on the capricious nature of European power politics. The withdrawal of French support and papal legitimacy by the 1760s ensured the end of Jacobitism in the Highlands. Indeed, it might be argued that the painful and mournful tone of Gaelic Jacobite poetry in the period was in direct proportion to the utter hopelessness and isolation of post-1746 Jacobites. That is not to say Jacobitism died overnight; it clearly did not.[17] But its survival as an important political force was predicated on having widespread and determined support in the Highlands during the rebellion itself, which is questionable.

Third, while much of the post-rebellion repression was vengeful and punitive, it was not as systematic or complete as pro-Jacobite sentimentality portrayed it; nor was it carried on in a political vacuum.[18] Recent scholarship has demonstrated the ameliorating influence on the repression of various political relationships, and how much of the terror and cultural imperialism was directed to obtain specific ends, misguided as they were.[19] This is not to revise the deserved reputation of the British state in the eighteenth century as a body politic capable of horrific brutality. But what emerges from the period is the frustration of the army influence by a furtive and distrusting civil administration in Scotland.[20] Consequently, the Gaelic Highlands were not as exposed, as a uniform body, to the ravages of cultural imperialism to the extent we might expect, a fact that had repercussions for Gaelic self-perception.

The principal reason for a more complicated Gaelic identity in the

post-Culloden world was the ability of many Highlanders to accrue benefits from imperial participation. These benefits expanded greatly after 1756 with the emergence of a serious ministerial commitment to war in the colonies. For Gaelic society at large, there was an immeasurable cultural payoff, which has not yet been fully appreciated. War in the colonies not only exported a potential problem out of the Highlands; it also exported Gaelic domestic concerns into a different intellectual sphere. Imperial wars created an ambiguous space where cultural concerns and political loyalties could be segregated from domestic realities. The Highland soldier, when he was interpreted in Gaelic popular culture through the medium of poetry, was made to engender a pride in the Gaels' martial qualities and became a figurehead for Gaelic confidence. Deployed as Highland battalions, complete with distinct cultural trappings, these battalions provided an explicitly Highland role in the burgeoning commitments of the British Empire. As that empire increasingly could be interpreted as a victorious political entity, excessive celebrations of Gaelic martial triumph did not strain credulity, but offered an appealing alternative to a narrative of victimhood. John Gillies, whose collection of poetry was published in 1786, reproduced a poem written on the occasion of the departure of the Highland regiments for North America in 1756. To the departing soldiers, it advised them:

> Fierce lions of Scottish descent,
> Be loyal to your arms and to your uniform;
> Get light brightly decorated shields,
> That will take the blow of tomahawks,
> A bright-ended musket in every hunter's hand, Gallant
> youths killing slim stags;
> Oh it is time for Scots to go hunting,
> After treacherous Frenchmen and Forest-folk.[21]

Other songs written in the aftermath of the Seven Years' War were equally unrepentant in their praise for the Highland soldier. It was important, to justify the celebratory tone of Gaelic poetic culture, that the Gael had a central role in imperial victories. It was this that assured the centrality of the Battle of the Plains of Abraham in the Highland narrative. A song written by a soldier of the 78th Foot in the aftermath of the battle was positively ebullient about the defeat of the French:

The French were imprudent,
Their hard hearts like steel,
When that rabble realised
That we had not the strength to fight.
But wait a moment!
The battle of Quebec is yet to be told.
The French were destroyed,
That is something that will stay in their memories!

But this author was keen to create a special place for the Gael in the battle, one that consciously associated the 78th Foot with the moment of victory and invoked imagery not unlike that in Benjamin West's *Death of General Wolfe* (1771):

He [Wolfe] wanted to be lifted,
So that he could see the battle,
While he was in that terrible plight!
He could not see the heroes,
As death took away his sight!
They said to him in high spirits,
'We have suddenly won the battlefield,
And the Gaels are among them,
Annihilating them as they run downhill.'[22]

The triumph of a 'Gaelic' victory at Quebec began what became a wider celebration of the uniformed Gael across the British Empire, though North America retained a privileged position in the Gaelic world view. America was the major overseas deployment for Highland soldiers and where most Highlanders had imperial interactions as soldiers, officials, and settlers, at least until the 1780s. Poets such as Kenneth Mackenzie continued to reference military service in North America as late as the 1790s. In *Oran don Fhreiceadan dubh*, or *Song for the Black Watch*, Mackenzie noted that, 'In North *America*, Frequently were they heroic.' He continued:

The Gael was ever manly,
They were generous and bold,
When they got into the fight,
It is they who would not forsake the banner.[23]

Mackenzie also specifically honoured the 42nd Foot for its role in the assault on Fort Carillon in 1758:

> As long as a Briton lives,
> They will be renowned in history,
> With enjoyment from generation to generation,
> elucidating their heroism,
> They were expert at Ticonderoga;
> Cutting heads from shoulders.
> Putting Frenchmen out of their batteries.[24]

Of course, the inconvenient truth about Carillon was that the French had not been forced from their batteries, and only a handful of High-landers had got close enough to cut heads from shoulders. Indeed, the 42nd Foot had suffered horribly, losing 647 killed and wounded out of a total strength of a thousand men (or 65 per cent of the regiment).[25] Men who had actually taken part in the assault came away with a very dif-ferent vision of the event; Lieutenant William Grant remembered 'being ordered to receive the enemy's fire, and march[ing] with shouldered arms until we came up close to their breastwork,' upon which the 42nd were mown down 'like a field of corn.'[26] Casualties for the three High-land regiments that served in North America during the Seven Years' War ran at an alarmingly high rate. It is likely that, over the course of the war, all three regiments suffered attrition rates of as much as 100 per cent of their original complements, with deaths rates of around one-third.[27] This was unimportant, however, if a vision of strength and heroism was to be propagated. Victory was important, and Carillon would not have been portrayed as a victory if it were not, but only in a general sense and only so long as victory suited the meta-narrative to be constructed around the Highland soldier. Here then, was the es-sential divergence between the domestic and imperial spheres of Gaelic self-perception. Within the domestic confines of social change and state intrusion in the region itself, defeat, misery, and sorrow were logical outcomes of communal self-expression. Yet, within an imperial sphere, a military disaster on the scale of Carillon could become a Gaelic tri-umph, demonstrating martial prowess, courage, and a commitment to an ultimately victorious cause.

This did not mean that the poets were being disingenuous. The poet served as a negotiator, a public relations figure in integrating Gaelic values with wider political and social contexts. The poet provided the

intellectual glue for conflicting ideas and imperatives. The emphasis on explaining why Highland soldiers were being sent to North America and the histrionic accounting of Gaelic triumphs when much of the available evidence pointed to the true human cost of warfare in the colonies had their origins in these negotiations. The poet had to accommodate not only Gaelic heritage, but also a subordinate relationship with the British state in a coherent and confident form. This did not mean that the poet simply emphasized one interpretation, but, as a negotiator, used accepted cultural norms to provide conceptual meaning to potentially incomprehensible political contexts. And as many of the poems that reached printed form had been collected in the Highlands by Gaelic intellectuals (who perceived a declension in Gaelic oral culture), there was a pan-Gaelic aspect for these ideas. Throughout the eighteenth century, the poet generally served as a focal point for the communities' ideals. Songs and poems were intended to be memorized, transmitted, and critiqued orally. As Wilson Macleod has highlighted, however, blanket acceptance that the poet represented the community is problematic and, at the very least, requires 'elaboration and qualification.' The highly stylized fashion of Gaelic poetry is, for example, a barrier to a literal understanding of the poetry as a statement of fact.[28] Furthermore, we do not know what reception such poetry received among the illiterate of the Highlands.

The impact on the literate, however, was significant. English literacy in the Highlands was probably around 40 per cent (those literate in Gaelic probably even lower), and the inconsistency of Gaelic spelling in the period, even by Gaelic scholars, suggests a lack of proficiency in written Gaelic culture.[29] These caveats aside, there was still an important Gaelic readership for the printed book. Over two hundred Gaelic texts were published in the eighteenth century, many of them religious in nature, but others were devoted to language, grammar, vocabulary, and poetry.[30] The Gillies and Stewart collections, both quoted in this chapter, were extremely popular, and Mackenzie's volume had a print run of over one thousand, of which at least seventeen survive.[31] Most of what came to be written down reflected earlier generic forms of poetry, and were included for their subject matter and cultural resonance, rather than for their intrinsic poetic value. In addition, the poets' role as negotiators did not mean that they were misleading in their emphasis of certain themes. Mackenzie, for example, spent the years 1775 to 1789 in the navy, and composed most of his songs during this time. He also obtained, through Francis Mackenzie, 1st Baron Seaforth, a com-

mission in the 78th Foot (Ross-shire Buffs), which was raised the year after the publication of his work, before ending his professional career as a postmaster in Ireland.[32] Mackenzie had seen, and benefited from, the available avenues of fiscal-military state patronage. The interest in service he brought to his poetry certainly resonated among other soldiers. Some forty-six serving army officers were among the subscribers to Mackenzie's text, in addition to numerous others with military connections, such as agents, patriarchs of military families, and regimental chaplains. Indeed, military networks were probably vital to Mackenzie's ability to collect subscribers to allow his volume to be published.[33]

The poetry was probably well received because the cultural space created by the empire also permitted imperial triumphs to be interpreted as being in the interests of the Highlands specifically. The soldier was identified as the principal beneficiary, with Kenneth Mackenzie contrasting his lowly place as a poet with the success of a recruiting sergeant. Non-poetic sources reflected the elevation of the soldier in the social hierarchy of the Highlands. Both James MacLagan, who served as a chaplain to the 42nd Foot while in North America, and Samuel Johnson offered similar views of the benefits of military service to the rural poor.[34] Moreover, the entire population of the Highlands could benefit from the actions of the Highland regiments, and there was no question that the expansion of imperial boundaries was sanctioned, even positively encouraged. Highland settlers celebrated the Conquest of Canada, in some cases arguing that 'providence had ordered for the peopling of that vast continent [North America].'[35] In most cases, the political actors benefiting from the Highland soldiers' actions remained a secondary consideration, and soldiers contextualized military service as a professional means to a material end; occupational fraternity and identity were at least as important as national distinctions and political loyalties.[36]

It would be an error, however, to ignore the number of Gaelic references to wider British identities and interests or to dismiss them as obsequious gestures to political patrons. Highland motives for the Conquest were linked with the honour of the king and the kingdom, military service to both these entities being a moral imperative in the panegyric code. Donnchadh Bàn Mac an t-Saoir was most effective in articulating the benefits of imperial authority, which, like many Gaels, he viewed as emanating from the king, but which clearly called upon wider sovereignties:

In the four corners of the world
George has land and men;
And heads of churches in each place
To save men from iniquity;
They have law and parliament,
Maintaining right and justice for them;
And thieving has ceased,
Raiding and plundering stopped.[37]

Political loyalty was essential, as loyalty to the rightful sovereign created the conditions for a peaceful and secure realm and the pursuit of individual interest. Michael Newton has convincingly demonstrated that, across the period, Gaelic poetry remained consistent – altering loyalties to fit the political context, but not the method by which loyalties were expressed. The Gaelic panegyric code, with its emphasis on the moral imperative of loyalty, precedence and tradition, renown, and the eventual triumph of the Gaelic people, remained central, though transferred to the imperial sphere.[38] Thus, the empire did not create an entirely new imperial identity, but helped develop pre-existing notions of identity and loyalty. This explains why Gaels could easily partake in the celebration of British feats, since they had never denied being a part of a united kingdom, only torn by the nature of the relationship with its central government and by the proper dynasty to lead it.[39]

There was also some engagement with pan-British heroes, who were increasingly celebrated; James Wolfe, for example, was accorded the same level of elegy usually associated with slain chieftains.[40] Lieutenant Laurence Norcop, an English officer stationed in the Highlands during the Seven Years' War, noted first hand the appreciation accorded to Wolfe in Scotland, adding sardonically that it was 'an Honour the Scott [sic] seldom confe[rs] on the English.' A non-commissioned officer of the 78th Foot, Sergeant James Thompson, who met Wolfe, was equally generous in his praise of the hero, whom he called a 'noble fellow' and 'The Soldier's friend.' It might seem odd that an officer who had stood with government forces at Culloden could be revered in the Highlands, but this was entirely consistent with a drift in the Highlands towards the celebration of pan-British valour. Three days after the battle on the Plains of Abraham, the Gaelic chaplain of the 78th Foot described it as the most glorious gained for 'British troops' since the days of Marlborough.[41] While individual or familial interest did stand at the apex of

motivation, they were consciously placed within a British and imperial framework. By the end of the century, James MacLagan could compare Napoleon Bonaparte's threat to the history and culture of Scotland to the previous invasions of Edward I and Oliver Cromwell. Here, then, was a convoluted, confused, and ahistoric welding of the interests of Gaeldom with the integrity of Britain and its empire.[42]

Although adjusting the internal points of reference for the benefit of Gaelic self-imagery was done in relation to pre-existing notions of identity, the extent to which Gaels were physically proactive in the expansion of imperial authority is revealing. Pre-existing notions of political authority, religious affiliations, and social organizations were moulded to the contours of imperial hegemony; this was no less true in Quebec. In settlement and the establishment of the cultural institutions of imperialism, Gaels proved central to ministerial visions for the former French territories. The peopling of Quebec was a major problem for both Governor James Murray and his superiors in London. The French population of the St Lawrence valley was some seventy-five thousand in 1763, dwarfing the tiny British minority.[43] For the ministry, the problem of Quebec was how to control a Catholic population that could not be accommodated within the representative institutions of church and state.[44] The ministry's solution, as Stephen Conway argues, was to adopt an Irish model of governance, working through local Protestant elites who would dominate landownership and office holding and who would underscore the establishment of British rule in the province. The prerequisite of this model was large-scale Protestant settlement, and to this end military settlement was encouraged in the province by offering land grants to soldiers through the Royal Proclamation of 7 October 1763. Grading these land grants to conform to military rank – five thousand acres to field officers, falling to fifty acres for the private soldier – created a ready-made, hierarchical Protestant landowning class. Demobilized soldiers would be a paragon of Lockean individualism, both politically supportive of the Protestant interest and militarily capable enough to keep watch over the *Canadiens*.[45]

Few groups were better suited to this task than the veterans of the 78th Foot. For all the evident fear of Catholicism and a dangerous subversion of constitutional values in the Highlands, such unreconstructed views of the region were increasingly in the minority.[46] Confidence in the qualities of the Highland fighting man, at first purely utilitarian, spilled over into a new cultural definition of the Highlander. This definition placed a premium on the ability of the Highland soldier to create

the conditions for imperial vitality, facilitating the 'Blessings of Peace ... hav[ing] restored a beneficial and advantageous commerce.' If correctly governed, it was believed there was no reason Highlanders could not provide 'a bulwark ... to liberty ... united to the constitution.'[47]

There was also a societal reason for the advantages of Highland military settlement, albeit predicated on this shift in metropolitan perceptions. As control of Quebec's population necessitated, in effect, a hierarchical Protestant landed elite, what was required was the transplanting of Georgian social organizations onto a colonial space. Given contemporaneous metropolitan views of Highland society – that it possessed strong bonds of social organization and was militarily potent – Highland veterans were expertly placed to enforce the Protestant ascendency in Canada.[48] There was, of course, some inconsistency here: the supposedly arbitrary nature of social organization in the Highlands was the subject of a great deal of criticism in the period, largely associated with the problems of Jacobitism and emigration.[49] Yet, in challenging contexts such as Quebec, such concerns were disconnected from these domestic issues. As much as Whig commentators criticized clanship in the Highlands, they accepted without question that a landed elite–based hierarchy was to be fully encouraged at home and abroad. The idea that Highlanders could be used to underpin a Protestant ascendancy and commercial progress in the colonies had its origins as early as the 1670s, reinforced by partial successes in Georgia in the 1730s and 1740s.[50] John Macdonald, a half-pay officer and the leader of an emigration party to St John's Island (Prince Edward Island) in 1772, would later recommend to Lord George Germain that Highlanders could be 'usefully spared ... for the purpose of laying the foundation of a useful scheme for government' in the colonies. Travellers to Canada over the next few decades consistently highlighted the achievements of disbanded Highland soldiers in bringing areas of settlement into cultivation and civility, if gradually and with some difficulty.[51] It is likely that metropolitan conceptions of clanship in the Gaelic diaspora informed the choice of Highlanders for imperial settlement and that this was at least as important as government confidence in the martial capacities of the Highlander, though the two were interconnected. It would also explain why, in advance of the Royal Proclamation's details being made public, Jeffery Amherst directed that even invalids from the Highland regiments, who were unlikely to be of much use in operations against aboriginal war parties, were to be encouraged to settle in the colonies, even though their wounds entitled them to a passage home. Accord-

ing to Amherst, their remaining in the colonies was important to the
development of commerce, a theme not unrelated to the strengthening
of Protestant interest in Canada.[52]

Demobilized Highland officers carried out ministerial hopes of a
Protestant ascendency in Quebec in pursuit of their own security. Both
officers and men of the 78th Foot had an equal distrust of what they
saw as Catholic licentiousness and corruption, whether in Canada or
elsewhere. Both consequently trumpeted Protestant values as a morally
superior imperative for the colonies. Even those officers who were the
sons of Jacobite elites or Catholic themselves were aware of the dangers
to imperial stability from the influence of 'papists,' and were hostile
to the influence of Catholic priests on the lower orders.[53] For Robert
Kirkwood, a Protestant enlisted man of the 77th, then the 42nd Foot, his
experience of the *Canadiens* offered 'striking proof of the difference be-
tween a free and independent people, and an abject multitude.'[54] Most
important, the preferred method of social organization pursued by
Highland officers reflected ministerial desires for the province. There
was an evident and real desire on the part of army officers and emi-
gration leaders to establish quasi-feudal authorities over Gaelic settle-
ments in North America.[55]

Metropolitan ideas of social organization in the Highlands might
have been deeply flawed, given to exaggerating the social control of
landowners over their people, but they did reflect the interests or de-
luding self-perception of many Highland leaders.[56] Following the regi-
ment's disbanding in 1763, as many as eighty men of the 78th Foot,
around half of all those who remained in North America, chose to re-
main in Quebec. Most settled on the five seigneuries acquired by James
Murray in the province.[57] By 1791, around a third of the seigneuries in
Quebec were owned, or partly owned, by British residents, and, during
this time, Highland officers sought to establish social models consistent
with security and their own social importance.[58] Alexander Fraser, an
officer of the 78th Foot, acquired the seigniories of Beauchamp, Vitré,
and St Gilles following the Treaty of Paris, property he gifted to his
grandson in 1791. As owner, he accepted *foi et homage* from those to
whom he rented the land on the old French model.[59] John Nairne was
another officer who settled in the province, acquiring land at La Mal-
baie in 1761, where he settled with five former soldiers. The undoing of
British hopes for the protestantization of the province was reflected in
Nairne's experiences; as late as the end of the century, there were only
five hundred inhabitants in the region (and only one confirmed former

member of the 78th Foot), with only three Protestant families, including Nairne's.[60] Yet, in the absence of settlers and with relatively few Anglo-Scottish settlers in the province, commerce proved an effective means of establishing familial security. In 1762, Nairne began petitioning General Murray to purchase the king's stock of cattle jointly with a fellow 78th officer, Malcolm Fraser, and Nairne eventually would be involved in the exporting of timber, furs, and oils.[61] Malcolm Fraser differed from Nairne, marrying a French Canadian and devoting all his energies to commerce and the purchase of property in Quebec itself. Nevertheless, he still managed to form dependent economic relationships with former members of the 78th Foot, and later the 84th Foot, raised partly from demobilized soldiers of the 78th in 1775 for the American War of Independence. Nairne and Fraser (both of whom served in the 78th and the 84th) continued to acquire land despite the absence of willing settlers, for ownership of land was still viewed as the primary form of economic security.[62]

The enlisted men of the 78th Foot, as Nairne's failure to acquire tenants suggests, were not simply dependent economic units. A number settled in Quebec City, and the impact of this small collection of disbanded Highlanders should not be underestimated. John Fraser, who was wounded during the Battle of Ste-Foy in 1760, established an English school in Garden Street, the first English school in the town; the majority of the children of 78th veterans were educated there. These veterans established a close community that was an intrinsic part of the town's post-war redevelopment. John Macleod kept a hotel; his fellow soldier Lauchlan Smith kept a store. Sergeant Hugh McKay also kept a store until it was demolished to make way for extended fortifications, following which he served as the First Sergeant at Arms for the House of Assembly in the 1790s.[63] It even appears that the Highland veterans were broadly supportive of the repeal of the Quebec Act of 1774 and of the Constitution of 1791.[64]

Much of this support probably emanated from resistance to the provisions allowed to Catholicism that were key to the Quebec Act. Religion was a key component of the relationship between Highlanders and Quebec. Many veterans of the 78th were extremely suspicious of the Catholic population and, in June 1762, had to be warned to behave during a French-Canadian parade in the city, and were explicitly warned not to break the windows of houses not illuminated to mark the king's birthday.[65] Most of the veterans who settled entertained thoughts of converting the local populace. John Nairne attempted to

bring a Presbyterian minister from Scotland for the task but failed to enlist a candidate, and the region remained overwhelmingly Catholic. James Cuthbert, an Inverness man formerly of the 15th Foot, did succeed in bringing over a minister from Scotland to educate his children and established the first Presbyterian church in Lower Canada, at Berthier in 1786.[66]

An understudied but vital part of the machinery of empire, one in which Highlanders were heavily involved, was Protestant freemasonry. Freemasonry was a key cultural institution in the spread of proto-British values. On 27 November 1827, the day the cornerstone of the monument to Montcalm and Wolfe was laid in Quebec, officers of the Provincial Grand Lodge of Ancient, Free and Accepted Masons of Quebec and Three Rivers staged an elaborate ceremony as part of the event. Lord Dalhousie had asked the pillars of the imperial establishment to conduct the ceremony, the lodges' members taking their place alongside the army, the civil administrators, and the Anglican clergy.[67] The lodges arrived with British troops, quickly initiating civilian members who cooperated with demobilized soldiers in founding more permanent institutions when the regiment was redeployed. This was the case in both Quebec, where there was a travelling lodge with the 78th Foot, and Montreal, where Lodge 195 of the Grand Lodge of Ireland operated in the 1st Battalion of the 42nd Foot.[68] Within two months of the victory on the Plains of Abraham, representatives of six regimental field lodges had met to form a permanent institution in Quebec. Members of the 78th Foot were prominent members, with the chaplain of the regiment, Robert Macpherson, also serving as chaplain in the Quebec Select Lodge and Lieutenant-Colonel Simon Fraser of the 78th serving as grandmaster from the summer of 1760. One of the Quebec Lodge's first actions was the collection of funds for the widows and orphans of masons killed at Quebec as well as charitable funds for the inhabitants of the town.[69]

An active freemason society thus developed in Quebec out of its military embryo. The lodge in the 78th Foot maintained its military character from disbanded veterans, changed its name to the St Andrew's Lodge, and functioned in its original form until around 1792.[70] Among the Highland freemasons in Quebec was Sergeant James Thompson, who served the lodge almost continuously as master, senior, warden, and secretary, and through his son left the most complete diary of the activities of the 78th Foot still extant. Thompson served as head of the military engineering service in Quebec from 1759 until the 1820s, helped

lay the cornerstone of the monument to Montcalm and Wolfe, and at the end of his life boasted he had served three King Georges. Thompson married twice, and his eldest son, also James, served as assistant commissary general to the garrison.[71] Thompson's stay in Quebec coincided with a shift in the political repercussions of British freemasonry. After about 1780, the inclusive ideals of global brotherhood gave way to a more limited, circumscribed order, with an increasing emphasis on political loyalty.[72] There is no question that membership was a deeply personal choice, but the strength of freemasonry in the Highland regiments during this time was a demonstration of commitment to British political and cultural institutions.

This was no simple or clear-cut process of anglicization. As Colin Coates has demonstrated, the British minority found it easier to operate in French due to demographic pressures, as well as the privilege given to the high culture of the French language and the disinclination of many *Canadiens* to adopt English.[73] Already schooled in the French language, many Highland officers had little difficulty passing between French and English Canada, a process possibly facilitated by the fact that many came from Catholic Jacobite families. Some courted and married *Canadiennes*. It even appears that the years spent in Quebec were a great relief to many of the soldiers of the 78th Foot. The *Canadiens*, it was noted, lived 'plentifully and much more delicately' than people in the Highlands. Consequently, both officers and men looked 'fair and blooming and live now at their ease.' Most of the soldiers were quartered in French houses and reputedly spent their pay on wine and women, something that resulted in a number of cases of venereal disease. The officers were perhaps more discerning, and went for horse and sleigh rides with local women of quality, 'laying close siege to them for many months,' as the chaplain reported in a military analogy.[74] Of the eventual settlers, most of their legal documents, and increasingly their personal papers, were written in French. John Nairne was extremely particular that his son and daughter become fully educated, yet both spoke French as their first language, their grasp of English being rudimentary at best, at least until Nairne took his son to Scotland in 1787. Cuthbert, who had established the first Presbyterian church in Lower Canada, found that, having sent his children to France to be educated, they returned converted to Catholicism.[75] Later Gaelic immigrants to Quebec demonstrated similar cultural hybridization and contradiction, quickly and with few difficulties adopting the French language, but often remaining Gaelic in thought and self-perception.[76]

Nor did an absence of francophile thought result in a single-mind-ed pursuit of anglo hegemony. Murray had perennial difficulties with the British merchants of Quebec, many of whom were Highlanders. In some official capacities, Highlanders also found themselves compet-ing against each other. In 1784, James Thompson was responsible for proving that a claim made by James Cuthbert for damages caused to his property by the British army was unjustified. Within the empire, attempts to replicate domestic social structures inevitably became un-stuck on the variegated aims of various colonisers, colonization often consisting of competing aims and objectives.[77]

The relationship between the *Canadiens* and the British minority was complex, both in personal associations between people and in their dealings with institutional and civic bodies.[78] It lacked the essential-ist conception of identity and the social order that would come with further institutional intrusions – particularly those that were religious in nature – into Canadian society.[79] Settled veterans of the 78th Foot did not create a 'British' identity in Canada; arguably, they and their families were subsumed by a French-Canadian experience, with de-mographic pressures and fluid notions of identity easing this process. But they did help establish the institutional structures of imperial he-gemony in Canada, assisting a process that would transform political, ethnic, religious, and linguistic identities into an 'aristocratic, agrarian patriotism' in nineteenth-century Canada.[80]

Imperial expansion, therefore, was a key ingredient in Gaelic self-expression in the eighteenth century. It did not alter fundamentally the object of Gaelic identity – just as private interest remained at the heart of individual agendas, so too did Gaelic achievement and prowess lie at the centre of identity. Ignoring the political contexts of interest, how-ever, can only ever provide a partial understanding of the motivations of people. The empire created a space where cultural identity was re-invigorated. But it also provided a space where interest and identity interacted, and ideological imperatives helped frame the pursuit of personal advantage. It was a symbiotic relationship. As long as the em-pire provided avenues for personal advantage, and a separate imperial sphere for the creation of confident identity, a de facto acceptance and identification with the empire was increasingly assured among High-land Scots.

Quebec serves as the archetypal model of these processes. The Con-quest of Canada offered explicit proof of the merits in fashioning a self-imagery around the British Empire. Martial identity was reinforced

and victory was interpreted as advantageous for Highland society in general. In the aftermath of the Conquest, the vision of imperial administrators for the province reflected the pursuit of individual veterans of the Highland regiments. Socio-economic security, consistent with Highlanders' own self-imagery, necessitated the imposition of certain values onto what was seen as a problematic society. Within the Highland experience of imperialism, then, was the duality of the empire: the assertiveness of traditional values of landownership and religion and the radical modern revolution of identities and ideas within the imperial sphere. Cutting heads from French shoulders in Canada was, for the Highlanders, a recognizable expression of this dichotomy. It was a traditional way of expressing a current imperative, as Gaels rationalized their interests within an imperial framework in the aftermath of the Jacobite rebellion.

NOTES

1 The author would like to express his sincere thanks to Stephen Brumwell, Phillip Buckner, Francis Cogliano, Stephen Conway, Harry Dickinson, Wilson McLeod, Donald Meek, Alexander Murdoch, Michael Newton, and John Reid for their assistance in discussing various aspects of this chapter.

2 [William Amherst], *Journal of William Amherst in America, 1758–1760*, ed. J.C. Webster (London: Frome, 1927); J.R. Harper, *The Fraser Highlanders* (Montreal: Society of the Montreal Military & Maritime Museum, 1979), 28; and James Michael Hill, *Celtic Warfare, 1595–1763* (Edinburgh: John Donald, 1986), 158.

3 *Boston Evening Post*, no. 1456 (1763), 2.

4 See Peter Womack, *Improvement and Romance: Constructing the Myth of the Highlands* (London: Macmillan, 1989); Murray G.H. Pittock, *The Invention of Scotland: The Stuart Myth and the Scottish Identity, 1638 to the Present* (London: Routledge, 1991); Hugh Trevor-Roper, 'The Invention of Tradition: The Highland Tradition of Scotland,' in *The Invention of Tradition*, ed. Eric Hobsbawm and Terence Ranger (Cambridge: Cambridge University Press, 1992); Robert Clyde, *From Rebel to Hero: The Image of the Highlander, 1745–1830* (East Linton, UK: Tuckwell, 1995); and J.E. Cookson, 'Napoleonic Wars, Military Scotland and Tory Highlandism in the Early Nineteenth Century,' *Scottish Historical Review* 78 (1999): 60–75.

5 Andrew Mackillop, *More Fruitful than the Soil: Army, Empire and the Scottish Highlands* (East Linton, UK: Tuckwell, 2000), 215–24.

6 *Extract from a Manuscript Journal relating to the Siege of Quebec in 1759, kept by Colonel Malcolm Fraser Then Lieutenant of the 78th and serving in that Campaign* (Quebec: Literary and Historical Society of Quebec, 1865), 21.

7 Mackillop, *More Fruitful than the* Soil, 41–167; Stana Nenadic, *Lairds and Luxury: The Highland Gentry in Eighteenth-Century Scotland* (Edinburgh: John Donald, 2007), 90–106; and Andrew Mackillop, 'The Highlands and the Returning Nabob: Sir Hector Munro of Novar, 1760–1807,' in *Emigrant Homecomings: The Return Movement of Emigrants, 1600–2000, ed. Marjory Harper* (Manchester: Manchester University Press, 2005).

8 T.M. Devine, 'A Conservative People? Scottish Gaeldom in the Age of Improvement,' in *Eighteenth Century Scotland: New Perspectives*, ed. T.M Devine and J.R. Young (East Linton, UK: Tuckwell, 1999); Andrew Mackillop, 'Highland Estate Change and Tenant Emigration,' in ibid.; Mackillop, *More Fruitful than the Soil*, 139-67; idem, 'For King, Country and Regiment? Motive and Identity in Highland Soldiering, 1746–1815,' in *Fighting for Identity: Scottish Military Experience, c.1550–1900*, ed. Steve Murdoch and Andrew Mackillop (Leiden, Netherlands: Brill, 2003); and Peter Way, 'Soldiers of Misfortune: New England Regulars and the Fall of Oswego, 1755–1756,' *Massachusetts Historical Review* 3 (2001): 49–88. For the sums involved, see Sir James Grant to George Mackenzie, 28 September 1778, National Archives of Scotland (hereafter cited as NAS), GD248/277/37; Lawrence Leith to James Ross, 3 January 1776, NAS, GD170/415; Recruiting Accounts 1776, NAS GD44/47/1/49; and Cathcart Recruiting Accounts 1778, Blair Castle Archives, Mss. 341.

9 Mackillop, 'For King, Country and Regiment?' 185–212; Stephen Conway, 'Scots, Britons and Europeans: Scottish Military Service, c.1739–1783,' *Historical Research* 82, no. 215 (2009): 114–30; and John Marsden, *Galloglas: Hebridean and West Highland Mercenary Warrior Kindreds in Medieval Ireland* (East Linton, UK: Tuckwell, 2003).

10 George K. McGilvary, *East India Patronage and the British State: The Scottish Elite and Politics in the Eighteenth Century* (London: I.B. Tauris, 2008); T.M. Devine, *Scotland's Empire, 1600–1815* (London: Penguin, 2003), 305; Allan I. Macinnes, *Clanship, Commerce and the House of Stuart, 1603–1788* (East Linton, UK: Tuckwell, 1996), 188–209; and J. Hayes, 'Scottish Officers in the British Army 1714–1763,' *Scottish Historical Review* 37 (1958): 22–4.

11 W.A. Speck, *The Butcher: The Duke of Cumberland and the Suppression of the '45* (Oxford: Blackwell, 1981); Allan I. Macinnes, 'The Aftermath of the '45,' in *1745: Charles Edward Stuart and the Jacobites*, ed. Robert Woosnam-Savage (Edinburgh: Her Majesty's Stationery Office, 1995); Geoffrey Plank, *Rebellion and Savagery: The Jacobite Rising of 1745 and the British Empire* (Philadel-

phia: University of Pennsylvania Press, 2006); and Jonathan Oates, *Sweet William or the Butcher? The Duke of Cumberland and the '45* (Barnsley, UK: Pen & Sword, 2008).

12 *'Gun sòlas, sonas no seanns, Ach dònas is plàigh Mar bha air ginealach Chlann na h-Éipheit,'* from *Clann Chatain an t-Sroil* le Iain Ruadh Stiubhart, in *An Lasair: Anthology of 18th Century Scottish Gaelic Verse*, ed. Ronald Black (Edinburgh: Birlinn, 2001), 172–3.

13 Macinnes, *Clanship, Commerce and the House of Stuart*, 211–12.

14 Donnchadh Ban Mac an t-Saoir, *Orain Ghaidhealach le Donnchadh Macantsaoir*, ed. Deorsa Caldair (Edinburgh: John Grant, 1912), 142–8.

15 Murray G.H. Pittock, *The Myth of the Jacobite Clans* (Manchester: Manchester University Press, 1995); Macinnes, *Clanship, Commerce and the House of Stuart*, 249; and Independent Company Accounts 1746, Huntington Library, LO11562 and LO11564.

16 For these fears and intelligence about a possible rising, see National Library of Scotland, MS 5079, f. 41.

17 Doron Zimmermann, *The Jacobite Movement in Scotland and in Exile, 1746–1759* (Basingstoke, UK: Macmillan, 2003); and Daniel Szechi, 'The Jacobite Movement,' in *A Companion to Eighteenth-Century Britain*, ed. H.T. Dickinson (Oxford: Blackwell, 2002), 81–96.

18 For an example of pro-Jacobite vilification of government forces, see Robert Forbes, *The Lyon in Mourning*, ed. Henry Paton (Edinburgh: Scottish Historical Society, 1895–6), vol. 1, 216.

19 Bob Harris, *Politics and the Nation: Britain in the Mid-Eighteenth Century* (Oxford: Oxford University Press, 2002), 160–1; and Plank, *Rebellion and Savagery*, 75.

20 Bland to the Earl of Holderness, 13 June 1754, United Kingdom National Archives (hereafter cited as UKNA), SP54/44/67; and *The Albemarle Papers: Being the Correspondence of William Anne, Second Earl of Albemarle*, ed. Charles Stanford Terry (Aberdeen: Aberdeen University Press, 1902), 286.

21 *'Leomh' naidh gharg; a fhuil Albnach, Lean re'r 'n airm 's re'r 'n eideadh; Faghaibh taragaid eatrom bhall-bhuidh, Ghabhas dearg-thuadh Chaoilt-Mhach; 'S cuilbheir earr-bhuidh 'n laimh gach fealgair, Seoid air marbhadh chaoil-daimh; O's mighich d'Albannaich dol a shealg, Air Francaich chealgach 's Coilt mhich,'* in John Gillies, *A Collection of Ancient and Modern Gaelic Poems* (Peairt, UK: John Gillies, 1786), 113–14. All songs from primary sources have been left in the original spelling as they appear. I wish to express my sincere thanks to Dòmhnall Meek for his assistance in the translation of these sources.

22 *'Bha na Frangaich cho dàna, An cridhe cruaidh mar an stàillin, Nuair a dh'aithnich a' ghràisg' Nach robh sinn làidir gu gnìomh. Ach fuirich ort fhathast!*

Tha latha Chuibic ri labhairt. Fhuair na Frangaich an sgàthadh A bhios grathann *'nan cuimhne!'*; and *'Dh'iarr e 'thogail, 's gum faiceadh E an cath, is e 'na gh-* *leachd chruaidh! Cha bu lèir dha na gaisgich, 'S am bàs 'ga chur dall! Thuirt iad* *ris ann am misnich "Is leinn an àrach a chlisgeadh, Tha na Gàidheil nam measg* *A' cur sgrios orra sìos,"'* in Michael Newton, *We're Indians Sure Enough:* *The Legacy of the Scottish Highlanders in the United States* (Richmond, VA: Saorsa, 2001), 135. Many of the poems and songs quoted in this chapter are featured with translation in Newton's excellent book. I returned to the original sources for the completion of this work, but his vastly superior knowledge of the Gaelic world made my own meagre tapping of those resources possible.

23 *'An America gu tuath, Stric a fhuaradh ìad gàisgeil'*; and *'Bha na* Gaidheil *duineil rìamh 'S tha iad fiallaidh, ro thapaidh, 'S 'nuair a theannadh ìad ri stri,* *'S ìad nach dìobradh a bhratach,'* in Kenneth Mackenzie, *Orain Ghaidhealach* (Duneadainn, UK, 1792), 35.

24 *'Cho fad sa mhaireas Breatanach, Bi' dh clìu orr ann a'n èachraidheachd, O lìnn* *gu lìnn le taitneachas, A' cuir 'an geill a 'n tapachais, A 'n* Tiganderoga *b' acuin-* *neach; A gearradh chìnn o chraitichean, 'S cuir* Fraingich *as a'm batraidhean,'* in ibid., 12.

25 Ian Macpherson McCulloch, *Sons of the Mountains: The Highland Regiments* *in the French & Indian War, 1756–1767* (New York: Purple Mountain Press, 2006), vol. 1, 103.

26 *The Scots Magazine*, 20 (1758): 698–9; and Nicholas Westbrook, '"Like roar-ing lions breaking from their chains": The Highland Regiment at Ticond-eroga,' *Bulletin of the Fort Ticonderoga Museum* 16 (1998): 17–91.

27 Robert Kirk[wood], *The Memoirs and Adventures of Robert Kirk, late of the* *Royal Highland Regiment* (Limerick, Ireland, 1775), 107; and Colin G. Cal-loway, *White People, Indians, and Highlanders: Tribal Peoples and Colonial* *Encounters in Scotland and America* (Oxford: Oxford University Press, 2008), 96.

28 Wilson MacLeod, 'Gaelic Poetry as Historical Source: Some Problems and Possibilities,' in *Ireland (Ulster) Scotland; Concepts, Contexts, Comparisons,* ed. Edna Longley, Eamonn Hughes, and Des O'Rawe (Belfast: Cló Ollscoil na Banríona, 2003), 171–3.

29 R.A. Houston, *Scottish Literacy and the Scottish Identity: Illiteracy and Society* *in Scotland and Northern England, 1600–1800* (Cambridge: Cambridge Uni-versity Press, 1985), 55; and James MacLagan to Rev. Hugh McDearmad, 20 September 1778, Dundee Council Archives (hereafter cited as DCA), GD/We/5/12.

30 *Scottish Gaelic Union Catalogue: A List of Books Printed in Scottish Gaelic from*

1567 to 1973, ed. Mary Ferguson and Ann Matheson (Edinburgh: National Library of Scotland, 1984).

31 *An Lasair* (see note 11), 509. Mackenzie is reputed to have destroyed many copies of the book himself; see Donald Maclean, *Typographia Scoto-Gadelica or Books Printed in the Gaelic of Scotland from the Year 1567 to the Year 1914* (Edinburgh: John Grant, 1915), 251. I wish to thank Professor William Gillies for his kind assistance with details of the publication of Mackenzie's volume.

32 John Mackenzie, *Sàr-Obair nam Bard Gaelach, or the Beauties of Gaelic Poetry and Lives of the Highland Bards* (Glasgow: Maclachlan and Stewart, 1841), 270–1.

33 Mackenzie, *Orain Ghaidhealach*, 242–73.

34 Ibid., 35; *A Tour Through the Ebridee* (1774), DCA, GD/We/6/4; and Samuel Johnson, *A Journey to the Western Isles of Scotland* (London: T. Cadell, 1775), 75.

35 [Scotus Americanus], *Information Concerning the Province of North Carolina addressed to Emigrants from the Highlands and Western Isles of Scotland, by an impartial hand* (Glasgow, 1773), 10; Hector to Alexander McAllister, September 1771, North Carolina State Archives, McAllister Papers PC 1738.i. I wish to thank Alexander Murdoch for bringing this source to my attention.

36 Conway, 'Scots, Britons and Europeans,' 115; Stana Nenadic, 'The Impact of the Military Profession on Highland Gentry Families, c.1730–1830,' *Scottish Historical Review* 85 (2006): 75–99.

37 'An ceithir àirdean an t-saoghail Tha fearann is daoin' aig Deòrsa; 'S tha chinn-eaglais anns gach àite Chum an sàbhaladh o dhò-bheairt; Tha lagh is pàrlamaid aca, Chumail ceartais riu is còrach; 'S tha mheirl' an déidh a casgadh, Sguir na creachan is an tòrachd,' in Mac an t-Saoir, *Orain Ghaidhealach le Donnchadh Macantsaoir*, 26.

38 Michael Newton, 'Jacobite Past, Loyalist Present,' *Journal of Interdisciplinary Celtic Studies* 5 (2003): 58; and John Macinnes, 'The Panegyric Code in Gaelic Poetry,' in *Dùthchas nan Gàidheal: Selected Essays of John Macinnes*, ed. Michael Newton (Edinburgh: Birlinn, 2006). It should be noted that Macinnes's vision of the panegyric code is not the last word on the subject, and some refinement might be made to it as a model of study. During the eighteenth century, other modes and rhetorical codes than the panegyric also emerged in the poetry, largely thanks to the influence of Alastair mac Mhaighstir Alastair.

39 Vincent Morley, 'The Idea of Britain in Eighteenth-century Ireland and Scotland,' *Studia Hibernica* 33 (2004–5): 114.

40 Newton, *We're Indians Sure Enough*, 135.

41 Guy St-Denis, 'Letters from the 32nd Regiment, 1756–1765,' *Journal of the Society for Army Historical Research* 87 (2009): 113; James Thompson Journal, vol. 1, Bibliothèque et Archives nationales du Québec (hereafter cited as BAnQ), P450 (Microfilm) M502/1; and Reverend Robert Macpherson to Andrew Macpherson, 16 September 1759, Library of Congress (hereafter cited as LOC), James Grant Papers (Microfilm) M22671, Reel 46.

42 Alexander Stewart and Donald Stewart, *Cochruinneacha taoghta de shaothair nam bard Gaelach*, vol. 2 (Duneidin, UK: Stiuart, 1804), 524–5; and James MacLagan to John Stewart, 1 September 1800, DCA, GD/We/5/15.

43 Security problems on the frontiers to the south precluded the expulsion of such a large population, though the expulsion of seven thousand Acadians suggests there would have been no moral qualms about such a policy; see Geoffrey Plank, *An Unsettled Conquest: The British Campaign against the Peoples of Acadia* (Philadelphia: University of Pennsylvania Press, 2001), 140.

44 Philip Lawson, *The Imperial Challenge: Quebec and Britain in the Age of the American Revolution* (Montreal; Kingston, ON: McGill-Queen's University Press, 1989); and Peter Marshall, 'British North American, 1760–1815,' in *The Oxford History of the British Empire*, vol. 2, *The Eighteenth Century*, ed. P.J. Marshall (Oxford: Oxford University Press, 1998).

45 My thanks go to Professor Stephen Conway for providing me with a written draft of his paper that appears elsewhere in this collection.

46 The duke of Cumberland's fears are the most noteworthy in this regard, though by the early 1760s he was largely isolated from political decision-making; see *Military Affairs in North America, 1748–1765: Selected Documents from the Cumberland Papers in Windsor Castle*, ed. Stanley Pargellis (London: Appleton-Century, 1936), 6–7.

47 *Pennsylvania Gazette*, no. 1287 (1767), 1; [Anon.], *A Second Letter to a Noble Lord Containing A Plan for effectually uniting and sincerely attaching the Highlanders to the British Constitution, and Revolution Settlement* (London, 1748), 29.

48 Josiah Martin to Earl of Dartmouth 30 June 1775, UKNA, PRO 30/29/3/5; [Anon.], *Considerations Upon the Different Modes of Finding Recruits for the Army* (London, 1775), 5; and *New Hampshire Mercury*, no. 1 (1784), 2.

49 [Anon.], *Remarks on the People and government of Scotland. Particularly the Highlanders; their original Customs, Manners* (Edinburgh, 1747), 7–10; NAS, GD248/654/1-2; and UKNA, CO54/45, 5880, 164.

50 [Anon.], 'Complaint from Heaven with a Hue and Crye and a Petition out of Virginia and Maryland,' *Proceedings of the Council of Maryland, 1667–1687/8*, ed. William Hand Browne (Baltimore: Maryland Historical Society, 1887), 134–49; and Anthony W. Parker, *Scottish Highlanders in Colonial*

Georgia: The Recruitment, Emigration, and Settlement at Darien, 1735–1748 (Athens: University of Georgia Press, 1997).

51 John Macdonald to George Germain, 30 October 1776, UKNA, CO217/53, 101–2; Patrick Campbell, *Travels in the Interior Inhabited Parts of North America in the years 1791 and 1792*, ed. H.H. Langton (Edinburgh: John Guthrie, 1937), 295; and Joseph DeBarres Papers, *Report of John Macdonald on DeBarres Estate* (1795), 44, Library and Archives Canada (hereafter cited as LAC), MG23 F1(2).

52 Jeffrey Amherst to Henry Bouquet, 7 August 1763, British Library, Add. Mss. 21634, f. 347.

53 William Munro to father, 9 June 1757, NAS, GD146/11; James Thompson Journal, vol. 5, 68, BAnQ, P450 (Microfilm) M502/1; Reverend Robert Macpherson to William Macpherson, 24 December 1761, LOC, James Grant Papers (Microfilm) M22671, Reel 46; and John Macdonald to George Germain, 30 October 1776, UKNA, CO217/53, 71.

54 Kirk[wood], *Memoirs and Adventures of Robert Kirk*, 68.

55 Robert McGeachy, 'Captain Lauchlin Campbell and Early Argyllshire Emigration to New York,' *Northern Scotland* 19 (1999), 21–46; UKNA, AO13/87/59; UKNA, PRO 30/29/3/5; UKNA, T1/520/37; and John Macdonald to Helen Macdonald, 26 June 1781, Public Archives and Record Office of Prince Edward Island, Acc. 2664/5.

56 Mackillop, *More Fruitful than the Soil*, 56–64.

57 Harper, *Fraser Highlanders*, 122–3; and Ian Macpherson McCulloch, *Highlander in the French-Indian War* (Oxford: Osprey, 2008), 38–9, 59.

58 John Dickinson and Brian Young, *A Short History of Quebec* (Montreal; Kingston, ON: McGill-Queen's University Press, 2000), 170–3.

59 Alexander Fraser Papers, LAC, MG23 GIII11, 1–12, 13–19.

60 Lucille Campey, *Les Écossais: The Pioneer Scots of Lower Canada, 1763–1855* (Toronto: Natural Heritage Books, 2006), 19–23, 240n.

61 John and Thomas Nairne Fonds, LAC, MG23 GIII23, vol. 1, 5–9.

62 Jean-Claude Masse, *Malcolm Fraser: de soldat écossaise á seigneur canadien, 1733–1815* (Sillery, QC: Septentrion, 2006); Malcolm Fraser Fonds, LAC, MG23 K1, vol. 12, 35; John and Thomas Nairne Fonds, LAC, MG23 GIII23, vol. 5, 50.

63 James Thompson Fonds, BAnQ, P254/Box 9.

64 Malcolm Fraser Fonds, LAC, MG23 K1, vol. 32, 103–6.

65 John and Thomas Nairne Fonds, LAC, GIII23 vol. 4, 3 June 1762, 10 June 1762.

66 Campey, *Les Écossais*, 9, 22.

67 Jessica Leigh *Harland-Jacobs*, '"The essential link": Freemasonry and British

Imperialism, 1751–1918' (PhD thesis, Duke University, 2000), 1–3, 22.

68 Ibid., 45.

69 *Whence We Come? Freemasonry in Ontario, 1764–1980*, ed. Wallace Mcleod (Hamilton, ON: Grand Lodge A.F. & A.M. of Canada, 1980), 11; further details of freemasonry in the 78th Foot can be found in McCulloch, *Highlander in the French-Indian War*, 38–9.

70 Brother A.J.B. Milborne, 'The Lodge in the 78th Regiment,' *Quatuor Coronati Lodge* 65 (1952): 19–33; idem, 'Provincial Grand Lodge of Quebec, 1759–1792,' *Quatuor Coronati Lodge* 68 (1955): 11–29; and idem, 'British Military Lodges in the American War of Independence,' *Transactions of the American Lodge of Research* 10 (1966): 22–85.

71 James Thompson Fonds, BAnQ, P254/Boxes 2–6.

72 *Harland-Jacobs*, '"The essential link,"' 78–122.

73 Colin M. Coates, 'French Canadians' Ambivalence to the Empire,' in *Canada and the British Empire*, ed. Phillip Buckner (Oxford: Oxford University Press, 2008), 184.

74 John and Thomas Nairne Fonds, LAC, MG23 GIII23, vol. 4, 30 October 1762; and Robert Macpherson to William Macpherson, 24 December 1761, LOC, James Grant Papers (Microfilm) M22671, Reel 46.

75 John and Thomas Nairne Fonds, LAC, MG23 GIII23, vol. 1, 28–31, 36–8, 89–92; Campey, *Les Écossais*, 9.

76 Margaret Bennett, 'From Quebec-Hebrideans to "Les Écossais-Québécois": Tracing the Evolution of a Scottish Cultural Identity in Canada's Eastern Townships,' in *Transatlantic Scots*, ed. Celeste Ray (Tuscaloosa: University of Alabama Press, 2005).

77 Nancy Christie, 'Introduction: Theorizing a Colonial Past: Canada as a Society of British Settlement,' in *Transatlantic Subjects: Ideas, Institutions, and Social Experience on Post-Revolutionary British North America*, ed. Nancy Christie (Montreal; Kingston, ON: McGill-Queen's University Press, 2008), 17; and Christian Rioux, 'James Thompson (1733–1830),' *Dictionary of Canadian Biography*, http://www.biographi.ca.

78 Donald Fyson, 'The Canadiens and British Institutions of Local Governance in Quebec from the Conquest to the Rebellions,' in *Transatlantic Subjects* (see note 76), 45–82.

79 J.I. Little, *Borderland Religion: The Emergence of an English-Canadian Identity, 1792–1852* (Toronto: University of Toronto Press, 2004), xiii; and Dror Wahrman, *The Making of the Modern Self: Identity and Culture in Eighteenth-Century England* (London: Yale University Press, 2004), 198–264.

80 Christie, 'Introduction,' 7.

Contributors

Stephen Brumwell is an independent historian based in Amsterdam.

Phillip Buckner is Professor Emeritus of History, University of New Brunswick, and Senior Research Fellow at the Institute of Commonwealth Studies at the University of London.

Stephen Conway is Professor of History at University College, London.

Matthew P. Dziennik is the Bernard and Irene Schwartz post-doctoral fellow at the New York Historical Society and The New School University, New York.

Donald Fyson is a member of the Department of History, Université Laval, and co-director of the Centre interuniversitaire d'études québécoises.

Jack P. Greene is Andrew W. Mellon Professor in the Humanities Emeritus at Johns Hopkins University.

Barry M. Moody is a member of the Department of History at Acadia University.

Thomas Peace is a Social Sciences and Humanities Research Council of Canada post-doctoral fellow in the Native American Studies program at Dartmouth College.

John G. Reid is a member of the Department of History, Saint Mary's

University, and Senior Research Fellow at the Gorsebrook Research Institute.

François-Joseph Ruggiu is Professor of Early Modern History at the University of Paris-Sorbonne (Paris IV) – Centre Roland Mousnier (UMR 8596 – CNRS).

Matthew C. Ward is a member of the School of Humanities at the University of Dundee.

Heather Welland is a PhD candidate in the Department of History at the University of Chicago.

Index